DAVID BUSCH'S SONY® ALPHA NEX-7

GUIDE TO DIGITAL PHOTOGRAPHY

David D. Busch

Course Technology PTR

A part of Cengage Learning

David Busch's Sony® Alpha NEX-7 Guide to Digital Photography David D. Busch

Publisher and General Manager, Course Technology PTR:Stacy L. Hiquet

Associate Director of Marketing:Sarah Panella

Manager of Editorial Services: Heather Talbot

Senior Marketing Manager: Mark Hughes

Executive Editor:

Project Editor: Jenny Davidson

Kevin Harreld

Series Technical Editor: Michael D. Sullivan

Interior Layout Tech:
Bill Hartman

Cover Designer:

Mike Tanamachi

Indexer:Katherine Stimson

Proofreader:Sara Gullion

© 2013 David D. Busch

ALL RIGHTS RESERVED. No part of this work covered by the copyright herein may be reproduced, transmitted, stored, or used in any form or by any means graphic, electronic, or mechanical, including but not limited to photocopying, recording, scanning, digitizing, taping, Web distribution, information networks, or information storage and retrieval systems, except as permitted under Section 107 or 108 of the 1976 United States Copyright Act, without the prior written permission of the publisher.

For product information and technology assistance, contact us at Cengage Learning Customer & Sales Support, 1-800-354-9706.

For permission to use material from this text or product, submit all requests online at **cengage.com/permissions**.

Further permissions questions can be emailed to permissionrequest@cengage.com.

Sony and Alpha are registered trademarks of Sony Corporation. All other trademarks are the property of their respective owners.

All images © David D. Busch unless otherwise noted.

Library of Congress Control Number: 2012930935

ISBN-13: 978-1-133-59745-2

ISBN-10: 1-133-59745-9

Course Technology, a part of Cengage Learning

20 Channel Center Street Boston, MA 02210 USA

Cengage Learning is a leading provider of customized learning solutions with office locations around the globe, including Singapore, the United Kingdom, Australia, Mexico, Brazil, and Japan. Locate your local office at: international.cengage.com/region.

Cengage Learning products are represented in Canada by Nelson Education. Ltd.

For your lifelong learning solutions, visit courseptr.com.

Visit our corporate website at cengage.com.

For Cathy

From the Library of: Daniel Thau Teitelbaum, M.D.

Physician, Rabbi, Photographer, Printmaker Hamilton College, Class of 1956

Acknowledgments

Once again, thanks to the folks at Course Technology PTR, who have pioneered publishing digital imaging books in full color at a price anyone can afford. Special thanks to executive editor Kevin Harreld, who always gives me the freedom to let my imagination run free with a topic, as well as my veteran production team, including project editor, Jenny Davidson and series technical editor, Mike Sullivan. Also thanks to Bill Hartman, layout; Katherine Stimson, indexing; Sara Gullion, proofreading; Mike Tanamachi, cover design; and my agent, Carole Jelen, who has the amazing ability to keep both publishers and authors happy.

Also, big thanks to the folks at Campus Camera (www.campuscamera.net), who obtained a Sony NEX-7 for me when even Sony had none to provide. Their help made it possible for me to be using this great camera and putting together this book while most Sonyphiles were still waiting for delivery.

Thanks again to master photographer Nancy Balluck for the back cover photo of yours truly (www.nancyballuckphotography.com).

About the Author

With more than a million books in print, **David D. Busch** is the world's #1-selling author of digital camera guidebooks, and one of the top authors of books on digital photography and imaging technology. He is the originator of popular series like *David Busch's Compact Field Guides*, *David Busch's Pro Secrets*, and *David Busch's Quick Snap Guides*. He has written more than 40 hugely successful guidebooks for Sony and other digital models, including the all-time #1 bestsellers for several different cameras, additional user guides for other camera models, as well as many popular books devoted to digital imaging, including *Mastering Digital SLR Photography, Third Edition* and *Digital SLR Pro Secrets*. As a roving photojournalist for more than 20 years, he illustrated his books, magazine articles, and newspaper reports with award-winning images. He's operated his own commercial studio, suffocated in formal dress while shooting weddings-for-hire, and shot sports for a daily newspaper and upstate New York college. His photos and articles have been published in *Popular Photography & Imaging, Rangefinder, The Professional Photographer*, and hundreds of other publications. He's also reviewed dozens of digital cameras for CNet and *Computer Shopper*.

When About.com named its top five books on Beginning Digital Photography, debuting at the #1 and #2 slots were Busch's *Digital Photography All-In-One Desk Reference for Dummies* and *Mastering Digital Photography*. During the past year, he's had as many as five of his books listed in the Top 20 of Amazon.com's Digital Photography Bestseller list—simultaneously! Busch's 150-plus other books published since 1983 include best-sellers like *David Busch's Quick Snap Guide to Using Digital SLR Lenses*.

Busch is a member of the Cleveland Photographic Society (www.clevelandphoto.org), which has operated continuously since 1887.

Visit his website at http://www.dslrguides.com/blog.

Contents

Preface	XV
Introduction	xvii
Chapter 1 Getting Started with Your Sony Alpha NEX-7	1
Your Out-of-Box Experience	
Initial Setup	5
Battery Included	
Final Steps	7
Formatting a Memory Card	13
Selecting a Shooting Mode	15
Choosing a Metering Mode	19
Choosing a Focus Mode	
Selecting a Focus Point	20
Other Settings	21
Adjusting White Balance and ISO	22
Using the Self-Timer	22
Using the NEX's Flash	23
An Introduction to Movie Making	24
Reviewing the Images You've Taken	25
Transferring Files to Your Computer	27
Chapter 2	
Sony Alpha NEX-7 Roadmap	31
Front View	33
The Sony Alpha's Business End	37
LCD Panel Readouts	
Going Topside	

Working with Triple-Dial-Control	49
Settings Cycles	
Underneath Your Sony Alpha	57
Lens Components	58
Chapter 3	
Setting Up Your Sony Alpha NEX-7	61
Anatomy of the Sony Alpha NEX's Menus	62
Camera Menu	
Drive Mode	
Flash Mode	
AF/MF Select	
Autofocus Area	
Autofocus Mode	
Object Tracking	
Precision Digital Zoom	
Face Detection	
Face Registration	
Smile Shutter	
Smile Detection	69
Soft Skin Effect	69
LCD Display (DISP)	70
Finder Display (DISP)	
DISP Button (Monitor)	70
Image Size Menu	76
Image Size (Still)	
Aspect Ratio	
Quality	
Image Size (3D Panorama)	
3D Panorama Direction	
Image Size (Panorama)	
Panorama Direction	
File Format (Movie)	
Record Setting (Movie)	
Brightness/Color Menu	
Exposure Compensation	
ISO	
White Balance	
Metering Mode	87

Flash Compensation	87
DRO/Auto HDR	
Picture Effect	
Creative Style	
Playback Menu	
Delete	
Slide Show	
View Mode	
Image Index	
Rotate	
Protect	
3D Viewing	
Enlarge Image	
Volume Settings	
Specify Printing	
Setup Menu	
AEL	
AF/MF Control	
Dial/Wheel Lock	
AF Illuminator	
Red Eye Reduction	
FINDER/LCD Setting	
Live View Display	
Auto Review	
Grid Line	
Peaking Level	
Peaking Color	
MF Assist	
MF Assist Time	
Color Space	
SteadyShot	
Release w/o Lens	
Eye-Start AF	
Front Curtain Shutter	
Long Exp. NR/High ISO NR	
Lens Compensation: Shading/Chromatic Aberration/Distortion.	
Movie Audio Recording	
Wind Noise Reduction	
AF Micro Adjustment	

Menu Start	115
Function Settings	115
Custom Key Settings	
Beep	
Language	116
Date/Time Setup	117
Area Setting	
Help Guide Display	
Power Save	
LCD Brightness	
Viewfinder Brightness	
Display Color	119
Wide Image	
Playback Display	119
HDMI Resolution	
CTRL for HDMI	
USB Connection	121
Cleaning Mode	121
Version	122
Demo Mode	123
Reset Default	123
Format	123
File Number	124
Folder Name	125
Select Shooting Folder	125
New Folder	
Recover Image DB	126
Display Card Space	
Upload Settings	127
Chapter 4	
Getting the Right Exposure	129
Getting a Handle on Exposure	130
How the Sony Alpha NEX Calculates Exposure	
Correctly Exposed	136
Overexposed	136
Underexposed	
Choosing a Metering Method	

Choosing an Exposure Method	141
Aperture Priority	
Shutter Priority	144
Program Auto Mode	145
Making Exposure Value Changes	
Manual Exposure	146
Adjusting Exposure with ISO Settings	148
Bracketing	149
Dealing with Noise	150
Fixing Exposures with Histograms	152
Automatic and Specialized Shooting Modes	156
Intelligent Auto and Scene Modes	156
Anti Motion Blur and Panorama Modes	158
Chapter 5	
Mastering the Mysteries of Autofocus	163
Getting into Focus	163
Focus Modes and Options	
Focus Pocus	
Adding Circles of Confusion	
Making Sense of Sensors and Autofocus Points	
Using Manual Focus.	
Your Autofocus Mode Options	
Setting the AF Area	
AF Lock	
Focus Stacking	
Todas stacking	
Chapter 6	
•	
Advanced Shooting with Your Sony	4.04
Alpha NEX-7	181
Exploring Ultra-Fast Exposures	182
Long Exposures	185
Three Ways to Take Long Exposures	
Working with Long Exposures	
Delayed Exposures	
Continuous Shooting	192

Setting Image Parameters	
Customizing White Balance	
Fine-Tuning Preset White Balance	
Setting White Balance by Color Temperature	
Setting a Custom White Balance	
Image Processing	
D-Range Optimizer and In-Camera HDR	
HDR in Post-Processing	
Using Creative Styles	
Wi-Fi	
Tablets, Smart Phones, and the NEX-7	
What Else Can You Do with Them?	215
Chapter 7	
Movie Making with Your Sony Alpha NEX-7	217
Some Fundamentals	217
Preparing to Shoot Video	219
More About Frame Rates and Formats	221
Steps During Movie Making	223
Tips for Shooting Better Video	
Keep Things Stable and on the Level	224
Shooting Script	225
Storyboards	225
Storytelling in Video	225
Composition	226
Lighting for Video	
Audio	
Lens Craft	236
01	
Chapter 8	
Working with Lenses	239
But Don't Forget the Crop Factor	
Choosing a Lens	
Using the LA-EA1 and LA-EA2 Adapters	
Other Lens Options	
Using the Lensbaby	

What Lenses Can Do for You. Categories of Lenses. Using Wide-Angle and Wide-Zoom Lenses. Avoiding Potential Wide-Angle Problems Using Telephoto and Tele-Zoom Lenses. Avoiding Telephoto Lens Problems. Telephotos and Bokeh	
Fine-Tuning the Focus of Your Lenses	
Lens Tune-Up	
SteadyShot and Your Lenses	
Charten 0	
Chapter 9	271
Making Light Work for You	
Continuous Illumination versus Electronic Flash	
Continuous Lighting Basics	
Daylight	
Incandescent/Tungsten Light	
Fluorescent Light/Other Light Sources	
Adjusting White Balance	
Electronic Flash Basics	
Avoiding Sync Speed Problems	
Ghost Images	
Using the Built-in Flash	
Flash Exposure Compensation	
Red Eye Reduction	
Using the External Electronic Flash	
HVL-F58AM Flash Unit	
HVL-F43AM Flash Unit	
HVL-F36ΛM Flash Unit	
HVL-F20AM Flash Unit	
More Advanced Lighting Techniques	
Diffusing and Softening the Light	
Using Multiple Light Sources	
Other Lighting Accessories	297

Chapter 10	
Downloading and Editing Your Images	301
What's in the Box?	301
Picture Motion Browser	302
Image Data Lightbox SR	303
Image Data Converter SR	304
Transferring Your Photos	306
Using a Card Reader and Software	
Dragging and Dropping	309
Editing Your Photos	
Image Editors	
RAW Utilities	311
Sony Alpha NEX-7: Troubleshooting and Prevention	
Trevention	317
Updating Your Firmware	
	318
Updating Your Firmware	318
Updating Your Firmware	318 320 321 323
Updating Your Firmware	318 320 321 323
Updating Your Firmware	318 320 321 323 324 326
Updating Your Firmware	318 320 321 323 324 326 327
Updating Your Firmware	318 320 321 323 324 326 327
Updating Your Firmware	318 320 321 323 324 326 327 328
Updating Your Firmware	318 320 321 323 324 326 327 328
Updating Your Firmware	318 320 321 323 324 326 327 328

Preface

A camera with 24 megapixels of resolution, continuous shooting at up to 10 frames per second, full high-definition movie making, and a full range of professional features priced at around \$1,400 for the body alone? No wonder you're excited about the new Sony NEX-7 camera! You don't expect to take good pictures with such a camera—you demand *outstanding* photos. After all, this Alpha model is one of the most innovative cameras that Sony has ever introduced. This model is the flagship of Sony's NEX product line, a whole new type of picture-taking machine, combining a tiny, mirrorless body with the same large 24-megapixel sensor found in bulky digital "mirrored" models (like Sony's own SLT lines), interchangeable lenses, and the kind of full control over settings and features that serious photographers demand.

But your gateway to pixel proficiency is dragged down by the slim little book included in the box as a manual. You know everything you need to know is in there, somewhere, but you don't know where to start. In addition, the camera manual doesn't offer much information on photography or digital photography. Nor are you interested in spending hours or days studying a comprehensive book on digital SLR photography that doesn't necessarily apply directly to your Alpha NEX-7.

What you need is a guide that explains the purpose and function of the Alpha's basic controls, how you should use them, and why. Ideally, there should be information about file formats, resolution, aperture/priority exposure, and special autofocus modes available, but you'd prefer to read about those topics only after you've had the chance to go out and take a few hundred great pictures with your new camera. Why isn't there a book that summarizes the most important information in its first two or three chapters, with lots of full-color illustrations showing what your results will look like when you use this setting or that?

Now there is such a book. If you want a quick introduction to the Alpha's focus controls, flash synchronization options, how to choose lenses, or which exposure modes are best, this book is for you. If you can't decide on what basic settings to use with your camera because you can't figure out how changing ISO or white balance or focus defaults will affect your pictures, you need this guide.

Introduction

Sony doesn't play it safe. Sony doesn't stick to the old digital camera paradigms and technology. At a time when the top dogs in the digital camera world are vying to produce the best digital SLRs and newest full-frame camera models, Sony has concentrated on non-dSLR cameras, including mirrorless models like the Sony Alpha NEX-7.

With this camera, Sony has packaged up the most alluring features of advanced digital SLRs and stuffed them into a compact, highly affordable body, which boasts some features you won't find on other cameras. The NEX-7 boasts a body that is, minus your choice of lens, as compact as any point-and-shoot camera. But, tucked inside is a large 24-megapixel sensor with the same size, light gathering power, and resolution of those found in the typical digital SLR. Add in the ability to use an expanding roster of interchangeable lenses, programmable "soft" keys, and a reasonably affordable price tag, and you have a compact camera that sacrifices nothing in terms of features and capabilities. The original products in the NEX lineup were great, and the new NEX-7 is even better.

You'll find your new camera is loaded with features that few would have expected to find in such a basic camera. Indeed, the Alpha retains the ease of use that smoothes the transition for those new to digital photography. For those just dipping their toes into the digital pond, the experience is warm and inviting. The Sony Alpha NEX-7 isn't a snapshot camera— it is a point-and-shoot (if you want to use it in that mode) for the thinking photographer.

But once you've confirmed that you made a wise purchase, the question comes up, *how do I use this thing?* All those cool features can be mind numbing to learn, if all you have as a guide is the manual furnished with the camera. Help is on the way. I sincerely believe that this book is your best bet for learning how to use your new camera, and for learning how to use it well.

If you're a Sony Alpha NEX-7 owner who's looking to learn more about how to use your camera, you've probably already explored your options. There are DVDs and online tutorials—but who can learn how to use a camera by sitting in front of a television or computer screen? Do you want to watch a movie or click on HTML links, or do you want to go out and take photos with your camera? Videos are fun, but not the best answer.

There's always the manual furnished with the Alpha. It's compact and filled with information, but there's really very little about *why* you should use particular settings or features, and its organization may make it difficult to find what you need. Multiple cross-references may send you flipping back and forth between two or three sections of the book to find what you want to know. The basic manual is also hobbled by black-and-white line drawings and tiny monochrome pictures that aren't very good examples of what you can do.

Also available are third-party guides to the Alpha, like this one. I haven't been happy with some of these guidebooks, which is why I wrote this one. The existing books range from skimpy and illustrated with black-and-white photos to lushly illustrated in full color but too generic to do much good. Photography instruction is useful, but it needs to be related directly to the Sony Alpha as much as possible.

I've tried to make *David Busch's Sony Alpha NEX-7 Guide to Digital Photography* different from your other Alpha learn-up options. The roadmap sections use larger, color pictures to show you where all the buttons and dials are, and the explanations of what they do are longer and more comprehensive. I've tried to avoid overly general advice, including the two-page checklists on how to take a "sports picture" or a "portrait picture" or a "travel picture." Instead, you'll find tips and techniques for using all the features of your Sony Alpha to take *any kind of picture* you want. If you want to know where you should stand to take a picture of a quarterback dropping back to unleash a pass, there are plenty of books that will tell you that. This one concentrates on teaching you how to select the best autofocus mode, shutter speed, f/stop, or flash capability to take, say, a great sports picture under any conditions.

This book is not a lame rewriting of the manual that came with the camera. Some folks spend five minutes with a book like this one, spot some information that also appears in the original manual, and decide "Rehash!" without really understanding the differences. Yes, you'll find information here that is also in the owner's manual, such as the parameters you can enter when changing your Alpha's operation in the various menus. Basic descriptions—before I dig in and start providing in-depth tips and information—may also be vaguely similar. There are only so many ways you can say, for example, "Hold the shutter release down halfway to lock in exposure." But not *everything* in the manual is included in this book. If you need advice on when and how to use the most important functions, you'll find the information here.

David Busch's Sony Alpha NEX-7 Guide to Digital Photography is aimed at both Sony veterans as well as newcomers to digital photography. Both groups can be overwhelmed by the options the Alpha offers, while underwhelmed by the explanations they receive in their user's manual. The manuals are great if you already know what you don't know, and you can find an answer somewhere in a booklet arranged by menu listings and written by a camera vendor employee who last threw together instructions on how to operate a camcorder.

Why the Sony Alpha NEX-7 Needs Special Coverage

There are many general digital photography books on the market. Why do I concentrate on books about specific digital cameras like the Alpha? When I started writing digital photography books in 1995, advanced digital cameras cost \$30,000 and few people other than certain professionals could justify them. Most of my readers a dozen years ago were stuck using the point-and-shoot low-resolution digital cameras of the time—even if they were advanced photographers. I took thousands of digital pictures with an Epson digital camera with 1024×768 (less than 1 megapixel!) resolution, and which cost \$500.

As recently as 2003 (years before the original Alpha was introduced), the lowest-cost enthusiast models were priced at \$3,000 or more. Today, a fraction of that amount buys you a sophisticated model like the Sony Alpha NEX-7 (with lens). The advanced digital camera is no longer the exclusive bailiwick of the professional, the wealthy, or the serious photography addict willing to scrimp and save to acquire a dream camera. Digital models have become the favored camera for anyone who wants to go beyond point-and-shoot capabilities.

Who Are You?

When preparing a guidebook for a specific camera, it's always wise to consider exactly who will be reading the book. Indeed, thinking about the potential audience for *David Busch's Sony Alpha NEX-7 Guide to Digital Photography* is what led me to taking the approach and format I use for this book. I realized that the needs of readers like you had to be addressed both from a functional level (what you will use the Sony Alpha NEX-7 for) as well as from a skill level (how much experience you may have with digital photography, or a Sony camera specifically).

From a functional level, you probably fall into one of these categories:

- Professional photographers who understand photography and digital cameras, and simply want to learn how to use the Sony Alpha NEX 7 as a backup camera, or as a camera for personal "off-duty" use.
- Individuals who want to get better pictures, or perhaps transform their growing interest in photography into a full-fledged hobby or artistic outlet with a Sony Alpha and advanced techniques.
- Those who want to produce more professional-looking images for their personal or business website, and feel that the Sony Alpha will give them more control and capabilities.

- Small business owners with more advanced graphics capabilities who want to use the Sony Alpha NEX-7 to document or promote their business.
- Corporate workers who may or may not have photographic skills in their job descriptions, but who work regularly with graphics and need to learn how to use digital images taken with a Sony Alpha for reports, presentations, or other applications.
- Professional webmasters with strong skills in programming (including Java, JavaScript, HTML, Perl, etc.) but little background in photography, but who realize that the Sony Alpha can be used for sophisticated photography.
- Graphic artists and others who already may be adept in image editing with Photoshop or another program, and who may have used an advanced film camera in the past, but who need to learn more about digital photography and the special capabilities of the Sony.

Addressing your needs from a skills level can be a little trickier, because the Sony Alpha is such a great camera that a full spectrum of photographers will be buying it, from absolute beginners who have never owned a digital camera before up to the occasional professional with years of shooting experience who will be using the Sony Alpha as a backup body.

Before tackling this book, it would be helpful for you to understand the following:

- What an advanced digital camera is: It's a camera that generally shows a view of the picture that's being taken through the interchangeable lens that actually takes the photo.
- How digital photography differs from film: The image is stored not on film (which I call the *first* write-once optical media), but on a memory card as pixels that can be transferred to your computer, and then edited, corrected, and printed without the need for chemical processing.
- What the basic tools of correct exposure are: Don't worry if you don't understand these; I'll explain them later in this book. But if you already know something about shutter speed, aperture, and ISO sensitivity, you'll be ahead of the game. If not, you'll soon learn that shutter speed determines the amount of time the sensor is exposed to incoming light; the f/stop or aperture is like a valve that governs the quantity of light that can flow through the lens; the sensor's sensitivity (ISO setting) controls how easily the sensor responds to light. All three factors can be varied individually and proportionately to produce a picture that is properly exposed (neither too light nor too dark).

It's tough to provide something for everybody, but I am going to try to address the needs of each of the following groups and skill levels:

- Digital photography newbies: If you've used only point-and-shoot digital cameras, or have worked only with film cameras, you're to be congratulated for selecting one of the very best entry-level enthusiast digital cameras available as your first camera. This book can help you understand the controls and features of your Sony Alpha, and lead you down the path to better photography with your camera. I'll provide all the information you need, but if you want to do some additional reading for extra credit, you can also try one of the other books I mentioned earlier. They complement this book well.
- Advanced point-and-shooters moving on up: There are some quite sophisticated pocket-sized digital cameras available, including those with many user-definable options and settings, so it's possible you are already a knowledgeable photographer, even though you're new to the world of the advanced digital model. You've recognized the limitations of the point-and-shoot camera: even the best of them have more noise at higher sensitivity (ISO) settings than a camera like the Sony Alpha; the speediest still have an unacceptable delay between the time you press the shutter and when the photo is actually taken; even a non-interchangeable super-zoom camera with 12X to 20X magnification often won't focus close enough, include an aperture suitable for low-light photography, or take in the really wide view you must have. Interchangeable lenses and other accessories available for the Sony Alpha NEX-7 are another one of the reasons you moved up. Because you're an avid photographer already, you should pick up the finer points of using the Sony Alpha from this book with no trouble.
- Film veterans new to the digital world: You understand photography, you know about f/stops and shutter speeds, and you thrive on interchangeable lenses. If you have used a newer film camera, it probably has lots of electronic features already, including autofocus and sophisticated exposure metering. Perhaps you've even been using a Minolta film SLR (a distant predecessor of the current Alphas) and understand many of the available accessories that work with both film and digital cameras. All you need is information on using digital-specific features, working with the Sony Alpha itself, and how to match—and exceed—the capabilities of your film camera with your new Sony Alpha NEX-7.
- Experienced users broadening their experience to include the Sony Alpha NEX-7: Perhaps you started out with a Sony or Konica Minolta digital SLR. You may have used a digital SLR from another vendor and are making the switch to a camera with a more compact size. You understand basic photography, and want to learn more. And, most of all, you want to transfer the skills you already have to the Sony Alpha, as quickly and seamlessly as possible.

■ Pro photographers and other advanced shooters: I expect my most discerning readers will be those who already have extensive experience with other advanced cameras. I may not be able to teach you folks much about photography. But, even so, an amazing number of Sony Alpha NEX-7 cameras have been purchased by those who feel it is a good complement or backup to their favorite advanced Sony model. That's the case with me. I use both an Alpha SLT-A77 and an NEX-7. With their matching 24MP resolution and quite a few similar features, they make an excellent pair. As you'll learn in Chapters 8 and 9, I am even able to use my A77's lenses and electronic flash units on my NEX-7.

Who Am I?

After spending years as the world's most successful unknown author, I've become slightly less obscure in the past few years, thanks to a horde of camera guidebooks and other photographically oriented tomes. You may have seen my photography articles in Popular Photography & Imaging magazine. I've also written about 2,000 articles for magazines like Petersen's PhotoGraphic (which is now defunct through no fault of my own), plus Rangefinder, Professional Photographer, and dozens of other photographic publications. But, first, and foremost, I'm a photojournalist and made my living in the field until I began devoting most of my time to writing books. Although I love writing, I'm happiest when I'm out taking pictures, which is why during the past 12 months I've taken off chunks of time to travel to Ireland and Salamanca, Spain. The past 18 months also took me to Zion National Park in Utah, the Sedona "red rocks" area and Grand Canyon in Arizona, Major League Baseball Spring training, and, for a few days, Las Vegas (I did a lot more shooting than gambling in Sin City). You'll find photos of some of these visual treats within the pages of this book.

Like all my digital photography books, this one was written by someone with an incurable photography bug. One of my first SLRs was a Minolta SRT-101, from the company whose technology was eventually absorbed by Sony in 2006. I've used a variety of newer models since then. I've worked as a sports photographer for an Ohio newspaper and for an upstate New York college. I've operated my own commercial studio and photo lab, cranking out product shots on demand and then printing a few hundred glossy 8 × 10s on a tight deadline for a press kit. I've served as a photo-posing instructor for a modeling agency. People have actually paid me to shoot their weddings and immortalize them with portraits. I even prepared press kits and articles on photography as a PR consultant for a large Rochester, N.Y., company, which once an icon of photography, has fallen on harder times and shall remain nameless. My trials and travails with imaging and computer technology have made their way into print in book form an alarming number of times, including a few dozen on scanners and photography.

Like you, I love photography for its own merits, and I view technology as just another tool to help me get the images I see in my mind's eye. But, also like you, I had to master this technology before I could apply it to my work. This book is the result of what I've learned, and I hope it will help you master your Sony Alpha NEX-7, too.

In closing, I'd like to ask a special favor: let me know what you think of this book. If you have any recommendations about how I can make it better, visit my website at www.dslrguides.com/blog, click on the E-Mail Me tab, and send your comments, suggestions on topics that should be explained in more detail, or, especially, any typos. (The latter will be compiled on the Errata page you'll also find on my website.) I really value your ideas, and appreciate it when you take the time to tell me what you think! Some of the content of the book you hold in your hands came from suggestions I received from readers like yourself. If you found this book especially useful, tell others about it. Visit http://www.amazon.com/dp/1133597459 and leave a positive review. Your feedback is what spurs me to make each one of these books better than the last. Thanks!

Getting Started with Your Sony Alpha NEX-7

Don't panic if you opened this book to the "Getting Started..." chapter and realized that you've already taken several hundred or a thousand (or two) photos. While the information in this chapter is designed to get the rawest beginner up and running with the Sony Alpha NEX-7 quickly, you'll find that the advice I'm about to offer is even more useful for those who have already become somewhat comfortable with this well-designed (yet complex) camera. You can zip right through the basics, and then dive into learning a few things you probably didn't know about your NEX-7.

Fortunately, this camera is incredibly easy to use, right out of the box, especially for the absolute beginner. Even the newest digital camera owner can start taking great pictures with about five seconds of effort. Just flick the power switch to On, press the metallic MENU button to the right of the display screen, select Shoot Mode on the menu, and spin the selection dial on the back of the camera to move the green Intelligent Auto icon next to the gray selection mark. And press the large silver button in the middle of the control wheel to confirm your choice.

Preparing for those steps by charging the battery, mounting a lens, and inserting a Secure Digital or Memory Stick memory card isn't exactly rocket science, either. Sony has cleverly marked the power switch (located at the far right of the top of the camera, concentric with the shutter release button) with large ON and OFF labels, and the menu system provides very informative descriptions of each option as you spin the virtual dial on the screen by using the physical dial on the back of the camera. If you select the SCN shooting mode, the camera will present you with another dial's worth

of icons for Scene modes that will let you take excellent shots of people, landscapes, flowers, night scenes, and more. These icons are accompanied not just by text descriptions on the display, but also by photographic examples of the shots you can take with each setting.

So, budding photographers are likely to muddle their way through getting the camera revved up and working well enough to take a bunch of pictures without the universe collapsing. Eventually, though, many may turn to this book when they realize that they can do an even better job with a little guidance.

Also, I realize that most of you didn't buy this book at the same time you purchased your Sony Alpha NEX. As much as I'd like to picture thousands of avid photographers marching out of their camera stores with an Alpha NEX-7 box under one arm, and my book in hand, I know that's not going to happen *all* the time. A large number of you had your camera for a week, or two, or a month, became comfortable with it, and sought out this book in order to learn more. So, a chapter on "setup" seems like too little, too late, doesn't it?

In practice, though, it's not a bad idea, once you've taken a few orientation pictures with your camera, to go back and review the basic operations of the camera from the beginning, if only to see if you've missed something. This chapter is my opportunity to review the setup procedures for the camera for those among you who are already veteran users, and to help ease the more timid (and those who have never before worked with an interchangeable-lens camera) into the basic pre-flight checklist that needs to be completed before you really spread your wings and take off. For the uninitiated, as easy as it is to use initially, the Sony Alpha NEX *does* have some dials and buttons, especially those two mysterious (but useful) control dials on the top surface that might not make sense at first, but will surely become second nature after you've had a chance to review the instructions in this book.

But don't fret about wading through a manual to find out what you must know to take those first few tentative snaps. I'm going to help you hit the ground running with this chapter (or keep on running if you've already jumped right in). If you *haven't* had the opportunity to use your Alpha NEX yet, I'll help you set up your camera and begin shooting in minutes. You won't find a lot of detail in this chapter. Indeed, I'm going to tell you just what you absolutely *must* understand, accompanied by some interesting tidbits that will help you become acclimated. I'll go into more depth and even repeat some of what I explain here in later chapters, so you don't have to memorize everything you see. Just relax, follow a few easy steps, and then go out and begin taking your best shots—ever.

Your Out-of-Box Experience

Your Sony Alpha NEX comes in an attractive box filled with stuff, including USB cable, instructions, a CD, some pamphlets, and a few other items. The most important components are the camera and lens, battery, battery charger, the flash unit, and, if you're the nervous type, the neck strap. You'll also need a Secure Digital or Memory Stick card, as one is not included. If you purchased your Alpha from a camera shop, the store personnel may have attached the neck strap for you, run through some basic operational advice that you've already forgotten, tried to sell you a memory card, and then, after they'd given you all the help you could absorb, sent you on your way with a handshake.

Perhaps you purchased your Sony Alpha from one of those mass merchandisers that also sell washing machines and vacuum cleaners. In that case, you might have been sent on your way with only the handshake, or, maybe, not even that if you resisted the hardsell efforts to sell you an extended warranty. You save a few bucks at the big-box stores, but you don't get the personal service a professional photo retailer provides. It's your choice. There's a third alternative, of course. You might have purchased your camera from a mail order or Internet source, and your camera arrived in a big brown (or purple/red) truck. Your only interaction when you took possession of your camera was to scrawl your signature on an electronic clipboard.

In all three cases, the first thing to do is to carefully unpack the camera and double-check the contents with the checklist on one side of the box. While this level of setup detail may seem as superfluous as the instructions on a bottle of shampoo, checking the contents *first* is always a good idea. No matter who sells a camera, it's common to open boxes, use a particular camera for a demonstration, and then repack the box without replacing all the pieces and parts afterwards. Someone actually might have helpfully checked out your camera on your behalf—and then mispacked the box. It's better to know *now* that something is missing so you can seek redress immediately, rather than discover two months from now that the USB cable you thought you'd never use (but now *must* have) was never in the box.

So, check the box at your earliest convenience, and make sure you have (at least) the following:

■ Sony Alpha NEX-7 camera. This is hard to miss. The camera, accompanied by an eyepiece cup and cleaning cloth, is the main reason you laid out the big bucks, and it is tucked away inside a nifty protective envelope you should save for re-use in case the Alpha needs to be sent in for repair. It almost goes without saying that you should check out the camera immediately, making sure the color LCD on the back isn't scratched or cracked, the battery compartment and connection port doors open properly, and, when a charged battery is inserted and lens mounted, the camera powers up and reports for duty. Out-of-the-box defects in these areas are

rare, but they can happen. It's probably more common that your dealer played with the camera or, perhaps, it was a customer return. That's why it's best to buy your Alpha from a retailer you trust to supply a factory-fresh camera.

- Lens. You can buy the NEX-7 with or without a lens. I bought mine with the Sonar T* E 24mm F/1.8 ZA lens, because I already had purchased other "E" mount lenses for my previous NEX cameras. You should be able to buy the camera in a kit, too, with one or both of two other "E" series Sony lenses: the 18-55mm zoom lens, or the 16mm ultra-thin "pancake" wide-angle lens. In that case, one of these lenses will accompany the camera. I discuss your lens options in detail in Chapter 8.
- Battery pack NP-FW50. The power source for your Sony Alpha is packaged separately. It should be charged as soon as possible (as described next) and inserted in the camera. It's smart to have more than one battery pack (a spare costs about \$80, though prices may go down as generic or "clone" batteries appear), so you can continue shooting when your battery is discharged or, after many uses, peters out entirely. Make sure you get this model number of battery; while it will work in several earlier NEX models, it is different from the batteries used in some earlier Sony dSLRs, and this is the *only* battery that will work in your NEX-7.
- Battery charger BC-VW1. This battery charger will be included.
- Shoulder strap. Sony provides you with a suitable neck or shoulder strap, with the Sony logo subtly worked into the design. While I am justifiably proud of owning a fine Sony camera, I never attach the factory strap to my camera, and instead opt for a more serviceable strap from UPstrap (www.upstrap-pro.com). If you carry your camera over one shoulder, as many do, I particularly recommend UPstrap (shown in Figure 1.1). It has a patented non-slip pad that offers reassuring traction and eliminates the contortions we sometimes go through to keep the camera from slipping off. I know several photographers who refuse to use anything else. If you do purchase an UPstrap, be sure to tell photographer-inventor Al Stegmeyer that I sent you hence.
- **USB cable.** This is the USB cable that is used to link your Sony Alpha NEX to a computer, and it is especially useful when you need to transfer pictures but don't have a card reader handy. This cable also is needed when you have occasion to upgrade the camera's firmware, an operation that I'll discuss in Chapter 11.
- **Application software CD.** The disk contains useful software that will be discussed in more detail in Chapter 10.
- **Printed instruction manual.** The camera comes with a brief printed instruction booklet; a longer guide to the camera's operation is included on the software CD. There will also be assorted pamphlets listing accessories, lenses, and warranty and registration information.

Figure 1.1
Third-party
neck straps, like
this UPstrap
model, are often
preferable to the
Sony-supplied
strap.

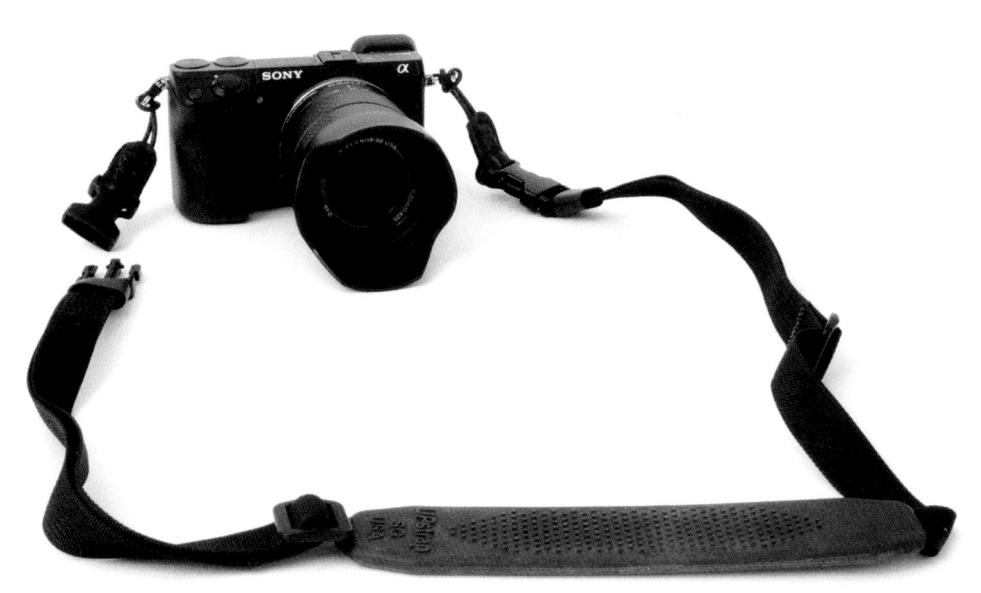

Initial Setup

The initial setup of your Sony Alpha NEX is fast and easy. Basically, you just need to charge the battery, attach a lens (if that hasn't already been done), and insert a memory card. I'll address each of these steps separately, but if you already feel you can manage these setup tasks without further instructions, feel free to skip this section entirely. You should probably at least skim its contents, however, because I'm going to list a few options that you might not be aware of.

Battery Included

Your Sony Alpha NEX is a sophisticated hunk of machinery and electronics, but it needs a charged battery to function, so rejuvenating the NP-FW50 lithium-ion battery pack furnished with the camera should be your first step. A fully charged power source should be good for approximately 430 shots under normal temperature conditions, based on standard tests defined by the Camera & Imaging Products Association (CIPA) document DC-002. The calculated figures assume you'll be using the back-panel color LCD for viewing and review; if you work with the internal electronic viewfinder (EVF) most of the time, you can expect to take fewer shots (perhaps 350 or fewer) before it's time for a recharge. Also, optional actions like picture review can use up more power than you might expect. If your pictures are important to you, always take along one spare, fully charged battery.

And remember that all rechargeable batteries undergo some degree of self-discharge just sitting idle in the camera or in the original packaging. Lithium-ion power packs of this type typically lose a small amount of their charge every day, even when the camera isn't

turned on. Li-ion cells lose their power through a chemical reaction that continues when the camera is switched off. So, it's very likely that the battery purchased with your camera, even if charged at the factory, has begun to poop out after the long sea voyage on a banana boat (or, more likely, a trip by jet plane followed by a sojourn in a warehouse), so you'll want to revive it before going out for some serious shooting.

Charging the Battery

When the battery is inserted into the charger properly (it's impossible to insert it incorrectly), a Charge light begins glowing yellow-orange, without flashing. It continues to glow until the battery completes the charge and the lamp turns off. (See Figure 1.2.) Be sure to plan for charging time before your shooting sessions, because the battery for this camera takes a long time to charge—about 250 minutes to fully restore a completely depleted battery. The full charge is complete about one hour after the charging lamp turns off, so if your battery was really dead, don't remove it from the charger until the additional time has elapsed.

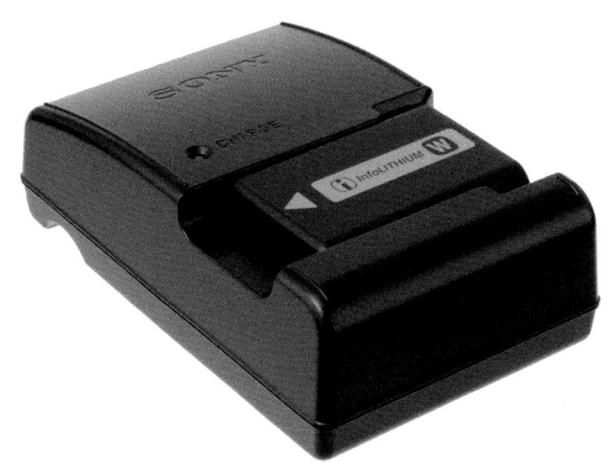

Figure 1.2
The BC-VW1 charger takes about four hours to provide a normal charge to the battery pack.

If the charging lamp flashes when you insert the battery, that indicates an error condition. Make sure you have the correct model number of battery and that the charger's contacts (the shiny metal prongs that connect to the battery) are clean. Fast flashing that can't be stopped by re-inserting the battery indicates a problem with the battery. Slow flashing (about 1.5 seconds between flashes) means the ambient temperature is too high or low for charging to take place.

When the battery is charged, slide the latch on the bottom of the camera, open the battery door, and ease the battery in with the three contact openings facing down into the compartment (see Figure 1.3). To remove the battery, you must press a blue lever in the battery compartment that prevents the pack from slipping out when the door is opened. (See Figure 1.4.)

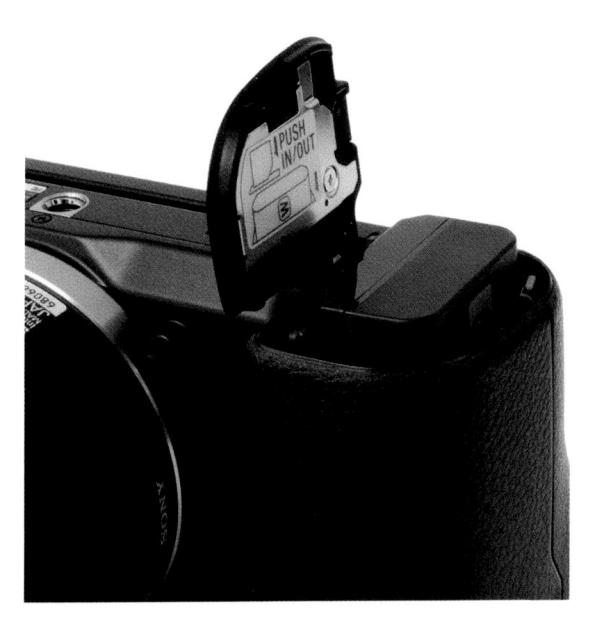

Figure 1.3 Insert the battery in the camera; it only fits one way.

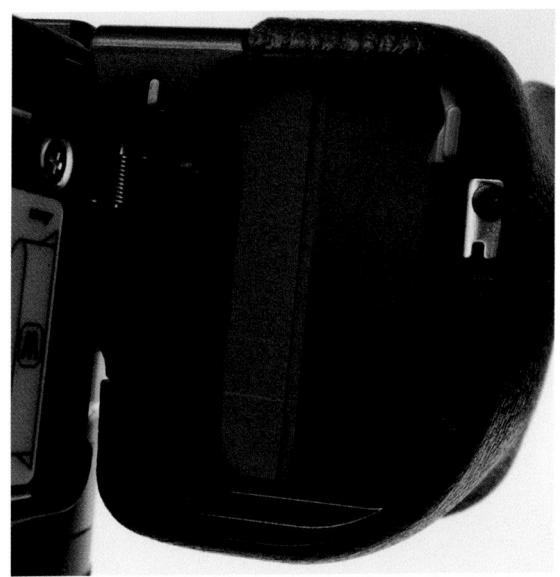

Figure 1.4 To remove the battery, press the blue battery release lever.

Final Steps

Your Sony Alpha NEX is almost ready to fire up and shoot. You'll need to select and mount a lens (if necessary) and insert a memory card. Each of these steps is easy, and if you've used any similar camera in the past, such as a Sony or other brand of dSLR, you already know exactly what to do. I'm going to provide a little extra detail for those of you who are new to the Sony or interchangeable-lens camera worlds.

Mounting the Lens

Of course, as I noted, it's possible that your Sony Alpha NEX-7 camera shipped with a kit lens already attached. It may be, though, that you purchased the camera in a "body-only" configuration, leaving it up to you to select and attach a lens, as is the case with many interchangeable lens cameras. In any event, sooner or later you're likely to want to switch to a different lens for different photographic uses, so it's important to know how to attach and remove a lens.

As you'll see, my recommended lens mounting procedure emphasizes protecting your equipment from accidental damage, and minimizing the intrusion of dust. If your Alpha has no lens attached, select the lens you want to use and loosen (but do not remove) the rear lens cap. I generally place the lens I am planning to mount vertically in a slot in my camera bag, where it's protected from mishaps but ready to pick up quickly. By loosening the rear lens cap, you'll be able to lift it off the back of the lens at the last instant, so the rear element of the lens is covered until then.

After that, remove the body cap that protects the camera's exposed sensor by rotating the cap toward the shutter release button. You should always mount the body cap when there is no lens on the camera, because it helps keep dust out of the interior of the camera, where it potentially can find its way onto the sensor. This is a particular issue with the NEX, because, unlike the case with dSLRs, there are no intermediate items protecting the sensor from exposure, such as the mirror that provides the dSLR with its view through the viewfinder or the shutter. (By the way, when I got my first NEX camera, it didn't come with a body cap, as the lens was already mounted on the camera when I bought it. If your camera didn't come with a cap, you should try to locate one through Sony or another vendor if you possibly can; a camera body should never be left with its sensor exposed.)

Once the body cap has been removed, remove the rear lens cap from the lens, set the cap aside, and then mount the lens on the camera by matching the raised white alignment indicator on the lens barrel with the white dot on the camera's lens mount (see Figure 1.5). Rotate the lens clockwise until it seats securely and clicks into place. (Don't press the lens release button during mounting.) If a lens hood is bayoneted on the lens in the reversed position (which makes the lens/hood combination more compact for transport), twist it off and remount with the rim facing outward (see Figure 1.6). A lens hood protects the front of the lens from accidental bumps, and reduces flare caused by extraneous light arriving at the front element of the lens from outside the picture area.

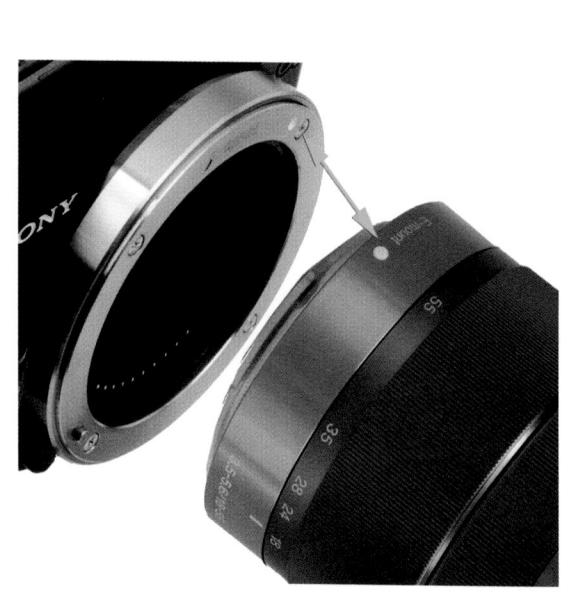

Figure 1.5 Match the raised white dot on the lens with the white dot on the camera mount to properly align the lens with the bayonet mount.

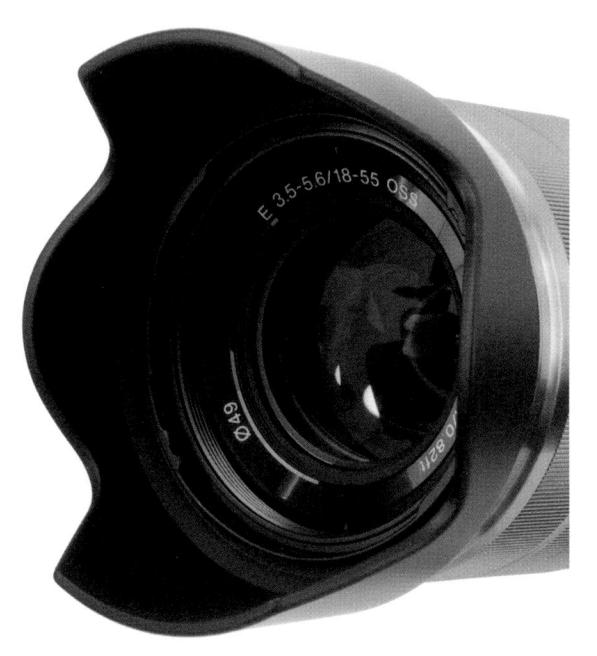

Figure 1.6 A lens hood protects the lens from extraneous light and accidental bumps.

Inserting a Memory Card

You can't take actual photos without a memory card inserted in your Sony Alpha. If you don't have a card installed, the camera will upbraid you with a No Card warning at the upper left of the LCD. If you press the shutter button anyway, the shutter will release and the camera will seem to take a picture. If you go back later and try to view that image, though, it will not be there. So, be sure you have inserted a compatible card with adequate capacity before you start shooting stills or videos.

The Alpha NEX accepts Secure Digital (SD), Secure Digital High Capacity (SDHC), and Sony Memory Stick Pro Duo (or Memory Stick Pro-HG Duo) cards. The NEX also will accept the newest type of SD card—the super-high capacity SDXC card, which, at this writing, is available in capacities of 32GB, 64GB, and 128GB. You may not want to jump on the SDXC bandwagon too quickly—the cards are pricey, costing as much as \$200 (and up), and they are not compatible with many existing card readers, and even with some computers. If you need the extra capacity and speed that these cards can provide, be sure to do some research to make sure there are no compatibility issues to surprise you.

Whichever card you decide on, it fits in the single slot underneath the battery compartment door on the bottom of the camera. You should remove the memory card only when the camera is switched off. Insert the card with the label facing toward the lens (for any type of SD card), or away from the lens if inserting any type of Memory Stick Pro card. (See Figure 1.7.) In either case, the card should be oriented so the edge with the metal contacts goes into the slot first.

Figure 1.7
The memory card is inserted in the slot on the bottom of the camera.

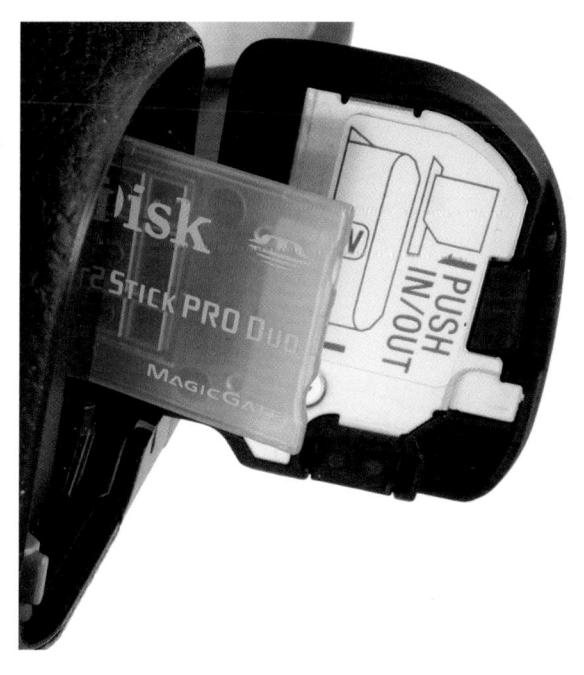

Close the door, and your pre-flight checklist is done! (I'm going to assume you remember to remove the lens cap when you're ready to take a picture!) When you want to remove the memory card later, just press down on the card edge that protrudes from the slot, and the card will pop right out.

Turn on the Power

Locate the On/Off switch that is wrapped around the shutter release button and rotate it to the On position. The camera will remain on or in a standby mode until you manually turn it off. After one minute of idling, the NEX goes into the standby mode to save battery power. Just tap the shutter release button to bring it back to life. (The one-minute time is the default setting. You can select a longer time before power-save mode kicks in through the menu system, as I discuss in Chapter 3.)

When the camera first powers up, you may be asked to set the date and time. The procedure is fairly self-explanatory (although I'll explain it in detail in Chapter 3). You can use the left/right direction buttons to navigate among the date, year, time, date format, and daylight savings time indicator, and use the up/down buttons to enter the correct settings. When finished, press the center controller button to confirm the settings and return to the menu system.

CONTROL TERMINOLOGY

Sony's nomenclature for the Alpha's controls can be confusing. The large circular pad on the back of the camera is referred to as the control wheel, and the directional/function keys at the north, south, east, west positions of this wheel are referred to only as "parts of the control wheel." The large metallic button in the center of the control wheel that activates many choices is called a soft key (officially Soft Key C), a name given to all three of the shiny metallic buttons on the right side of the camera's back. (Soft Key A is located above and to the left of Soft Key C, while Soft Key B is below and to the left of it.)

Because of this potentially confusing arrangement, for this book, I will use the term "center controller button" for the large button in the center of the control wheel (Soft Key C), and I will refer to the upper and lower soft keys as—the upper and lower soft keys. I will refer to the four outer positions on the control wheel as the left/right and up/down direction buttons when they're used for navigation, and by their functions (DISP, Drive Mode, Flash Mode, etc.) when they are used to select various settings.

The NEX-7 also has two control *dials* on top of the camera (see Figure 1.8), called control dial L and control dial R (for left and right).

The final important control, not seen in the figure, is the navigation button (located to the right of the shutter release button), which is pressed repeatedly to assign different functions to Dial L and Dial R. I'll explain the various ways to use these dials, wheels, and buttons as we go along, with detailed explanations in Chapter 2. For now, I just wanted to get the terminology straight.

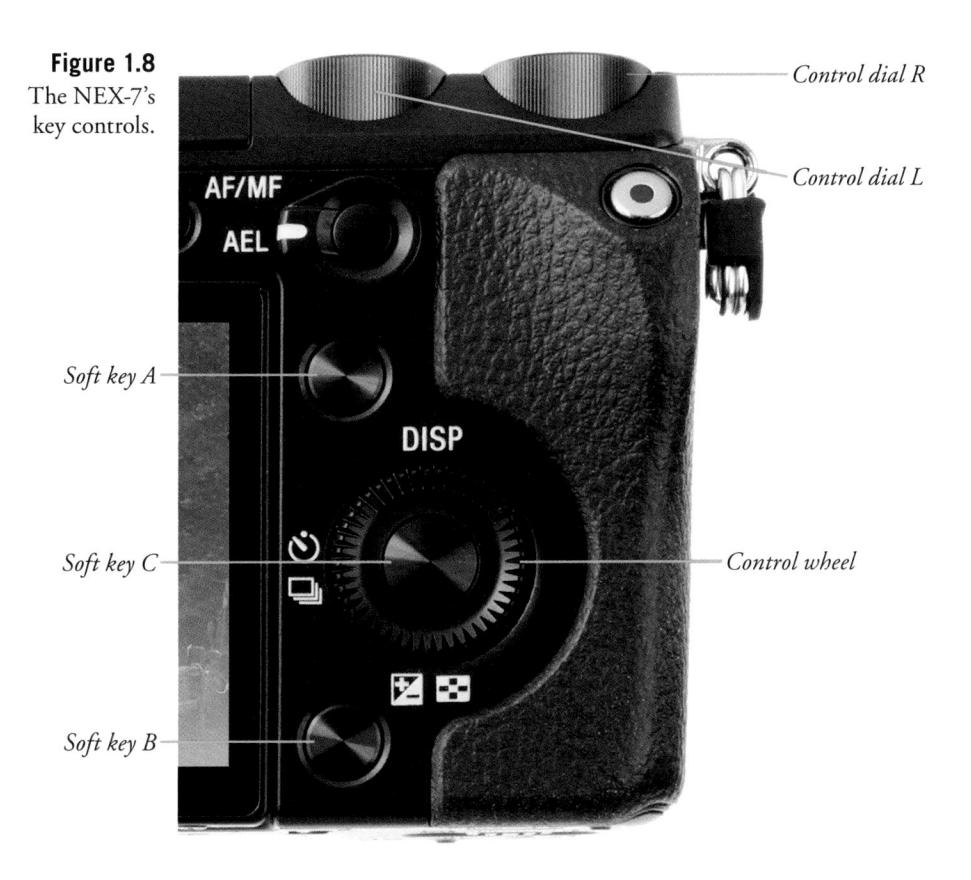

Once the Sony Alpha is satisfied that it knows what time it is, you will still be viewing the camera's menu system. Look at the top right of the LCD display, where you should see the word "MENU" next to an image that looks like the metallic button at the top of the camera's back. This is the NEX's way of telling you to press the upper soft key to go back one level. In this case, if you press that key, you should be taken back to the main menu screen, which has six icons showing the six main selections you can make—Shoot Mode, Camera, Image Size, Brightness/Color, Playback, and Setup.

From the main menu screen, press the upper soft key again or just tap lightly on the shutter release button, and the live view display should appear on the LCD. The live view display shows the scene the camera is aimed at, overlaid with icons and numbers showing the basic settings of the camera, including current shutter speed and lens opening, shooting mode, ISO sensitivity, and other parameters. Press the DISP button (up direction button) to produce this screen if you want to activate this display when it has gone dark. There are several versions, a standard display (see Figure 1.9), and a graphic display (Figure 1.10), along with a screen with a bare minimum of information—aperture, shutter speed, and exposure compensation (if any) are shown, and the same screen with a histogram displayed. I'll explain these features in more detail in later chapters of this book (especially in Chapter 4, which deals with exposure and histograms).

Figure 1.9

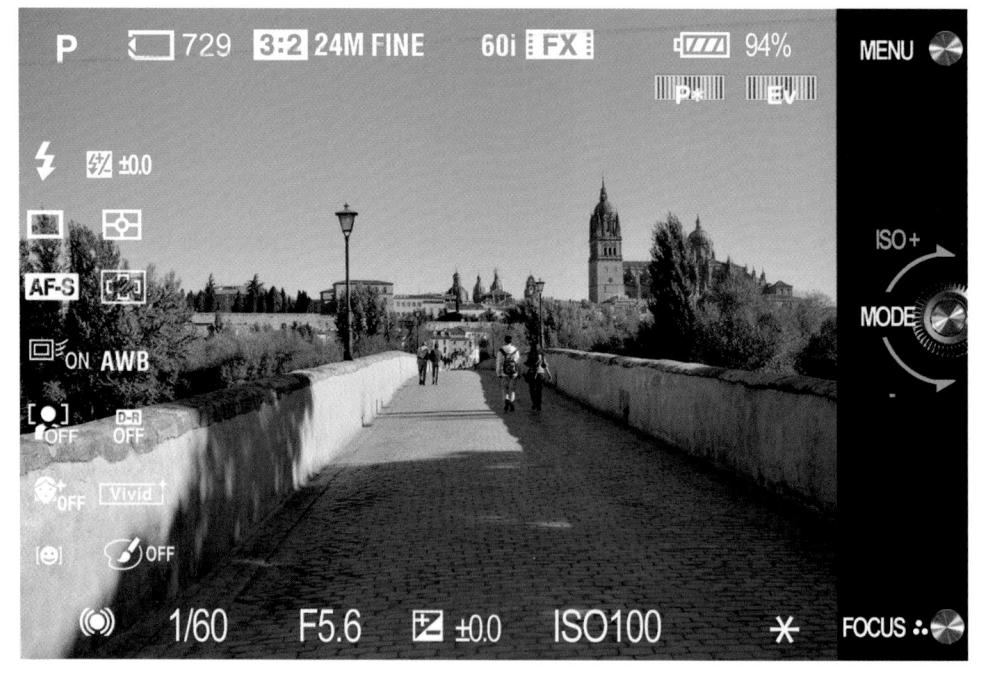

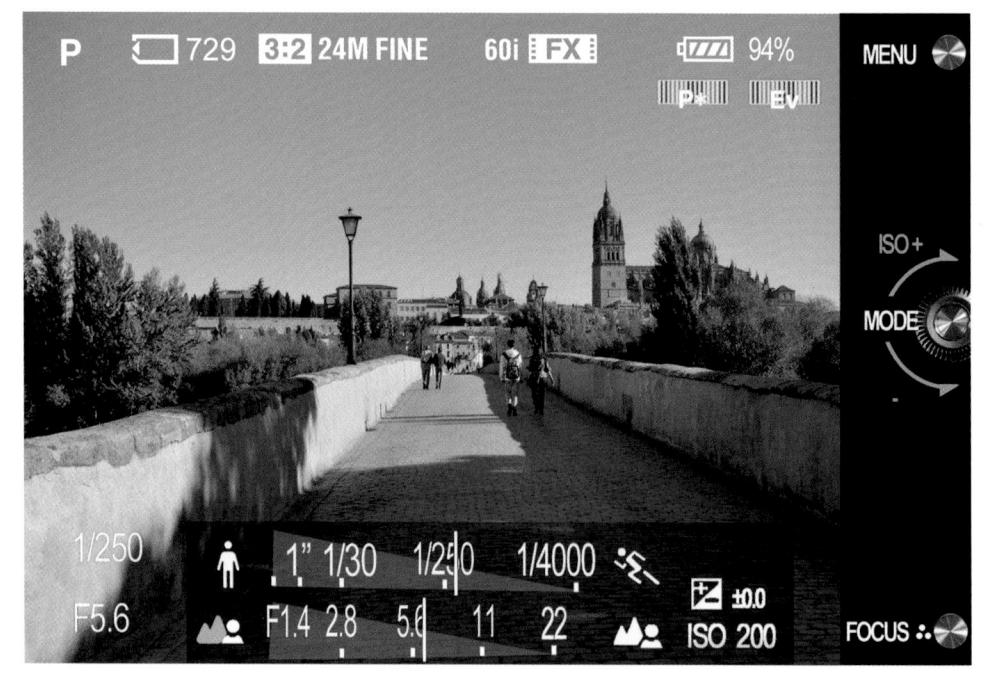

Figure 1.10
Formatting a Memory Card

There are three ways to create a blank Secure Digital or Memory Stick Pro Duo card for your Sony Alpha NEX, and two of them are at least partially wrong. Here are your options, both correct and incorrect:

- Transfer (move) files to your computer. When you transfer (rather than copy) all the image files to your computer from the memory card (either using a direct cable transfer or with a card reader and appropriate software, as described later in this chapter), the old image files can, at your option, be erased from the card, leaving the card blank. Theoretically. Unfortunately, this method does not remove files that you've labeled as Protected (by choosing Protect from the Playback menu during playback), nor does it identify and lock out parts of your card that have become corrupted or unusable since the last time you formatted the card. Therefore, I recommend always formatting the card, rather than simply moving the image files, each time you want to make a blank card. The only exception is when you want to leave the protected/unerased images on the card for a while longer, say, to share with friends, family, and colleagues.
- (Don't) Format in your computer. With the memory card inserted in a card reader or card slot in your computer, you can use Windows or Mac OS to reformat the memory card. Don't! The operating system won't necessarily arrange the structure of the card the way the Alpha likes to see it (in computer terms, an incorrect file system may be installed). The only way to ensure that the card has been properly formatted for your camera is to perform the format in the camera itself. The only exception to this rule is when you have a seriously corrupted memory card that your camera refuses to format. Sometimes it is possible to revive such a corrupted card by allowing the operating system to reformat it first, then trying again in the camera.
- Sctup menu format. To use the recommended method to format a memory card, press the MENU button, use the left/right direction buttons or turn the control wheel to choose the Setup menu (which is represented by the red toolbox icon), and press the center controller button to open up that menu. Then press the down button (or, for quicker motion, spin the control wheel clockwise) to navigate all the way down to the Format entry. Press the center controller button, and then press the lower soft key (as indicated on the screen) to confirm your choice and begin the format process. (Press the upper soft key if you want to cancel and return to the menu system.)

Tables 1.1 and 1.2 show the typical number of shots and lengths of video footage you can expect using a good-sized 16GB SD memory card (which I expect will be a popular size card among Alpha users as prices continue to plummet during the life of this book).

Take those numbers and cut them in half if you're using an 8GB SD card; multiply by 25 percent if you're using a 4GB card, or by 12.5 percent if you're working with a 2GB SD card. The numbers shown may differ from what you read in the camera's manual: I obtained them by formatting my own 16GB card and writing down the number of shots available at each setting. Although the NEX-7 can shoot more than 10,000 images with appropriately sized memory cards, the maximum number of recordable images displayed on the LCD will never exceed 9,999. Also note that, for movies, the times shown are total movie recording times that will fit on the card; you can record only up to about 29 minutes of video in any one recording.

Table 1.1 Typical Shots with a 16GB Memory Card							
	3:2 Aspect Ratio			16:9 Asp	16:9 Aspect Ratio		
	Large	Medium	Small	Large	Medium	Small	
JPEG Standard	2,868	4,277	5,669	3,186	4,599	5,946	
JPEG Fine	1,735	3,105	4,473	1,974	3,409	4,827	
RAW	627	N/A	N/A	623	N/A	N/A	
RAW+JPEG	460	N/A	N/A	473	N/A	N/A	

Table 1.2 Typical Movie Recording Capacity with a 16GB Memory Card (H:M:S)				
AVCHD (1920 × 1080)	1:58:50			
MP4 (1440 × 1080)	2:52:30			
MP4 (1280 × 720) (Fine)	3:45:10			

HOW MANY SHOTS?

The Sony Alpha NEX provides a fairly accurate estimate of the number of shots remaining on the LCD, in the number at the upper left of the screen, to the right of the memory card icon. It is only an estimate, because the actual number will vary, depending on the capacity of your memory card, the file format(s) you've selected (more on those later), the aspect ratio (proportions) of the image (the NEX can use both traditional 3:2 proportions and 16:9—HDTV—aspect ratios), and the content of the image itself. (Some photos may contain large areas that can be more efficiently squeezed down to a smaller size.)

Selecting a Shooting Mode

When it comes time to select the shooting mode and other settings on the NEX camera, you may start to fully experience the "feel" of the NEX user interface. There's nothing wrong with it—it's actually very nicely set up for convenience and simplicity of use—but it is quite different from the interface on many other cameras with this level of sophistication. The most striking feature of the approach taken with the NEX is that a large number of settings can be reached only through the menu system, using the LCD display along with the soft keys and the control wheel.

A very good introduction to this high-tech approach is the method for choosing a shooting mode. On many other cameras, there is a physical mode dial on top of the camera that you turn to select one of several modes, including Program, Aperture priority, Scene modes, and others. With the NEX, there is no such physical mode dial. Instead, the camera shows you a virtual dial on the LCD display, and you "turn" that virtual dial using the control wheel on the back of the camera.

To get to the screen with the virtual shooting mode dial, there are two possible routes. First you can start by pressing the upper soft key when you see the image of that button next to the word "Menu" at the top of the screen. After you press the Menu button, you will see the main menu screen with its six colorful icons (see Figure 1.11). Navigate with the direction buttons or the control dial until the Shoot Mode icon is highlighted. Now press the center controller button to select Shoot Mode, and you will see the virtual shooting mode dial at the right of the screen (see Figure 1.12).

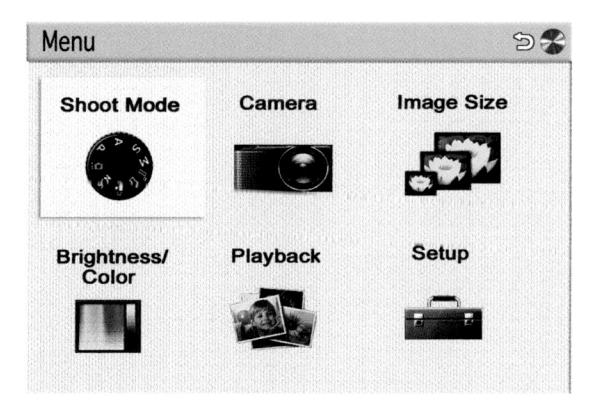

Figure 1.11 Pressing the upper soft key (Menu button) produces the camera's main menu screen. Select one of these six icons to change settings for shooting, playback, or general operation of the camera.

Figure 1.12 The virtual shooting mode dial is used to select a shooting mode; you turn this on-screen dial using the physical control wheel on the back of the camera. A brief description of the shooting mode appears on the screen to help you decide if it's the mode you want for a particular shot.

You also can reach the shooting mode dial more directly, from the live view screen, by pressing the center controller button, which is labeled on the right of the screen as the Mode button. One press of this soft key takes you directly to the screen that displays the virtual shooting mode dial.

There are several shooting modes, including Intelligent Auto and the various sub-varieties of Scene modes (Portrait, Landscape, Sports Action, Sunset, etc.), in which the camera makes most of the decisions for you (except when to press the shutter), and four semi-automatic or manual modes (Program, Aperture Priority, Shutter Priority, and Manual), which allow you to provide more input over the exposure and settings the camera uses. There also are some specialized modes that are available directly from the Shoot Mode menu: Anti Motion Blur, Sweep Panorama, and 3D Sweep Panorama. You'll find a complete description of the various shooting modes in Chapter 4. To select a shooting mode with the virtual shooting mode dial, use the up/down buttons, or the control wheel to move through the modes one at a time. You don't have to press the center controller button to confirm your choice; you can press it if you want to, or you can just press halfway down on the shutter button, which will take you to the live view screen, ready to shoot using the new shooting mode.

Now that we've seen how to use the virtual shooting mode dial, let's put it to use. If you're very new to digital photography, you might want to set the camera to Intelligent Auto (the green camera icon setting on the virtual mode dial) or Program auto (the P setting) and start snapping away. Either mode will make all the appropriate settings

Figure 1.13 The SCN setting of the virtual mode dial includes 8 different Scene mode options, including Portrait, Landscape, Macro, and others that are designed for particular photographic situations.

for you for many shooting situations. If you have a specific type of picture you want to shoot, you can try out one of the Scene modes indicated on the mode dial by SCN. When you switch to a new shooting mode, a help screen like the one shown previously in Figure 1.13 appears, to provide a "briefing" about that mode.

- Intelligent Auto. In this mode, the Alpha NEX makes the basic exposure settings of aperture and shutter speed for you. You still can make some decisions on your own, though, such as whether to use single shots or continuous shooting through a drive mode setting, whether to use the flash (if you've attached the flash unit), and whether to use autofocus or manual focus. In this mode, if the camera detects certain types of scenes, it adjusts its settings appropriately. I discuss this topic in more detail in Chapter 4.
- Scene Selection. This mode allows you to choose one of eight different Scene modes, each suited for a different type of subject. They include:
 - Portrait. This is the first of the eight Scene modes, selected as sub-choices under the SCN heading on the shooting mode dial. With the Portrait setting, the camera uses settings to blur the background and sharpen the view of the subject, while using soft skin tones.
 - Landscape. Select this Scene mode when you want extra sharpness and vivid colors of distant scenes.
 - Macro. This mode is helpful when you are shooting close-up pictures of a subject such as a flower, insect, or other small object.
 - **Sports Action.** Use this mode to freeze fast-moving subjects. The camera uses a fast shutter speed if possible and sets itself to shoot continuously while the shutter button is held down.
 - Sunset. This is a great mode to accentuate the colors of a sunrise or sunset.
 - Night Portrait. Choose this mode when you want to illuminate a subject in the foreground with flash, but still allow the background to be exposed properly by the available light. Be prepared to use a tripod or to rely on the SteadyShot feature to reduce the effects of camera shake. If there is no foreground subject that needs to be illuminated by the flash, you may do better by using the Night View mode, discussed next.
 - **Night Scene.** This mode also is for night scenes, using slower shutter speeds to provide a useful exposure, but without using flash. Again, you should use a tripod to avoid the effects of camera shake with a slow shutter speed.
 - Hand-held Twilight. This mode is similar to Anti Motion Blur, because the camera takes a burst of six shots to let it use a faster shutter speed to counteract camera shake; it then uses image processing to combine the images. The flash is not used, and you do not need to use a tripod.

- Anti Motion Blur. This special mode is designed for use indoors or in low lighting, to reduce the blur caused by moving subjects or a shaky camera. The camera takes six shots in succession at a high ISO (light sensitivity), then combines them in the camera into a single image. Using the high ISO setting allows the camera to use a fast shutter speed, and combining six images counteracts the image degradation caused by visible "noise" at high ISO settings.
- Sweep Panorama. This special mode lets you "sweep" the camera across a scene that is too wide for a single image. The camera takes multiple pictures and combines them in the camera into a single, wide panoramic final product.
- 3D Sweep Panorama. With this setting, the camera takes a sweeping panorama that can be displayed in 3D on a compatible 3D Sony (naturally) HDTV. You can also convert the camera's 3D images to a format that can be printed out or viewed on a computer screen or non-3D TV using ordinary red/blue 3D glasses. I'll explain how to do that in Chapter 4.

If you have more photographic experience, you might want to opt for one of the semiautomatic or manual modes, which, like Intelligent Auto and the Panorama settings, can be selected from the mode dial. These, too, are described in more detail in Chapter 4. These modes, which let you apply a little more creativity to your camera's settings, are indicated on the virtual shooting mode dial by the letters P, A, S, and M:

- P (Program auto). This mode allows the Alpha NEX to select the basic exposure settings, but you can still override the camera's settings to fine-tune your image.
- A (Aperture priority). Choose this mode when you want to use a particular lens opening, especially to control sharpness or how much of your image is in focus. The Alpha will select the appropriate shutter speed for you, while you set your desired aperture using the left control dial.
- **S** (**Shutter priority**). This mode is useful when you want to use a particular shutter speed to stop action or produce creative blur effects. You dial in your chosen shutter speed with the left control dial, and the Alpha will select the appropriate f/stop for you.
- M (Manual). Select this mode when you want full control over the shutter speed and lens opening, either for creative effects or because you are using a studio flash or other flash unit not compatible with the Alpha's automatic flash metering. You also need to use this mode if you want to use the Bulb setting for a long exposure, as explained in Chapter 6. You select both shutter speed (with left control dial) and aperture (right control dial). There's more about this mode, and the others, in Chapter 4.

Choosing a Metering Mode

You might want to select a particular exposure metering mode for your first shots, although the default Multi metering is probably the best choice as you get to know your camera. If you want to select a different metering pattern, you must not be using one of the Scene modes or Intelligent Auto, in which the Multi mode is set and cannot be changed. To change the metering mode, from the main menu select Brightness/Color and, using the up/down directional buttons or by turning the control wheel, navigate down to the Metering Mode option and select it with the center controller button. Then use the up/down directional keys, and highlight one of the three modes described below. Press the center controller button again to confirm your choice. The three metering options are shown in Figure 1.14:

- Multi metering. The standard metering mode; the Alpha attempts to intelligently classify your image and choose the best exposure based on readings from 1,200 different zones in the frame. You can read about these zones in Chapter 4.
- Center metering. The Alpha meters the entire scene, but gives the most emphasis to the central area of the frame.
- **Spot metering.** Exposure is calculated from a smaller central spot.

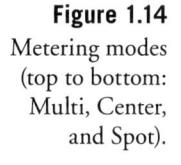

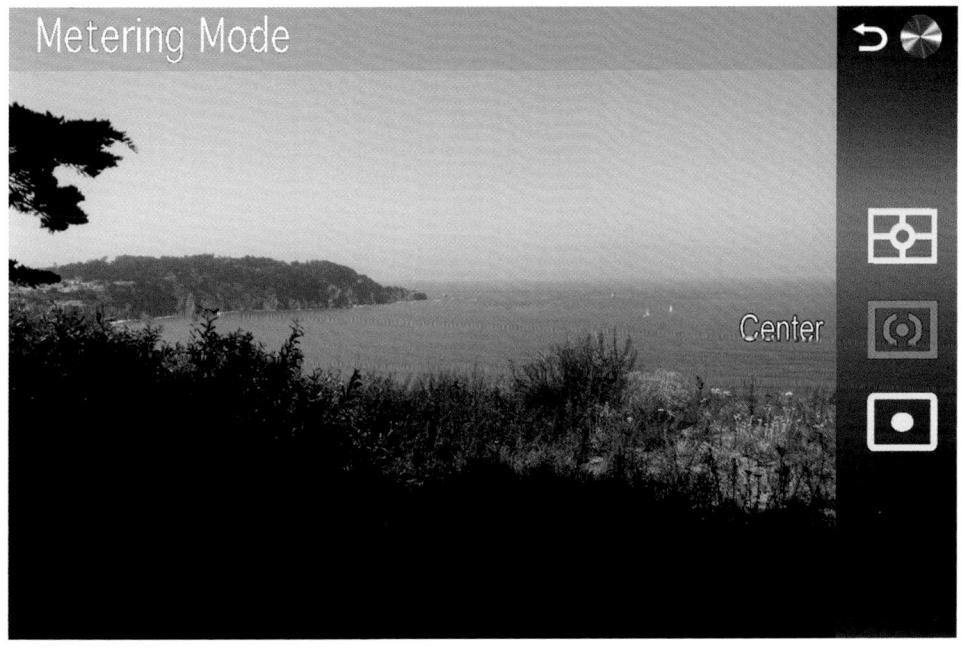

Choosing a Focus Mode

You can easily switch between autofocus and manual focus by using the AF/MF Select option on the Camera menu, or by holding down the AF/MF button located to the right of the playback button. If you select MF, for manual focus, or DMF, for direct manual focus (which allows you to manually adjust initial autofocus), there are no further focusing choices to be made. However, if you select AF, for autofocus, you may want to take the further step of deciding which autofocus mode the camera will use. If you don't make this selection, the default setting is likely to work fine, but you're better off making a conscious choice of exactly how the camera goes about achieving automatic focus. (You can read more on selecting focus parameters in Chapter 6.) If you're using a Scene mode or Intelligent Auto, the autofocus method is set for you automatically.

If you're using the P, A, S, or M shooting mode, here's how to set the camera's autofocus mode. Press the upper soft key to enter the menu system, and use the direction buttons to navigate to the Camera menu and select it. Then use the down button or spin the control wheel to navigate down to Autofocus Mode on the menu screen and press the center controller button; select the mode you want from the screen that pops up using the up/down buttons, or the control wheel. Press the center controller button to confirm your selection. The two available choices are as follows:

- Single-shot AF (AF-S). This mode, sometimes called *single autofocus*, locks in a focus point when the shutter button is pressed down halfway, and, when focus is achieved, the camera beeps (unless you've turned the beeps off) and the green focus confirmation circle shows up at the far left of the bottom line of the LCD display. The focus will remain locked until you release the button or take the picture. If the camera is unable to achieve sharp focus, the focus confirmation circle will blink. This mode is best when your subject is relatively motionless.
- Continuous AF (AF-C). This mode, sometimes called *continuous servo*, sets focus when you partially depress the shutter button, but continues to monitor the frame and refocuses if the camera or subject is moved. No beep sounds, and the confirmation circle does not appear; instead, a circle surrounded by curved lines appears, to indicate that focusing is still in progress. This is a useful mode for photographing sports and moving subjects.

Selecting a Focus Point

The Sony Alpha NEX uses 25 different focus points to calculate correct focus. In Scene modes, the focus point is selected automatically by the camera. In the semi-automatic and manual modes (P, A, S, and M), you can allow the camera to select the focus point automatically, or you can specify which focus point should be used.

Figure 1.15
Select the
Autofocus Area
from Multi (the
NEX selects one
of the 25 possible AF areas),
Center (only the
center focus
spot is used), or
Flexible Spot
(you can choose
which area
to use).

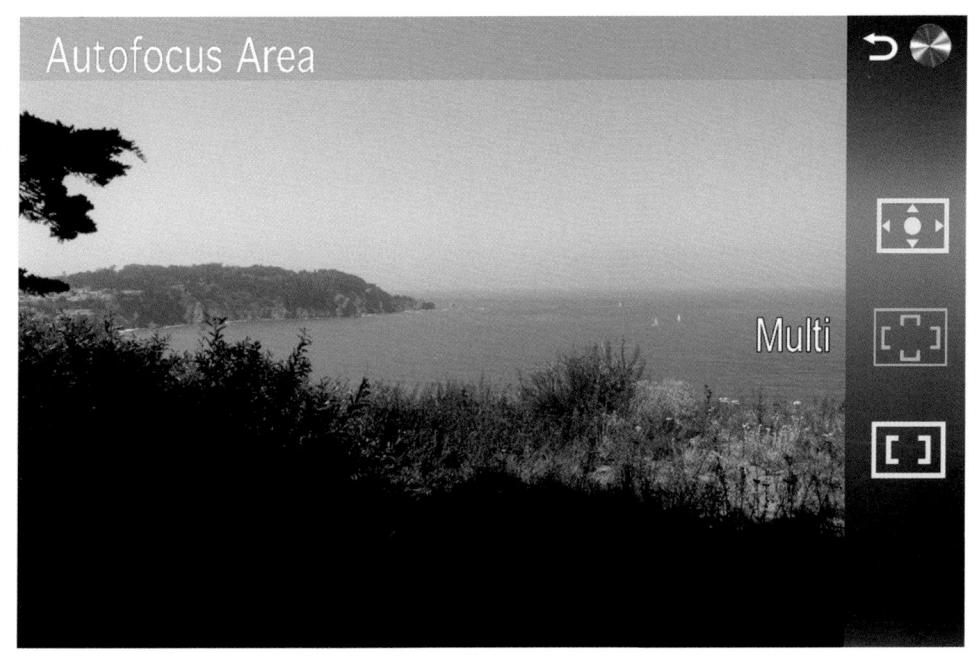

You make your decision about how the focus point is chosen through the Autofocus Area option on the Camera menu. There are three autofocus area options, shown in Figure 1.15, and also described in Chapter 6. Once you're in the Camera menu, navigate to the Autofocus Area selection, then press the center controller button, and select one of these three choices. Press the center controller button again to confirm.

- **Multi.** The NEX chooses the appropriate focus zone from the 25 AF areas on the screen. The selected areas are displayed on the LCD.
- Center. The Alpha always uses the focus zone in the center of the image to calculate correct focus.
- Flexible Spot. Once you select this option from the Autofocus Area selection on the Camera menu, you can use the four direction buttons to move the focus frame around the screen to your desired location. Then press the center controller button to lock it into place. I'll discuss this topic again in Chapter 6, where I explain your focus options in more detail.

Other Settings

There are a few other settings you can make if you're feeling ambitious, but don't feel bad if you postpone using these features until you've racked up a little more experience with your Sony Alpha NEX.

Adjusting White Balance and ISO

If you like, you can custom-tailor your white balance (color balance) and ISO sensitivity settings, as long as you're not using one of the Scene modes or Intelligent Auto. To start out, it's best to set white balance (WB) to Auto, and ISO to ISO 200 for daylight photos, and to ISO 400 for pictures in dimmer light. You'll find complete recommendations for both settings in Chapters 4 (ISO) and 6 (white balance). You can adjust white balance and ISO by selecting the Brightness/Color option from the main menu screen and navigating with the direction buttons or the control wheel to the White Balance and ISO options on the LCD.

Using the Self-Timer

If you want to set a short delay before your picture is taken, the self-timer is what you need. You can get to this setting from the Camera menu by selecting Drive Mode, but there's a much easier way to activate the self-timer. When you're on the live view shooting screen (not the menu screen), press the drive mode/self-timer button (the left direction button), and use the up/down buttons or spin the control wheel to scroll through the various options until you reach the 10-second self-timer. Press the center controller button to confirm your choice (see Figure 1.16) and a self-timer icon will appear on the live view display. Press the shutter release to lock focus and exposure and start the timer. The self-timer lamp will blink and the beeper will sound (unless you've silenced it in

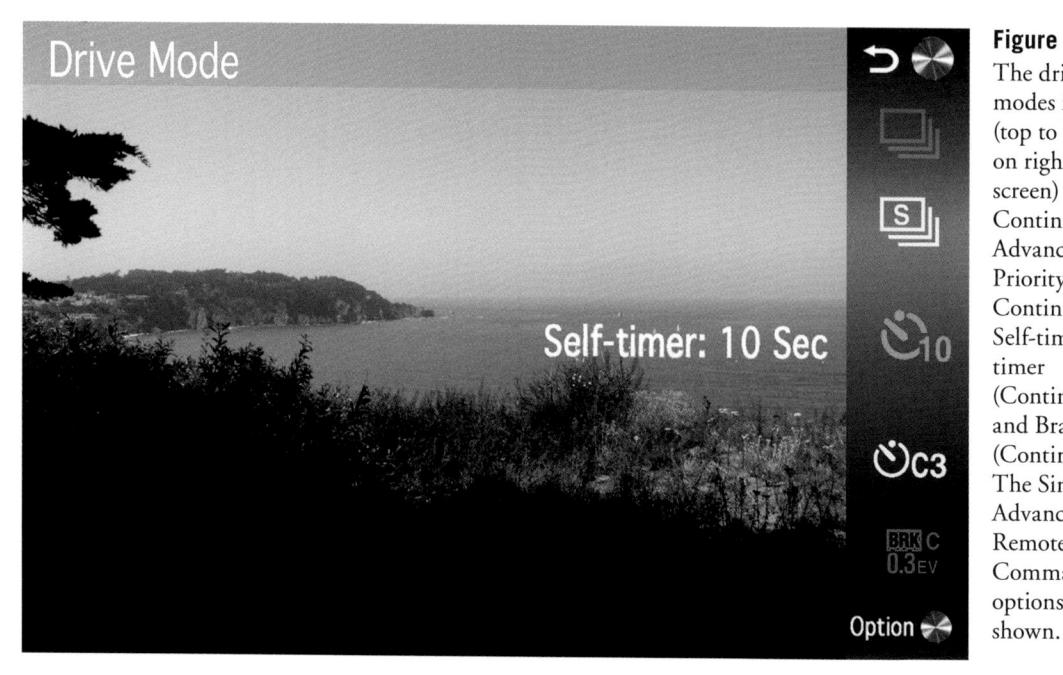

Figure 1.16 The drive modes include (top to bottom on right side of screen) Continuous Advance, Speed Priority Continuous, Self-timer, Selftimer (Continuous), and Bracket (Continuous). The Single-Shot Advance and Remote Commander options are not

the menus) until the final two seconds (in 10-second mode), when the lamp remains on and the beeper beeps more rapidly until the picture is taken.

There are a few options you can select to vary the operation of the self-timer. When the self-timer option is first highlighted, press the lower soft key, which is then labeled Option. Then use the up and down buttons to choose between 10-second and 2-second times for the self-timer's delay. Also, on the drive mode selection menu, just below self-timer, there is an option labeled C3, which means the camera takes three images after the self-timer's 10 seconds run out. Here, again, the lower soft key is labeled Option; if you press it, you can then choose an alternate setting of taking five images after the self-timer period ends. The multiple image option is handy if you are taking family group pictures with a few known inveterate blinkers to be pictured. Note that the self-timer setting is "sticky" and will still be in effect if you turn the camera off and power up again. When done using the self-timer, turn it off in the Camera menu.

In addition to the Self-timer, Continuous shooting, and Single-shot choices in the Drive menu, there also is an exposure bracketing option and an infrared remote control option (not shown in the figure).

Using the NEX's Flash

Working with the built-in flash unit (see Figure 1.17) deserves a chapter of its own, and I'm providing one in Chapter 9. But the NEX's flash is easy enough to work with that you can begin using it right away, either to provide the main lighting of a scene, or as supplementary illumination to fill in the shadows. The NEX will automatically balance the amount of light emitted from the flash so that it illuminates the shadows nicely, without overwhelming the highlights and producing a glaring "flash" look. (Think Baywatch when they're using too many reflectors on the lifeguards!)

Now, as you may have noticed, in producing the NEX, Sony has marched to the beat of a different drummer. This camera is quite different from non-NEX models, in its construction, appearance, extensive use of menus for a highly sophisticated camera, and the like. In supplying a flash unit, Sony has continued its trend towards the unconventional, with a tiny flip-up flash. In many cases, you won't need it, because the camera is equipped with strong tools for shooting in low light, including ISO settings that go all the way up to 12800 and the Anti Motion Blur and Hand-held Twilight shooting modes. In both of those modes, the camera takes six shots in rapid succession to enhance its ability to capture images in low light that are not ruined by excessive visual noise. However, there always will be occasions when flash is at least worthy of consideration as an option, so let's look at how to use it.

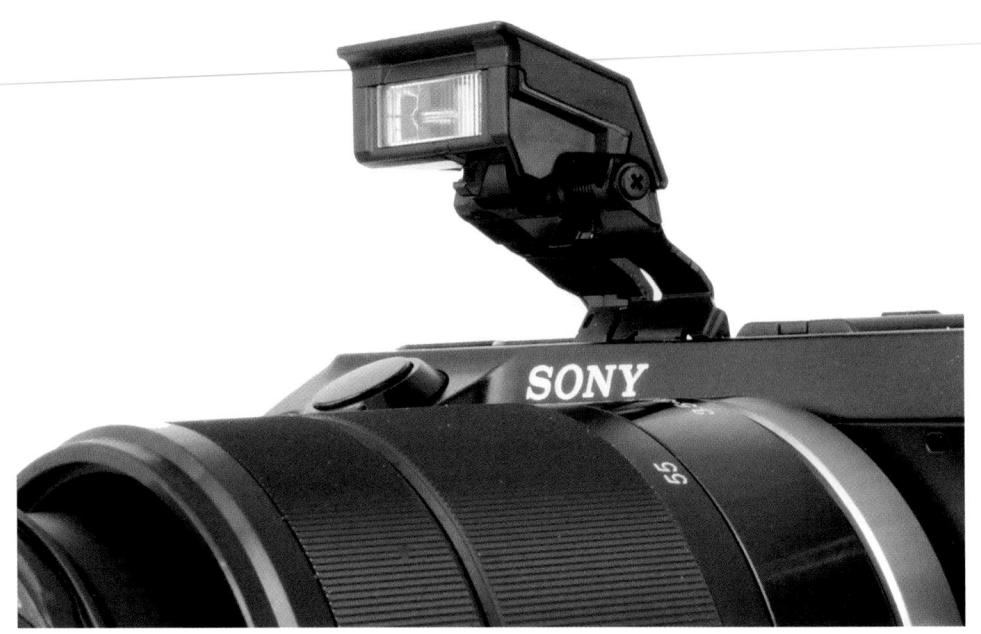

Figure 1.17
The Sony Alpha
NEX includes a
small built-in
flash unit.

To elevate the flash, press the flash pop-up button located just to the right of the electronic viewfinder window. It will automatically charge itself using the camera's internal battery. Your options for using the flash depend on what shooting mode the camera is set to. For example, in Intelligent Auto mode, you can choose to have the flash forced off, or set to Auto flash, so the camera decides when to fire it. In two of the Scene modes—Portrait and Macro—you have three flash options available to choose: forced off, Auto flash, or forced on (fill flash). In the other Scene modes, you have only one or two flash options. In the less automatic P, A, S, and M modes, you have three flash options: forced on (fill flash), slow sync, and rear sync. In those shooting modes, you don't have the forced off or Auto flash options available.

An Introduction to Movie Making

I'm going to talk in more detail about your movie-making options with the NEX camera in Chapter 7. For now, though, I'll give you enough information to get started, in case a cinematic subject wanders into your field of view before you get to that chapter.

There are not very many settings you can make that affect movie making; you get access to the settings for the movie file formats through the Image Size menu, one of the six choices on the main menu screen. Some of the basic shooting settings, such as white balance, also affect movies. I'll talk about how to set up the camera to make movies in Chapter 7.

For the moment, let's just make a basic movie. With the camera turned on, aim at your subject and locate the red Movie button at the upper far right of the back of the camera. Press that button once to start the recording, and again to stop it; don't hold the button down. You can record for up to about 29 minutes consecutively if you have sufficient storage space on your memory card and charge in your battery. The camera will adjust the focus and exposure automatically, and you can zoom while recording, if you have a zoom lens attached to the camera. When the movie has been recorded, you can press the Playback button on top of the camera to view it immediately. (To play a movie after you have taken some still photos, so the movie is not the latest item available to play, you need to use the index screen; see the last bullet of the section below on "Reviewing the Images You've Taken" for that procedure.) While a movie is playing, the buttons on the control wheel act like VCR buttons, as follows:

- Pause/Resume. Press the center controller button.
- Fast-forward. Press the right direction button, or turn the control wheel to the right.
- Fast-reverse. Press the left direction button, or turn the control wheel to the left.
- Adjust sound volume. Press the bottom direction button to bring up the volume control on the screen, then raise or lower the volume by using the top and bottom buttons or by turning the control wheel.
- Slow-forward. While paused, turn the control wheel to the right.
- **Slow-reverse.** While paused, turn the control wheel to the left.

Reviewing the Images You've Taken

The Sony Alpha NEX has a broad range of playback and image review options. I'll cover them in more detail in Chapters 2 and 3. For now, you'll want to learn just the basics. Here is all you really need to know at this time, as shown in Figure 1.18.

- Press the Playback button to display the most recent image on the LCD. (It's the small button located between the flash pop-up button and the AF/MF/AEL button on the upper back edge of the camera, marked with a right-pointing triangle.)
- Press the left direction button, or scroll the control wheel to the left, to view a previous image.
- Press the right direction button, or scroll the control dial to the right, to view the next image.
- Press the lower soft key, labeled with a trash can icon on the screen, to delete the currently displayed image.

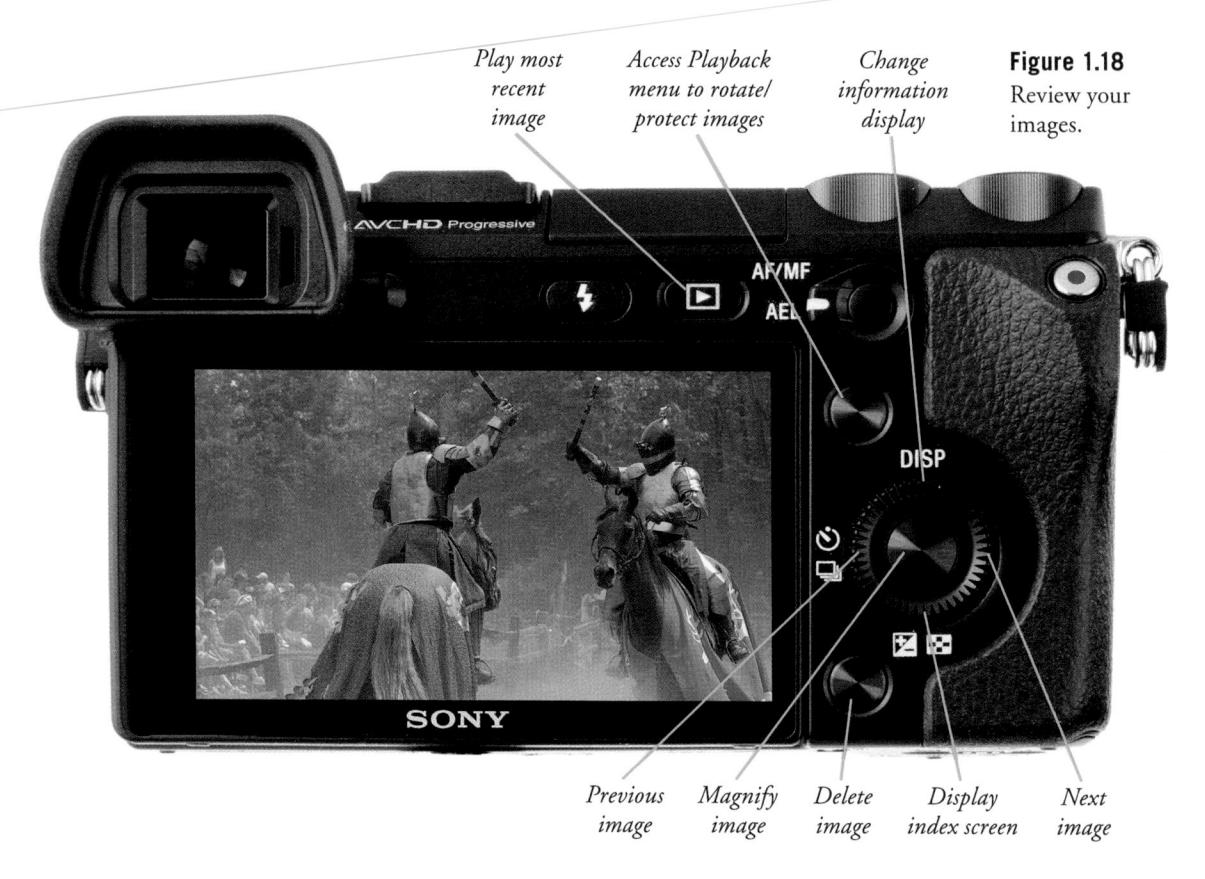

- From the Playback menu, select Rotate, followed by pressing the center controller button, to rotate the image on the screen 90 degrees. Successive presses of the center controller button rotate the image 90 degrees each time. (You won't likely need this feature unless you have disabled automatic rotation, which causes the camera to display your vertically oriented pictures already rotated. I'll explain how to activate/ deactivate automatic rotation in Chapter 3.)
- Press the center controller button to enlarge the image. You can then turn the control wheel to change the degree of enlargement, and you can scroll around inside the image using the direction buttons. Press the center controller button or the upper soft key to exit back to normal view.
- Press the DISP button (top direction button) repeatedly to cycle among views that have no recording data, full recording data (f/stop, shutter speed, image quality/size, etc.), and a thumbnail image with histogram display. (I'll explain all these in Chapter 2.)

■ Press the exposure compensation/playback index button (down direction button) to display an index screen showing 6 thumbnail images. If you want to display 12 images at a time instead of 6, select that option from the Playback menu. You can't display both movies and still images on the same index screen. To select one or the other, move to the left of the index screen with the left direction button, so the narrow strip at the left is highlighted. Press the center controller button and you'll be given a choice of three folders to view: Folder view (Still), Folder View (MP4), and AVCHD view. Select one with the direction buttons and then press the center controller button again.

You'll find more information on viewing thumbnail indexes of images and other image review functions in Chapter 2.

Transferring Files to Your Computer

The final step in your picture taking session will be to transfer the photos or movies you've taken to your computer for printing, further review, or editing. (You can also take your memory card to a retailer for printing if you don't want to go the do-it-yourself route.) Your Alpha NEX allows you to print directly to PictBridge-compatible printers and to create print orders right in the camera, plus you can select which images to transfer to your computer. I'll outline those options in Chapter 3.

For now, you'll probably want to transfer your images by either using a cable transfer from the camera to the computer or removing the memory card from the Alpha and transferring the images with a card reader (shown in Figure 1.19). The latter option is ordinarily the best, because it's usually much faster and doesn't deplete the battery of your camera. However, you can use a cable transfer when you have the cable and a computer but no card reader (perhaps you're using the computer of a friend or colleague, or you're at an Internet café).

To transfer images from a memory card to the computer using a card reader:

- 1. Turn off the camera.
- 2. Slide open the memory card door, and press on the card, which causes it to pop up so it can be removed from the slot. (You can see a memory card being removed in Figure 1.7.)
- 3. Insert the memory card into a memory card reader that is plugged into your computer. Your installed software detects the files on the card and offers to transfer them. (You'll find descriptions of your transfer software options in Chapter 10.) The card can also appear as a mass storage device on your desktop, which you can open and then drag and drop the files to your computer.

Figure 1.19 A card reader is the fastest way to transfer photos.

Figure 1.20 Images can be transferred to your computer using a USB cable plugged into the USB port.

To transfer images from the camera to a Mac or PC computer using the USB cable:

- 1. Turn off the camera.
- 2. Open the port door on the left side of the camera (the upper door, marked with the candelabra-like USB symbol) and plug the USB cable furnished with the camera into the USB port inside that door. (See Figure 1.20.)
- 3. Connect the other end of the USB cable to a USB port on your computer.
- 4. Turn on the camera. Your installed software usually detects the camera and offers to transfer the pictures, or the camera appears on your desktop as a mass storage device, enabling you to drag and drop the files to your computer. I'll cover using the Sony Alpha NEX's bundled software to transfer images in Chapter 10.

Finally, if you are a die-hard technophile and don't mind spending a little extra money to use the coolest method for transferring your photos to your computer, go out and get an Eye-Fi card. This relatively recent entry on the digital scene looks and acts exactly like an ordinary SDHC card, but with a big difference—once you have the card set up with your local Wi-Fi (wireless) network, whenever you take a picture (or record a

movie) with this card in the camera, the card wirelessly connects to your computer over that network and transmits the image or video file to any location you have specified. For example, my Eye-Fi card sends any new pictures directly to the Pictures/Eye-Fi folder on my computer and my movies to the Movies/Eye-Fi folder.

I have tested this system with the Sony NEX camera, and it works beautifully. In fact, the camera has a special setting on the Setup menu to turn the Eye-Fi upload functioning on or off. Just make sure that setting is turned on once you have inserted the Eye-Fi card. Now, I will admit that it's no trouble at all to just take an ordinary card out of the camera and pop it into a card reader, or to hook up a USB cable to the camera and the computer. The Eye-Fi card has to be classified as a bit of a luxury. But it will save you a few moments, and you can amaze your friends as your photos almost instantly show up on your computer, as if by magic.

If you want to explore this option, I strongly recommend you look for the Pro X2 version of the Eye-Fi card, shown in Figure 1.21, which can upload RAW files. The other models of the card, at this writing, are capable of handling only JPEG files.

Figure 1.21
With an Eye-Fi
card, you can
have your
images transmitted wirelessly to your
computer as
soon as your
camera is in
range of your
local wireless
network.

Sony Alpha NEX-7 Roadmap

One thing that often causes consternation in new owners of digital cameras is the bewildering array of buttons, dials, switches, levers, latches, and knobs bristling from the camera's surface. At first glance, the Sony Alpha NEX-7 appears to be not much different, because it has on the back panel seven buttons and a control wheel (which rotates and can be pressed in four different locations) plus two control dials on top, a shutter release, power switch, and "navigation" button. But that's a deceptive count, because most of the controls have more than one function, and some of them are like chameleons in their ability to take on widely varying identities. The navigation button changes the function of other controls, and you can redefine certain controls to perform a function of your choice.

So, although there are a reasonable number of buttons and switches, there are many operations handled by this small group of physical and virtual controllers. Despite the button count, there is a lot of information that needs to be discussed about how these controls can help you reach the results you want with your still images and videos.

Traditionally, there have been two ways of providing a roadmap to guide you through this maze of features. One approach uses two or three tiny 2-inch black-and-white line drawings or photos impaled with dozens of callouts labeled with cross-references to the actual pages in the book that tell you what these components do. You'll find this tactic used in the pocket-sized manual Sony provides with the Sony Alpha NEX-7, and most of the other third-party guidebooks as well. Deciphering one of these miniature camera layouts is a lot like being presented with a world globe when what you really want to know is how to find the capital of Belgium.

I originated a more useful approach in my field guides, providing you, instead of a satellite view, a street-level map that includes close-up, full-color photos of the camera from several angles (see Figure 2.1), with a smaller number of labels clearly pointing to each individual feature. And, I don't force you to flip back and forth among dozens of pages to find out what a particular component does. Each photo is accompanied by a brief description that summarizes the control, so you can begin using it right away. Only when a particular feature deserves a lengthy explanation do I direct you to a more detailed write-up later in the book.

So, if you're wondering what the left direction button on the control wheel does, I'll tell you up front, rather than have you flip to three different pages, as the Sony instruction manual does. This book is not a scavenger hunt. But after I explain how to use the drive mode button to select continuous shooting, I *will* provide a cross-reference to a longer explanation later in the book that clarifies the use of the various drive modes, the self-timer, and exposure bracketing. I've had some readers write me and complain about even my minimized cross-reference approach; they'd like to open the book to one page and read everything there is to know about bracketing, for example. Unfortunately, it's impossible to understand some features without having a background in what related features do. So, I'll provide you with introductions in the earlier chapters, covering simple features completely, and relegating some of the really in-depth explanations to later chapters. I think this kind of organization works best for a camera as sophisticated as the Sony Alpha NEX-7.

By the time you finish this chapter, you'll have a basic understanding of every control and of the various roles it can take on. I'm not going to delve into menu functions here—you'll find a discussion of your many Shoot Mode, Camera, Image Size, Brightness/Color, Playback, and Setup menu options in Chapter 3. Everything here is devoted to the button pusher and dial twirler in you.

Front View

When we picture a given camera, we always imagine the front view. That's the view that your subjects see as you snap away, and the aspect that's shown in product publicity and on the box. The frontal angle is, essentially, the "face" of a camera like the Sony Alpha NEX-7. But, not surprisingly, most of the "business" of operating the camera happens *behind* it, where the photographer resides. The front of the Alpha actually has very few controls and features to worry about. These few controls are most obvious in Figure 2.2:

■ Shutter release button. Angled on top of the hand grip is the shutter release button. Press this button down halfway to lock exposure and focus (in Single-shot autofocus mode and Continuous autofocus mode with non-moving subjects). The Alpha assumes that when you tap or depress the shutter release, you are ready to take a picture, so the release can be tapped to activate the exposure meter or to exit from most menus.

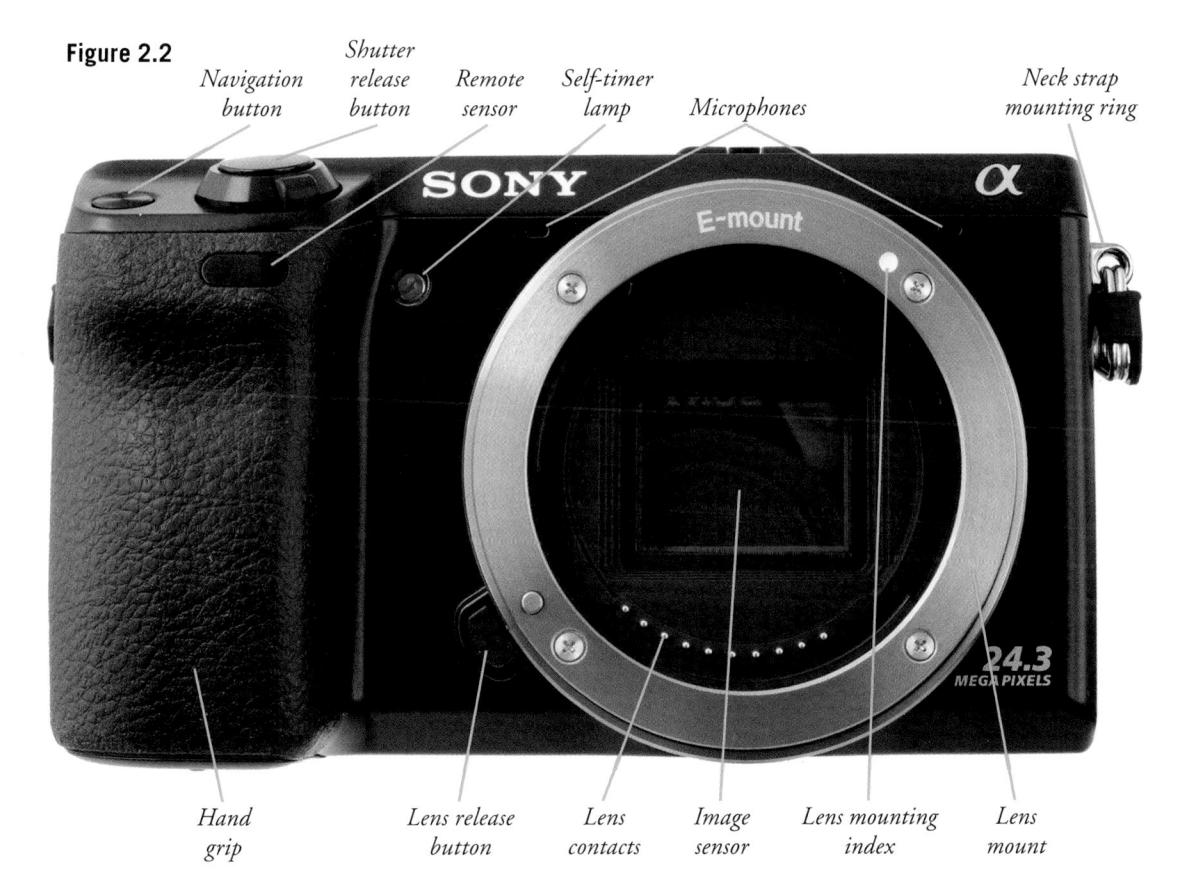

- Navigation button. When you press this button, the two control dials on top of the camera (described later in this chapter) cycle among their default Focus, White Balance, D-Range, Creative Style, and Exposure settings. (The first four in this list can be changed to something else.) That is, a different type of adjustment is available with those dials, depending on the mode selected by this navigation button. I'll have a complete explanation of what Sony calls "Triple-Dial-Control" functions later in this chapter.
- Self-timer lamp. This bright LED flashes red while your camera counts down the 2-second or 10-second self-timer. In 10-second mode, the lamp blinks at a measured pace off and on at first, then switches to a constant glow in the final moments of the countdown. When the self-timer is set to 2 seconds, the lamp stays lit throughout the countdown. It also serves as the AF (autofocus) Illuminator, shining its light in dark conditions to help the camera's autofocus system achieve sharp focus. Finally, this lamp functions as the Smile Shutter indicator, flashing on when the camera detects a smile and triggers the shutter. I discuss focus options in Chapter 5. I discuss the Smile Shutter in Chapter 3.
- Remote sensor. On the NEX-7, this little window is where you point an infrared remote control such as Sony's RMT-DSLR1 Remote Commander, which lets you actuate the camera's shutter without causing the camera shake that can result from pressing the shutter button on the camera. I'll discuss remote control options in more detail in Chapter 6.
- **Microphones.** A pair of stereo microphones for recording sound during movie shooting are arrayed on either side of the lens mount.
- **Hand grip.** This provides a comfortable hand-hold, and also contains the Alpha's battery and memory card compartments.
- Lens release button. Press and hold this button to unlock the lens so you can rotate the lens to remove it from the camera.
- Lens mounting index. Match this recessed, white index button with a similar white indicator on the camera's lens mount to line the two up for attaching the lens to the Alpha.
- Lens contacts. These metal contact points match up with a similar set of points on the lens so the lens can communicate with the camera about matters such as focus and aperture.
- Neck strap mounting ring. Attach the strap that comes with your Alpha to this ring and its counterpart on the other side of the camera, or use a third-party strap of your choice.

■ Image sensor. This fairly ordinary-looking little rectangle is the heart and soul of your digital camera. On the Sony Alpha NEX camera, this small marvel is a CMOS (complementary metal-oxide semiconductor) device, 23.5mm × 15.6mm in size. That may not sound huge, but, in the world of compact cameras like the NEX model, to have a sensor this large—the same APS-C size found on the majority of much bulkier dSLR cameras—is quite a big deal. This sensor delivers a very respectable resolution of 24.3 megapixels, for extremely high quality still and video pictures.

The main features on the left side of the Sony Alpha are two hinged doors (see Figure 2.3) that provide a modicum of protection for the ports underneath from dust and moisture. The connectors hidden under those doors, shown in Figure 2.4, are as follows:

■ **USB port.** Connect your camera to your computer using this port, with the USB cable that is supplied with the camera. That connection can be used to upload images to the computer and to upgrade the camera's firmware to the latest version, using a file downloaded from the Sony support website (www.esupport.sony.com).

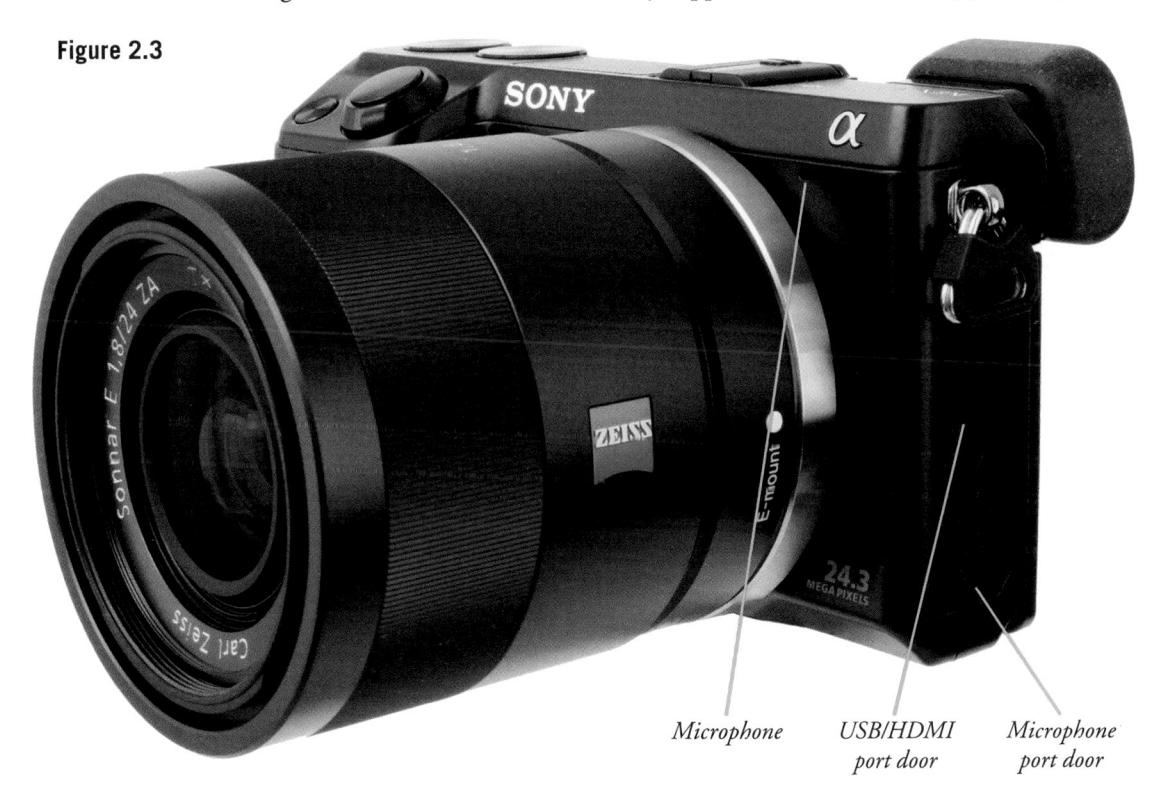

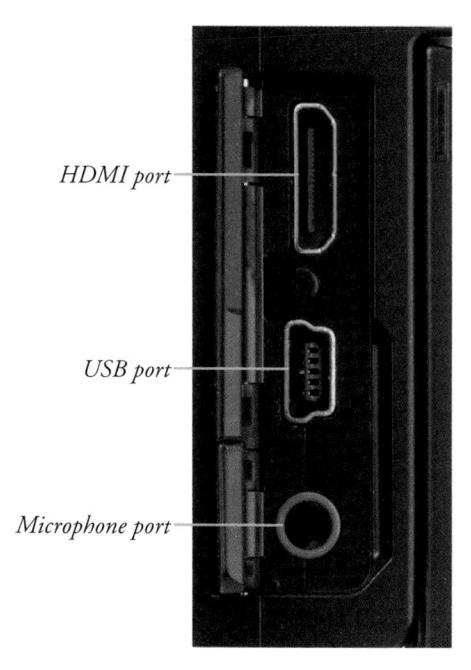

Figure 2.4

■ HDMI port. If you'd like to see the images from your camera on a television screen, you'll need to buy an HDMI cable (not included with the camera) to connect this port to an HDTV set or monitor. Be sure to get a cable that has a male mini-HDMI connector at the camera end and a standard male HDMI connector at the TV end. Once the cable is connected, you can not only view your stored images on the TV in Playback mode, you can also see on your TV screen what the camera sees. So, in effect, you can use your HDTV set as a large monitor to help with composition, focusing, and the like.

One unfortunate point is that these Alpha models no longer support video output to an old-style TV's yellow composite video jack. If for some reason it's *really* important to you to connect the camera to one of those inputs, you'll need to find a device that can "down-scale" the HDMI signal to composite video. I have done this successfully with a device by Gefen called the HDMI to Composite Scaler, which costs somewhat more than \$200 at Amazon.com, svideo.com, and other sites.

The good news is that if you own a TV that supports Sony's Bravia sync protocol, you can use your Bravia remote control to control image display, mark images for printing, switch to index view, or perform other functions.

■ Microphone port. You can plug in a monaural or stereo microphone here, such as the pricey (\$170) Sony ECM-CG50. Less expensive microphones can also do a good job, and the port on the NEX-7 can supply power to many microphones that require an external power source. When a microphone is plugged in here, the built-in microphones on the front of the camera are disabled.

The Sony Alpha's Business End

The back panel of the Sony Alpha NEX is where most of the camera's physical controls reside. There aren't that many of them, but, as I noted earlier, some of them can perform a formidable number of different functions, depending on the context. So, while we have only a few buttons and one dial to talk about, there is a lot to say about these items.

Most of the controls on the back panel of the NEX-7 are clustered on the right side of the body, with several located on the top edge.

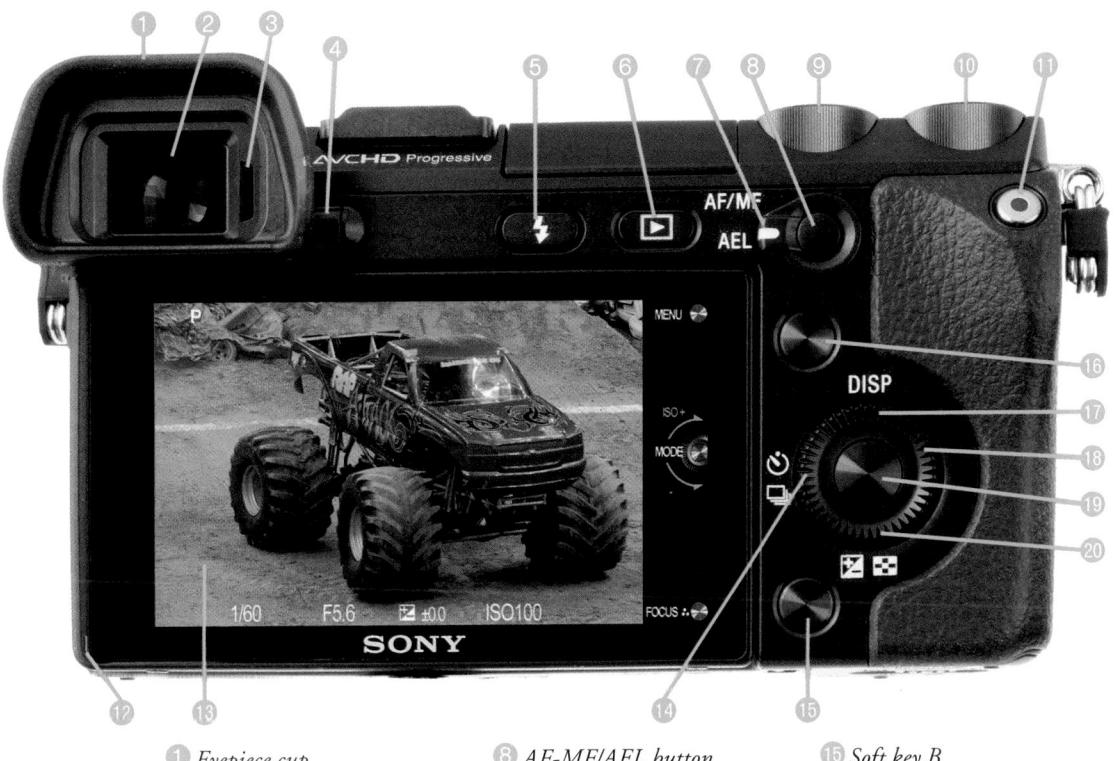

- DEyepiece cup
- Viewfinder window
- 3 Eyepiece sensor
- 4 Diopter correction wheel
- 5 Flash pop-up button
- 6 Playback button
- AF-MF/AEL switch

- 3 AF-MF/AEL button
- Control dial L
- Control dial R
- Movie button
- Light sensor
- 1 LCD
- Drive mode

- Soft key B
- 1 Soft key A
- DISP button
- 1 Control wheel
- 1 Soft key C/ center controller button
- Exposure compensation/ Image index button

Figure 2.5

The key components labeled in Figure 2.5 include:

- Viewfinder window. Use this window to view the NEX-7's sensational electronic eye-level viewfinder, an internal 0.5-inch 1024 × 768 OLED (organic LED) display with 2.4 million dots of resolution. It shows 100 percent of the frame at 1.09X magnification, making it virtually the equal of the optical viewfinders found in traditional digital SLR cameras. I actually like it better in some circumstances, such as when shooting in dim light, because the NEX-7's focus peaking feature (discussed in Chapter 5) makes it easier to achieve sharp focus manually. You can frame your composition and see the information on the electronic viewfinder's display, including shooting settings, recorded images, and menu screens, by peering into this eyepiece.
- Eyepiece sensor. This solid-state device senses when you (or anything else) approach the viewfinder, triggering a switch from the back-panel LCD to EVF viewing, and/or commencing autofocus automatically. You can enable or disable either of these features, as I'll explain in Chapter 3.
- Eyepiece cup. This soft rubber frame seals out extraneous light when pressing your eye tightly up to the viewfinder, and it also protects your eyeglass lenses (if worn) from scratching.
- **Diopter correction wheel.** As described in Chapter 1, you can spin this to adjust the built-in diopter correction to suit your vision. Tucked underneath the eyepiece cup, it's difficult to change the diopter setting accidentally (or even on purpose).
- Light sensor. This little sensor window is so small and unobtrusive that I wouldn't be sure it was there if it weren't for Sony's diagram identifying it. But it is indeed there at the extreme lower-left corner of the LCD. Its function is simply to measure the amount of light hitting the LCD, so the brightness of the screen can be automatically adjusted to suit the ambient light conditions, when you have the LCD set to automatic brightness through the Setup menu. By the way, as I'll explain in Chapter 3, if you have trouble viewing the screen in sunlight, there is a special setting available that provides you with a super-bright display to cut through the glare.
- Flash pop-up button. Press this button to elevate the built-in electronic flash unit, which readies itself for action faster than Optimus Prime skirmishing Decepticons. I advise using caution when the flash is in its ready position, and when retiring it back into the camera. It doesn't appear to be the most rugged pop-up I've seen.
- Playback button. Displays the last picture taken. Thereafter, you can move back and forth among the available images by pressing the left/right direction buttons or spinning the control wheel to advance or reverse one image at a time. To quit playback, press this button again. The Alpha also exits playback mode automatically when you press the shutter button halfway (so you'll never be prevented from taking a picture on the spur of the moment because you happened to be viewing an image).

- Control dial L/Control dial R. These two dials adjust a varying set of parameters displayed in the upper left and upper right (respectively) of the display screens, as part of Sony's Triple-dial-control interface, which will be explained in detail later in this chapter.
- **AF-MF/AEL button/switch.** This button has two functions, and you can flip between them using the switch that is concentric with the button itself.
 - AF-MF. In the switch *up* position, the button serves as a way to cycle between autofocus and manual focus temporarily. When the NEX-7 is set for autofocus, pressing the button changes to manual focus; if the camera is set for manual focus, the button switches to autofocus. The change persists for as long as you keep the button depressed (in the default Hold mode), or, you can change the behavior of the button so that the opposite focus mode remains in effect until you press the button a second time (Toggle mode), using the AF/MF Control entry in the Setup menu. If you don't need either behavior, you can assign MF Assist or Focus Settings to this button using the Custom Key Settings > AF/MF button entry in the Setup menu. I'll describe both options in Chapter 3.
 - AEL (auto exposure lock). In the switch down position, press the button to lock the exposure. An asterisk appears in the lower right of the display when exposure is locked. As with the AF-MF button, you can specify either Hold or Toggle, using the AEL entry in the Setup menu.
- Movie recording button. Another of the handy features of the NEX camera is this convenient button with central red dot, which lets you start recording a movie at any moment with one press, rather than having to change shooting modes or fiddle with menu systems, as you have to do on some other cameras to switch from stills to video. I'll discuss your movie-making options in Chapter 7.
- Upper soft key. One of the hallmarks of the NEX camera is its use of "soft keys," the three metallic buttons on each camera's back. They are called "soft" because their functions are not fixed; they take on different duties depending on the context. And, instead of having fixed labels engraved next to them, these buttons are identified by variable labels that appear on the LCD next to images of the buttons. So, for example, when you first power on the camera, you will see an image of the upper soft key at the top right of the LCD, just to the left of the actual button, with the label "Menu." If you press the upper soft key, the main menu screen will be displayed. But you will then see that the label for that button has changed to a reversing arrow icon, meaning that, if you now press the upper soft key, you will go back to the previous screen. At other times, the button will be labeled as the "Cancel" button or the "Exit" button (using the same reversing arrow symbol, rather than those words).

■ Lower soft key. The upper soft key's mate is located in the nether regions, and functions in the same way as the upper one. The lower soft key has a very important function in connection with several settings—it is then labeled "Option," and lets you select additional values for the setting you are making. For example, when selecting the D-Range Optimizer settings from the Brightness/Color menu, the only choices immediately available are D-R Off, DRO Auto, and HDR Auto. However, if you press the lower soft key ("Option") key while DRO Auto is selected, you can then use the up/down buttons to dial in a specific level of DRO, from 1 to 5. Likewise, with the self-timer settings you can alternate between 10-second and 2-second delays using the Option key; and several other settings benefit from the use of this key. Just be sure to check whenever you are making a setting from the menu screens to see if the Option key is active.

In shooting mode, the lower soft key is labeled Focus, and you can press it to change Autofocus Area. When you have set the Autofocus Area to Flexible Spot, and in that context, when you press this button, the camera brings up a screen that lets you move the focus point around the screen; you then press the center controller button to confirm the focus spot and return to shooting mode and the live view screen. I'll discuss this and other focus options in Chapter 6.

When the camera is in playback mode, the lower soft key becomes the "Delete" button, labeled with a trash can icon. Press it when an image is shown on the screen (or a movie is paused), and the camera asks you to confirm the deletion by pressing the center controller button, which is now labeled as the "OK" button. (If you want to select multiple images for deletion at one time, you need to use the Playback menu; I'll discuss that procedure in Chapter 3.)

When you select the Format command from the Setup menu or the Delete command from the Playback menu, the lower soft key is used as the "OK" button, which is usually the function of the center controller button. This is done presumably because pressing "OK" will delete some or all of the data on your memory card, so the camera forces you to show that you really mean it by pressing an unusual key to confirm the action. The lower soft key also is used as an "OK" or "Exit" button in connection with some other menu items, including Protect and DPOF Setup on the Playback menu.

■ Control wheel. This ridged dial, which surrounds the large, metallic center controller button, performs several important functions. It also has the distinction of being the only control on the NEX camera that can be activated in two different ways: you turn the ridged part of the wheel to perform certain actions, and you press in on the various direction buttons that are incorporated into the north, east, south, and west positions of the dial. I discuss the functions of those integrated buttons a little later.

■ Soft key C/Center controller button. This is the largest of the three soft keys. I prefer to call it the center controller button, because of its location in the middle of the control wheel. This button functions somewhat differently from the upper and lower soft keys, because its function is not always labeled. When it is not labeled on the LCD, it functions as the selection button; press in on it to select or confirm a choice from a menu screen. At other times, the screen shows an image of this button along with a label stating its current function. One of its main functions is to select a new shooting mode. When the "Mode" label appears next to an image of this button, pressing it once will summon the screen with the virtual shooting dial, allowing you to "spin" that dial with the control wheel or the up/down direction buttons, until you reach the shooting mode you want. You can then press the center controller button again to confirm your selection and go into the live view screen, or you can skip that step and just press halfway down on the shutter button to go into the live view screen. When Mode is set to Scene, the center controller button allows you to scroll through the various Scene modes using the control wheel or up/down buttons. In any shooting mode, press this button immediately after a picture is taken to enlarge the central portion of the image to check focus; and zoom in and out by rotating the control wheel.

In other contexts, the center controller button takes on different purposes. When the Autofocus Area is set to Flexible Spot, this button confirms the new location of the focusing spot after you have moved it around the screen. When you press the button in that shooting mode, a new screen appears, letting you control the camera's aperture to defocus the background while keeping the subject in sharp focus. I'll discuss this feature in Chapter 4, when I talk more about Intelligent Auto mode. At other times, the center controller button is used as an OK button, to let you acknowledge a message on the screen and exit from that screen.

When you are viewing an individual image in playback mode, this button is labeled with a plus sign; pressing it magnifies the image displayed on the screen. When you are viewing a playback index screen, this button is used to select an image from the index view. When you are viewing a movie, the center controller button is used for play and pause functions.

■ Direction buttons. On the NEX-7 camera, all four of the direction buttons, which are at the north, south, east and west areas of the rim of the control wheel on the camera's back, are used to navigate through the menus and the choices on various selection screens. All four buttons also are used to move the viewing area around within magnified images and within index screens during playback. The left/right buttons also move to the previous/next image on your memory card in playback mode. And, when the Autofocus Area is set to Flexible Spot, you can use all four of the direction buttons to move the focus bracket to any of its 160 possible positions on the screen.

In addition to their duties as navigational controls, all four of the direction buttons have other identities, which are set forth on their labels. Those other functions are discussed next for each of the four buttons.

■ **Up/DISP button.** The up button is also known as the DISP or Display Contents button because of its display-oriented functions. When the camera is in shooting mode, showing the live view of the scene, press the DISP button repeatedly to cycle among the seven different shooting information screens that are available. These include a full information display with icons showing what settings are in effect (Figure 2.6); and a graphic display that shows the shutter speed and aperture on two related scales along with some recording information (see Figure 2.7). (The graphic display of shutter speed and aperture does not appear when the shooting mode is set to Intelligent Auto, Sweep Panorama, or 3D Sweep Panorama.)

When viewing still images in playback mode, press the DISP button to cycle among the three available playback screens: full recording data; histogram with recording data; and no recording data. When displaying a movie on the screen, the DISP button produces only two screens: with or without recording information. There is no histogram display available. I'll explain histograms in Chapter 4.

You can set which of the many possible views are available for both the EVF and LCD in the Camera menu. I'll show you each of those viewing options, and how to specify them in Chapter 3.

■ **Down/exposure compensation button/playback index button.** This button has several functions, which differ depending on the camera's active mode.

In shooting mode, with the mode dial set to Program, Aperture priority, Shutter priority, Anti Motion Blur, Sweep Panorama, or 3D Sweep Panorama, press this button to produce the exposure compensation display. Then, rotate the left/right control dials to add or subtract from the camera's exposure setting. I'll discuss exposure compensation and other exposure-related topics in Chapter 4.

In playback mode, press this button to display an index screen showing 6 or 12 of your images at a time (choose 6 or 12 in the Playback menu). Navigate through the index screens with the direction buttons; press the center controller button to select an image to view individually. Press the upper soft key (labeled as the Menu button) to exit to the menu system, or press the Playback button to exit to the live view. You can also exit to the live view by pressing halfway down on the shutter release button.

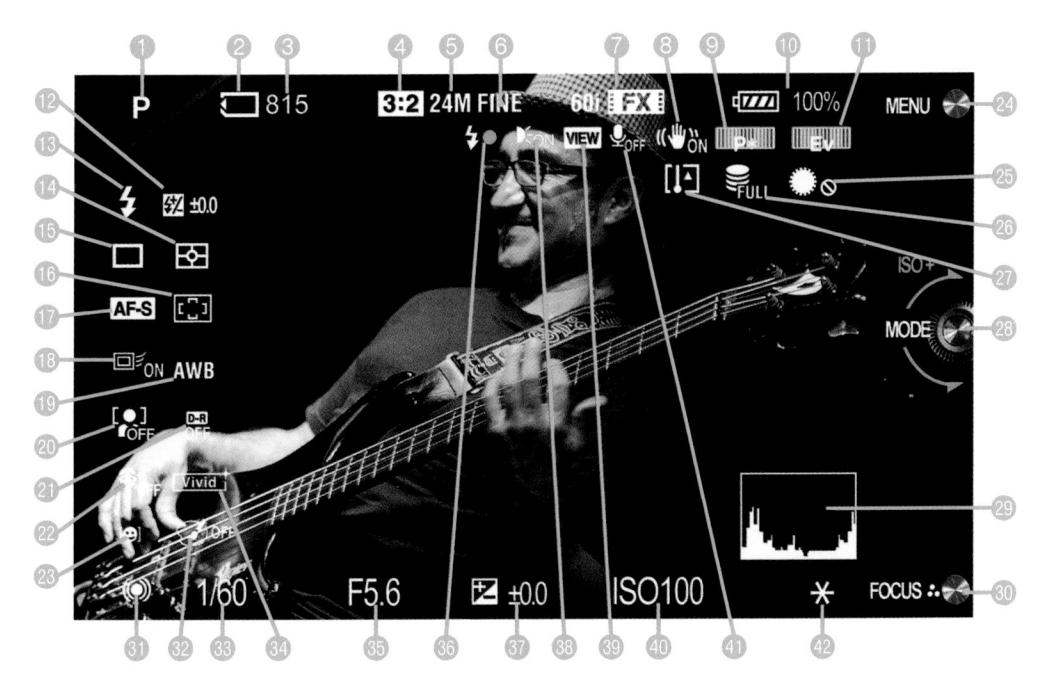

- Shooting mode
- 2 Memory card
- Number of recordable images
- Aspect ratio
- (in megapixels)
- (a) Image quality
- Movie recording mode
- 8 SteadyShot/Warning
- Control dial L
- 1 Battery status
- Control dial R
- Plash exposure compensation
- 13 Flash mode/Red-eye reduction

- Metering mode
- 1 Drive mode
- 1 Focus area mode
- Pocus mode
- Object tracking
- 19 White balance setting
- 20 Face Detection
- Dynamic Range Optimization/Auto HDR
- 2 Soft skin effect
- 28 Smile Shutter
- 2 Upper soft key
- ② Dial/wheel lock
- 26 Database error
- ② Overheating warning

- 23 Control wheel soft key
- 4 Histogram
- 30 Lower soft key
- Focus status
- 2 Picture Effect
- ③ Shutter speed
- 34 Creative Style
- 33 Aperture
- 36 Flash charge
- 3 Exposure compensation
- 33 AF illuminator status
- 39 Live view
- 40 ISO setting
- Movie sound OFF
- 4 AE lock

Figure 2.6

Figure 2.7

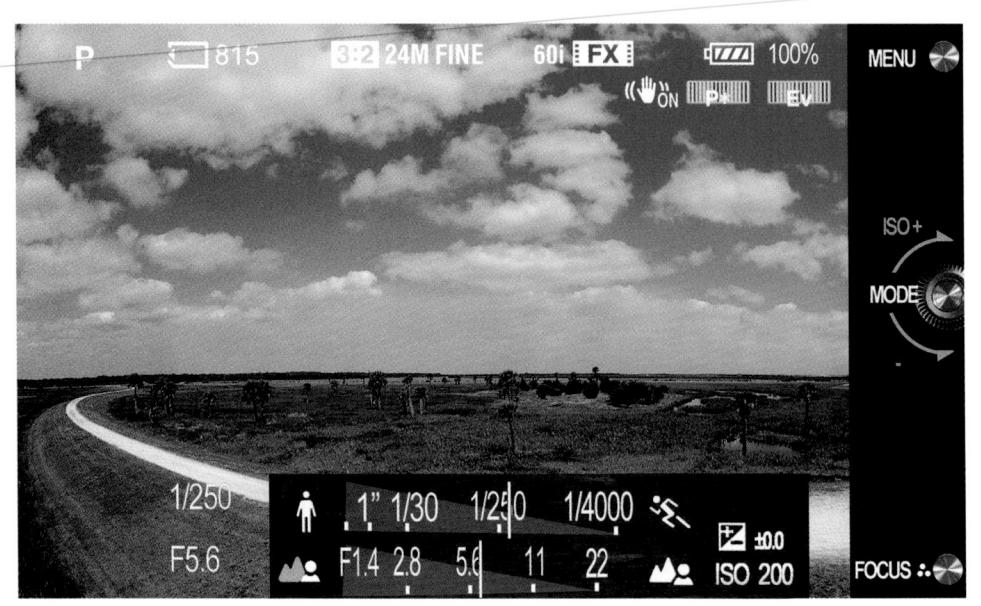

■ Left/drive mode/self-timer button. This direction button provides leftward motion, but also gives direct access to some of the most useful functions on the NEX-7—the drive mode options. One press of this button, in a compatible shooting mode, leads to a series of options that let you set the self-timer, enable the camera to shoot continuously at speeds up to 10 shots per second, or set up exposure bracketing, so you can automatically take a series of shots at three different exposure settings to help ensure you get the best exposure possible. I'll discuss continuous shooting and the self-timer in Chapter 6 and exposure bracketing in Chapter 4.

The drive mode button leads you to an additional option—setting the camera for use of the optional wireless remote control, known as the Remote Commander. I'll discuss that control and its uses in Chapter 6.

■ Right button. When not helping you navigate to the right through menus and other screens, this button lets you activate a function of your choice. Use the Custom Key Settings > Right Key entry in the Setup menu, and choose Flash Mode, Flash Compensation, MF Assist, Focus Settings, or Not Set (no function). I prefer the Flash Mode option, in part because that was how this button was used by default with my earlier NEX cameras, such as my NEX-5N. With that setting, the button allows you to choose whether, and in what circumstances, the flash will fire.

With the Sony Alpha NEX-7, the LCD monitor can be pulled away from the camera body and tilted 85 degrees up or 45 degrees downward to provide a variety of views from different viewing positions. The 3-inch display shows your live view of the scene while in shooting mode; image review after the picture is taken; and all the menus used by the Sony Alpha NEX.

LCD Panel Readouts

The Sony Alpha NEX's generously expansive 3-inch color LCD shows you everything you need to see, from images to a collection of informational data displays. The displays that appear on the various screens include the following information, with not all of the data available all the time, and the different types of screens showing slightly different types of data. I've indicated which information is available in only the full or graphic display screens when using the LCD. The electronic viewfinder shows similar information, and you can customize what appears on the LCD or EVF, as I'll explain in Chapter 3. Here's what you can see in the displays:

- Shooting mode. Shows whether you're using Program auto, Aperture priority, Shutter priority, Manual, one of the Scene modes, or one of the other special modes: Intelligent Auto, Anti Motion Blur, Sweep Panorama, or 3D Sweep Panorama. (If the camera is set to Intelligent Auto or any of the other Scene or special modes, the information shown on the various shooting information display screens is considerably less than the full amount that appears in the P, A, S, or M modes.)
- **Memory card.** Indicates whether a Secure Digital card, a Memory Stick Pro Duo card, or an Eye-Fi card is being used.
- Images remaining. Shows the approximate number of shots available to be taken on the memory card, assuming current conditions, such as image size and quality.
- Image size/Aspect ratio. Shows whether you are shooting Large, Medium, or Small resolution images, and whether the Alpha NEX is set for the 3:2 aspect ratio or wide-screen 16:9 aspect ratio (the image size icon changes to a "stretched" version when the aspect ratio is set to 16:9). If you're shooting RAW images only, not RAW & JPEG, there is no symbol shown, because all RAW images are the same size and no size choice is available. In addition, when the camera is set to the 16:9 aspect ratio, the display has black bands at the top and the bottom, unlike the display in 3:2 aspect ratio, in which the image extends to the top and bottom of the screen.
- Image quality. Your image quality setting (JPEG Fine, JPEG Standard, RAW, or RAW & JPEG).

- Movie image size. This icon shows what movie image size you have chosen. On the NEX-7, your options for this selection are FH (for Full HD video), 1080, and VGA. I'll discuss your movie-making options, including file formats and image sizes, in Chapter 7.
- Battery status. Remaining battery life is indicated by this icon.
- Flash ready. This lightning bolt icon appears on the screen when the flash unit is attached and ready to fire. If the flash is still charging, a circle appears to the right of this icon.
- **AF Illuminator status.** This icon appears when conditions are dark enough that the AF Illuminator will be needed in order to light up the area so that the autofocus system can operate properly.
- Flash mode (Full display only). Provides flash mode information. The possible choices are Flash Off, Autoflash, Fill Flash, Slow Sync, Rear Curtain, and Red-Eye Reduction. Not all of these choices are available at all times. I'll discuss flash options in more detail in Chapter 9.
- Flash exposure compensation (Full display only). This icon is shown whenever the flash is attached to the accessory shoe and activated. When the flash is in use, the icon appears next to a numerical indicator showing how much flash exposure compensation is being applied, if any.
- **Drive mode** (Full display only). Shows whether the camera is set for Single-shot, Continuous shooting, Speed Priority Continuous shooting, Self-timer, Self-timer with continuous shooting, or Exposure bracketing. There is one additional option available: Remote Commander, which sets up the camera to be controlled by an infrared remote control.
- Metering mode (Full display only). The icons represent Multi, Center, or Spot metering. (See Chapter 4 for more detail.)
- Autofocus mode (Full display only). Tells whether the camera is set for Singleshot autofocus (AF-S) or Continuous autofocus (AF-C), as described in Chapter 1 and discussed in more detail in Chapter 5.
- Autofocus area (Full display only). Shows the Autofocus Area mode in use: Multi (the camera chooses one or more of 25 AF areas to use); Center (the camera uses the center AF area exclusively); or Flexible Spot (you select which area the camera uses). I'll explain autofocus options in more detail in Chapter 5.
- Face Detection (Full display only). When this feature is activated, the camera attempts to detect faces in the scene before it, and, if it does, it adjusts autofocus, exposure, and white balance accordingly. I'll discuss this feature in Chapter 5.
- White balance (Full display only). Shows current white balance setting. The choices are Auto White Balance, Daylight, Shade, Cloudy, Incandescent,

- Fluorescent, Flash, Color Temperature, and Custom. I'll discuss white balance settings and adjustments in Chapters 3 and 6.
- Smile Shutter (Full display only). With this feature turned on, the camera will automatically trigger the shutter when the subject smiles. I'll discuss the use of this feature in Chapter 3.
- Creative Style (Full display only). Indicates which of the six Creative Style settings (Standard, Vivid, Portrait, Landscape, Sunset, or Black-and-White) is being applied. I'll discuss the use of these settings in Chapter 6.
- ISO setting (Full display only). Indicates the sensor ISO sensitivity setting, either Auto ISO or a numerical value from 200 to 25600. I'll discuss this setting in Chapter 4.
- **D-Range Optimizer (Full display only).** Indicates the type of D-Range optimization (highlight/shadow enhancement) in use: Off, Auto DRO, levels 1-5 of DRO, or Auto HDR, as described in Chapter 6.
- Shutter speed. Shows the current shutter speed, either as metered by the camera's autoexposure system or as set by the user if the camera is set to Manual or Shutter priority shooting mode. With the NEX camera, when autoexposure modes are being used (Intelligent Auto or Scene modes), the camera constantly updates the shutter speed and aperture displays without your having to press the shutter button halfway.
- **Aperture.** Displays the current f/stop, either as metered by the camera or set by the user, in the same way as with shutter speed, discussed above.
- Exposure compensation. This icon and accompanying value show what degree of exposure compensation is in effect, if any. I discuss the use of exposure compensation in Chapter 4.
- **SteadyShot status.** Shows whether the Alpha NEX's anti-shake features are turned on or off.
- Shutter speed indicator (Graphic display only). Graphically illustrates that faster shutter speeds are better for action/slower for scenes with less movement.
- Aperture indicator (Graphic display only). Icons indicate that wider apertures produce less depth-of-field (represented by a "blurry" background icon).
- Current function of upper soft key. This label changes according to the context, to show you what will happen if you press the upper soft key.
- Current function of center controller button. This label indicates what will happen if you press the larger soft key, also known as the center controller button.
- Current function of lower soft key. This label shows what will happen if you press the lower soft key.

Going Topside

The top surface of the Sony Alpha NEX has several frequently accessed controls of its own. They are labeled in Figure 2.8:

- **Sensor focal plane.** Precision macro and scientific photography sometimes requires knowing exactly where the focal plane of the sensor is. The symbol etched on the top of the camera marks that plane.
- Flash/Accessory shoe. Slide an external electronic flash into this mount when you need a more powerful strobe. A dedicated flash unit, like those from Sony, can use the multiple contact points shown to communicate exposure, zoom setting, white balance information, and other data between the flash and the camera. There's more on using electronic flash in Chapter 9. Unfortunately, Sony, like its Minolta predecessor (since 1988), uses a non-standard accessory/flash shoe mount, rather than the industry-standard ISO 518 configuration. This keeps you from attaching electronic flash units, radio triggers, and other accessories built for the standard shoe, unless you use one of the adapters that are available.

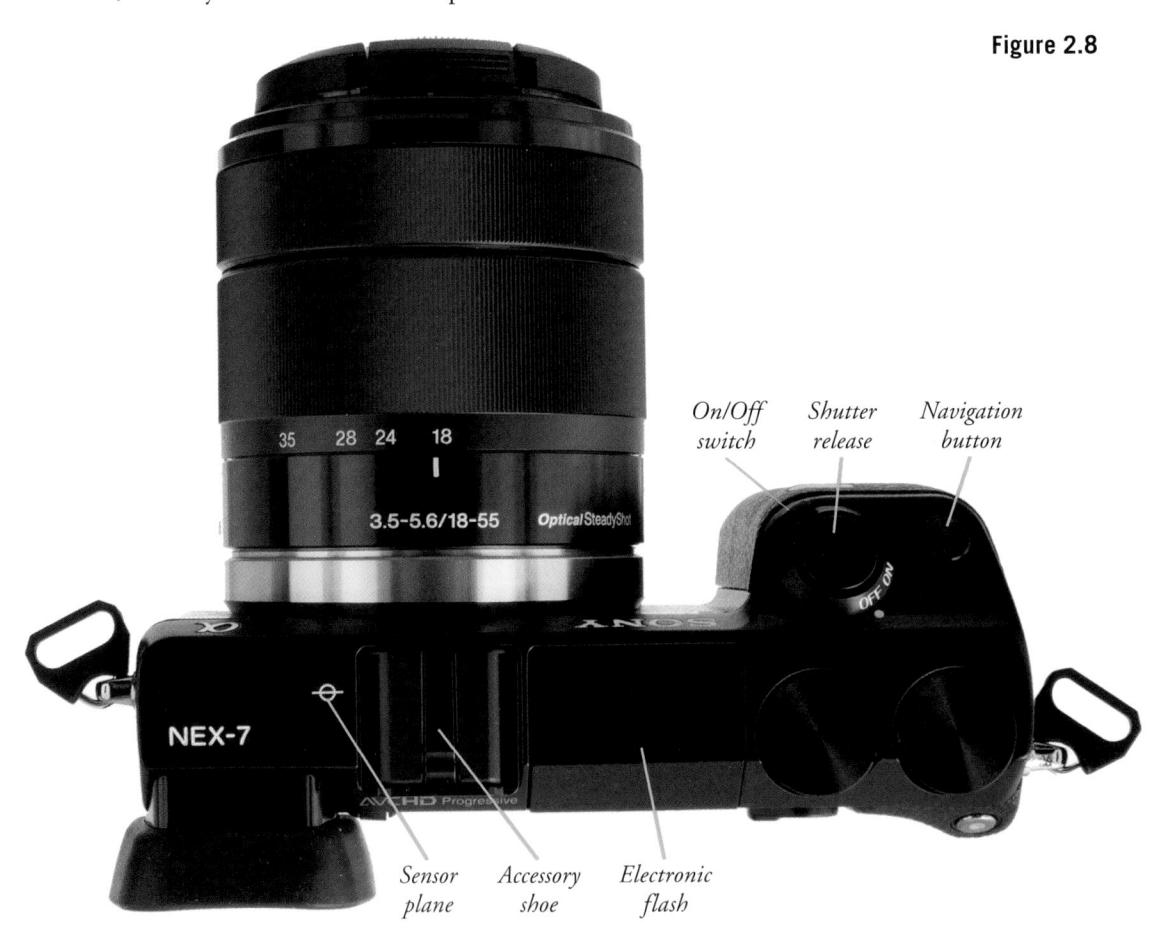
- **Pop-up flash.** The top surface of the pop-up flash fits flush with the top of the camera until you elevate it.
- **Power switch.** Rotate to the right to turn the Alpha on; to the left to switch it off.
- Shutter release button. Partially depress this button to lock in exposure and focus. Press all the way to take the picture. Hold this button down to take a continuous stream of images when the drive mode is set for Continuous shooting. Tapping the shutter release when the camera's power save feature has turned off the autoexposure and autofocus mechanisms reactivates both. When a review image or menu screen is displayed on the LCD, tapping this button removes that image or screen from the display and reactivates the autoexposure and autofocus mechanisms.
- Navigation button. This button changes the options available with the Control dial L and Control dial R, as I'll explain shortly.

Working with Triple-Dial-Control

The three-dial control system, new to the NEX-7, is simultaneously one of the most confusing features for new users, but one of the most simple to use once you get the hang of it. I'm going to explain the system, available when using P, A, S, or M modes, here so that you can begin enjoying its benefits immediately. While Sony calls it "triple-dial-control" in the manual, you may see it referred to as "Trinavi" in the NEX-7 brochures. The "Trinavi" combination reminds me of a melding of an old Sony television brand with the Pandoran natives in James Cameron's *Avatar* flick, so you won't see it used further in this book. Here are the basic principles you need to understand:

- Three "zones." The system adjusts settings available on the LCD screen or view-finder, and divides them into three zones, which correspond to the physical and logical arrangement of the two top dials (Control dial L and Control dial R), and the mid-body control wheel.
- Control dial L. The left dial is used to adjust a wide range of settings that appear on the top-left part of the LCD or EVF.
- Control dial R. The right dial adjusts the settings that are shown on the top-right side of the LCD or EVF.
- Control wheel. The control wheel sets the items that are shown vertically on the right side of the displays. Figure 2.9 shows the screen when Focus Settings (discussed in the next section) is active. The settings that can be adjusted using the left and right control dials and control wheel are outlined.
- Settings cycle. The settings available for both the left and right control dials change each time you press the Navigation button on top of the camera, cycling among Exposure Settings, Focus Settings, White Balance Settings, D-Range Settings, and Creative Style Settings.

- Customizing L/R functions. You have the option of redefining four of the five types of settings (Exposure Settings must always be available), so that the remaining settings can appear in a different order, or you can substitute another available type of setting (say replacing Creative Style Settings with Picture Effect Settings). I'll show you how to do this shortly.
- Customizing Soft Key C (the center controller button.) You can also customize the functions available when using the control wheel's center button.
- **Disabled in Intelligent Auto/Scene modes.** Triple-dial-control is disabled when you're using the Intelligent Auto and Scene selection modes. You must be using P, A, S, or M modes to use the triple-dial-controls.

Those are the basics. I'm going to tackle them one at a time to help you understand just how powerful and flexible the three-dial system is.

Settings Cycles

There are seven possible types of settings available: Exposure Settings, Focus Settings, White Balance Settings, D-Range Settings, Creative Style Settings, Picture Effects Settings, and Custom settings. Five can be active at any one time (Exposure, plus a combination of any of the other four). How each of them work can vary, depending on whether you are using, P, A, S, or M exposure modes.

Exposure

Exposure settings are the default adjustments, and are always available when you press the Navigation button to cycle around to them, or when you are not using one of the other triple-dial-control settings. You can't redefine exposure settings to one of the other options. When this choice is activated, you can adjust the aperture, shutter speed, exposure compensation, or ISO, depending on the shooting mode. Table 2.1 shows the functions of the three dials when Exposure Settings has been activated with the Navigation button:

Focus Settings

Press the Navigation button until Focus Settings appears on the screen. Figure 2.9 shows the focus area settings screen when Flexible Spot is chosen. Here's how the dials work:

- Control dial L. At upper left in Figure 2.9, you can see that spinning Control dial L allows you to choose from Multi, Flexible Spot, or Center focus area.
- Control dial R. At upper right, the icon shows that in Flexible Spot mode, the right dial allows moving the focus spot (shown in orange in the center of the figure) left and right.

- Control wheel. In Flexible Spot mode, the control wheel moves the orange focus spot up and down.
- **Upper soft key.** Cancels the settings.
- Lower soft key. Moves the orange focus area to the center of the screen.

In other focus area modes, the functions of the controls are different. A summary of the actions that become available with the controls in each focus mode is shown in Table 2.2. You'll find more on how to use these focus settings in Chapter 5.

Table 2.1 Exposure Settings								
Shooting mode	Control dial L	Action L	Control dial R	Action R	Control Wheel			
P—Program Auto	Program Shift	Left—slower shutter, smaller f/stop Right—faster shutter, wider f/stop	Exposure compensation	Left—Darker Right—Brighter	ISO			
A—Aperture Priority	Aperture	Left—wider f/stop Right—smaller f/stop	Exposure compensation	Left—Darker Right—Brighter	ISO			
S—Shutter Priority	Shutter speed	Left—Slower Right—Longer	Exposure compensation	Left—Darker Right—Brighter	ISO			
M—Manual Exposure	Shutter speed	Left—Slower Right—Longer	Aperture	Left—wider f/stop Right—smaller f/stop	ISO			
(3D) Sweep Panorama	Sweep Direction	Left/Right	Exposure Compensation	Left—Darker Right—Brighter	Sweep Direction			
Anti-Motion Blur	No Function	_	Exposure Compensation	Left—Darker Right—Brighter	No Function			
Intelligent Auto/ Scene Modes	No Function	_	No Function	_	No Function			

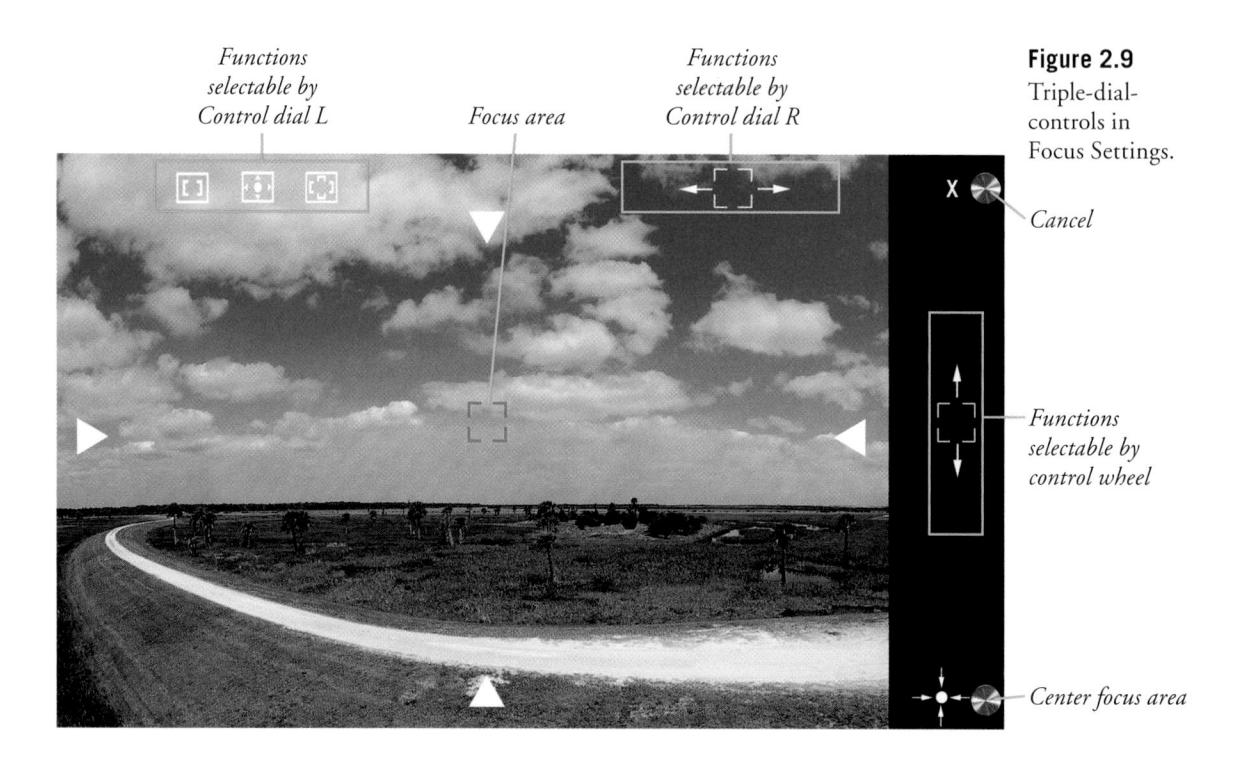

Table 2.2 Focus Settings							
Control dial L (choose mode)	Action	Control dial R	Control Wheel	Other			
Multi	Camera selects one of 25 AF areas automatically. Faces given priority in Face Detection mode.	No function	No function	No function			
Center	Camera uses center AF area only.	No function	No function	No function			
Flexible Spot	You can choose which AF area to use.	Moves focus spot left/right	Moves focus spot up/down	Directional buttons move focus spot up/down/left/right. Lower soft key B moves focus spot to middle.			

Manual Focus

The control dials have a special function during manual focus: changing the location of the magnified image when you're using the MF Assist feature. Unlike the other settings in this section, this control isn't activated by pressing the Navigation button. Instead, when the NEX-7 is set to manual focus, and you've enabled the MF Assist feature in the Setup menu, then rotating the focus ring on the lens activates Control dial L and control wheel. I'll show you how to activate Manual Focus and MF Assist in Chapter 3, and explain manual focus in more detail in Chapter 5. However, if you want to use manual focus right away, here are the basic steps:

- 1. Activate MF Assist. In the Setup menu, find the MF Assist entry and select On.
- 2. Choose assist time. Also in the Setup menu, you can select how long the magnified focus is available, from 2 seconds (the default), to 5 seconds, or No Limit.
- 3. Activate Manual Focus. In the Camera menu, find AF/MF Select and choose MF.
- 4. Rotate the focus ring of the lens, and then use the triple-dial-controls to position this magnified image within the frame:
 - Control dial L. Rotate left or right to move the magnified image up or down.
 - Control dial R. Moves the magnified image left or right.
 - Control wheel. Rotate clockwise and counterclockwise to move the magnified image left or right. An orange box moves around in a darkened rectangle in the lower-left corner of the screen to show the relative position of the magnified area in the overall image. (See Figure 2.10.)
 - Lower soft key B. Toggle between 5.9X and 11.7X magnification.

Using the triple-dial-controls in Manual Focus Assist mode.

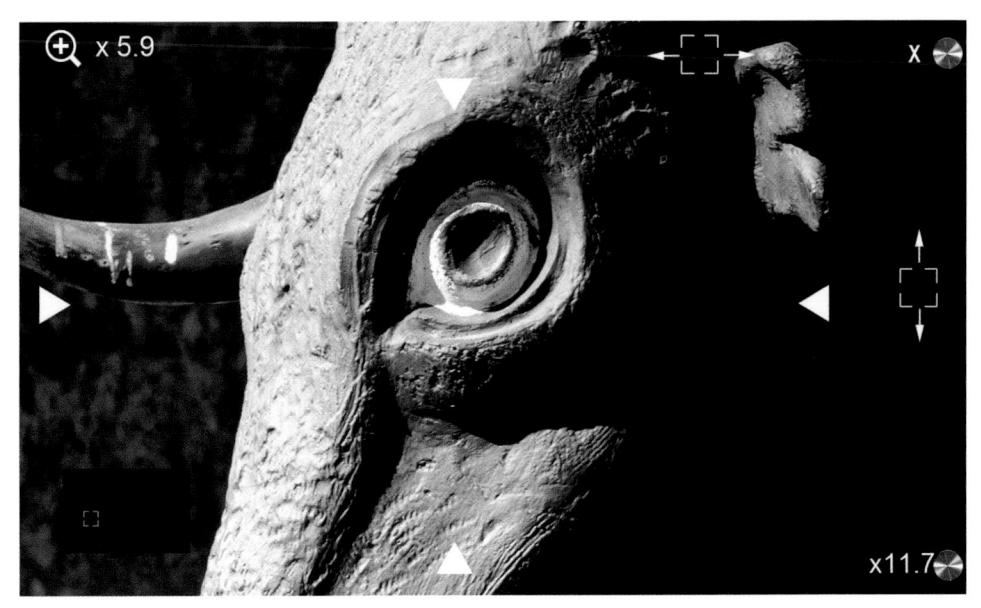

White Balance Settings

The next set of adjustments in the Navigation button cycle are White Balance Settings. I'll explain more about adjusting white balance in Chapter 4. The functions of the controls are as follows:

- Control dial L. Choose from among the available preset balances, including Auto white balance (AWB), Daylight, Shade, Cloudy, Incandescent, four types of Fluorescent illumination, Flash, Color Temperature, and Custom.
- Control dial R. Lets you tweak the color bias along the blue-amber (colderwarmer) axis.
- Control wheel. Can be used to bias color along the green-magenta axis. It can be used independently, or in conjunction with Control dial R to apply both types of color bias.

D-Range Settings

As you'll learn, the D-Range Optimizer/Auto HDR feature can be used to optimize the tonal values of an image, by adjusting the exposure and contrast of the image. I'll explain the use of this feature and its options in Chapter 4. When you've activated D-Range Settings using the Navigation button, the controls available are as follows:

- Control dial L (D-Range Optimizer Mode). Select from five levels, shown on a scale at the top left of the screen, starting with Auto at the leftmost position, and progressing through Lv1 (weak) to Lv5 (strong). A histogram appears underneath the scale, with a double-headed arrow showing the width of the tones affected at your selected level. (See Chapter 4 for a complete discussion of histograms.)
- Control dial L (Auto HDR Mode). In Auto HDR mode, the NEX-7 shoots three images at differing exposures, then combines the brightest tones from the underexposed version with the darkest tones of the overexposed image. The optimized image is saved to your memory card, along with the version captured at the metered exposure. This control dial allows you to specify the exposure difference between the under and overexposed versions, ranging from Auto to 1.0EV (weak) and 6.0 EV (strong).
- Control wheel. Select either DRO (D-Range Optimizer) or HDR (Auto HDR), or disable both by choosing Off.
- **Control dial R.** Sets the amount of exposure compensation from the metered exposure, from –5.0 to +5.0 EV, regardless of whether you've chosen DRO, HDR, or Off.

Creative Style Settings

When you press the Navigation button to activate Creative Style Settings, the triple-dial-controls have the following functions.

- Control dial L. Rotate to choose a Creative Style from among Standard, Vivid, Neutral, Clear, Deep, Light, Portrait, Landscape, Sunset, Night, Autumn, Black and White, or Sepia.
- Control dial R. Rotate left or right to adjust the intensity of the contrast, saturation, or sharpness of the Style, on a scale from −3 to +3.
- Control wheel. Rotate to choose which of the three parameters—contrast, saturation, or sharpness—will be modified by Control dial R.

Picture Effect Settings

By default, Exposure Settings, Focus Settings, White Balance Settings, D-Range Settings, and Creative Style Settings are the five options available by pressing the Navigation button. However, you can replace any of them (except for Exposure Settings) with Picture Effect Settings or Custom Settings in the Function Settings entry of the Setup menu (as I'll explain in Chapter 3). That will add the new choice to the Navigation button rotation. When Picture Effects Settings is active, the control dials have the following functions:

- Control dial L. Rotate to choose a Picture Effect from among Off, Toy Camera, Pop Color, Posterization, Retro Photo, Soft High-key, Partial Color, High Contrast Mono, Soft Focus, HDR Painting, Rich-tone Mono, and Miniature. I'll describe what each of these effects does, and some limitations in choosing them, in Chapter 4.
- Control dial R. Rotate to select from the options available for your chosen Picture Effect. The nature of the options varies from effect to effect.
- Control wheel. No function.

Custom Settings

If you don't like the default Navigation button cycle of Exposure Settings, Focus Settings, White Balance Settings, D-Range Settings, and Creative Style Settings, you can exchange any of them (except for Exposure Settings, as I insist on reminding you) for one of the other available settings. I'll explain how to set up Custom Settings in more detail in Chapter 3, but here are the button basics for this Roadmap chapter (in which I pledged to tell you what every button and dial was for, even though Sony has

a confoundingly complicated set of options that let you change many of them from their default values).

1. **Swap one of the exchangeable settings.** Access the Function Settings entry in the Setup menu, where you'll find a list with default values shown:

Function Settings 1: Focus Settings

Function Settings 2: White Balance Settings

Function Settings 3: D-Range Settings

Function Settings 4: Creative Style Settings

- 2. **Highlight the setting you want to change.** Press the control wheel center button.
- 3. **Select the alternate value.** For any of them you can select Focus Settings, White Balance Settings, D-Range Settings, Creative Style Settings, Picture Effect Settings, Custom Settings, or Not Set (which disables that setting).
- 4. **Confirm and Exit.** If none of the values have been registered as Custom Settings, press the upper soft key to confirm and exit. Otherwise, continue with Step 5.
- 5. **Assign Custom Settings.** While still in the Function Settings menu, scroll down to Custom Settings 1, press the control wheel center button.
- 6. Choose a function for Control dial L. Custom Settings 1 tells the NEX-7 what action to perform with the left control dial when the Navigation button cycles to the Custom Settings position you specified in Step 3. You can choose Focus Settings, White Balance Settings, D-Range Settings, or Creative Style Settings, but that wouldn't be any fun. You get additional choices here: You can assign the left dial to ISO, Metering Mode, Exposure Compensation, Autofocus, and Quality, in addition to Not Set. Press the center controller button to confirm.
- 7. **Choose a function for Control dial R.** Custom Settings 2 tells the NEX-7 what action to perform when the *right* control dial is spun. You have the same expanded list of choices available. Confirm and continue with Step 8.
- 8. **Choose a function for the control wheel.** Custom Settings 3 tells the NEX-7 what action to perform when the control wheel is spun, using the same list of options.
- 9. Exit the Function Settings entry. Now that you've defined your three Custom Settings functions, you can use the Control dial R, Control dial L, and control wheel to make the adjustments you specified whenever the Navigation button cycles to the Custom Settings entry.

I'll have some tips on some fun things you can do when specifying Custom Settings in Chapter 3.

Underneath Your Sony Alpha

The bottom panel of your Sony Alpha is not as bare as with some cameras, which often have just a tripod socket and battery compartment door. The NEX-7 has several other components located here, several of them bordering on the bizarre, at least in terms of placement. Figure 2.11 shows the underside view of the camera.

- **Tripod socket**. Attach the camera to a vertical grip, flash/microphone bracket, tripod, monopod, or other support using this standard receptacle. The socket is positioned roughly behind the optical center of the lens, a decent location when using a tripod with a pan (side rotating) movement, compared to an off-center orientation. For most accurate panning, the socket would ideally be placed a little forward (actually in *front* of the camera body) so the pivot point is located *under* the optical center of the lens, but you can't have everything. There are special attachments you can use to accomplish this if you like.
- Battery/memory card compartment door. Slide open to access the battery and memory card.

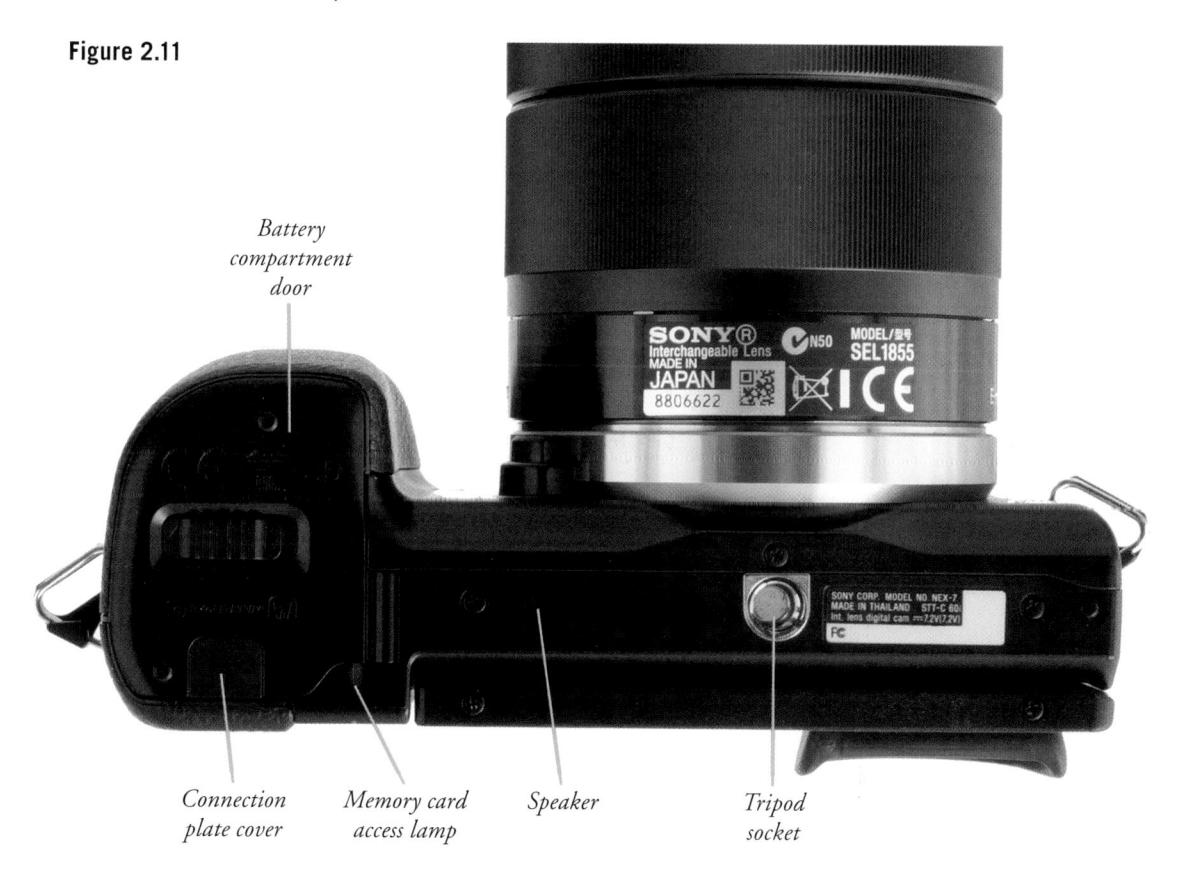

- Connection plate cover. This is a separate port in the battery/card compartment door that allows passing the cord from the connection plate of the optional AC-PW20 AC adapter (\$120 MSRP) out of the battery compartment so it can link with the power module.
- **Speaker.** There are three tiny holes on the bottom of the camera that emit sound generated by electronic beeps and movie audio. Most cameras locate the speaker on the top or side of the camera, and in this unusual location it may be difficult to hear the sound when the camera is mounted on a tripod, especially if you're using a quick release plate that may cover the holes.
- Memory card access lamp. Sometimes it's comforting, or even useful, to be able to monitor the flashing of the memory card access lamp, as reassurance that the camera is indeed writing your precious photos to the card. For some unknown reason, Sony has located the flashing red lamp on the *bottom* of the NEX-7, so that you have to flip the camera to watch it (assuming that your NEX is not mounted on a tripod). Of course, the EVF and LCD both blank for a moment when a picture is actually taken, but if you want to know when the NEX-7 has finished its writing chores, you'll need to tilt the camera.

Lens Components

There's not a lot going on with most Sony lenses in terms of controls because, in the modern electronic age, most of the functions previously found on lenses in the ancient film era, such as autofocus options, are taken care of by the camera itself. Nor do Sony lenses designed for the NEX require an on/off switch for image stabilization, because that feature is controlled through the camera's menu system. Figure 2.12 shows the Sony NEX's18-55mm lens and its components. I'm also going to mention some other features not found in this particular lens.

- Lens hood bayonet. This is used to mount the lens hood for lenses that don't use screw-mount hoods (the majority).
- **Zoom ring.** Turn this ring to change the zoom setting.
- Zoom scale. These markings on the lens show the current focal length selected.
- Focus ring. This is the ring you turn when you manually focus the lens.
- Electrical contacts. On the back of the lens are electrical contacts that the camera uses to communicate focus, aperture setting, and other information.
- Lens bayonet. This mount is used to attach the lens to a matching bayonet on the camera body.

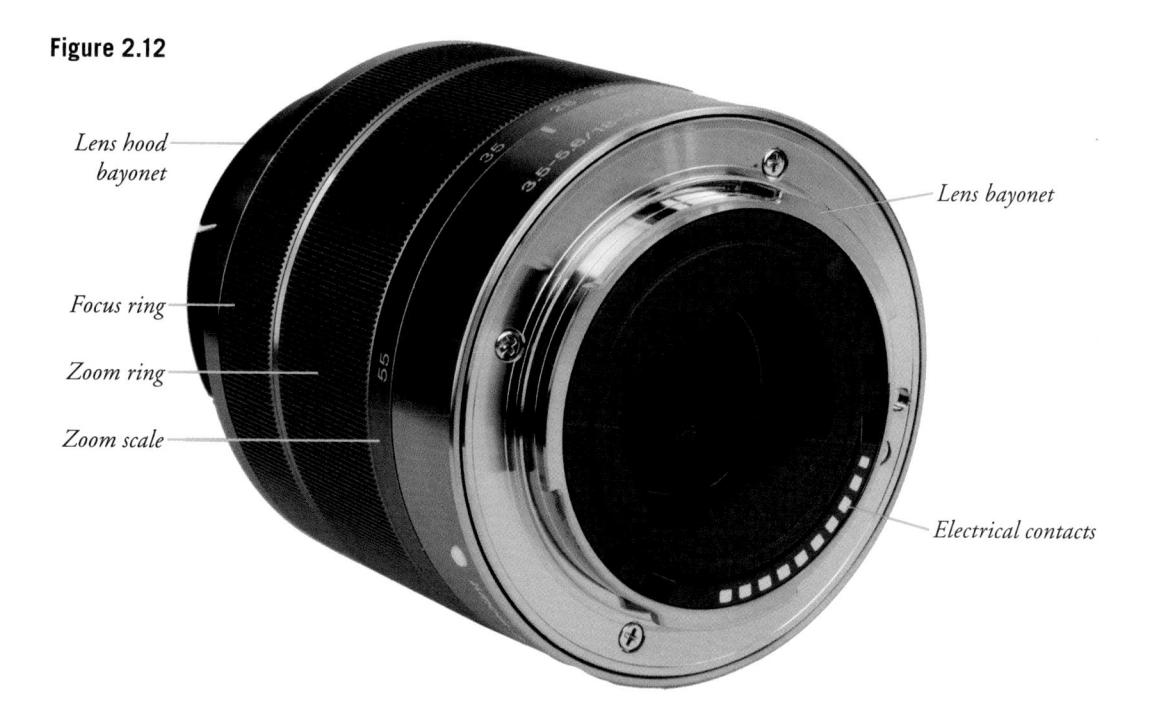

- Filter thread (not shown). Lenses (including those with a bayonet lens hood mount) have a thread on the front for attaching filters and other add-ons. Some also use this thread for attaching a lens hood (you screw on the filter first, and then attach the hood to the screw thread on the front of the filter). Both the 18-55mm standard zoom lens and the 16mm "pancake" lens for the Sony NEX camera have a 49mm filter thread, not shown in this figure.
- Distance scale (not shown). Some upscale lenses, including the Zeiss optics, have this readout that rotates in unison with the lens's focus mechanism to show the distance at which the lens has been focused. (The illustrated lens does not have a distance scale.) It's a useful indicator for double-checking autofocus, roughly evaluating depth-of-field, and for setting manual focus guesstimates.

Setting Up Your Sony Alpha NEX-7

The Sony Alpha NEX-7 has a remarkable number of options and settings you can use to customize the way your camera operates. Not only can you change shooting settings used at the time the picture is taken, but you can adjust the way your camera behaves. This chapter will help you sort out the settings for all the Alpha NEX's menus. These include the Shoot Mode, Camera, Image Size, Brightness/Color, and Playback menus, which determine how the Alpha uses many of its shooting features to take a photo and how it displays images on review. I'll also show you how to use the Setup menu to adjust power-saving timers, specify LCD brightness, set up your image file folders, and adjust options like noise reduction and red-eye reduction.

This book isn't intended to replace the manuals you received with your Alpha (one printed and one on CD), nor have I any interest in rehashing their contents. You'll still find the original manuals useful as standby references that list every possible option in exhaustive (if mind-numbing) detail—without really telling you how to use those options to take better pictures. There is, however, some unavoidable duplication between the Sony manuals and this chapter, because I'm going to explain all the key menu choices and the options you may have in using them. You should find, though, that I will give you the information you need in a much more helpful format, with plenty of detail on why you should make some settings that are particularly cryptic.

I'm not going to waste a lot of space on some of the more obvious menu choices in these chapters. For example, you can probably figure out, even without my help, that the Beep option deals with the solid-state beeper in your camera that sounds off during various activities (such as the self-timer countdown). You can certainly decipher the

import of the settings available for Beep (AF Sound, High, Low, and Off). In this chapter, I'll devote no more than a sentence or two to the blatantly obvious settings and concentrate on the more complex aspects of Alpha NEX setup, such as autofocus. I'll start with an overview of using the camera's menus themselves.

Anatomy of the Sony Alpha NEX's Menus

If you've used the menu systems of other cameras, including those on Sony's NEX-5N and SLT camera models, you'll find some familiar features in the menus of the NEX-7, such as the broad range of choices available for shooting, playback, and setup options, and the clearly recognizable graphical elements that help you choose the settings you want. You'll also notice some significant differences, though. For example, instead of a more standard collection of menus, including Recording, Playback, and Setup, the NEX menus are divided into six categories: Shoot Mode, Camera, Image Size, Brightness/Color, Playback, and Setup. (See Figure 3.1.) The first of these categories, Shoot Mode, is not really a menu; instead, it's a virtual shooting mode dial that replaces the physical mode dial found on many other cameras. The Camera, Image Size, and Brightness/Color menus include the settings that relate to shooting images. On many other cameras, all of those settings are included in one Recording menu, perhaps a long menu with several tabs.

The NEX menu system is quite easy to navigate, whether you're using the physical controls, and, once you have figured out that you have to look for exposure-related

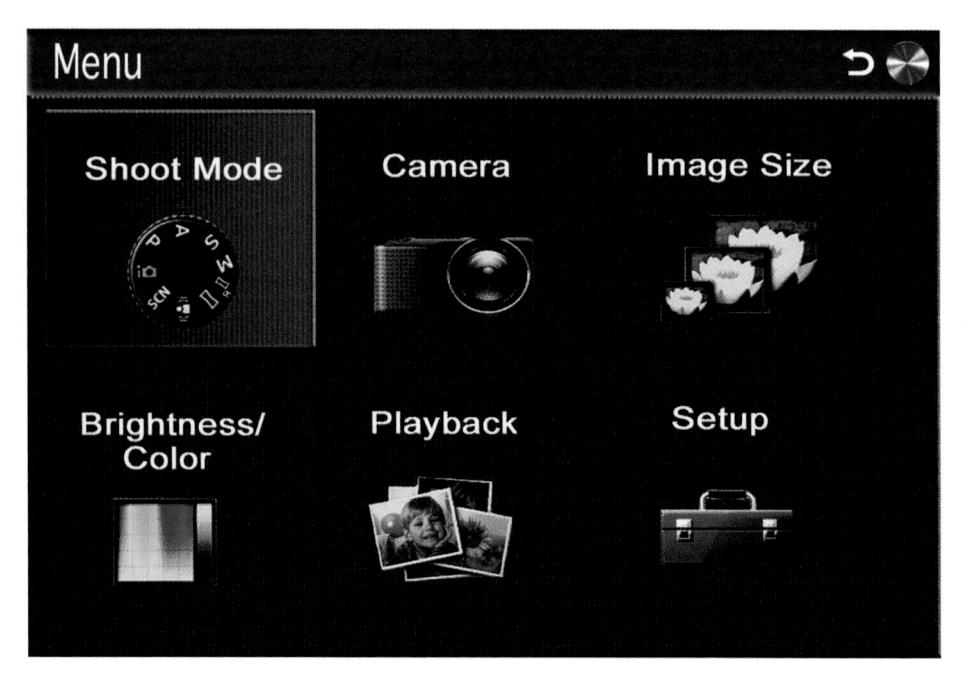

Figure 3.1 The Sony Alpha NEX's main menu screen shows six icons that represent the six categories of menu. The first option, Shoot Mode, is not really a menu, but a virtual shooting mode dial. The other five icons are the entry points for the five actual menus that contain the camera's many settings.

settings such as ISO, white balance, exposure compensation, and metering mode in the Brightness/Color menu, and Drive mode, Flash mode, and focus-related settings in the Camera menu, you should have no trouble moving quickly to the appropriate listing. Sony has done a good job of placing the items you are likely to need most often near the tops of the menus, so you should not have much difficulty in getting to the settings you want.

To enter the menu system, press the upper soft key at the top of the camera's back whenever you see the "Menu" label next to the image of that button on the LCD screen. Use the direction buttons or the control wheel to navigate to and highlight the icon for the menu category you want to access and press the center controller button to open that menu. Then use the down button or spin the control wheel to navigate down to and highlight the menu entry you want. (On long menus like the Setup menu, I strongly recommend that you use the control wheel, so you can spin quickly down through the lengthy list of options.)

Of course, not everything has to be set using these menus. The NEX has a few convenient direct setting controls, such as the drive mode, exposure compensation, and DISP button on the control wheel, plus the left button on the wheel, which summons drive mode choices. These buttons bypass the multilayered menu system to provide quick access to some features. You can set up definitions for custom keys in the Setup menu, as described later in this chapter. For the most part, though, you will be making your adjustments to the NEX's settings using its menu system, so we will explore that system in depth.

When working with any of the menus, after you've moved the highlighting bar with the up/down direction buttons (or the control wheel) to the menu item you want to work with, press the center controller button to select it. A submenu with a list of options for the selected menu item will appear. Within the submenu options, you can scroll with the up/down direction buttons or with the control wheel to choose a setting, and then press the center controller button to confirm the choice you've made. Press the upper soft key again (the button should now be labeled with a reversing arrow icon) to exit. Or, if you prefer, you can press halfway down on the shutter button to exit the menu system and go directly into shooting mode, ready to snap a photo with your new menu settings.

At times you will notice that some lines on various menu screens are "grayed out," so you can read them but they cannot be selected. This means that the item is not available for adjustment with your current settings. For example, if you have set Quality to RAW, the Image Size line will be grayed out, because RAW files are all the same size, and no size setting is possible.

With that introduction, it's time to explore the NEX's feature-packed menu system.

Camera Menu

Figure 3.2 shows the first screen of the Camera menu, which includes several often used functions related to shooting your images. (For each of the five menu systems, I have divided the menu into several screens for convenience in illustrating the menus, even though the Sony menu system is not formally sub-divided into separate screens; each menu just scrolls from beginning to end with no page breaks.) The choices you'll find on the Camera menu's screens include the following:

- Drive Mode
- Object Tracking
- Soft Skin Effect

- Flash Mode
- Precision Digital Zoom
- LCD Display (DISP)

- AF/MF Select
- Face Detection
- Finder Display (DISP)

- Autofocus Area
- Face Registration
- DISP Button (Monitor)

- Autofocus Mode
- Smile Shutter

Drive Mode

Options: Single Shooting; Continuous Shooting; Speed Priority Continuous Advance; Self-timer; Self-timer (Continuous); Bracket; Remote Commander

Default: Single Shooting

There are several choices available through this single menu item: Continuous shooting mode at up to 3 or 10 frames per second; Speed-priority continuous shooting at up to 10 frames per second; Self-timer; Self-timer with multiple shots; Exposure bracketing; and Remote Commander (allowing the use of the infrared remote control). I discuss

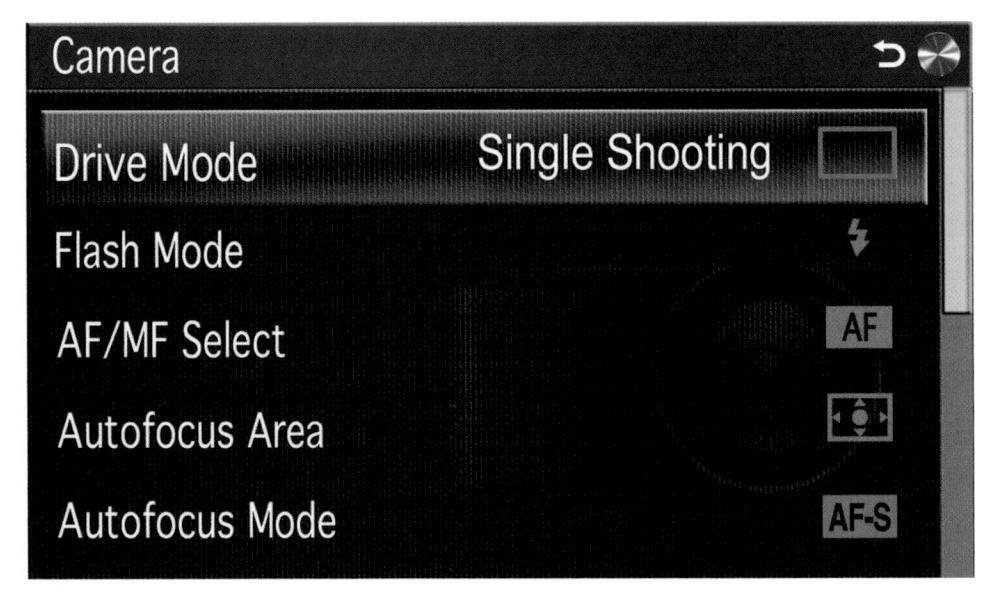

Figure 3.2
The first screen of the Sony
Alpha NEX-7's
Camera menu.

bracketing in Chapter 4, and continuous shooting and the Remote Commander in Chapter 6. You can also get access to these settings without using the menu system, by pressing the left direction button, which doubles as the drive mode button.

Flash Mode

Options: Flash Off, Auto Flash, Fill Flash, Slow Sync, Rear Sync

Default: None (depends on shooting mode)

This entry calls forth a submenu that allows you to choose among the several flash modes that are available: Flash Off, Auto Flash, Fill Flash, Slow Sync, and Rear Curtain. Not all of these modes are available at all times. I'll describe the use of flash in detail in Chapter 9. You can also get access to these options by pressing the right direction button (flash mode button).

AF/MF Select

Options: Autofocus, DMF, Manual focus

Default: Autofocus

With the NEX camera, you select your focusing mode with this menu option; there is no focus selection switch on the lens or camera body, as there is with some other cameras. (You can, however, temporarily switch between autofocus and manual focus using the AF/MF button, as described later in this chapter.) Besides the default choice of Autofocus, there are two other choices: DMF and Manual focus. If you select Manual focus, you turn the focusing ring on the lens to achieve the sharpest possible focus. With DMF, which stands for Direct Manual Focus, you press the shutter button halfway down to let the camera start the focusing process; then, keeping the button pressed halfway, turn the focusing ring to fine-tune the focus manually. You might want to use DMF when you are focusing from a short distance on a small object, and want to make sure the focus point is exactly where you want it. With both DMF and Manual focus, the camera will show you an enlarged image to help with the focusing process, if you have the MF Assist option turned on through the Setup menu. I'll discuss focus procedures in more detail in Chapter 5.

Autofocus Area

Options: Multi, Center, Flexible Spot

Default: Multi

When the camera is set to Autofocus, use this menu option to determine where the camera places its focus area in the scene. If you choose Multi, the camera uses its own electronic intelligence to determine what part of the scene should be in sharpest focus, and selects for itself among the 25 possible focus areas. If you choose Center, then the

camera always uses the center of the image for the focus point. With Flexible Spot, you have the ability to move the camera's focus point around the scene to any one of multiple locations, using the direction buttons. You can then press the lower soft key when it's labeled "Focus" to reactivate the focus point so it can be moved again using the direction buttons. The Multi option is automatically selected in certain shooting modes, including Intelligent Auto and all Scene modes. In addition, if you want to use Face Detection (discussed later in this chapter), you have to set this option to Multi.

Autofocus Mode

Options: AF-S, AF-C

Default: AF-S

When the camera is set to Autofocus, this menu option is used to set the way in which the camera focuses. Your two choices are AF-S, or Single-shot autofocus, and AF-C, or Continuous autofocus. With AF-S, the default option, focus is locked once you press the shutter button down halfway and the camera achieves sharp focus; even if the subject later moves, the focus will stay where it was set. With AF-C, on the other hand, even after you have aimed at the subject and pressed the shutter button halfway down, the camera will continue to adjust the focus if the subject (or camera) moves. This mode is useful when you're photographing active children, animals, sports, or other moving subjects. I'll discuss focus options in detail in Chapter 5.

Object Tracking

Options: On/Off

Default: On

This is the first setting on the second full screen of the Camera menu, as shown in Figure 3.3. This option tells the NEX-7 to retain focus while tracking a moving object. A target frame appears, and you line up the frame with the subject you want to track. Press the center controller button and the camera will lock in focus and continue to change focus as required while tracking the subject as it moves around within the frame. This is an excellent tool for sports photography, and for follow focus of pets, kids, and other subjects that may move erratically or unexpectedly.

Precision Digital Zoom

Options: 1.1x to 10x

Default: 1.1x

This feature is available in limited circumstances, and is not of much practical use, though it's worthwhile knowing it exists. Choose this option and then use the control wheel or the direction buttons to zoom the image electronically from 1.1 times normal

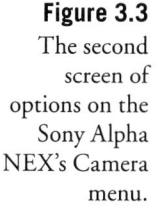

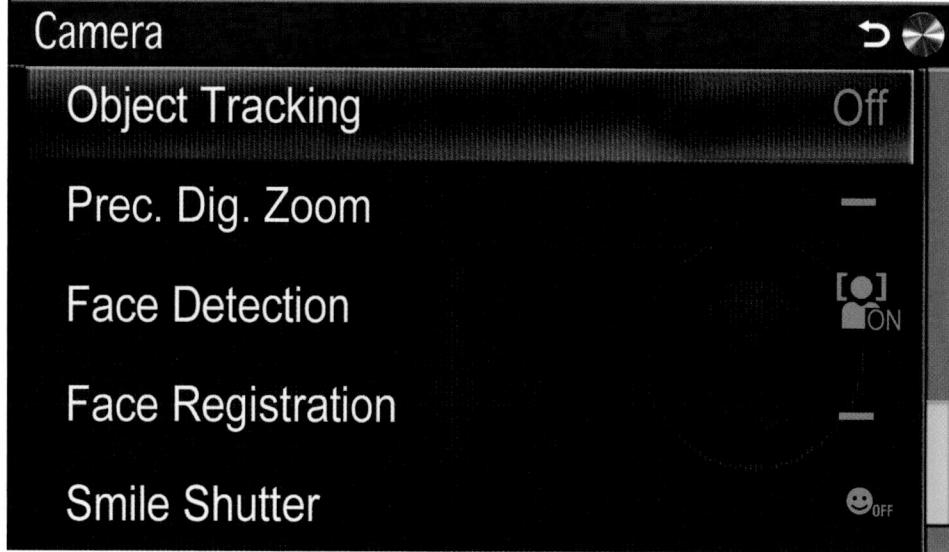

to as much as 10 times normal. This is an electronic "zoom," which actually just magnifies the pixels, making the image quality deteriorate proportionally with the zoom factor. The feature could be of use when you are using the pancake lens and want to have a close-up view of your subject to help with focusing or composition. I recommend against actually shooting pictures while zoomed with this option. Instead, shoot at the lens's normal focal length and crop the image later in your editing software to enlarge the portion you want to emphasize. This feature isn't available when using the Handheld Twilight Scene mode or when using Anti Motion Blur, Sweep Panorama, 3D Sweep Panorama, Smile Shutter, Auto HDR, or in RAW or RAW & JPEG quality modes.

Face Detection

Options: Off, On, On (Registered Faces)

Default: On (Registered Faces)

With this option activated, the camera will survey the subjects before it and try to determine if it is looking at any human faces. If it decides that it is, it sets focus, flash, exposure, and white balance settings for you. When a face is detected, the camera will select a main subject and place a white frame around that face. Press the shutter release halfway, and the frame around the priority face will turn green as the settings lock in. Other faces in the picture will be framed in gray, or, if that face has been logged using Face Registration (described next), a magenta frame will appear. When set to On (Registered Faces), any faces previously logged will be given priority. As you press the shutter button to take the picture, the camera will attempt to set the exposure and white balance using the face it has selected as the main subject. If that result is not what you

want, you can start over, or you may want to take control back from the camera by choosing Flexible Spot or Center for the Autofocus Area and placing the focus spot exactly where you want it. If you want to use Face Detection, you have to have Autofocus turned on, Autofocus Area set to Multi, and Metering Mode set to Multi. The feature does not work when using Sweep Panorama, 3D Sweep Panorama, Manual Focus, or Precision Digital Zoom. Face Detection is turned on (regardless of how it's set here) when you are using Smile Shutter, described later.

Face Registration

Options: New Registration, Order Exchanging, Delete, Delete All

Default: None

This menu entry is used to log into your camera's Face Detection memory the visages of those you photograph often. New Registration allows you to log up to eight different faces. Line up your victim (subject) against a brightly lit background, to allow easier detection of the face. Use the directional buttons to align the green frame that appears with the face, and press the shutter button. A confirmation message appears, and you press the center OK button to confirm.

The Order Exchanging Option allows you to review and change the priority in which the faces appear, from 1 to 8. The NEX-7 will use your priority setting to determine which face to focus on if several registered faces are detected in a scene.

You can also select a specific face and delete it from memory (say, you broke up with your significant other!) or delete *all* faces from the registry (your SO got custody of the camera).

Smile Shutter

Options: On, Off

Default: Off

This function is related to Face Detection; when you turn Smile Shutter on, Face Detection is automatically turned on also. With Smile Shutter, the camera watches for a smile, and fires the shutter automatically each time it sees one. This is an interesting high-tech feature, because the subject's smile acts as a sort of remote control. Each time a person smiles, the camera clicks the shutter and takes a picture. There is no limit to the number of smiles and images; you, or whoever is in front of the camera, can keep smiling repeatedly, and the camera will keep taking more pictures, until it runs out of memory storage or battery power. Of course, the main purpose of this feature is not to act as a remote control; it's really intended to make sure your subject is smiling before the shutter fires. Whenever the Smile Shutter triggers the shutter release, it also flashes the red light of the AF Illuminator to signal that a picture is being taken.

Smile Detection

Options: Big Smile, Normal Smile, Slight Smile

Default: Normal Smile

Smile Detection isn't a separate menu entry. Press the lower soft key (labeled Option) when using the Smile Shutter menu entry, and then select the sensitivity of the Smile Shutter feature according to the size of the subject's smile. You will need to experiment to find out which level to use; the sensitivity of this feature depends on factors such as whether the subject shows his or her teeth when smiling, whether the eyes are covered by sunglasses, and others. I suggest leaving it at the default setting of Normal Smile and adjusting from there as needed.

Soft Skin Effect

Options: On/Off

Default: On

This entry, the second entry in the third screen of the Camera menu (see Figure 3.4), is used with the Face Detection function, telling the NEX-7 to add a slight amount of blurring to the skin of detected faces, which usually helps produce a more flattering picture. Choose On or Off, then press the Option button and select High, Mid, or Low skin softening. This effect does not work when shooting movies or in any continuous shooting mode, including bracketing and continuous self-timer, nor when using the Sports Action Scene mode, Sweep Panorama, 3D Sweep Panorama, or RAW quality mode.

Figure 3.4

The third screen of the Camera menu.

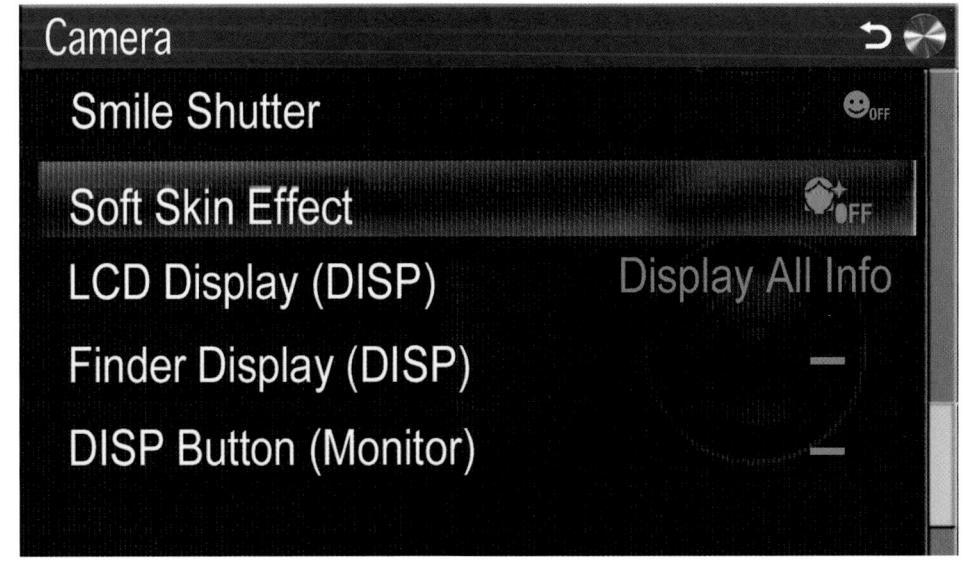

LCD Display (DISP)

Options: Graphic Display, Display All Info., Big Font Size Disp., No Disp. Info, Live View Priority, Level, Histogram, For Viewfinder (Choose any one)

Default: Display All Info

As mentioned in Chapter 2, you can select which of the information displays is shown on the back-panel LCD (monitor) and EVF (finder) separately. This entry specifies the screen that will be the default value that is shown first, from those you have activated using DISP Button (Monitor), described below. In shooting mode you can press the DISP button repeatedly to switch to any of the others that have been activated.

Finder Display (DISP)

Options: Disp. Basic Info, Level, Histogram (Choose any one)

Default: Disp. Basic Info

This entry specifies the screen that will be the default value that is shown first, from those you have activated using DISP Button (Monitor), described next. In shooting mode you can press the DISP button repeatedly to switch to any of the others that have been activated.

DISP Button (Monitor)

Options: Graphic Display, Display All Info., Big Font Size Disp., No Disp. Info., Live View Priority, Level, Histogram, For Viewfinder

Default: Display All Info+No Disp. Info.+Level+Histogram

This menu option allows you to specify which of the available LCD screen displays will be available in shooting mode. Pressing the DISP button cycles through each of the display options that you've activated here. You can select a minimum of one display option, or all eight, from the choices shown in Figure 3.5:

- **Graphic Display.** Shows basic shooting information, plus a graphic display of shutter speed and aperture (except when Sweep Panorama or 3D Sweep Panorama are active). (See Figure 3.6.)
- **Display All Info.** Offers a complete selection of recording information. (See Figure 3.7.)
- **Big Font Size Disp.** Displays only basic information in an enlarged font size. (See Figure 3.8.)

Figure 3.5
Select which display screens are shown on the LCD.

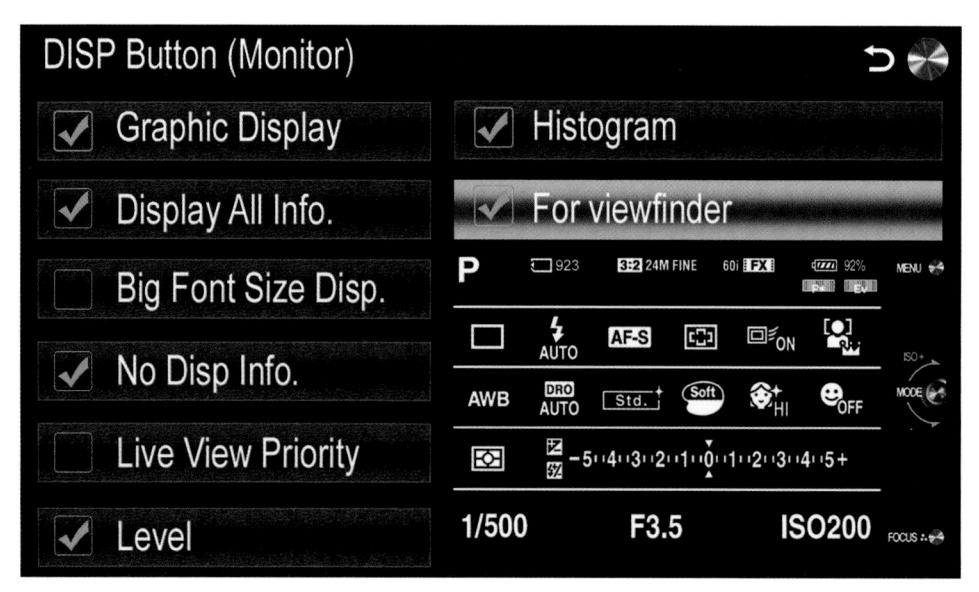

Figure 3.6
Graphic Display.

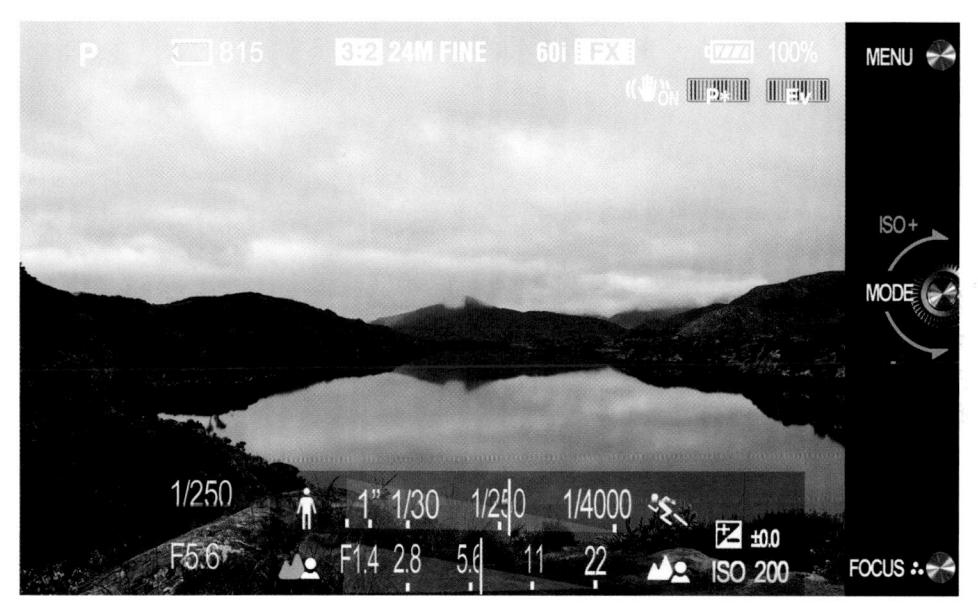

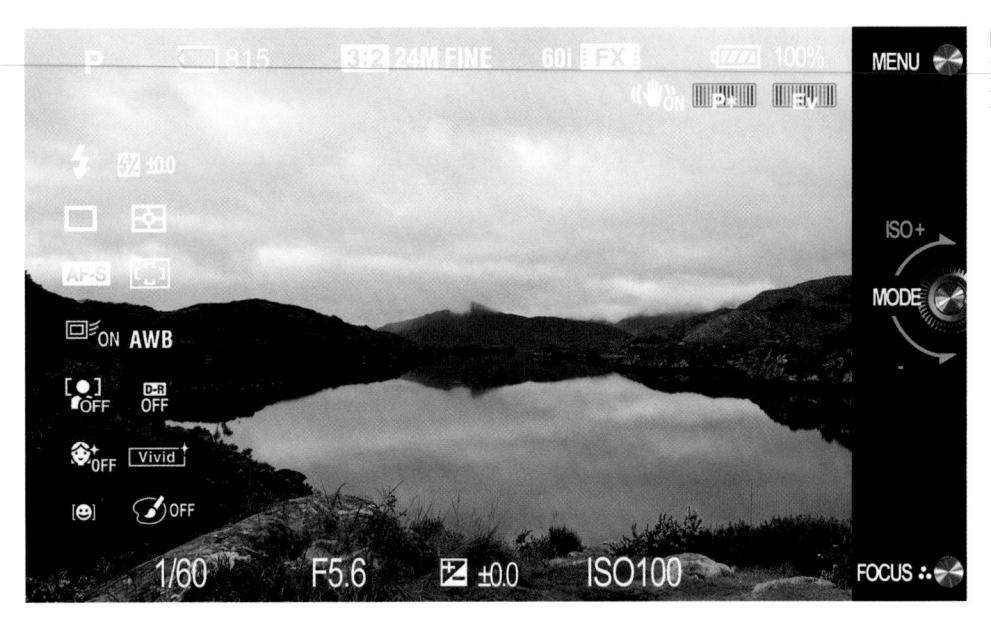

Figure 3.7
Display All
Information.

Figure 3.8Big Font Size Display.

- **No Disp. Info.** Shows just a blank screen with basic shooting information arrayed along the bottom. (See Figure 3.9.)
- Live View Priority. Replaces the soft key labels with the most important shooting information at the right of the screen. (See Figure 3.10.)

Figure 3.9 No Display Information.

Figure 3.10 Live View Priority.

■ Level. Helps you correct side-to-side and front-back tilting of the camera. In Figure 3.11, top, the ideal positions for the indicators are shown in white, with the current horizontal tilting (shown at the arcs at the edges) in orange, and the front-back tilting by two orange indicators that move up and down the brackets in the center. When the camera is level, the indicators turn green (Figure 3.11, bottom).

Figure 3.11
Top, camera not level; Bottom, camera leveled.

- **Histogram.** Histogram shows no recording information except for a live luminance histogram. (See Figure 3.12.)
- For Viewfinder. For Viewfinder shows only the shooting information on the LCD; the live image is not displayed. You'd use this choice if composing exclusively through the EVF or an optional viewfinder attachment, such as the Sony CLM-V55 5-Inch external LCD monitor. (See Figure 3.13.)

Figure 3.12
Histogram
display.

Figure 3.13 Informationonly display.

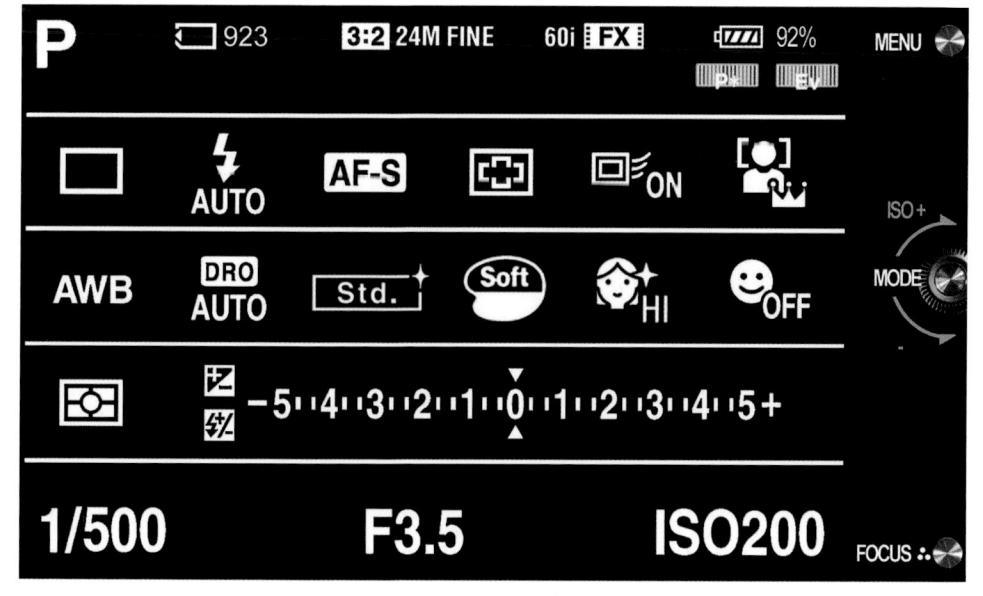

Image Size Menu

Figure 3.14 shows the first screen of choices on the Image Size menu. The options on this menu are among the most important ones in the menu system, and none of them are accessible in any other way, so you should take time to become very familiar with these settings and practice getting access to them quickly. They control several critical factors affecting the size and quality of your images. The choices you'll find on these two screens include the following, subdivided by banners included in the menu system into four categories (shown below in bold type): Still, 3D Panorama, Panorama, and Movie:

- STILL
 - Image Size
 - Aspect Ratio
 - Quality
- 3D Sweep Panorama
 - Image Size
 - Panorama Direction

- Panorama
 - Image Size
 - Panorama Direction
- Movie
 - File Format
 - Record Setting

Image Size (Still)

Options: Large, Medium, Small

Default: Large

Here you can choose between the NEX-7's Large, Medium, and Small settings for still pictures. (If you have selected RAW or RAW & JPEG for Quality, the Image Size option is grayed out, because the only size available in those cases is Large.) Select the

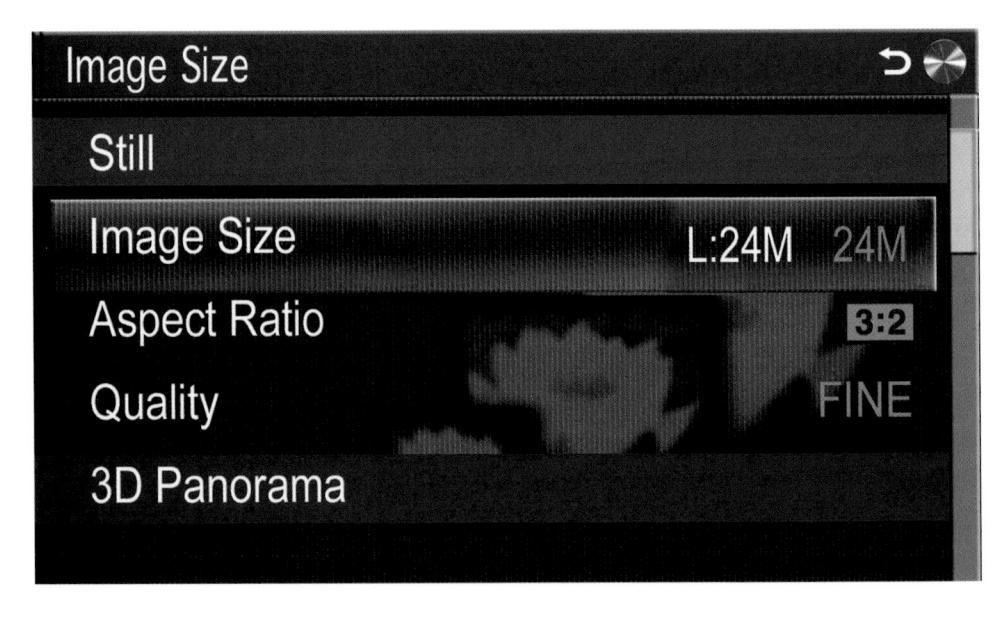

Figure 3.14
The first screen of options on the Sony Alpha NEX's Image Size menu.

Table 3.1	Image Sizes Available					
Image Size	Megapixels 3:2 Aspect Ratio	Resolution 3:2 Aspect Ratio	Megapixels 16:9 Aspect Ratio	Resolution 16:9 Aspect Ratio		
Large (L)	24 MP	6000 × 4000	20 MP	6000 × 3376		
Medium (M)	12 MP	4240×2832	10 MP	4240 × 2400		
Small (S)	6 MP	3008×2000	5.1 MP	3008 × 1688		

menu option, and use the up/down direction buttons or the control wheel to choose L, M, or S. Then press the center controller button to confirm your choice. The actual size of the images depends on what aspect ratio you have chosen for your shots—either the standard 3:2 or the widescreen 16:9. (That setting is discussed below). Table 3.1 provides a comparison.

There are few reasons to use anything other than the Large setting with this camera, even if reduced resolution is sufficient for your application, such as photo ID cards or web display. Starting with a full-size image gives you greater freedom for cropping and fixing problems with your image editor. An 800×600 -pixel web image created from a full-resolution original often ends up better than one that started out at 2448×1624 pixels.

Of course, the Medium and Small settings make it possible to squeeze more pictures onto your memory card, and a 12 MP or 10 MP image (the Medium sizes for NEX images at the 3:2 and 16:9 aspect ratios) is nothing to sneeze at—either one is a resolution that approaches the maximum of some very fine cameras of the last few years. Smaller image sizes might come in handy in situations where your storage is limited and/or you don't have the opportunity to offload the pictures you've taken to your computer. For example, if you're on vacation and plan to make only 4×6 -inch snapshot prints, a lower resolution can let you stretch your memory card's capacity. The NEX can fit more than 1,000 of those 12 MP Medium shots in JPEG Finc quality mode onto an 8GB memory card. Most of the time, however, it makes more sense to simply buy more memory cards and use your camera at its maximum resolution.

Aspect Ratio

Options: 3:2, 16:9 aspect ratios

Default: 3:2

The aspect ratio is simply the proportions of your image as stored in your image file. The standard aspect ratio for digital photography is approximately 3:2; the image is two-thirds as tall as it is wide, as shown by the outer green rectangle in Figure 3.15.

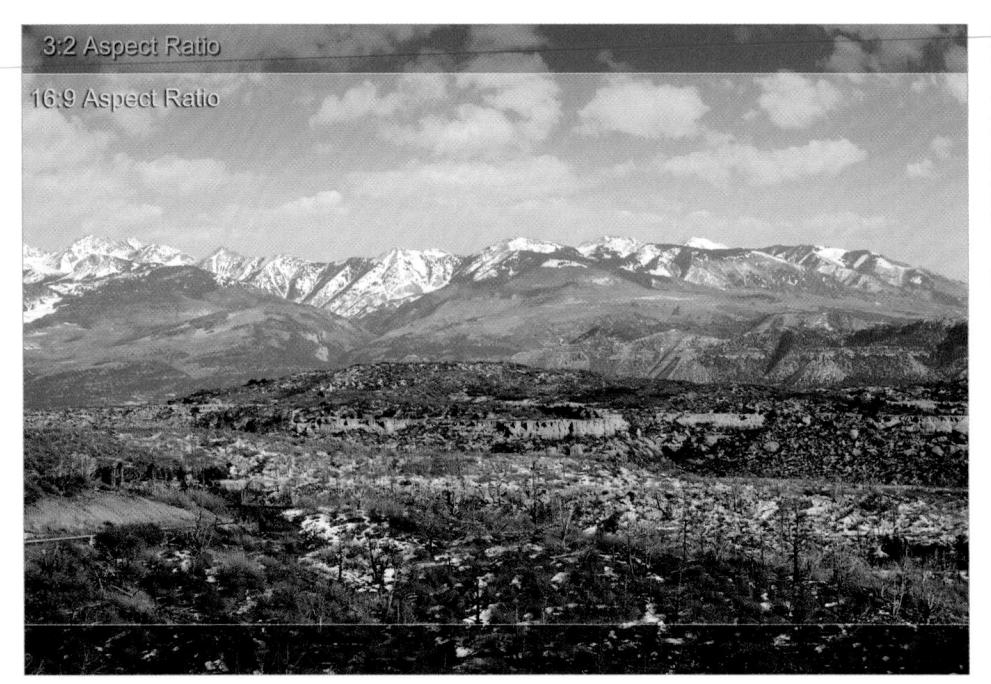

Figure 3.15
The 3:2 aspect ratio is shown by the outer green box. The yellow bars indicate the 16:9 aspect ratio cropping.

These proportions conform to those of the most common snapshot size in the USA, 4×6 inches. Of course, if you want to make a standard 8×10 -inch enlargement, you'll need to trim some image area from either end, or use larger paper and end up with an 8×12 -inch print. Aspect ratios are nothing new for 35mm film photographers (or those who own a "full-frame" digital SLR). The 36×24 mm (or 24×36 mm) frame of those cameras also has a 3:2 (2:3) aspect ratio.

If you're looking for images that will "fit" a wide-screen computer display or a high-definition television, the Alpha models can be switched to a 16:9 aspect ratio that is much wider than it is tall. The camera performs this magic by cutting off the top and bottom of the frame (see the yellow boundaries in Figure 3.15), and storing a reduced resolution image (as shown in Table 3.1). Your 24 MP image becomes a 20 MP shot with the NEX-7. If you need the wide-screen look, the 16:9 aspect ratio will save you some time in image editing, but you can achieve the same proportions (or any other aspect ratio) by trimming a full-resolution image in your editor. As with the other basic menu choices in this chapter, just navigate to the entry, press the center controller button, choose the option you want, and press the button again to confirm your choice.

Quality

Options: RAW, RAW & JPEG, Fine, Standard

Default: Fine

This menu option lets you choose the image quality settings used by the Alpha NEX to store its files for still photos. You have four choices to select from within this menu entry: RAW, RAW & JPEG, Fine, and Standard. (The two latter options are JPEG formats.) Here's what you need to know to choose intelligently:

- **JPEG compression.** To reduce the size of your image files and allow more photos to be stored on a given memory card, the Alpha NEX uses JPEG compression to squeeze the images down to a smaller size. This compacting reduces the image quality a little, so you're offered your choice of Fine compression and Standard compression. Fine should really be your *standard*, because it offers the best image quality of the two JPEG options.
- JPEG, RAW, or both. You can elect to store only JPEG versions of the images you shoot (Fine or Standard), or you can save your photos as "unprocessed" RAW files, which consume several times as much space on your memory card. Or, you can store both file types at once as you shoot. Many photographers elect to save both a JPEG and a RAW file (RAW & JPEG), so they'll have a JPEG version that might be usable as-is, as well as the original "digital negative" RAW file in case they want to do some processing of the image later. You'll end up with two different versions of the same file: one with a JPG extension, and one with the .ARW extension that signifies a Sony RAW file.

As I noted under Image Size, there are some limited advantages to using the Medium and Small resolution settings, and similar space-saving benefits accrue to the Standard JPEG compression setting. All of these settings help stretch the capacity of your memory card so you can shoehorn quite a few more pictures onto a single card. That can be useful when you're on vacation and are running out of storage, or when you're shooting non-critical work that doesn't require full resolution (such as photos taken for real estate listings, web page display, photo ID cards, or similar applications). Some photographers like to record RAW & JPEG Fine so they'll have a JPEG file for review, while retaining access to the original RAW file for serious editing.

But for most work, using lower resolution and extra compression is false economy. You never know when you might actually need that extra bit of picture detail. Your best bet is to have enough memory cards to handle all the shooting you want to do until you have the chance to transfer your photos to your computer or a personal storage device.

JPEG vs. RAW

You'll sometimes be told that RAW files are the "unprocessed" image information your camera produces, before it's been modified. That's nonsense. RAW files are no more unprocessed than your camera film is after it's been through the chemicals to produce a negative or transparency. A lot can happen in the developer that can affect the quality of a film image—positively and negatively—and, similarly, your digital image undergoes a significant amount of processing before it is saved as a RAW file. Sony even applies a name (BIONZ) to the digital image processing (DIP) chip used to perform this magic in the Sony Alpha NEX.

A RAW file is more similar to a film camera's processed negative. It contains all the information, with no compression, no sharpening, no application of any special filters or other settings you might have specified when you took the picture. Those settings are *stored* with the RAW file so they can be applied when the image is converted to a form compatible with your favorite image editor. However, using RAW conversion software such as Adobe Camera Raw or Sony's Image Data Converter SR, you can override those settings and apply settings of your own. You can select essentially the same changes there that you might have specified in your camera's picture-taking options.

RAW exists because sometimes we want to have access to all the information captured by the camera, before the camera's internal logic has processed it and converted the image to a standard file format. RAW doesn't save as much space as JPEG. What it does do is preserve all the information captured by your camera after it's been converted from analog to digital form.

So, why don't we always use RAW? Although some photographers do save only in RAW format, it's more common to use either RAW plus the JPEG option, or to just shoot JPEG and eschew RAW altogether. While RAW is overwhelmingly helpful when an image needs to be fine-tuned, in other situations working with a RAW file can slow you down significantly. RAW images take longer to store on the memory card and require more post-processing effort, whether you elect to go with the default settings in force when the picture was taken or make minor adjustments.

As a result, those who depend on speedy access to images or who shoot large numbers of photos in one session may prefer JPEG over RAW. Wedding photographers, for example, might expose several thousand photos during a bridal affair and offer hundreds to clients as electronic proofs for inclusion in an album. Wedding shooters take the time to make sure that their in-camera settings are correct, minimizing the need to post process photos after the event. Given that their JPEGs are so good, there is little need to get bogged down shooting RAW. Sports photographers also avoid RAW files for similar reasons.

JPEG was invented as a more compact file format that can store most of the information in a digital image, but in a much smaller size. JPEG predates most digital SLRs, and was initially used to squeeze down files for transmission over slow dialup connections. Even if you were using an early dSLR with 1.3 megapixel files for news photography, you didn't want to send them back to the office over a modem at 1,200 bps.

But, as I noted, JPEG provides smaller files by compressing the information in a way that loses some image data. JPEG remains a viable alternative because it offers several different quality levels. At the highest quality Fine level, you might not be able to tell the difference between the original RAW file and the JPEG version. With Standard compression, you'll usually notice a quality loss when making big enlargements or cropping your image tightly.

In my case, I shoot virtually everything at RAW & JPEG. Most of the time, I'm not concerned about filling up my memory cards, as I usually have a minimum of three 32GB memory cards with me. If I know I may fill up all those cards, I have a tiny battery-operated personal storage device that can copy a typical card in about 15 minutes. As I mentioned earlier, when shooting sports I'll shift to JPEG Fine (with no RAW file) to squeeze a little extra speed out of my Alpha's continuous shooting mode, and to reduce the need to wade through long series of photos taken in RAW format. On the other hand, on my last trip to Europe, I took only RAW photos and transferred more images onto my netbook, as I planned on doing at least some post-processing on many of the images for a travel book I was working on.

MANAGING LOTS OF FILES

The only long-term drawback to shooting everything in RAW & JPEG is that it's easy to fill up your computer's hard drive if you are a prolific photographer. Here's what I do. My most recent photos are stored on my working hard drive in a numbered folder, say Alpha-01, with subfolders named after the shooting session, such as 120202Groundhog, for pictures of groundhogs taken on February 2, 2012. An automatic utility for Windows called Allway Sync (http://allwaysync.com/) copies new and modified photos to a different hard drive for backup as soon as they appear.

When the top-level folder accumulates about 30GB of images, I back it up to multiple DVDs and then move the folder to a drive dedicated solely for storage of folders that have already been backed up onto DVD. Then I start a new folder, such as Alpha-02, on the working hard drive and repeat the process. I always have at least one backup of every image taken, either on another hard drive or on a DVD.

Image Size (3D Panorama)

Options: 16:9, Standard, Wide

Default: Standard

This setting is available only when the camera's shooting mode is set to 3D Panorama. Select from 16:9, Standard, and Wide for the size of the resulting panoramic image. Note that with this mode you get the additional option of shooting with the 16:9 aspect ratio, as opposed to just the Wide and Standard options that are available for non-3D panoramas. This option lets you shoot normal-sized images in 3D, rather than only panoramas. I'll discuss this shooting mode in more detail in Chapter 4.

This is the first option on the second full screen of the Image Size menu. (See Figure 3.16.) This setting is available only when the shooting mode is set to Sweep Panorama. In this case, there are only two options—the default choice of Standard, or the optional setting of Wide. With the Standard setting, if you are shooting a horizontal panorama, the size of your images will be 8192×1856 pixels; if your shots are vertical, the size will be 2160×3172 pixels. With the Wide setting, horizontal panoramas will be at a size of 12416×1856 pixels, and vertical shots will be 2160×5536 pixels.

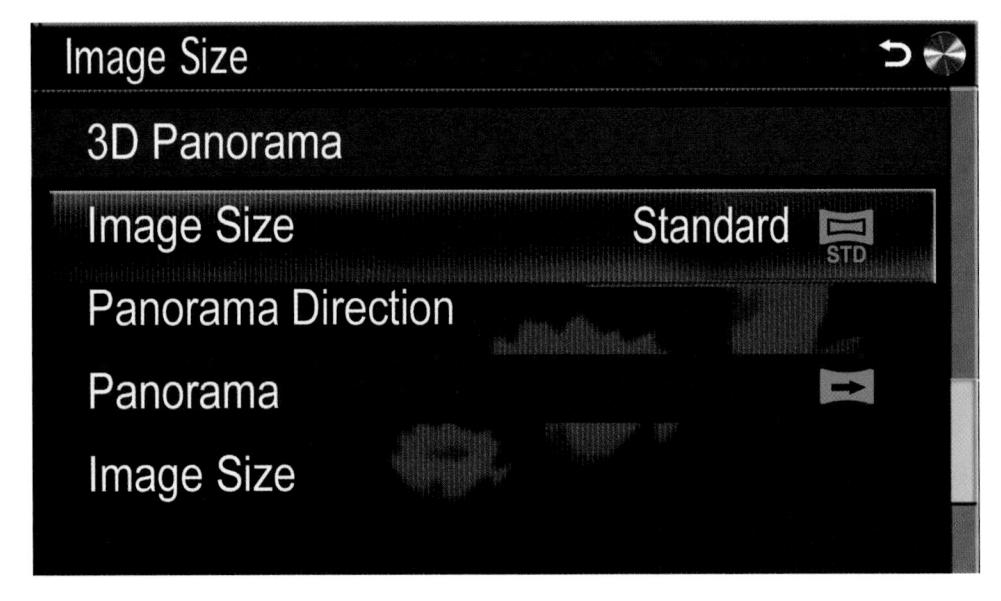

Figure 3.16
The second screen of options on the Sony Alpha
NEX's Image
Size menu.

3D Panorama Direction

Options: Right, Left

Default: Right

This menu option is available only if you have set your shooting mode to 3D Panorama. The choice here is very simple: select either right or left for the direction in which the camera will prompt you to pan when shooting a 3D Panorama. (Unlike the normal Sweep Panorama mode, 3D Panorama images cannot be shot vertically.) I'll discuss various aspects of panorama shooting in Chapter 4.

Image Size (Panorama)

Options: Standard, Wide

Default: Standard

This is the first option on the second full screen of the Image Size menu. This setting is available only when the shooting mode is set to Sweep Panorama. In this case, there are only two options—the default choice of Standard, or the optional setting of Wide. With the Standard setting, if you are shooting a horizontal panorama, the size of your images will be 8192×1856 pixels; if your shots are vertical, the size will be $2,160 \times 3,172$ pixels. With the Wide setting, horizontal panoramas will be at a size of 12416×1856 pixels, and vertical shots will be 2160×5536 pixels.

This setting is available only when the shooting mode is set to Sweep Panorama. In this case, there are only two options—the default choice of Standard, or the optional setting of Wide. With the Standard setting, if you are shooting a horizontal panorama, the size of your images will be 8192×1856 pixels; if your shots are vertical, the size will be 2160×3872 pixels. With the Wide setting, horizontal panoramas will be at a size of 12416×1856 pixels, and vertical shots will be 2160×5536 pixels. Figures 3.17 and 3.18 show the relative proportions of the horizontal and wide panorama formats. Of course, at the Wide setting, vertically panned shots are actually "tall" rather than wide.

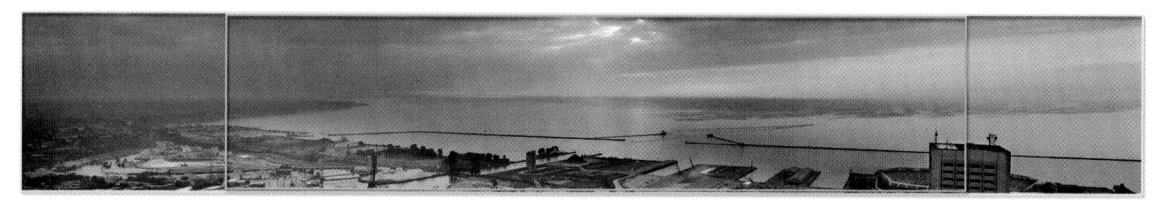

Figure 3.17 Horizontal wide format (yellow box) and standard format (green box).

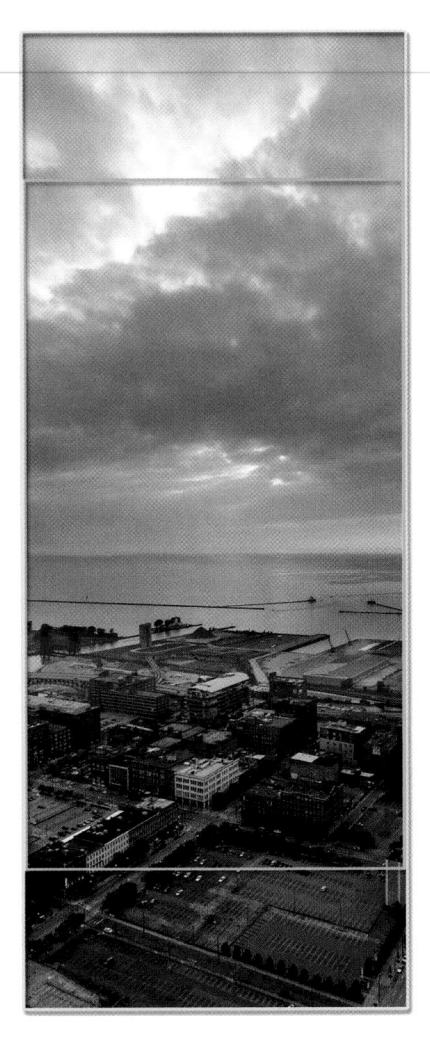

Figure 3.18 Vertical "wide" format (yellow box) and standard format (green box).

Panorama Direction

Options: Right, Left, Up, Down

Default: Right

When the shooting mode is set to Sweep Panorama, you have four options for the direction in which the camera will prompt you to pan or tilt the camera: right, left, up, or down. You have to select one of these so the camera will know ahead of time how to perform its in-camera processing of the images that it will stitch together into the final panorama. The default, right, is probably the most natural to sweep the camera, but you may have occasions to use the others, depending on the scene to be photographed. As with 3D Panorama Direction, you can set this option only when the shooting mode is set to Sweep Panorama.
File Format (Movie)

Options: MP4, AVCHD 60i/60p/AVCH 50i/50p

Default: AVCHD

This setting offers full high-definition video recording in the AVCHD format in addition to the somewhat lesser quality MP4 format. If you select AVCHD on the NEX-7, which is the default choice, you have no other choices to make for the movie image parameters—AVCHD provides only one image size of 1920 × 1080 pixels.

Record Setting (Movie)

Options: Varies

Default: N/A

Choose a file format for your AVCHD movies, or MP4 movies. I'll discuss selecting a movie file format in more detail in Chapter 7.

Brightness/Color Menu

Figure 3.19 shows the first full screen of choices on the Brightness/Color menu. As with the Image Size menu, the options on this menu are very important for your shooting settings, and only one of them (exposure compensation) can be adjusted through a physical button. So, it is very important to become well acquainted with these menu choices and how to change these settings quickly. The choices you'll find on these two screen include the following:

- Exposure Compensation
- ISO
- White Balance
- Metering Mode

- Flash Compensation
- DRO/Auto HDR
- Picture Effect
- Creative Style

Exposure Compensation

Options: 0.0, +0.3, +0.7, +1.0, +1.3, +1.7, +2.0, -0.3, -0.7, -1.0, -1.3, -1.7, -2.0

Default: 0.0

I discussed this option in Chapter 1, where I explained how it can be adjusted by pressing the down direction button, which doubles as the exposure compensation control. If you would rather use the menu system, go into the Brightness/Color menu and select this first option on the menu. Once you have reached the exposure compensation screen, use the control wheel or the up/down direction buttons to dial in your desired

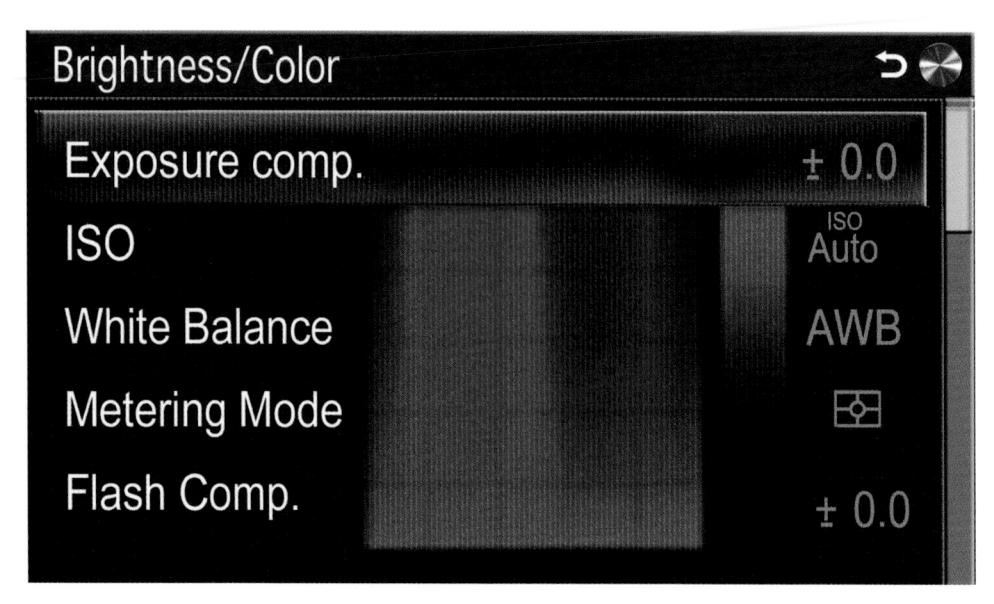

Figure 3.19
The first screen of options on the Sony Alpha NEX's
Brightness/
Color menu.

amount of compensation to make your shots lighter (with positive values) or darker (with negative ones). Remember that this setting will stay in place until you change it, even if the camera has been powered off in the meantime, so get in the habit of checking your display to see if any positive or negative exposure compensation is still in effect, and return to 0.0 before you start shooting. Also remember that exposure compensation is not available when you are shooting in Intelligent Auto or any of the Scene modes. It also cannot be used when you are shooting in Manual exposure mode. I discuss exposure compensation in more detail in Chapter 4.

IS₀

Options: ISO Auto, 200, 400, 800, 1600, 3200, 6400, 12800, 16000, 25600

Default: ISO Auto

This option is used to specify ISO sensor sensitivity settings, from ISO 200 to ISO 25600, plus Auto, the default setting, which lets the camera use its intelligence to make the best setting for the current shooting conditions. You cannot adjust ISO if you are using the Intelligent Auto shooting mode, any of the Scene modes, Anti Motion Blur mode, or either of the Panorama modes. In those cases, it is set to Auto ISO, in which the camera chooses a setting from 200–1600. (This means that you will not be able to take advantage of the higher settings, from 3200 to 25600, when shooting in those modes.) Finally, Auto ISO is not available in Manual exposure mode; you will have to choose a numerical setting for ISO when using that mode. I discuss ISO in more detail in Chapter 4.

White Balance

Options: Auto, Daylight, Shade, Cloudy, Incandescent, Fluorescent, Flash, Color Temperature/Filter, Custom

Default: Auto

The different light sources you shoot under have differing color balances. Indoor light, for example, is much redder than outdoor illumination, which tends to have a bluish bias. The Alpha NEX lets you choose the color/white balance that's appropriate, or it can make this adjustment automatically. You can choose the default option of Auto White Balance, and let the camera select the proper setting, or you can select from several preset options for commonly encountered lighting situations: Daylight, Shade, Cloudy, Incandescent (standard light bulbs), Fluorescent, Flash, Color Temperature, and Custom. I'll discuss the last two settings in Chapter 6, in the discussion of more advanced shooting options. The Auto White Balance setting works very well on the NEX camera, and one advantage of using it is that you don't have to worry about changing it for your next shooting session; there's no risk of having the camera set for, say, Daylight, when you're shooting indoors. If you shoot in RAW quality, though, you don't have to worry about white balance at all, because you can easily adjust it in your software after the fact. Here again, as with ISO and exposure compensation, the white balance setting is not available in the Intelligent Auto or Scene shooting modes; the camera uses the Auto White Balance in those modes.

Metering Mode

Options: Multi, Center, Spot

Default: Multi

The metering mode determines what part of the image is used to determine correct exposure. The Alpha NEX can be set to evaluate multiple points within the image, concentrate only on the center portion of the frame, or measure a small spot in the middle of the shot. The camera automatically sets the metering mode to Multi when you are recording movies, when you are using the Intelligent Auto or Scene shooting modes, or when you're using the Precision Digital Zoom function or the Smile Shutter. You'll learn how metering mode affects exposure in the next chapter, which covers exposure topics in detail.

Flash Compensation

Options: 0.0, +0.3, +0.7, +1.0, +1.3, +1.7, +2.0, -0.3, -0.7, -1.0, -1.3, -1.7, -2.0

Default: 0.0

This feature works like exposure compensation (discussed above), and allows you to dial in more or less exposure when using the flash. If your flash photo (such as a test shot)

is too dark or too light, access this menu entry. Press the up/down direction buttons or spin the control dial to reduce or increase flash exposure by up to two steps; then press the center controller button to confirm your choice, or just press halfway down on the shutter button to return to the live view display with the new setting in place. Like exposure compensation, flash compensation is "sticky" and should be canceled when you're finished using it. This option is not available when you're using Intelligent Auto, Scene modes, or the Anti Motion Blur or Panorama modes. This and other flash-related topics are discussed in detail in Chapter 9.

DRO/Auto HDR

Options: D-R Off, DRO Auto, DRO Levels 1-5, AUTO HDR (1-6 EV interval)

Default: DRO Auto

The brightness/darkness range of many images is so broad that the sensor has difficulty capturing both the brightest highlight areas and the darkest shadow areas. The Alpha NEX is able to expand its dynamic range using the D-Range Optimizer feature available from this menu entry. You can leave DRO turned off, set it to Auto, letting the camera decide how much processing to apply, or set it manually to any level of processing from 1 (weak) to 5 (strong). You also have an Auto HDR setting available.

Setting the DRO option is a bit tricky. Once you have selected this menu choice, use the up/down direction buttons or the control wheel to scroll to your selection—either D-R Off, DRO Auto, or Auto HDR. If you select D-R Off, you are done, and can exit back to the shooting screen. If you select DRO Auto, you can leave that setting in place, in which case the camera will evaluate the scene and use whatever level of DRO processing it finds appropriate. But, once you have highlighted DRO Auto, you will see that the lower soft key immediately becomes active, labeled as the Option button at the bottom right of the LCD. If you press the lower soft key, you can then use the up/down direction buttons or the control wheel to set the DRO to a specific level of processing, from 1 (weakest) to 5 (strongest). You can return this setting to Auto in the same way.

In addition, this feature of the NEX offers an Auto HDR (High Dynamic Range) setting. If you select Auto HDR, the camera takes three exposures at different exposure levels using an interval that you can select, from 1.0 to 6.0 EV. It then combines the three exposures so as to lighten the shadows and darken the highlights of the resulting image, producing an enhanced dynamic range. In the same way as with DRO, once you have highlighted Auto HDR, the Option button becomes active. Press the lower soft key, and you can then dial in a specific interval for the three exposures, from a slight difference of 1 EV to a dramatic difference of 6 EV. If you don't set a specific interval, the camera selects one for you. These DRO settings are available only in the PASM shooting modes (Program auto, Aperture priority, Shutter priority, and Manual).

I'll provide tips and examples of DRO and HDR in Chapter 6.

Picture Effect

Options: Off, Toy Camera, Pop Color, Posterization, Retro Photo, Soft High-key, Partial Color, High Contrast Monochrome, Soft Focus, HDR Painting, Rich Tone Monochrome, Miniature

Default: Off

All the Picture Effects modes perform significant image processing on your photos before saving them to the memory card. Picture Effects cannot be used when shooting RAW or RAW & JPEG; Soft Focus, HDR Painting, Rich-Tone Monochrome, and Miniature cannot be used when shooting movies. To choose one, press the center controller button and use the control wheel to highlight your selection. Your choices include:

- Toy Camera. Produces images like you might get with a Diana or Holga "plastic" camera, with vignetted corners, image blurring, and bright, saturated colors.
- **Pop Color.** This setting adds a lot of saturation to the colors, making them especially vivid and rich-looking. When used with subjects that have a lot of bright colors, the effect can be dramatic. Duller subjects gain a more "normal" appearance (try using this setting on an overcast day to see what I mean).
- **Posterization.** This option produces a vivid, high-contrast image that emphasizes the primary colors (as shown in Figure 3.20), or in black-and-white, with a reduced number of tones, creating a poster effect.

Figure 3.20
Posterization
creates an image
with a reduced
number of
tones.

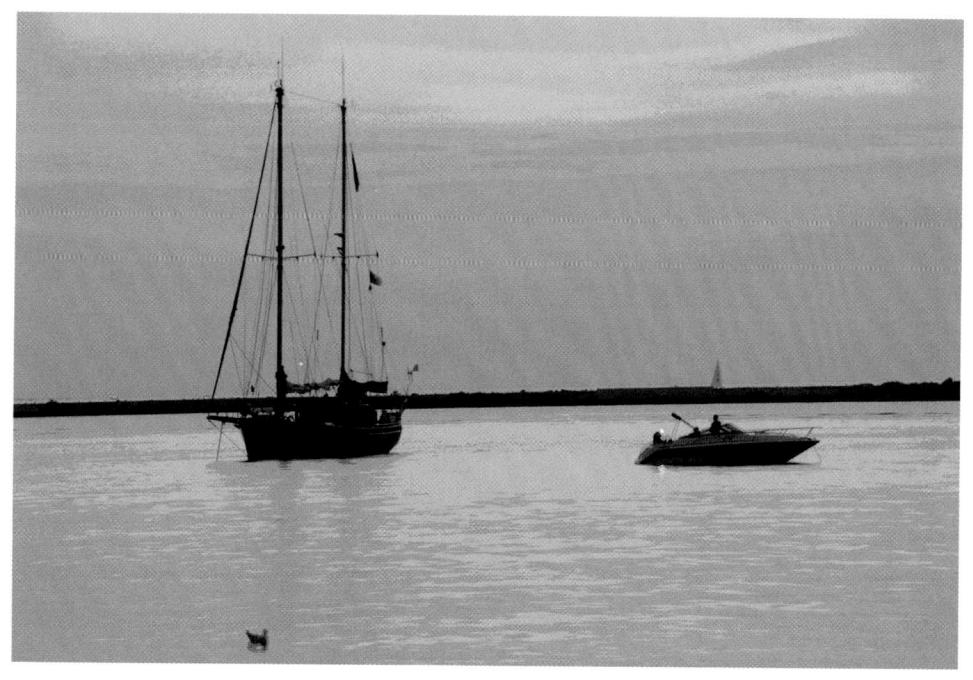

- Retro Photo. Adds a faded photo look to the image, with sepia overtones.
- Soft High-key. Produces bright images.
- Partial Color. Attempts to retain the selected color of an image, while converting other hues to black-and-white. (See Figure 3.21.)
- **High contrast monochrome.** Converts the image to black-and-white and boosts the contrast to give a stark look to the image.
- **Soft Focus.** Creates a soft, blurry effect. You can press the Option button to specify intensity.
- HDR Painting. Produces a painted look by taking three pictures consecutively and then using HDR techniques to enhance color and details. The Option button allows specifying the intensity of the effect.
- Rich-tone monochrome. Also uses HDR processes to create a long-gradation image from three consecutive exposures.
- Miniature. You select the area to be rendered in sharp focus using the Option button. The effect is similar to the tilt-shift look used to photograph craft models. (See Figure 3.22.)

Figure 3.21
Partial color isolates one hue, and changes others to black-and-white.

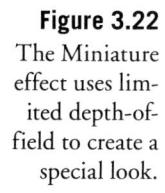

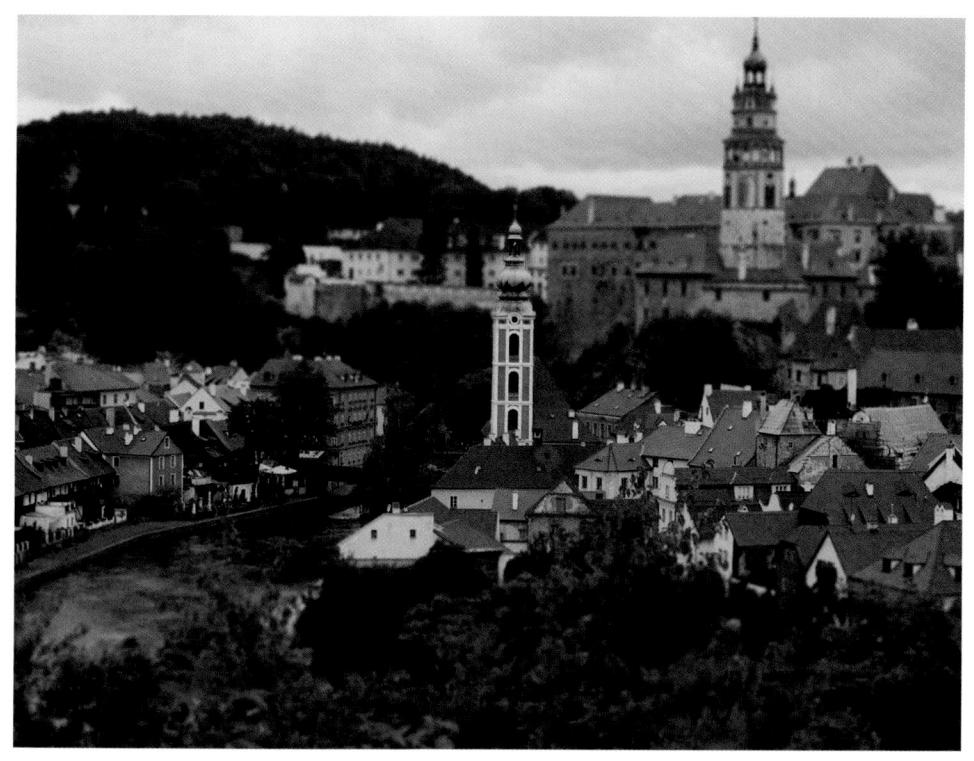

Creative Style

Options: Standard, Vivid, Neutral, Clear, Deep, Light, Portrait, Landscape, Sunset, Night, Autumn Leaves, Black & White, Sepia

Default: Standard

This option gives you fourteen different combinations of contrast, saturation, and sharpness. You can apply Creative Styles when you are using any shooting mode except Intelligent Auto or any of the Scene modes. Pressing the lower soft key Option button allows you to customize the Sharpness, Contrast, and Color Saturation of a Creative Style. I discuss the use of this option in Chapter 6.

Playback Menu

The Playback menu controls functions for deleting, protecting, displaying, and printing images. You can bring it up on your screen more quickly by pressing the Playback button first, then the Menu button, which causes the Playback icon to be highlighted on the main menu screen. The first full screen of Playback menu options is shown in Figure 3.23.

Figure 3.23
The first
options on the
Sony Alpha
NEX's Playback
menu.

- Delete
- Slide Show
- View Mode
- Image Index

- Rotate
- Protect
- 3D Viewing
- Enlarge Image
- Volume Settings
- Specify Printing
- Display Contents

Delete

Options: Multiple Images, All in Folder, All AVCHD View Files

Default: Multiple Images

All of us sometimes take pictures that we know should never see the light of day. Maybe you were looking into the lens and accidentally tripped the shutter. Perhaps you really goofed up your settings. You want to erase that photo *now*, before it does permanent damage. If you have Auto Review turned on through the Setup menu, you can delete a photo immediately after you take it by pressing the lower soft key (Delete button). Also, you can use that method to delete any individual image that's being displayed on the screen in playback mode. However, sometimes you need to wait for an idle moment to erase pictures. This menu choice makes it easy to remove selected photos (Multiple Images), or to erase all the photos from a particular folder on a memory card (All in Folder). Note that neither procedure removes images marked Protected (described below in the section on "Protect").

To remove selected images, select the Delete menu item, and use the up/down direction buttons or the control wheel to choose the Multiple Images option from the submenu. Press the center controller button, and the most recent image appears on the LCD. Scroll through your images using the left/right direction buttons or the control wheel,

and press the center controller button while an image that you want to delete is displayed; an orange checkmark is superimposed over each marked image. The number of images marked for deletion is incremented in the indicator at the lower right of the LCD, next to a trashcan icon. When you're satisfied (or have expressed your dissatisfaction with the really bad images), press the lower soft key, now marked as the OK button, and you will be asked to press the center controller button one more time to confirm the deletions.

While you can also use this menu choice in similar fashion to delete All in Folder, the process can take some time. If you have a large number of images on your memory card, you're better off using the Format command from the Setup menu, described later, unless you want to delete the contents of just one or two multiple folders. Finally, for movie files only, you can select All AVCHD View Files.

Slide Show

Menu Options: OK, Back

Slide Show Options:

Repeat: On, Off Default: Off

Interval (option available only for still images): 1 second, 3 seconds, 5

seconds, 10 seconds, 30 seconds

Default: 1 second

Image Type (option available only for still images): All, Display 3D Only

Default: All

Movie Type (option available only for movies): All, AVCHD, MP4

The Slide Show menu option allows you to display all the images on your memory card in a continuous show. The options available on this menu vary according to whether you have selected still images or movies to be played, using the separate menu option called Still/Movie select, discussed below.

You can display still images using the default one-second delay between images, or another delay period you select by choosing the Interval suboption. Choose 1, 3, 5, 10, or 30 seconds for your interval. Set the Repeat option on to make the show repeat continuously. During the show you can:

- Press the center controller button to stop the show. (There is no way to pause and resume the show.)
- Move forward or reverse in the show by pressing the left/right direction buttons.
- Press the DISP button to toggle between full screen images and the same images with date and time information overlaid.

With movies, your options are slightly different. Of course, there is no need for an interval between movies, so that option is not available. You can choose to have the movies repeat if you wish. Once the movies are playing, you can:

- Press the center controller button to stop the show. (There is no way to pause and resume the show.)
- Press the left direction button to go back to the previous movie.
- Press the right direction button to advance to the next movie.
- Press the DISP button to toggle between full-screen images and the same images with date and time information overlaid.

View Mode

Options: Folder View (Still), Folder View (MP4), AVCHD View

Default: Folder View (Still)

Selects the type of images to be displayed when the Playback button is pressed. Choose from Still images by folder, MP4 movies by folder, or AVCHD movies.

Image Index

Options: 6, 12

Default: 6

As I discussed in Chapter 1, you can view an index screen of your images by pressing the down direction button (Index button) while in playback mode. By default, that screen shows six images (either stills or thumbnail images from movies) at a time; you can change that value to twelve using this menu option.

Rotate

Options: None

This option works with still images only. When you select this menu item, you are immediately presented with a new screen showing the current image along with an indication that the center controller button can be used to rotate the image. Successive presses of that button will now rotate the image 90 degrees at a time. The camera will remember whatever rotation setting you apply here. You can use this function to rotate an image that was taken with the camera held vertically, when you have disabled the Auto Rotate function on the Setup menu. Press the upper soft key to exit.

Protect

Options: Multiple Images, Cancel All Images (unmark all images), Cancel All Movies

Default: None

You might want to protect certain images on your memory card from accidental erasure, either by you or by others who may use your camera from time to time. This menu choice, the first on the second screen of the Playback menu (see Figure 3.24), enables you to protect Multiple Images (using a procedure similar to the Delete Multiple Images process described earlier), or Cancel All Images (or Cancel All Movies, if you're viewing movies), which unmarks and unprotects any photos you have previously marked for protection.

To protect selected images or movies, make sure you're viewing either stills or movies, as desired, then select the Protect menu item and choose Marked Images. Press the center controller button, and the images (or movies) appear one by one on your LCD as you browse through them with the left/right controller buttons or with the control wheel. When an item you want to protect is displayed, press the center controller button to mark it for protection (or to unmark a selection that was previously marked). When you've marked all the items you want to protect, press the lower soft key (now labeled as the OK button) to confirm your choice, and then press the center controller button to confirm the protection operation. Later, if you want, you can go back and select the Cancel All Images (or Cancel All Movies) option to unprotect all still images (or movies), or you can unprotect them individually using the Multiple Images option.

Figure 3.24

The second
screen of
options on the
Sony Alpha
NEX's Playback
menu.

3D Viewing

Options: -

Default: -

This option is not available unless you have connected your NEX to a 3D-capable HDTV to display your 3D Panorama images. I can't tell you what the options are, because I have not been able to test this function with a 3D HDTV.

Enlarge Image

Options: None Default: N/A

As I discussed in Chapter 1, whenever you are playing back still images (not movies), you can magnify the image by pressing the center controller button, which is labeled with a plus sign during playback. If for some reason you want to access this feature from the Playback menu, you can do so with this option. This function acts in the same way as the one accessed with the center controller button—you can vary the degree of enlargement using the control wheel, and you can scroll around inside the enlarged image using the four direction buttons.

Volume Settings

Options: 0-7

Default: 2

This menu option affects only the audio volume of movies that are being played back in the camera. The menu item is grayed out and unavailable unless you have selected movies, as opposed to stills, for playback. When you select this option, the camera shows you a scale of loudness from 0 to 7; you can select a value, and it will remain in effect until changed. You can also adjust this volume control while a movie is playing back in the camera; to do so, press the down direction button, then use the up/down direction buttons or the control wheel to raise or lower the volume.

Specify Printing

Options (DPOF Setup): Multiple Images, Cancel All (unmark all images)

Options (Number of Copies): 1-9 Options (Date Imprint): On, Off

Defaults: None

Most digital cameras are compatible with the DPOF (Digital Print Order Format) protocol, which enables you to mark in your camera which of the JPEG images on the

memory card (but not RAW files or movies) you'd like to print, and specify the number of copies of each that you want. You can then transport your memory card to your retailer's digital photo lab or do-it-yourself kiosk, or use your own compatible printer to print out the marked images and quantities you've specified. You can access the Specify Printing options from this menu choice.

■ **DPOF Setup.** You can choose to print Multiple Images or Cancel All. Selecting images is similar to the method you use to mark images for deletion or protection, with an orange check mark indicating selected images. To print selected images, select the DPOF Setup option, press the center controller button, and choose Multiple Images from the submenu. Then press the lower soft key (now the "OK" button) to confirm. You can then browse through the images you want to print, using the left/right direction buttons or the control wheel. For each image, press the center controller button repeatedly to increment the number of prints to be made of that image, from 1 to 9. A number beside a printer icon in the lower-right area of the LCD shows the cumulative number of prints selected for all images. If you continue pressing the center controller button past 9 copies for a given image, the count wraps around to 0 copies again. That is the only way to reduce the number of copies, or to cancel the printing status of an individual image. Press the lower soft key to mark an image for printing.

When you have finished marking images and specifying the numbers of copies, press the lower soft key again to exit picture selection. If you're satisfied with your choices, press the center controller button to confirm. If not, the Cancel option available with the upper soft key removes all DPOF print selection and quantity marks. This canceling action is useful if you print photos from a memory card, but then leave the images on the card while you shoot additional pictures. Removing the DPOF markings clears the card of print requests so you can later select additional or different images for printing from the same collection.

■ **Date imprint.** Choose this menu option to superimpose the current date onto images when they are printed. Select On to add the date; Off (the default value) skips date imprinting. The date is added during printing by the output device, which controls its location on the final print.

Setup Menu

Use the lengthy Setup menu to adjust infrequently changed settings, such as language, date/time, and power saving options. As with the other menus, I have divided this menu into separate screens for purposes of illustration, even though Sony lets all the options scroll in one continuous grouping. The first screen of the Setup menu is shown in Figure 3.25.

■ Shooting Settings

- AEL
- AF/MF control
- Dial/Wheel Lock
- AF Illuminator
- Red Eye Reduction
- FINDER/LCD Setting
- Live View Display
- Auto Review
- Grid Line
- Peaking Level
- Peaking Color
- Histogram
- MF Assist

■ Main Settings

- Beep
- Language
- Date/Time Setup
- Area Setting
- Help Guide Display
- Power Save
- LCD Brightness
- Display Color

■ Memory Card Tool

- Format
- File Number
- Folder Name
- Select Shooting Folder

■ Eye-Fi Setup

■ Upload Settings

- MF Assist Time
- Color Space
- SteadyShot
- Release w/o Lens
- Long Exposure NR
- High ISO NR
- Lens Comp: Shading
- Lens Comp: Chro. Aber.
- Lens Comp: Distortion
- Movie Audio Recording
- Wind Noise Reduction
- AF Micro Adjustment
- Wide Image
- Playback Display
- CTRL for HDMI
- USB Connection
- Cleaning Mode
- Version
- Demo Mode
- Reset Default
- New Folder
- Recover Image DB
- Display Card Space

AEL

Options: Hold, Toggle

Default: Hold

This option, the first in the Setup menu, affects the operation of the AF-MF/AEL button located at the top of the camera's back (at the right side of the Playback button) when its switch is toggled to the AEL (autoexposure lock) position.

Most users like the AEL function and will choose the default setting AEL Hold over its variation, AEL Toggle. With the AEL Hold setting, when you press the AEL button your exposure is locked only as long as you hold down the button. If you set this option to AEL Toggle, then you can just press the button and release it, and the exposure will stay locked until you press and release it again. Use this setting if you want to lock in exposure and then reframe extensively or even point the camera at another subject that you want to photograph using the same exposure settings.

AF/MF Control

Options: Hold, Toggle

Default: Hold

This option comes into play when the AF-MF/AEL switch is toggled to the AF-MF position. The button itself switches temporarily between automatic focus and manual focus, depending on which mode is active on the camera at the time. With the Hold setting, you must keep the button pressed to use the opposite focus setting; with the

Toggle setting, the temporary switch to the alternate setting remains in effect until you press the button a second time.

Dial/Wheel Lock

Options: All, Control Wheel, Off

Default: All

You can disable the left and right control dials and control wheel, or both, when the Navigation button is pressed down. Choose All to disable all three dials, Control Wheel to lock only the wheel, or Off to allow all three dials to function normally.

AF Illuminator

Options: Auto, Off

Default: Auto

The AF illuminator is a red light that is emitted when there is insufficient light for the Alpha NEX's autofocus mechanism to zero in on the scene before it. This light emanates from the same lamp on the front of the camera that provides the signal for the self-timer's light, and that fires to indicate when the Smile Shutter is triggered. The extra blast from the AF illuminator helps the camera focus sharply. The default setting, Auto, allows the AF illuminator to work any time the camera judges that it is necessary. Turn it off when you would prefer not to use this feature, such as when you don't want to disturb the people around you or call attention to your photographic endeavors. The AF illuminator doesn't work when using AF-C focus mode (Continuous autofocus), when shooting movies or panoramas, or in certain other shooting modes, including the Landscape, Night View, or Sports Action varieties of Scene mode.

Red Eye Reduction

Options: On, Off

Default: Off

Unfortunately, your camera is unable, on its own, to *eliminate* the red-eye effects that occur when an electronic flash (or, rarely, illumination from other sources) bounces off the retinas of your subject's eyes and into the camera lens. Animals seem to suffer from yellow or green glowing pupils, instead; the effect is equally undesirable. The effect is worst under low-light conditions (exactly when you might be using a flash) as the pupils expand to allow more light to reach the retinas. The best you can hope for is to *reduce* or minimize the red-eye effect.

It's fairly easy to remove red-eye effects in an image editor (some image importing programs will do it for you automatically as the pictures are transferred from your

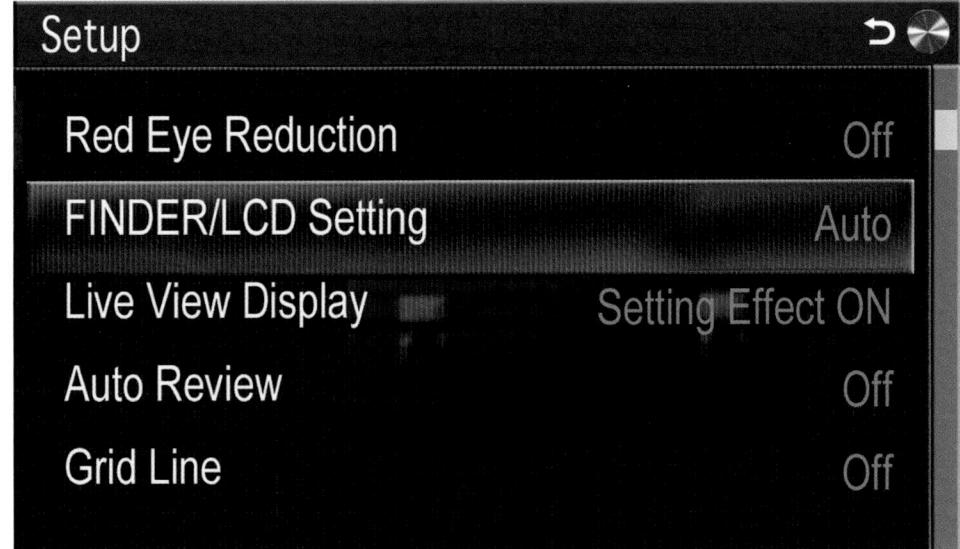

camera or memory card to your computer). But, it's better not to have glowing red eyes in your photos in the first place.

To use this feature, the first listed on the second screen of entries (see Figure 3.26), you first have to pop up the flash to its active position. When Red Eye Reduction is turned on through this menu item, the flash issues a few brief bursts prior to taking the photo, theoretically causing your subjects' pupils to contract, reducing the effect.

FINDER/LCD Setting

Options: Auto, Viewfinder, LCD Monitor

Default: Auto

The NEX 7 can detect whether you're looking through the EVF, or using the backpanel LCD screen. When this option is set to Auto, the display is switched from the LCD to the EVF when you bring the camera to your eye, and then back to the LCD when you stop using the electronic viewfinder. Choose Manual, and you can switch back and forth between the two viewing systems by pressing a button on the EVF.

This option is somewhat similar to the Eye-Start setting described below, although this setting controls only whether the camera turns off the LCD and switches the view to the viewfinder when your eye comes near the viewfinder. With the default setting of Auto, the screen goes blank and the viewfinder activates when your eye approaches the Eye-Start sensors. With the other two settings, only the display that you choose is active, and the other one is disabled. You might want to use this setting if you are doing work involving critical focusing, and you need to examine the LCD closely without having it turn off whenever your face gets too close to the screen.

Live View Display

Options: Setting Effect ON, Setting Effect OFF

Default: Setting Effect ON

As a mirrorless camera, the NEX-7 is always in "live view" mode, showing you exactly what the sensor sees. This option lets you choose whether the display shows any effects you've selected when using PSAM modes. Select Setting Effect ON if you'd like to preview the image with your effects supplied, or OFF if you'd rather see the unadorned image.

When Setting Effect ON is chosen (the default), the LCD and EVF display will change to reflect your current settings, which can be especially helpful when you're using any of the Picture Effects, because you can preview the exact rendition that the effect you've dialed in produces. You'll also find the On option helpful when working with exposure compensation, as you can visually see how much lighter or darker your adjustment makes the image. If you're trying to achieve correct color balance, it's useful to be able to preview how a particular white balance setting affects your image.

Unfortunately, the default ON setting has caused more than a few minutes of head-scratching among new users who switch to Manual exposure mode and find themselves with a completely black (or utterly white) screen. The black screen, especially, may fool you into thinking your camera has malfunctioned.

It happened to me the first time I used my NEX-7 in the studio. I attached the radio control that triggered my studio flash to the camera's accessory/hot shoe (using an adapter), flipped into Manual exposure mode (because the NEX-7 doesn't provide auto flash exposure with studio flash units), set the shutter speed to 1/250th second (the maximum speed that can be synchronized with electronic flash), and the aperture of my macro lens to f/22 (so I could get maximum depth-of-field for the tabletop setup I was shooting). Both the LCD and EVF were completely black, and, having had the NEX-7 for only a few hours, I had no idea what was going on.

With the feature activated, the modeling lights in my studio didn't provide enough illumination to produce an image on the LCD at ISO 100, f/22, and 1/250th second—the NEX-7 had no idea I was going to use flash. All was well when I switched to Setting Effect OFF, however, and the standard image at full brightness was displayed. I've had about a dozen e-mails since then from readers with the same problem, so I know I'm not alone in needing to remedy this vexing complication.

Auto Review

Options: Off, 2 seconds, 5 seconds, 10 seconds

Default: Off

With this option the Sony Alpha NEX can display an image on the LCD for your review immediately after the photo is taken. (When you shoot a continuous or bracketed series of images, only the last picture exposed is shown.) During this display, you can delete a disappointing shot by pressing the Delete button (lower soft key), or cancel picture review by tapping the shutter release or performing another function. (You'll never be prevented from taking another picture because you were reviewing images on your LCD.) This option can be used to specify whether the review image appears on the LCD for 2, 5, or 10 seconds, or not at all.

Depending on how you're working, you might want a quick display (especially if you don't plan to glance at each picture as it's taken), or you might prefer a more leisurely examination (when you're carefully checking compositions). Other times, you might not want to have the review image displayed at all, such as when you're taking photos in a darkened theater or concert venue, and the constant flashing of images might be distracting to others. Turning off picture review or keeping the duration short also saves power. You can always review the last picture you took at any time by pressing the Playback button.

Grid Line

Options: Rule of 3rds Grid, Square Grid, Diag.+Square Grid, Off

Default: Off

This feature turns on one of three optional grids to help you with composition while you are shooting and during Auto Review display of the image you just took. You can choose a Rule of Thirds grid, one that shows squares that make it easier to line up images, or a grid that includes diagonal, horizontal, and perpendicular lines.

Peaking Level

Options: High, Mid, Low, Off

Default: Off

This is a novel manual focusing aid that's difficult to describe and almost impossible to illustrate. You're going to have to try this feature for yourself to see exactly what it does. *Focus peaking* is a technique that outlines what is in focus in your choice of red, white, or yellow. The coloring shows you what the camera is focused on at that moment. The tool is used when manual focusing so you can see what is in focus (or not) at any time.

104

As the focus gets closer to ideal for a specific part of the image, the color outline develops around hard edges that are in focus. You can choose how much peaking is applied, or turn the feature off.

Peaking Color

Options: White, Red, Yellow

Default: White

This entry allows you to specify which color is used to indicate peaking. White is the default value, but if that color doesn't provide enough contrast with a similarly hued subject, you can switch to a more contrasting color, such as red or yellow. (See Figure 3.28 for an example using a white snake.)

MF Assist

Options: On, Off

Default: On

When you are using manual focus or DMF, this option enlarges the screen so you can better judge by eye whether the image is in focus. After you have turned this option on, whenever you focus manually, as soon as you start turning the focus ring on the lens, the image on the LCD will appear at 5.9 times its normal size. You can then scroll around the image using the four direction buttons, and you can increase the enlargement factor to 11.7 times by pressing the lower soft key, which will be labeled "x11.7.0." When you stop turning the focus ring, the image on the LCD will revert back to its normal size.

MF Assist Time

Options: No Limit, 5 Sec., 2 Sec.

Default: 2 Sec.

Use this setting to specify the length of time that the MF Assist feature zooms your image. If you find that it takes you longer than two seconds to manually focus using MF Assist, you can change the time to five seconds, or to No Limit, in which case the image remains zoomed until you press the Cancel button (the upper soft key).

Figure 3.27
The peaking color can be set to red, yellow, or white.

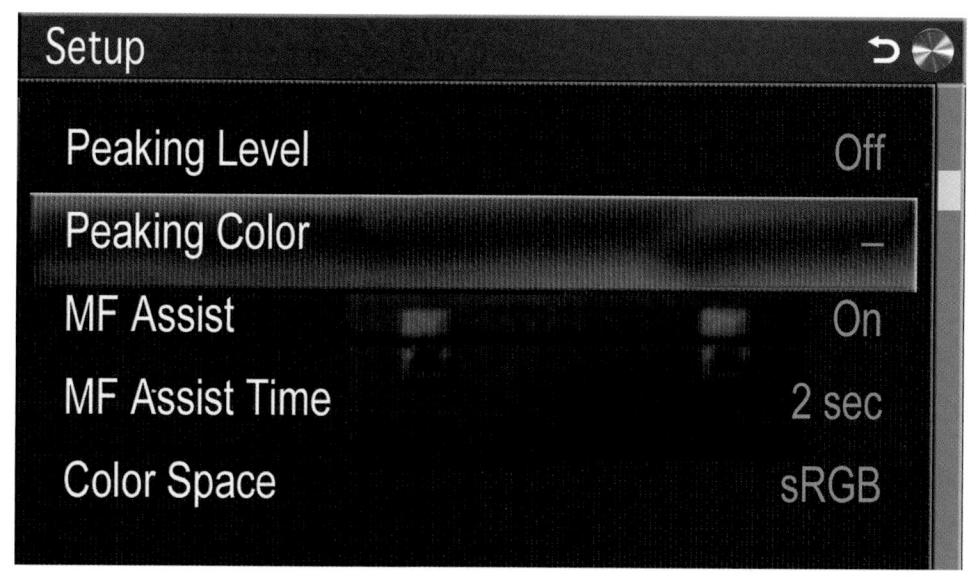

Figure 3.28
Yellow
outlining is a
better choice as
a peaking color
for this white
snake.

Color Space

Options: sRGB/Adobe RGB

Default: sRGB

The Alpha NEX's Color Space option gives you the choice of two different color spaces (also called *color gamuts*), named Adobe RGB (because it was developed by Adobe Systems in 1998), and sRGB (supposedly because it is the *standard* RGB color space). Each of these two color gamuts defines a specific set of colors that can be applied to the images your Alpha captures.

You're probably surprised that the Alpha NEX doesn't automatically capture *all* the colors we see. Unfortunately, that's impossible because of the limitations of the sensor and the filters used to capture the fundamental red, green, and blue colors, as well as that of the LEDs used to display those colors on your camera and computer monitors. Nor is it possible to *print* every color our eyes detect, because the inks or pigments used don't absorb and reflect colors perfectly.

Instead, the colors that can be reproduced by a given device are represented as a color space that exists within the full range of colors we can see. That full range is represented by the odd-shaped splotch of color shown in Figure 3.29, as defined by scientists at an

ADOBE RGB vs. sRGB

You might prefer sRGB, which is the default for the Sony Alpha NEX camera, as it is well suited for the colors displayed on a computer screen and viewed over the Internet. The sRGB setting is recommended for images that will be output locally on the user's own printer, or at a retailer's automated kiosk.

Adobe RGB is an expanded color space useful for commercial and professional printing, and it can reproduce a wider range of colors. It can also be useful if an image is going to be extensively retouched within an image editor. You don't need to automatically "upgrade" your camera to Adobe RGB, because images tend to look less saturated on your monitor and, it is likely, significantly different from what you will get if you output the photo to your personal inkjet printer.

Strictly speaking, both sRGB and Adobe RGB can reproduce the exact same absolute *number* of colors (16.8 million when reduced to 8 bits per channel from the original capture). Adobe RGB spreads those colors over a larger space, much like a giant box of crayons in which some of the basic colors have been removed and replaced with new hues not in the original box. The "new" gamut contains a larger proportion of "crayons" in the cyan-green portion of the box, a better choice for reproduction with cyan, magenta, and yellow inks at commercial printers, rather than the red, green, and blue LEDs of your computer display.

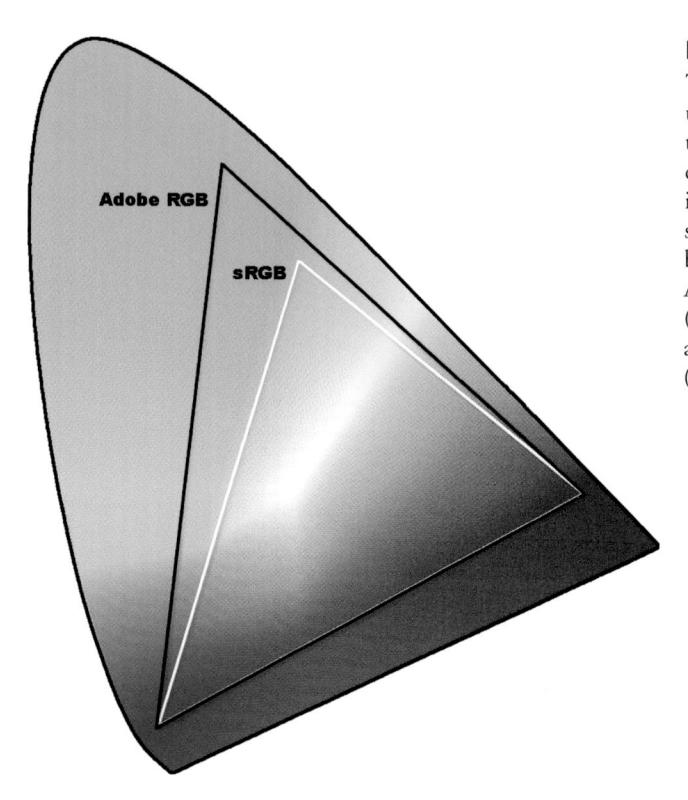

Figure 3.29
The outer figure shows all the colors we can see; the two inner outlines show the boundaries of Adobe RGB (black triangle) and sRGB (white triangle).

international organization back in 1931. The colors possible with Adobe RGB are represented by the larger, black triangle in the figure, while the sRGB gamut is represented by the smaller white triangle.

Regardless of which triangle—or color space—is used by the Alpha NEX, you end up with 16.8 million different colors that can be used in your photograph. (No one image will contain all 16.8 million!) But, as you can see from the figure, the colors available will be *different*.

Adobe RGB is what is often called an *expanded* color space, because it can reproduce a range of colors that is spread over a wider range of the visual spectrum. Adobe RGB is useful for commercial and professional printing.

SteadyShot

Options: On/Off

Default: On

This entry can be used to switch off the SteadyShot feature, Sony's optical image stabilization system, which is turned on by default to help counteract image blur that is caused by mild movements of the camera. You might want to turn it off when the camera is mounted on a tripod, as the additional anti-shake feature is not needed, and

slight movements of the tripod can sometimes "confuse" the system. In addition, the SteadyShot feature does not work at all in some conditions, so it might as well be turned off. For example, SteadyShot does not work when you're using the Sony16mm E-mount "pancake" lens or any A-mount lens. However, apart from when you're using a lens that can't function with SteadyShot, it's rarely advisable to turn SteadyShot off, and I recommend leaving it turned on at all times unless you find that it causes problems in some specific situations.

Release w/o Lens

Options: Enable, Disable

Default: Disable

When this option is enabled, it's possible to release the shutter when no lens is attached to the camera. This feature is needed when you have attached the camera body to some other piece of equipment, such as a telescope, for astrophotography or a similar activity. If you're not doing something that clearly requires this option, you should leave it disabled to avoid causing problems for your camera's delicate inner workings.

Eye-Start AF

Options: On, Off

Default: Off

It's great how the Sony Alpha is able to read your mind and start autofocusing the instant you move your eye to the optional electronic viewfinder. The image on the

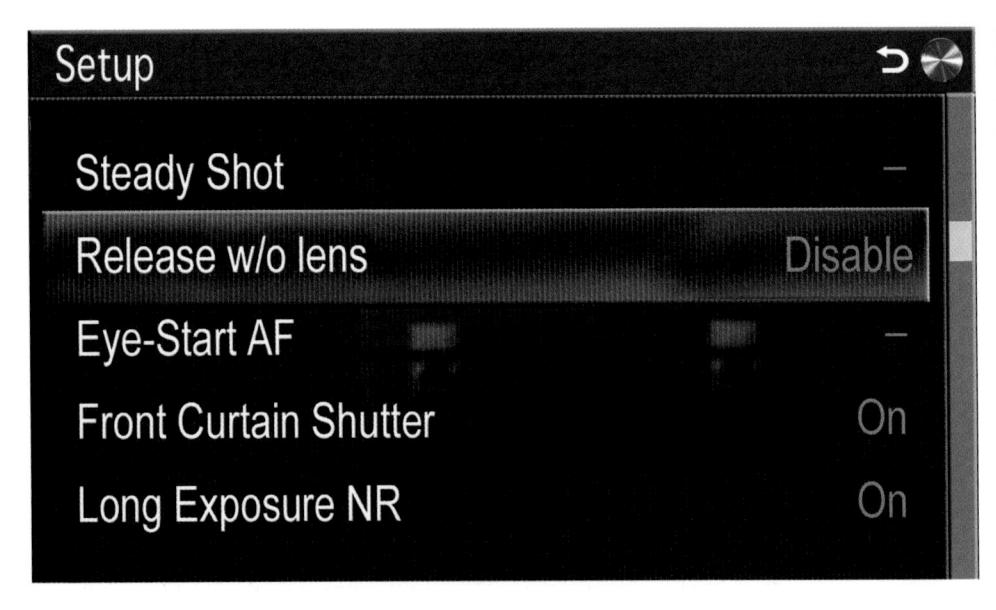

Figure 3.30 The next screen of Setup menu entries.

LCD vanishes, the camera adjusts autofocus, and, if you've selected any exposure mode other than Manual, it sets shutter speed and/or aperture for you. You don't even have to partially depress the shutter release.

On the one hand, Eye-Start AF can be convenient, especially when you're shooting fast-moving subjects and want to take pictures quickly. Indeed, you discover that focus is frequently achieved more rapidly than when Eye-Start AF is switched off and the NEX-7 defaults to the boring old behavior of not initiating focus until you partially depress the shutter button. On the other hand, some people find this feature annoying. The camera may turn off the LCD and switch on autofocus when a stray hand or other object passes near the viewfinder. Also, if you're wearing the camera around your neck, you may hear a continuous clicking as the camera rubs against your body, triggering the focusing mechanism. One other consideration is that this feature does use a significant amount of battery power. If you choose to, you can turn off Eye-Start AF using this menu setting.

Front Curtain Shutter

Options: On, Off

Default: On

As a mirrorless camera, your NEX-7's sensor is normally exposed to incoming light until just before the moment of exposure, when the shutter closes, the image that had been on the sensor is electronically "dumped" to make way for your actual exposure, and then the shutter opens again to take the picture. That takes time and introduces a certain amount of shutter lag time. This option, the fourth in the fourth Setup screen (see Figure 3.30), reduces that lag by electronically "closing" the shutter (and dumping the existing image), so the mechanical shutter can close and open immediately. Use this setting when taking action shots and other types of images where even a small amount of shutter lag is objectionable.

Long Exp. NR/High ISO NR

Long Exp. NR: Options: On/Off; Default: On

High ISO NR: Options: Auto/Weak; Default: Auto

I've grouped these two menu options together because they work together, each under slightly different circumstances. Moreover, the causes and cures for noise involve some overlapping processes.

Your Alpha NEX can reduce the amount of grainy visual noise in your photo, but it will, at the same time, eliminate some of the detail along with the noise. These two menu choices let you choose whether or not to apply noise reduction to exposures of longer than one second and how much noise reduction to apply (Auto or Weak) to

exposures made at high ISO settings (presumably ISO 1600 and above, as with other Sony cameras, although Sony doesn't specify the cutoff point for the NEX camera). Although noise reduction is usually a good thing, it's helpful to have the option to turn it off or minimize it when you want to preserve detail, even if it means putting up with a little extra noise.

Visual noise is that awful graininess that shows up as multicolored specks in images, and these settings help you manage it. In some ways, noise is like the excessive grain found in some high-speed photographic films. However, while photographic grain is sometimes used as a special effect, it's rarely desirable in a digital photograph.

The visual noise-producing process is something like listening to a CD in your car, and then rolling down all the windows. You're adding sonic noise to the audio signal, and while increasing the CD player's volume may help a bit, you're still contending with an unfavorable signal to noise ratio that probably mutes tones (especially higher treble notes) that you really want to hear.

The same thing happens when the analog signal is amplified: You're increasing the image information in the signal, but boosting the background fuzziness at the same time. Tune in a very faint or distant AM radio station on your car stereo. Then turn up the volume. After a certain point, turning up the volume further no longer helps you hear better. There's a similar point of diminishing returns for digital sensor ISO increases and signal amplification as well.

These processes create several different kinds of noise. As I noted, noise can be produced from high ISO settings. As the captured information is amplified to produce higher ISO sensitivities, some random noise in the signal is amplified along with the photon information. Increasing the ISO setting of your camera raises the threshold of sensitivity so that fewer and fewer photons are needed to register as an exposed pixel. Yet, that also increases the chances of one of those phantom photons being counted among the real-life light particles, too.

A second way noise is created is through longer exposures. Extended exposure times allow more photons to reach the sensor, but increase the likelihood that some photosites will react randomly even though not struck by a particle of light. Moreover, as the sensor remains switched on for the longer exposure, it heats, and this heat can be mistakenly recorded as if it were a barrage of photons.

You might want to turn off noise reduction for long exposures and minimize it for exposures at high ISOs to preserve image detail, and when the delay caused by the noise reduction process (it can take roughly the same amount of time as the exposure itself) interferes with your shooting. Or, you simply may not need NR in some situations. For example, you might be shooting waves crashing into the shore at ISO 200 with the camera mounted on a tripod, using a neutral-density filter and long exposure to cause the pounding water to blur slightly. To maximize detail in the non-moving portions of

your photos, you can switch off long exposure noise reduction. Note, though, that the menu option for setting the amount of high ISO noise reduction is grayed out and unavailable when shooting in RAW quality. (If you shoot in RAW & JPEG, the JPEG images, but not the RAW files, will be affected by this setting.)

Note that you cannot change the Long Exposure NR setting when you're shooting in Intelligent Auto or any of the Scene modes.

Lens Compensation: Shading/Chromatic Aberration/ Distortion

Options: Auto, Off

Default: Shading, Auto; Chromatic Aberration, Auto; Distortion, Off

This trio of menu entries on the next page of Setup menu options (see Figure 3.31) compensates for lens defects; all three work only with E mount lenses. Shading is an anti-vignetting correction feature, which can fully or partially compensate for darkened corners produced by some types of lenses (it works only with E mount lenses). Because the default setting is Auto, you may never know that this feature is at work—until you turn it off. (See Figure 3.32.) Chromatic Aberration reduces color distortion, while Distortion fixes inward or outward bowing of lines at the edges of images, caused by wide-angle and telephoto lenses (respectively). (See Figure 3.33.) Both these forms of distortion can also be fixed (somewhat) in an image editor like Photoshop. Doing it in the camera can be faster.

Figure 3.31
The fifth screen of options on the Sony Alpha NEX's Setup menu.

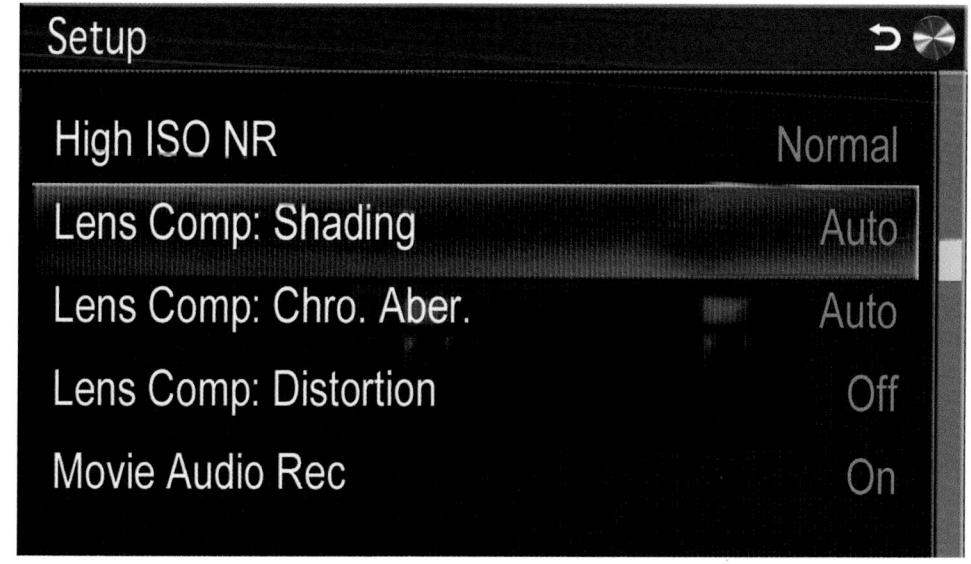

Figure 3.32
No shading
(vignetting)
correction (top);
shading corrected (bottom).

Figure 3.33
Chromatic aberration displayed as green fringe (top); chromatic aberration corrected (bottom).

Movie Audio Recording

Options: On, Off

Default: On

This option gives you the ability to turn off sound recording when you're recording movies. I personally am not likely to use this option, because I believe in capturing as much information as possible, and then deleting it later if I don't need it. However, I suppose there could be occasions when it's useful to disable sound recording for movies, if you know ahead of time that you will be dubbing in other sound, or if you have no need for sound, such as when panning over a vista of the Grand Canyon. At any rate, this option is there if you want to use it.

Wind Noise Reduction

Options: On, Off

Default: Off

This first choice on the next screen of options (see Figure 3.34) can be used to reduce the whistling effects of wind noise during movie recording. This feature is disabled if an external microphone is plugged into the NEX-7, and it should not be used if wind is not actually present, as the recording volume is reduced when activated.

Figure 3.34
The sixth full screen of options on the Sony Alpha
NEX's Setup menu.

AF Micro Adjustment

Options: AF Adjustment Setting, Amount, Clear

Default: None

If you've sprung for the \$400 required to purchase the optional LA-EA2 mount adapter and are using A mount lenses on your NEX-7, you may find that some slight autofocus adjustment is necessary to fine-tune your lens. This setting allows choosing a value from -20 (to focus closer to the camera) to +20 (to change the focus point to farther away). You can enable/disable the feature, and clear the value set for each lens. The camera stores the value you dial in for the lens currently mounted on the camera, and can log up to 30 different lenses (but each lens must be different; you can't register two copies of the same lens). Once you've "used up" the available slots, you'll need to mount a lesser-used lens and clear the value for that lens to free up a memory slot. This adjustment works reliably only with Sony, Minolta, and Konica-Minolta lenses. I'll show you how to use this feature in Chapter 8.

Menu Start

Options: Top, Previous

Default: Top

This menu option lets you determine which menu position is used by default when you press the Menu button. If you select Top, then the first tab, the Shooting 1 menu, appears. Select Previous, and the last menu you accessed will be shown. I find the Previous option is the most convenient, because it's very likely that the last setting I made will be the one I want to access the next time (say, to turn off an option I wanted to use only temporarily), and the other menu tabs can be selected quickly, even if the most recently used choice is not the one I want next time.

Function Settings

Options: Various functions for the left and right control dials and control wheel

Default: Various

I explained how to use this exhaustive (and exhausting) set of options in Chapter 2, and won't repeat that information here.

Custom Key Settings

Options: Definitions for control dials

Default: Various

The options available with this menu entry, the first in the next screen of the Setup menu (see Figure 3.35), were explained in Chapter 2.

Figure 3.35
The next screen of Setup menu options.

Beep

Options: On, Off

Default: On

As I mentioned at the beginning of this chapter, there's not a lot to be said about this option. If you set it to On, the electronic chirp or beep will sound only when autofocus is confirmed and you use control buttons.

Language

Options: English, French, Spanish, Italian, Japanese, Chinese languages

Default: Language of country where camera is sold

If you accidentally set a language you don't read and find yourself with incomprehensible menus, don't panic. Just find the Setup menu, the one with the red tool box for its icon, and scroll down to the line that has a symbol that looks like an alphabet block "A" to the left of the item's heading. No matter which language has been selected, you can recognize this menu item by the alphabet block. Once you're on the line with the alphabet block, press the center controller button to select it, then use the up/down direction buttons or the control wheel to scroll through the choices until you see a language you can read!

Date/Time Setup

Options: Year, Day, Month, Hour, Minute, Date Format, Daylight Savings Time

Default: None

Use this option to specify the date and time that will be embedded in the image file along with exposure information and other data. Having the date set accurately also is important for selecting movies for viewing by date. Use the left/right direction buttons to navigate through the choices of Daylight Savings Time On/Off; year; month; day; hour; minute; and date format. You can't directly change the AM/PM setting; you need to scroll the hours past midnight or noon to change that setting. Use the up/down direction buttons or the control wheel to change each value as needed.

Area Setting

Options: World time zones

Default: None

When you select this option, you are presented with a world map on the LCD. Use the control wheel or the left/right direction buttons to scroll until you have highlighted the time zone that you are in. Once the camera is set up with the correct date and time in your home time zone, you can use this setting to change your time zone during a trip, so you will record the local time with your images without disrupting your original date and time settings. Just scroll back to your normal time zone once you return home.

Help Guide Display

Options: On, Off

Default: On

This option is the first one on the eighth full screen of options on the Setup menu. (See Figure 3.36.) When this option is turned on, the camera pops up a small screen with additional information about a menu item that you have highlighted. At first I found this feature quite annoying, but I found some useful information in the little help screens, and I learned that they will disappear quickly if you continue to scroll down through a menu. So, you may want to give this feature a try, but turn it off if you find it unduly distracting.

Power Save

Options: 1 minute, 5 minutes, 10 minutes, 30 minutes

Default: 1 minute

This setting lets you set how long the Sony Alpha NEX remains active before going into Power Save mode, in which it enters a standby state. You can select 1, 5, 10, or 30

Figure 3.36
The eighth full screen of options on the Sony Alpha
NEX's Setup menu.

minutes. If the camera is connected to a video display through an HDMI cable or if the drive mode is set to Remote Commander, the camera will power down after 30 minutes regardless of the time period this option is set for. However, as long as the power switch remains in the On position, you can bring the camera back to life by performing a function, such as pressing the shutter button halfway.

LCD Brightness

Options: Auto, Manual, Sunny Weather

Default: Auto

When you access this menu choice, a pair of grayscale steps and a color chart appear on the screen, allowing you to see the effects of your brightness changes on the dark, light, and middle tones as well as colors. Select Auto to have the Alpha NEX choose screen brightness for you. Choose Manual instead and a scale appears. Use the left/right direction buttons to adjust the brightness by plus or minus two (arbitrary) increments. If you find you have no trouble viewing the dimmed screen, you can set the brightness manually to -2 increments to save some battery power. If you're shooting outdoors in bright sun and find it hard to view the LCD even when shading it with your hand, you can resort to the Sunny Weather setting, which boosts the screen's brightness beyond even what you can set in Manual mode. Obviously, you should not leave this setting in place for great lengths of time unless you have an ample supply of spare batteries.

Viewfinder Brightness

Options: Auto, Manual

Default: Auto

This is the equivalent of the LCD Brightness function, but for the optional electronic viewfinder

Display Color

Options: Black, White

Default: White

It's nice to have some options for the appearance of your display, and Sony has provided you with two design choices for the NEX's menu system's background. The default choice is white, but I have chosen the black scheme for most of the menu illustrations in this book. As you scroll down through the two choices in the Setup menu, the screen instantly changes to help you see the effects of each different color scheme.

Wide Image

Options: Full Screen, Normal

Default: Normal

This option on the next screen of entries (see Figure 3.37) controls how the camera's display is set up when you are shooting and playing back still images taken at the 16:9 (widescreen) aspect ratio. If you leave this setting at its default of Normal, the rightmost area of the LCD displays a plain black background for the images of the soft keys and their labels, so you can clearly see how those controls function; if you choose the Full Screen option, your image takes up the entire width of the screen. The soft key images and labels are still present, but they're a bit harder to see because they are overlaid over your image. The Full Screen setting takes effect whenever you are shooting stills with the 16:9 aspect ratio and whenever you're playing a 16:9 image on the screen. This setting has no effect on the display of movies, either when shooting them or playing them back.

Playback Display

Options: Auto Rotate, Manual Rotate

Default: Auto Rotate

When this item is set to Auto Rotate, the Sony Alpha NEX rotates pictures taken in vertical orientation on the LCD screen so you don't have to turn the camera to view them comfortably. However, this orientation also means that the longest dimension of

Figure 3.37
The ninth full screen of options on the Sony Alpha NEX's Setup menu.

the image is shown using the shortest dimension of the LCD, so the picture is reduced in size. Choose Manual Rotate instead, and you can rotate only those photos you want to re-orient, by using the Rotate function from the Playback menu.

HDMI Resolution

Options: Auto, 1080p, 1080i

Default: Auto

Adjusts the camera's output for display on a high-definition television. Usually, Auto will work with any HDTV. If you have trouble getting the image to display correctly, you can set the resolution manually here.

CTRL for HDMI

Options: On, Off

Default: On

CTRL for HDMI allows you to view the display output of your Alpha NEX on a high-definition television (HDTV) if you make the investment in an HDMI cable with a mini-HDMI connector on the camera end (which Sony does not supply) and you own an HDTV (which Sony does not supply with the camera, either). When connecting HDMI-to-HDMI, the camera automatically selects the correct image settings, including color broadcast system, for viewing. (Earlier Alpha models, which used a composite video connection instead of HDMI, had to be set to either NTSC or PAL broadcast.)
If you're lucky enough to own a TV that supports the Sony Bravia synchronization protocol, you can operate the camera using that TV's remote control. Just press the Link Menu button on the remote, and then use the device's controls to delete images, display an image index of photos in the camera, display a slide show, protect/unprotect images in the camera, specify printing options, and play back single images on the TV screen.

The CTRL for HDMI option on the Setup menu is intended for use when you have connected the camera to a non-Sony HDTV and find that the TV's remote control produces unintended results with the camera. If that happens, try turning this option off, and see if the problem is resolved. When you have the camera connected to a Sony Bravia TV, this option should be left on.

USB Connection

Options: Auto, Mass Storage, PTP

Default: Auto

This option allows you to switch your USB connection protocol between the default Mass Storage setting (used when you transfer images from your camera to your computer), and PTP (Picture Transfer Protocol), which you'd use to connect your camera to a PictBridge-compatible printer. In Mass Storage mode, your camera appears to the computer as just another storage device, like a disk drive. You can drag and drop files between them. In PTP mode, the device you're connected to recognizes your camera as a camera and can communicate with it, which is what happens when you use a PictBridge printer.

Most of the time, you'll want to leave this setting at Auto, and change it only when you're communicating with a PictBridge printer that requires a PTP connection.

Cleaning Mode

Options: OK, Cancel

Default: None

One of the Sony Alpha NEX's very helpful features is the automatic sensor cleaning system that reduces or eliminates the need to clean your camera's sensor manually using brushes, swabs, or bulb blowers (you'll find instructions on how to do that in Chapter 11). Sony has applied an anti-static coating to the low-pass filter over the sensor to counter charge build-ups that attract dust. (The low-pass filter is a thin layer that helps reduce moiré and other unwanted patterns in your images.) That filter also vibrates each time the Alpha is powered off, shaking loose any dust, which is captured by a sticky strip beneath the sensor.

When it's time to clean the sensor manually, use this menu entry to provide access to the complementary metal-oxide semiconductor device (CMOS). Use a fully charged battery or optional AC adapter and choose the Cleaning mode menu option. A warning screen pops up: "After cleaning, turn camera off. Continue?" Press the upper soft key to cancel out of this screen, or press the center controller button to continue on. The camera will vibrate its anti-dust mechanism one more time, and then will let you gain access to the sensor area for your cleaning operation. At this point, detach the lens and proceed as I advise you in Chapter 11. When you're done with your manual cleaning, turn the camera off (as advised by the on-screen prompt) to return the camera to normal operation so you can reattach the lens and get back to your photographic endeavors. (See Figure 3.38.)

Version

Options: None

Select this menu option to display the version number of the firmware (internal operating software) installed in your camera. From time to time, Sony updates the original firmware with a newer version that adds or enhances features or corrects operational bugs. When a new version is released, it will be accompanied by instructions, which generally involve downloading the update to your computer and then connecting your camera to the computer with the USB cable to apply the update. It's a good idea to check occasionally at the Sony website, www.esupport.sony.com, to see if a new version of the camera's firmware is available for download. (You can also go to that site to download updates to the software that came with the camera, and to get general support information.)

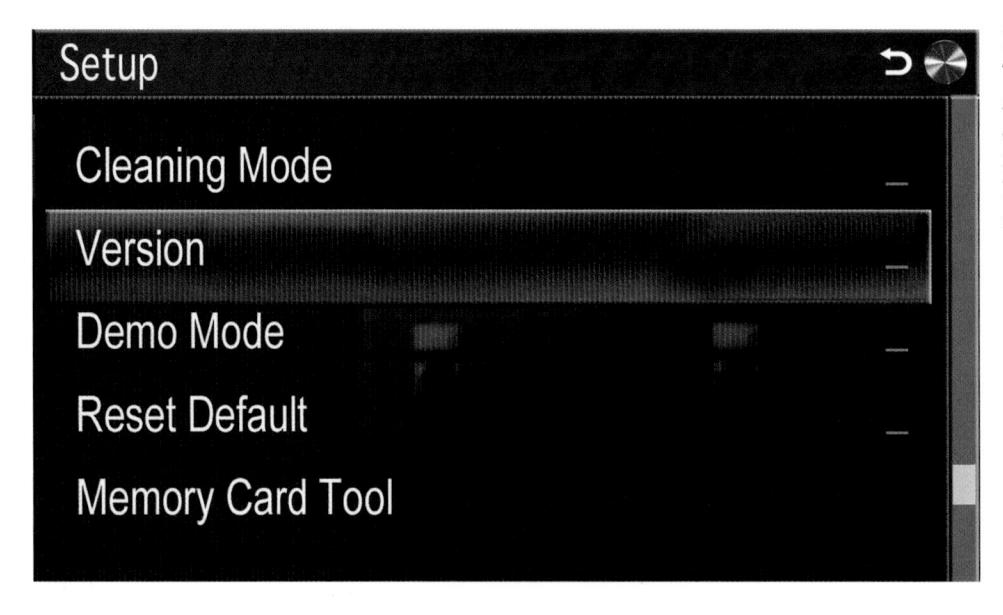

Figure 3.38
The tenth full screen of options on the Sony Alpha
NEX's Setup menu.

Demo Mode

Options: On, Off

Default: Off

If you turn this option on, the camera automatically enters its Demo mode after about one minute of inactivity. This mode causes the camera to play whatever movies are stored on the memory card, one after another. So, if you want to have the camera do a real "demo" of its features, you will have to create or obtain a movie that provides that sort of demonstration. The camera does not come with any built-in movie that serves that purpose, so this feature is not of much use to the average owner of a NEX camera.

Reset Default

Options: OK, Cancel

Default: None

If you've made a lot of changes to your Alpha NEX's settings, you may want to return the camera to its factory settings so you can start over without manually going back through the menus and restoring everything. This menu selection lets you do that with the press of a few buttons. It can be a handy function to have when you have been playing around with many settings, and would like to get the camera back to its normal, initial operating mode.

Format

Options: OK, Cancel

Default: None

The next group of oprions on the Setup menu (see Figure 3.39) comes under the heading of Memory Card Tool. One of the most important of these options is the Format command. To reformat your memory card, choose the Format menu entry and press the lower soft key (labeled "OK") to confirm. Press the upper soft key if you need to cancel out of the operation.

Use the Format option to erase everything on your memory card and set up a fresh file system ready for use. This procedure removes all the images on the memory card, and reinitializes the card's file system by defining anew the areas of the card available for image storage, locking out defective areas, and creating a new folder in which to deposit your images. It's usually a good idea to reformat your memory card in the camera (not in your camera's card reader using your computer's operating system) before each use. Formatting is generally much quicker than deleting images one by one.

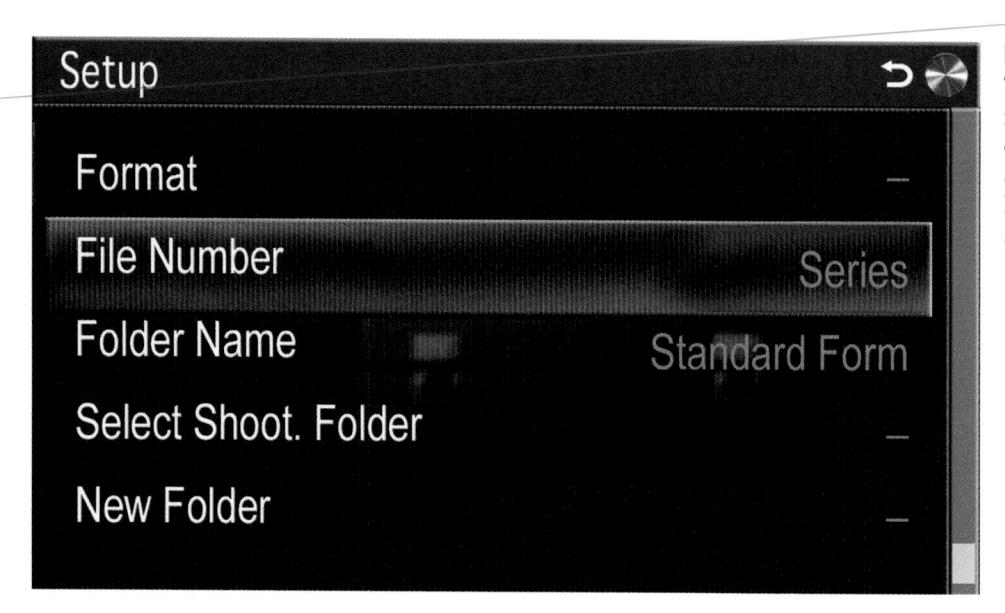

Figure 3.39
The eleventh full screen of options on the Sony Alpha NEX's Setup menu.

File Number

Options: Series, Reset

Default: Series

The File Number option controls how the camera sets up the file numbers for your images. The Sony Alpha NEX will automatically apply a file number to each picture you take when this option is set to Series, using consecutive numbering for all your photos over a long period of time, spanning many different memory cards, and even if you reformat a card. Numbers are applied from 0001 to 9999, at which time the camera starts back at 0001. The camera keeps track of the last number used in its internal memory. So, you could take pictures numbered as high as 100-0240 on one card, remove the card and insert another, and the next picture will be numbered 100-0241 on the new card. Reformat either card, take a picture, and the next image will be numbered 100-0242. Use the Series option when you want all the photos you take to have consecutive numbers (at least, until your camera exceeds 9999 shots taken).

If you want to restart numbering back at 0001 on a more frequent basis, set the Reset option. In that case, the file number will be reset to 0001 *each* time you format a memory card or delete all the images in a folder, insert a different memory card, or change the folder name format (as described in the next menu entry).

Folder Name

Options: Standard Form, Date Form

Default: Standard Form

If you have viewed one of your memory card's contents on a computer using a card reader, you noticed that the top-level folder on the card is always named DCIM. Inside that folder is another folder created by your camera. Different cameras use different folder names, and they can co-exist on the same card. For example, if your memory card is removed from your Sony camera and used in, say, a camera from another vendor that also accepts Secure Digital or Memory Stick cards, the other camera will create a new folder using a different folder name within the DCIM directory.

By default, the Alpha creates its folders using a three-number prefix (starting with 100), followed by MSDCF. As each folder fills up with 999 images, a new folder with a prefix that's one higher (say, 101) is used. So, with the "Standard Form," the folders on your memory card will be named 100MSDCF, 101MSDCF, and so forth.

You can select Date Form instead, and the Alpha will use a *xxxymmdd* format, such as 10000904, where the 100 is the folder number, 0 is the last digit of the year (2010), 09 is the month, and 04 is the day of that month. If you want your folder names to be more date-oriented, rather than generic, use the Date Form option instead of Standard Form.

Select Shooting Folder

Options: Select Shoot. Folder, New Folder

Default: None

Select Shoot. Folder and New Folder appear as two separate entries on the Setup menu, but they are so closely related that I'm discussing them both at one time. Although your Alpha NEX will create new folders automatically as needed, you can create a new folder at any time, and switch among available folders already created on your memory card. (But only, of course, if a memory card is installed in the camera.) This is an easy way to segregate photos by folder. For example, if you're on vacation, you can change the Folder Name convention to Date Form (described previously), and then deposit each day's shots into different folders, which you create with this menu entry.

■ Select Shoot. Folder. To switch to a different folder (when more than one folder is available on your memory card), when you are using Standard Form folder naming, choose Select Shoot. Folder from the menu. A scrolling list of available folders appears. Use the up/down direction buttons or spin the control wheel to choose the folder you want, then press the center controller button to confirm your choice.

■ New Folder. To create a brand new folder, choose New Folder from the Setup menu. Press the center controller button, and a message like "10100905 folder created" or "102MSDCF folder created" appears on the LCD. Press the center controller button again to dismiss the screen and return to the menu.

Tip

Whoa! Sony has thrown you a curveball in this folder switching business. Note that if you are using Date Form naming, you can *create* folders using the date convention, but you can't switch among them—but only when Date Form is active. If you *do* want to switch among folders named using the date convention, you can do it. But you have to switch from Date Form back to Standard Form. *Then* you can change to any of the available folders (of either naming format). So, if you're on that vacation, you can select Date Form, and then choose New Folder each day of your trip, if you like. But if, for some reason, you want to put some additional pictures in a different folder (say, you're revisiting a city and want the new shots to go in the same folder as those taken a few days earlier), you'll need to change to Standard Form, switch folders, and then resume shooting. Sony probably did this to preserve the "integrity" of the date/folder system, but it can be annoying.

New Folder

Options: OK, Cancel

Default: None

Creates new folders on your memory card, using a number one higher than the last folder used, with one dedicated to still photos and a second for movies. The NEX-7 will create a new folder automatically whenever 4,000 images are stored in the current folder.

Recover Image DB

Options: OK, Cancel

Default: None

The Recover Image DB function is provided in case errors crop up in the camera's database that records information about your movies. According to Sony, this situation may develop if you have processed or edited movies on a computer and then re-saved them to the memory card that's in your camera. I have never had this problem, so I'm not sure exactly what it would look like. But, if you find that your movies are not playing correctly in the camera, go ahead and try this operation. Highlight this menu

option and press the center controller button, and the camera will prompt you, "Check Image Database File?" Press the center controller button to confirm, or the upper soft key to cancel.

Display Card Space

Options: None Default: None

It makes sense that Sony placed this option almost at the extreme bottom of the Setup menu, because it's not really all that useful. It gives you a report of how many still images and how many movies can be recorded on the memory card that's in the camera, given the current shooting settings. Of course, the information about remaining still images is displayed on the shooting information display (unless you have cycled to the display with less information), and the information about minutes remaining for movie recording is displayed on the screen as soon as you press the Record button. But, if you want confirmation of this information, this menu option is available.

Upload Settings

Options: On, Off

Default: On

This final option on the Setup menu is the only entry under the last category heading, Eye-Fi Setup. This menu option appears only if you have an Eye-Fi card inserted in the memory card slot. As I mentioned in Chapter 1, an Eye-Fi card is a special type of SD card that connects to an available wireless (Wi-Fi) network and uploads the images from your memory card to a computer on that network. The Upload Settings option on the Setup menu lets you either enable or disable the use of the Eye-Fi card's transmitting capability. So, if you want to use an Eye-Fi card just as an ordinary SD card, for example, when no wireless network is available, you can turn this option off and save whatever power the camera uses to enable the Eye-Fi card to transmit. If you are using an Eye-Fi card to upload images, make sure this option is turned on.

Here's one note to consider: The Sony documentation for the NEX camera says that you cannot upload movies using an Eye-Fi card, but I have found that NEX movies uploaded quite nicely to my Macintosh using an Eye-Fi Pro X2 8GB card. The movies ended up in a Movies/Eye-Fi folder instead of the Pictures/Eye-Fi folder where the still images went, but they uploaded with no problems.

Getting the Right Exposure

When you bought your Sony Alpha NEX-7, you probably considered your days of worrying about getting the correct exposure were over. To paraphrase an old Kodak tagline dating back to the 19th Century—the goal is, "you press the button, and the camera does the rest." For the most part, that's a realistic objective. The Alpha NEX-7 is one of the smartest cameras available when it comes to calculating the right exposure for most situations. You can generally choose Intelligent Auto or one of the Scene modes, or spin the virtual mode dial to Program (P), Aperture priority (A), or Shutter priority (S) and shoot away.

So, why am I including an entire chapter on exposure? As you learn to use your Alpha NEX creatively, you're going to find that the right settings—as determined by the camera's exposure meter and intelligence—need to be *adjusted* to account for your creative decisions or special situations.

For example, when you shoot with the main light source behind the subject, you end up with *backlighting*, which can result in an overexposed background and/or an underexposed subject. The Sony Alpha NEX recognizes backlit situations nicely, and can properly base exposure on the main subject, producing a decent photo. Features like D-Range Optimizer (discussed in Chapter 6) can fine-tune exposure to preserve detail in the highlights and shadows.

But what if you *want* to underexpose the subject, to produce a silhouette effect? Or, perhaps, you might want to use the camera's flash unit to fill in the shadows on your subject. The more you know about how to use your Alpha NEX, the more you'll run into situations where you want to creatively tweak the exposure to provide a different look than you'd get with a straight shot.

This chapter shows you the fundamentals of exposure, so you'll be better equipped to override the Sony Alpha NEX's default settings when you want to, or need to. After all, correct exposure is one of the foundations of good photography, along with accurate focus and sharpness, appropriate color balance, and freedom from unwanted noise and excessive contrast, as well as pleasing composition.

The NEX-7 gives you a great deal of control over all of these, although composition is entirely up to you. You must still frame the photograph to create an interesting arrangement of subject matter, but all the other parameters are basic functions of photography. You can let your camera set them for you automatically, you can fine-tune how the camera applies its automatic settings, or you can make them yourself, manually. The amount of control you have over exposure, sensitivity (ISO settings), color balance, focus, and image parameters like sharpness and contrast make the NEX a versatile tool for creating images.

In the next few pages I'm going to give you a grounding in one of those foundations, and explain the basics of exposure, either as an introduction or as a refresher course, depending on your current level of expertise. When you finish this chapter, you'll understand most of what you need to know to take well-exposed photographs creatively in a broad range of situations.

Getting a Handle on Exposure

In the most basic sense, exposure is all about light. Exposure can make or break your photo. Correct exposure brings out the detail in the areas you want to picture, providing the range of tones and colors you need to create the desired image. Poor exposure can cloak important details in shadow, or wash them out in glare-filled featureless expanses of white. However, getting the perfect exposure requires some intelligence—either that built into the camera or the smarts in your head—because digital sensors can't capture all the tones we are able to see. If the range of tones in an image is extensive, embracing both inky black shadows and bright highlights, we often must settle for an exposure that renders most of those tones—but not all—in a way that best suits the photo we want to produce.

For example, look at two exposures presented in Figure 4.1. For the image at the top, the highlights (chiefly the clouds at upper left and the top-left edge of the skyscraper) are well exposed, but everything else in the shot is seriously underexposed. The version at the bottom, taken an instant later with the tripod-mounted camera, shows detail in the shadow areas of the buildings, but the highlights are completely washed out. The camera's sensor simply can't capture detail in both dark areas and bright areas in a single shot.

Figure 4.1
At top, the image is exposed for the highlights, losing shadow detail. At bottom, the exposure captures detail in the shadows, but the highlights are washed out.

With digital camera sensors, it's often tricky to capture detail in both highlights and shadows in a single image, because the number of tones, the *dynamic range* of the sensor, is limited. The solution, in this particular case, was to resort to a technique called High Dynamic Range (HDR) photography, in which the two exposures from Figure 4.1 were combined in an image editor such as Photoshop, or a specialized HDR tool like Photomatix (about \$100 from www.hdrsoft.com). The resulting shot is shown in Figure 4.2. I'll explain more about HDR photography in Chapter 6, including the Auto HDR feature of the Sony Alpha, which lets you accomplish a decent approximation of HDR processing right in the camera. For now, though, I'm going to concentrate on showing you how to get the best exposures possible without resorting to such tools, using only the ordinary exposure-related features of your Alpha NEX-7.

Figure 4.2 Combining the two exposures produces the best compromise image.

To understand exposure, you need to understand the six aspects of light that combine to produce an image. Start with a light source—the sun, an interior lamp, or the glow from a campfire—and trace its path to your camera, through the lens, and finally to the sensor that captures the illumination. Here's a brief review of the things within our control that affect exposure.

■ **Light at its source.** Our eyes and our camera—film or digital—are most sensitive to that portion of the electromagnetic spectrum we call *visible light*. That light has several important aspects that are relevant to photography, such as color and harshness (which is determined primarily by the apparent size of the light source as it illuminates a subject). But, in terms of exposure, the important attribute of a light source is its *intensity*. We may have direct control over intensity, which might be the case with an interior light that can be brightened or dimmed. Or, we might have only indirect control over intensity, as with sunlight, which can be made to appear dimmer by introducing translucent light-absorbing or reflective materials in its path.

- **Light's duration.** We tend to think of most light sources as continuous. But, as you'll learn in Chapter 9, the duration of light can change quickly enough to modify the exposure, as when the main illumination in a photograph comes from an intermittent source, such as an electronic flash.
- Light reflected, transmitted, or emitted. Once light is produced by its source, either continuously or in a brief burst, we are able to see and photograph objects by the light that is reflected from our subjects toward the camera lens; transmitted (say, from translucent objects that are lit from behind); or emitted (by a candle or television screen). When more or less light reaches the lens from the subject, we need to adjust the exposure. This part of the equation is under our control to the extent we can increase the amount of light falling on or passing through the subject (by adding extra light sources or using reflectors), or by pumping up the light that's emitted (by increasing the brightness of the glowing object).
- **Light passed by the lens.** Not all the illumination that reaches the front of the lens makes it all the way through. Filters can remove some of the light before it enters the lens. Inside the lens barrel is a variable-sized diaphragm which dilates and contracts to control the amount of light that enters the lens. You, or the Alpha NEX's autoexposure system, can control exposure by varying the size of the aperture. The relative size of the aperture is called the *f/stop*. (See Figure 4.3, which is a graphic representation of the relative size of the lens opening, not an actual photo of the aperture of a lens.)
- Light passing through the shutter. Once light passes through the lens, the amount of time the sensor receives it is determined by the Alpha NEX's shutter, which can remain open for as long as 30 seconds (or even longer if you use the Bulb setting) or as briefly as 1/4,000th second.
- Light captured by the sensor. Not all the light falling onto the sensor is captured. If the number of photons reaching a particular photosite doesn't pass a set threshold, no information is recorded. Similarly, if too much light illuminates a pixel in the sensor, then the excess isn't recorded or, worse, spills over to contaminate adjacent pixels. We can modify the minimum and maximum number of pixels that contribute to image detail by adjusting the ISO setting. At higher ISOs, the incoming light is amplified to boost the effective sensitivity of the sensor.

These four factors—quantity of light, light passed by the lens, the amount of time the shutter is open, and the sensitivity of the sensor—all work proportionately and reciprocally to produce an exposure. That is, if you double the amount of light, increase the aperture by one stop, make the shutter speed twice as long, or boost the ISO setting 2X, you'll get twice as much exposure. Similarly, you can increase any of these factors while decreasing one of the others by a similar amount to keep the same exposure.

F/STOPS AND SHUTTER SPEEDS

If you're new to more advanced cameras, you might need to know that the lens aperture, or f/stop, is a ratio, much like a fraction, which is why f/2 is larger than f/4, just as 1/2 is larger than 1/4. However, f/2 is actually *four times* as large as f/4. (If you remember your high school geometry, you'll know that to double the area of a circle, you multiply its diameter by the square root of two: 1.4.)

Lenses are usually marked with intermediate f/stops that represent a size that's twice as much/half as much as the previous aperture. So, a lens might be marked:

f/2, f/2.8, f/4, f/5.6, f/8, f/11, f/16, f/22, with each larger number representing an aperture that admits half as much light as the one before, as shown in Figure 4.3.

Shutter speeds are actual fractions of a second, such as 1/60, 1/125, 1/250, 1/500, and 1/1,000 second. To avoid confusion, the Sony Alpha NEX uses quotation marks to signify longer exposures: 2", 2"5, 4", and so forth representing 2.0, 2.5, and 4.0-second exposures, respectively.

Figure 4.3
Top row
(left to right):
f/2, f/2.8, f/4;
bottom row,
f/5.6, f/8, f11.

Table 4.1 Equivalent Exposures			
Shutter speed	f/stop	Shutter speed	f/stop
1/30th second	f/22	1/250th second	f/8
1/60th second	f/16	1/500th second	f/5.6
1/125th second	f/11	1/1,000th second	f/4

Most commonly, exposure settings are made using the aperture and shutter speed, followed by adjusting the ISO sensitivity if it's not possible to get the preferred exposure (that is, the one that uses the "best" f/stop or shutter speed for the depth-of-field or action stopping we want). Table 4.1 shows equivalent exposure settings using various shutter speeds and f/stops.

When the Alpha NEX is set for Program (P) mode, the metering system automatically selects the aperture and shutter speed that will result in what the camera judges to be the correct exposure. You cannot change the shutter speed or aperture individually, but you can choose a different combination using Program Shift, and you can cause the camera to change them by dialing in exposure compensation or by changing the ISO setting. In Aperture priority (A) and Shutter priority (S) modes, you can change to an equivalent exposure, but only by adjusting either the aperture (the camera chooses the shutter speed) or shutter speed (the camera selects the aperture). I'll cover all these exposure modes, as well as the more automatic and specialized modes, later in the chapter.

How the Sony Alpha NEX Calculates Exposure

Your NEX-7 calculates exposure by measuring the light that passes through the lens and reaches the sensor, based on the assumption that each area being measured reflects about the same amount of light as a neutral gray card that reflects a "middle" gray of about 12- to 18-percent reflectance. (The photographic "gray cards" you buy at a camera store have an 18-percent gray tone; your camera is calibrated to interpret a somewhat darker 12-percent gray; I'll explain more about this later.) That "average" 12- to 18-percent gray assumption is necessary, because different subjects reflect different amounts of light. In a photo containing, say, a white cat and a dark gray cat, the white cat might reflect five times as much light as the gray cat. An exposure based on the white cat will cause the gray cat to appear to be black, while an exposure based only on the gray cat will make the white cat look washed out.

This is more easily understood if you look at some photos of subjects that are dark (they reflect little light), those that have predominantly middle tones, and subjects that are highly reflective. The next few figures show some images of actual cats (actually, the

same off-white cat rendered in black, gray, and white varieties through the magic of Photoshop), with each of the three strips exposed using a different cat for reference.

Correctly Exposed

The three pictures shown in Figure 4.4 represent how the black, gray, and white cats would appear if the exposure were calculated by measuring the light reflecting from the middle, gray cat, which, for the sake of illustration, we'll assume reflects approximately 12 to 18 percent of the light that strikes it. The exposure meter sees an object that it thinks is a middle gray, calculates an exposure based on that, and the feline in the center of the strip is rendered at its proper tonal value. Best of all, because the resulting exposure is correct, the black cat at left and white cat at right are rendered properly as well.

Figure 4.4
When exposure is calculated based on the middle-gray cat in the center, the black and white cats are rendered accurately, too.

When you're shooting pictures with your NEX-7, and the meter happens to base its exposure on a subject that averages that "ideal" middle gray, then you'll end up with similar (accurate) results. The camera's exposure algorithms are concocted to ensure this kind of result as often as possible, barring any unusual subjects (that is, those that are backlit, or have uneven illumination). The NEX-7 has three different metering modes (described next), plus Scene modes, each of which is equipped to handle certain types of unusual subjects, as I'll outline.

Overexposed

The strip of three images in Figure 4.5 show what would happen if the exposure were calculated based on metering the leftmost, black cat. The light meter sees less light reflecting from the black cat than it would see from a gray middle-tone subject, and so figures, "Aha! I need to add exposure to brighten this subject up to a middle gray!" That lightens the black cat, so it now appears to be gray.

But now the cat in the middle that was *originally* middle gray is overexposed and becomes light gray. And the white cat at right is now seriously overexposed, and loses detail in the highlights, which have become a featureless white.

Figure 4.5
When exposure is calculated based on the black cat at the left, the black cat looks gray, the gray cat appears to be a light gray, and the white cat is seriously overexposed.

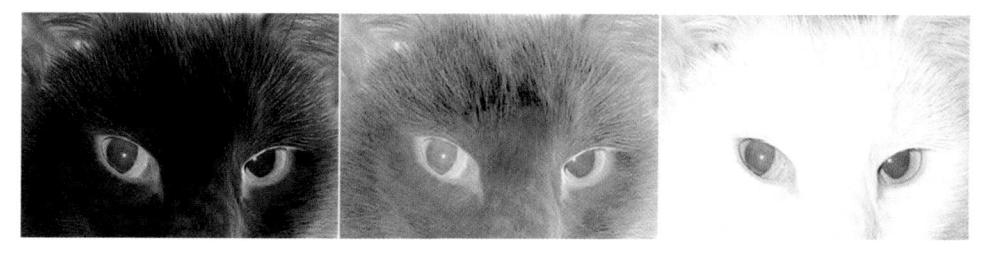

Underexposed

The third possibility in this simplified scenario is that the light meter might measure the illumination bouncing off the white cat, and try to render that feline as a middle gray. A lot of light is reflected by the white kitty, so the exposure is *reduced*, bringing that cat closer to a middle gray tone. The cats that were originally gray and black are now rendered too dark. Clearly, measuring the gray cat—or a substitute that reflects about the same amount of light—is the only way to ensure that the exposure is precisely correct. (See Figure 4.6.)

Figure 4.6
When exposure is calculated based on the white cat on the right, the other two cats are underexposed.

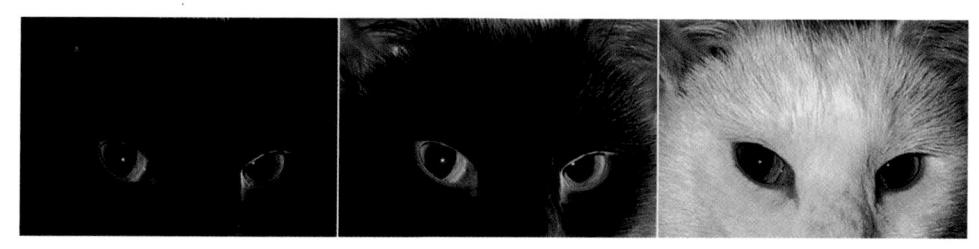

As you can see, the ideal way to measure exposure is to meter from a subject that reflects 12 to 18 percent of the light that reaches it. If you want the most precise exposure calculations, if you don't have a gray cat handy, the solution is to use a stand-in, such as the evenly illuminated gray card I mentioned earlier. But, because the standard Kodak gray card reflects 18 percent of the light that reaches it and, as I said, your camera is calibrated for a somewhat darker 12-percent tone, you would need to add about one-half stop *more* exposure than the value metered from the card.

Another substitute for a gray card is the palm of a human hand (the backside of the hand is too variable). But a human palm, regardless of ethnic group, is even brighter than a standard gray card, so instead of one-half stop more exposure, you need to add one additional stop. That is, if your meter reading is 1/500th of a second at f/11, use 1/500th second at f/8 or 1/250th second at f/11 instead. (Both exposures are equivalent.)

WHY THE GRAY CARD CONFUSION?

Why are so many photographers under the impression that cameras and meters are calibrated to the 18-percent "standard," rather than the true value, which may be 12 to 14 percent, depending on the vendor? You'll find this misinformation in an alarming number of places. I've seen the 18-percent "myth" taught in camera classes; I've found it in books, and even been given this wrong information from the technical staff of camera vendors. (They should know better—the same vendors' engineers who design and calibrate the cameras have the right figure.)

The most common explanation is that during a revision of Kodak's instructions for its gray cards in the 1970s, the advice to open up an extra half stop was omitted, and a whole generation of shooters grew up thinking that a measurement off a gray card could be used as-is. The proviso returned to the instructions by 1987, it's said, but by then it was too late. Next to me is a (c)2006 version of the instructions for KODAK Gray Cards, Publication R-27Q, and the current directions read (with a bit of paraphrasing from me in italics):

- For subjects of normal reflectance increase the indicated exposure by 1/2 stop.
- For light subjects use the indicated exposure; for very light subjects, decrease the exposure by 1/2 stop. (*That is, you're measuring a cat that's lighter than middle gray.*)
- If the subject is dark to very dark, increase the indicated exposure by 1 to 1-1/2 stops. (You're shooting a black cat.)

If you actually wanted to use a gray card, place it in your frame near your main subject, facing the camera, and with the exact same even illumination falling on it that is falling on your subject. Then, use the Spot metering function (described in the next section) to calculate exposure. Of course, in most situations, it's not necessary to do this. Your camera's light meter will do a good job of calculating the right exposure, especially if you use the exposure tips in the next section. But, I felt that explaining exactly what is going on during exposure calculation would help you understand how your NEX-7's metering system works.

In most cases, your camera's light meter will do a good job of calculating the right exposure, especially if you use the exposure tips in the next section. But if you want to double-check, or feel that exposure is especially critical, take the light reading off an object of known reflectance, such as a gray card. To meter properly, you'll want to choose both the *metering method* (how light is evaluated) and *exposure method* (how the appropriate shutter speeds and apertures are chosen). I'll describe both in the following sections.

Choosing a Metering Method

The Sony Alpha NEX has three different schemes for evaluating the light received by its exposure sensors. You can choose among them by going to the Brightness/Color menu and scrolling down to the fourth option, Metering Mode. (See Figure 4.7.)

- Multi. The Alpha slices up the frame into 1,200 different zones, as shown in Figure 4.8. The camera evaluates the measurements to make an educated guess about what kind of picture you're taking, based on examination of exposure data derived from thousands of different real-world photos. For example, if the top sections of a picture are much lighter than the bottom portions, the algorithm can assume that the scene is a landscape photo with lots of sky. This mode is the best all-purpose metering method for most pictures. A typical scene suitable for multimetering is shown in Figure 4.9.
- Frame to calculate exposure, as shown in Figure 4.10, on the theory that, for most pictures, the main subject will be located in the center. Center-weighting works best for portraits, architectural photos, and other pictures in which the most important subject is located in the middle of the frame. As the name suggests, the light reading is *weighted* towards the central portion, but information is also used from the rest of the frame. If your main subject is surrounded by very bright or very dark areas, the exposure might not be exactly right. However, this scheme works well in many situations if you don't want to use one of the other modes, for scenes like the one shown in Figure 4.11.

Figure 4.7
On the
Brightness/
Color menu,
the Metering
Modc option
offers three
methods for the
camera to use in
measuring the
available light:
Multi, Center,
and Spot.

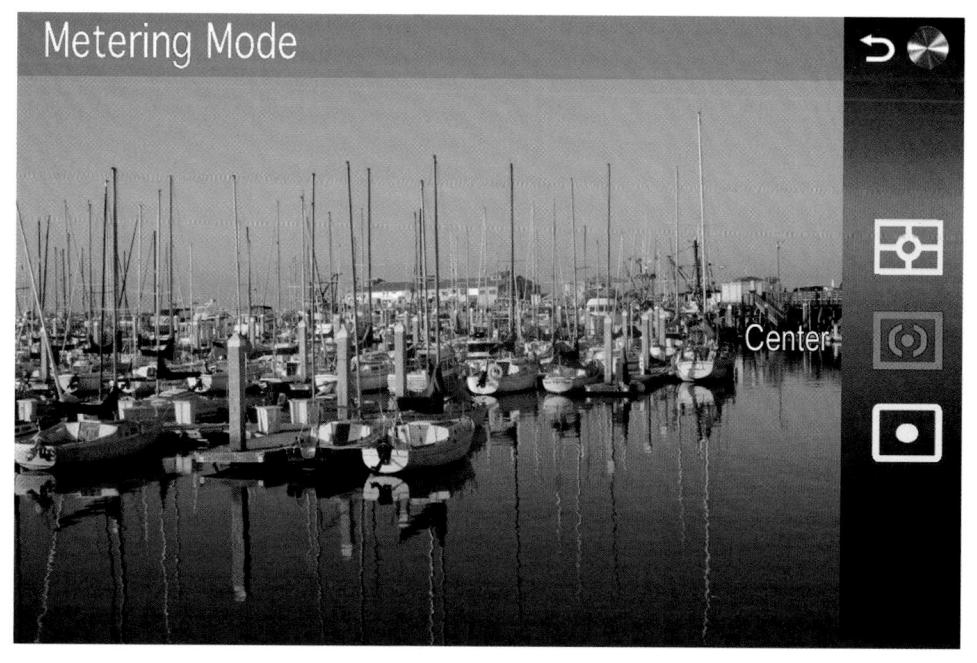

■ **Spot.** This mode confines the reading to a more limited area in the center of the image, as shown in Figure 4.12, or elsewhere in the image using Flexible Spot. This mode is useful when you want to base exposure on a small area in the frame. If that area is in the center of the frame, so much the better. If not, you'll have to use Flexible Spot, or make your meter reading on the center area and then lock exposure by pressing the shutter release halfway before re-aiming the camera at your actual subject. For Figure 4.13, Spot metering was used to fine-tune exposure for the musician's face.

Figure 4.8 Multi metering uses 1,200 zones.

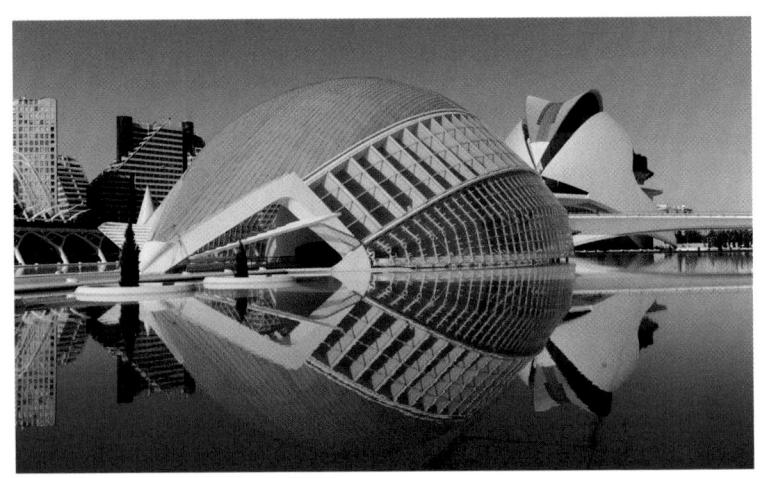

Figure 4.9 Multi metering is suitable for complex scenes like this one.

Figure 4.10 Center metering calculates exposure based on the full frame, but emphasizes the center area.

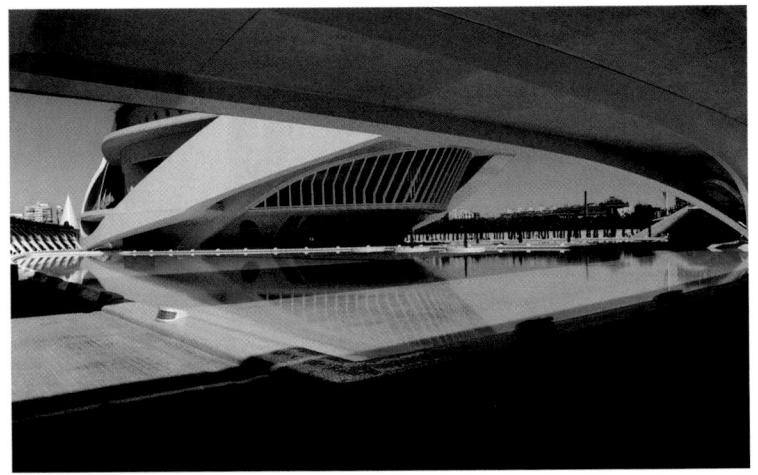

Figure 4.11 Scenes with the important tones in the center of the frame lend themselves to Center metering.

Figure 4.12 Spot metering calculates exposure based on a spot that's only a small percentage of the image area.

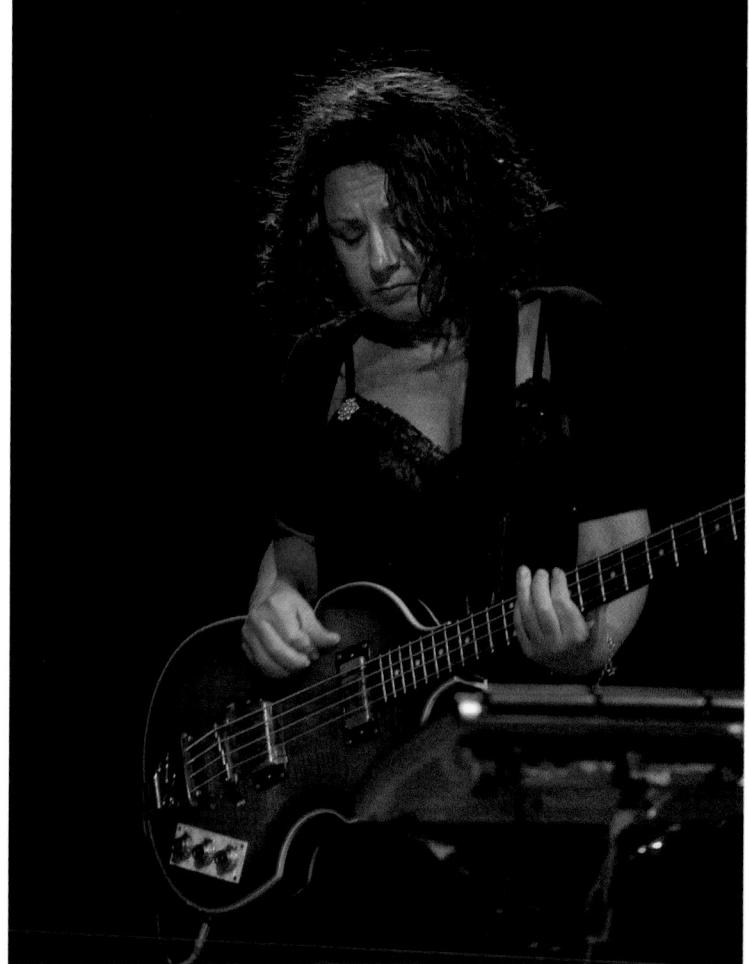

Figure 4.13 Meter from precise areas in an image, such as facial features, using Spot metering.

Choosing an Exposure Method

You'll find four methods for choosing the appropriate shutter speed and aperture semi-automatically or manually. Just go into the Shoot Mode menu screen and spin the virtual mode dial to choose the method you want to use (see Figure 4.14). Your choice of which mode is best for a given shooting situation will depend on things like your need for lots of (or less) depth-of-field, a desire to freeze action or allow motion blur, or how much noise you find acceptable in an image. Each of the Sony Alpha NEX-7's non-automatic exposure methods emphasizes one aspect of image capture or another. This section introduces you to all four.

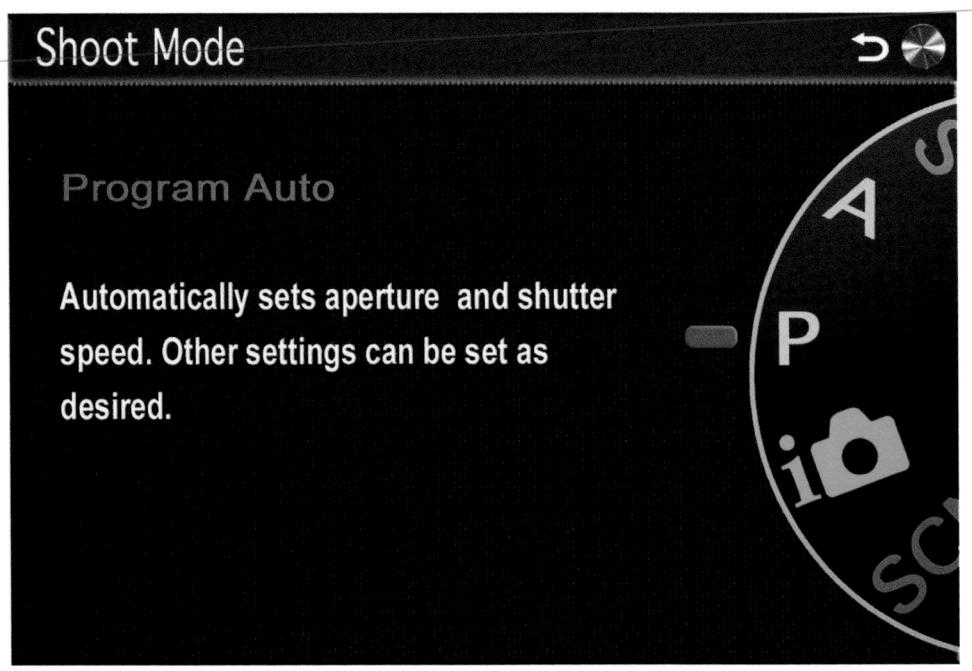

Figure 4.14
Choose exposure modes by going to the Shoot Mode screen and "spinning" the virtual shooting mode dial, using the up/down direction buttons or the control wheel.

Aperture Priority

In Aperture priority mode, you specify the lens opening used, and the Alpha NEX selects the shutter speed. Aperture priority is especially good when you want to use a particular lens opening to achieve a desired effect. Perhaps you'd like to use the smallest f/stop possible to maximize depth-of-field in a close-up picture. Or, you might want to use a large f/stop to throw everything except your main subject out of focus, as in Figure 4.15. Maybe you'd just like to "lock in" a particular f/stop because it's the sharpest available aperture with that lens. Or, you might prefer to use, say, f/4 on a lens with a maximum aperture of f/2.8, because you want the best compromise between speed and sharpness.

Aperture priority can even be used to specify a *range* of shutter speeds you want to use under varying lighting conditions, which seems almost contradictory. But think about it. You're shooting a soccer game outdoors with a telephoto lens and want a relatively high shutter speed, but you don't care if the speed changes a little should the sun duck behind a cloud. Set your Alpha NEX's shooting mode to A, and adjust the aperture using the left control dial until a shutter speed of, say, 1/1,000th second is selected at your current ISO setting. (In bright sunlight at ISO 400, that aperture is likely to be around f/11.) Then, go ahead and shoot, knowing that your Alpha will maintain that f/11 aperture (for sufficient DOF as the soccer players move about the field), but will drop down to 1/800th or 1/500th second if necessary should the lighting change a little.

Figure 4.15
Use Aperture priority mode to "lock in" a large f/stop when you want to blur the background.

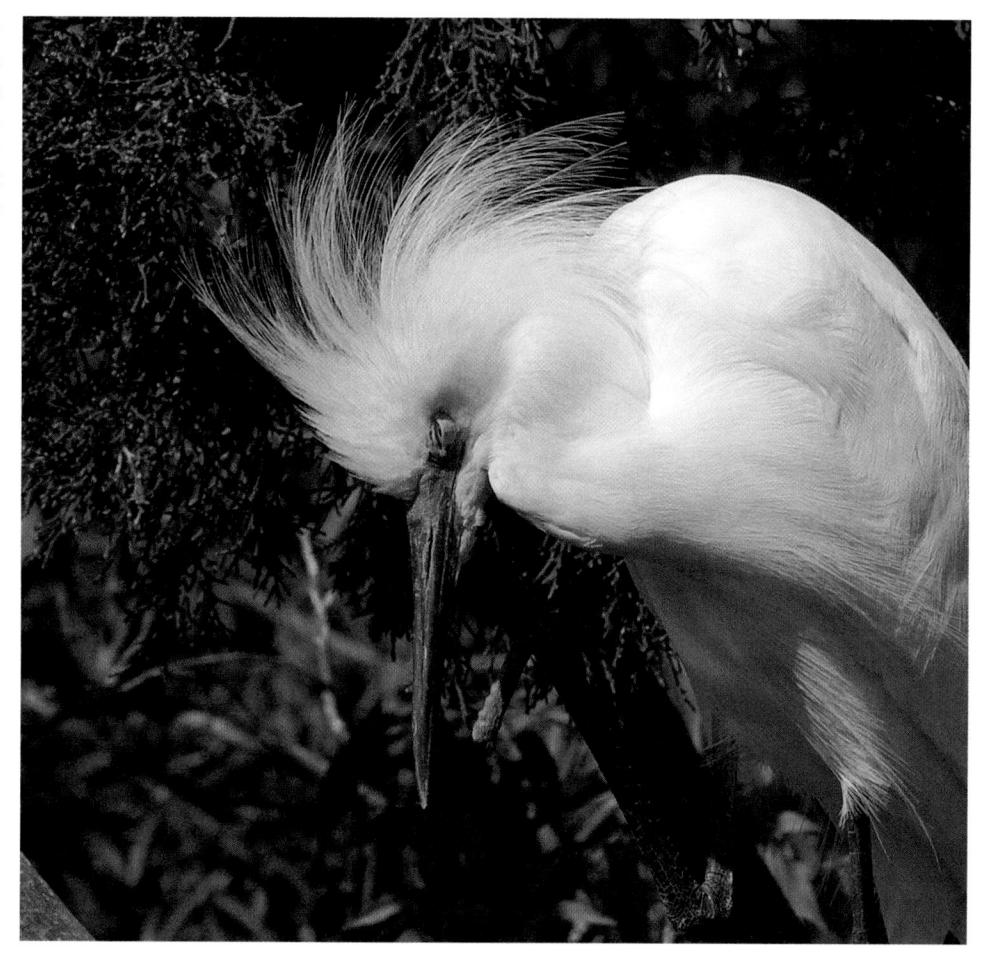

A blinking shutter speed indicator on the LCD indicates that the Alpha NEX is unable to select an appropriate shutter speed at the selected aperture and that over- or underexposure will occur at the current ISO setting. That's the major pitfall of using Aperture priority: you might select an f/stop that is too small or too large to allow an optimal exposure with the available shutter speeds. For example, if you choose f/2.8 as your aperture and the illumination is quite bright (say, at the beach or in snow), even your camera's fastest shutter speed might not be able to cut down the amount of light reaching the sensor to provide the right exposure. Or, if you select f/8 in a dimly lit room, you might find yourself shooting with a very slow shutter speed that can cause blurring from subject movement or camera shake. Aperture priority is best used by those with a bit of experience in choosing settings. Many seasoned photographers leave their Alpha set on Aperture priority all the time.

Shutter Priority

Shutter priority is the inverse of Aperture priority: you use the left control dial to choose the shutter speed you'd like to use, and the camera's metering system selects the appropriate f/stop. Perhaps you're shooting action photos and you want to use the absolute fastest shutter speed available with your camera; in other cases, you might want to use a slow shutter speed to add some blur to a sports photo that would be mundane if the action were completely frozen (see Figure 4.16). Shutter priority mode gives you some control over how much action-freezing capability your digital camera brings to bear in a particular situation.

You'll also encounter the same problem as with Aperture priority when you select a shutter speed that's too long or too short for correct exposure under some conditions. I've shot outdoor soccer games on sunny Fall evenings and used Shutter priority mode to lock in a 1/1,000th second shutter speed, only to find that my Alpha refused to produce the correct exposure when the sun dipped behind some trees and there was no longer enough light to shoot at that speed, even with the lens wide open.

As with Aperture priority mode, it's possible to choose an inappropriate shutter speed. If that's the case, the maximum aperture of your lens (to indicate underexposure) or the minimum aperture (to indicate overexposure) will blink on the LCD.

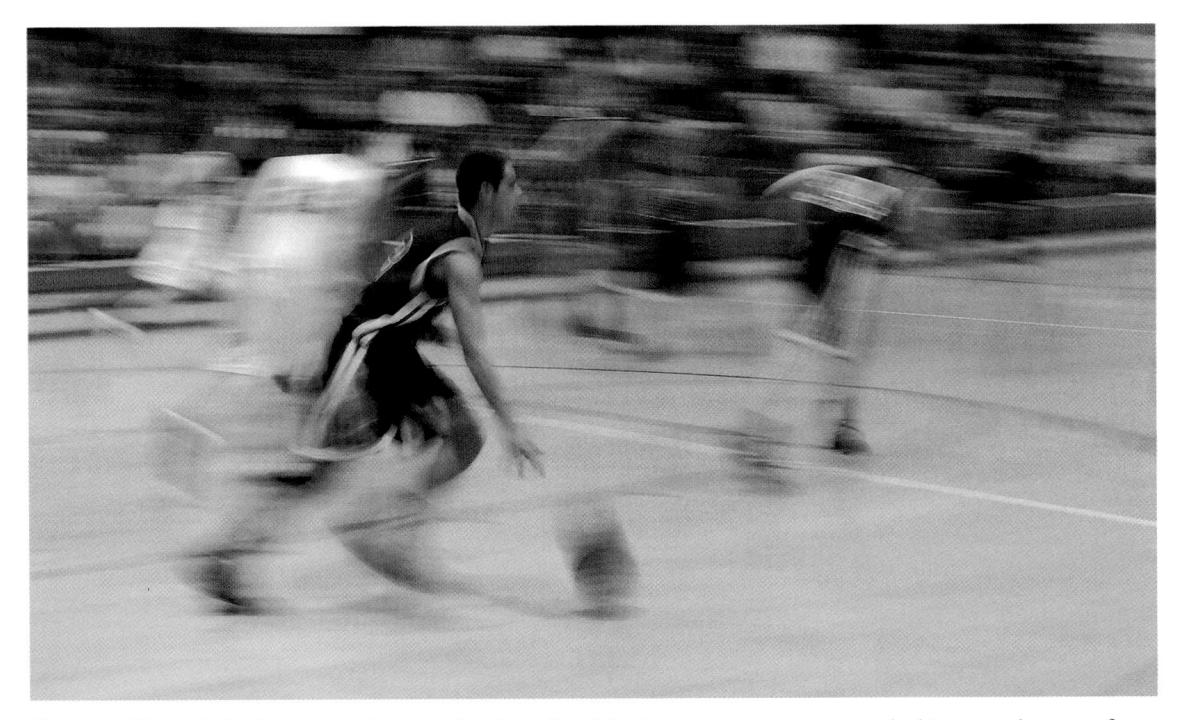

Figure 4.16 Lock the shutter at a slow speed to introduce blur into an action shot, as with this panned image of a basketball player.

Program Auto Mode

Program auto mode (P) uses the Alpha NEX's built-in smarts to select the correct f/stop and shutter speed using a database of picture information that tells it which combination of shutter speed and aperture will work best for a particular photo. In the unlikely event that the correct exposure cannot be achieved with the wide range of shutter speeds and apertures available, the shutter speed and aperture will both blink. This shooting mode is the one to use when you want to rely on the camera to make reasonable basic settings of shutter speed and aperture, but you want to retain the ability to adjust many of the camera's settings yourself, including ISO, white balance, metering mode, exposure compensation, and others.

Making Exposure Value Changes

Sometimes you'll want more or less exposure than indicated by the Sony Alpha NEX's metering system. Perhaps you want to underexpose to create a silhouette effect, or overexpose to produce a high-key look. It's easy to use the Alpha NEX's exposure compensation system to override the exposure recommendations. It's available only in the Program auto, Aperture priority, Shutter priority, Anti Motion Blur, Sweep Panorama, and 3D Sweep Panorama shooting modes. You can adjust exposure plus or minus five stops (or EV values) when shooting stills, and only plus/minus two EV when shooting movies. If you have set the live view to show the effects of your settings (as described in Chapter 3), only the results of plus/minus two stops adjustment will be shown; any EV changes you select that are more or less than that will be reflected in your finished shots, but not previewed on the screen.

In PAS modes, press the exposure compensation button (which doubles as the down direction button), which will bring up the exposure compensation controls displayed to the right of the live view of the scene. Press the up direction button or rotate the control wheel clockwise to make the image brighter (add exposure); use the down button or move the wheel counter clockwise to make the image darker (subtract exposure). A numerical indicator on the display's EV "wheel" indicates the EV change you've made. Any adjustment you've made remains for the exposures that follow, even after you've turned the camera off and back on, until you manually zero out the EV setting with the exposure compensation button and the control dial or direction buttons. (You also can get to the exposure compensation screen from the Brightness/Color menu, but there's really no reason to do that when you can press a single button and get there more quickly.)

Manual Exposure

Part of being an experienced photographer comes from knowing when to rely on your Sony Alpha NEX's automation (including Auto, P mode, and Scene mode settings), when to go semi-automatic (with Shutter priority or Aperture priority), and when to set exposure manually (using M). Some photographers actually prefer to set their exposure manually, as the Alpha will be happy to provide an indication of when its metering system judges your manual settings provide the proper exposure, using a numerical indicator of any exposure difference at the bottom of the LCD.

Manual exposure can come in handy in some situations. You might be taking a silhouette photo and find that none of the exposure modes or EV correction features gives you exactly the effect you want. For example, when I shot the windmill in Figure 4.17, there was no way any of my Sony Alpha's exposure modes would be able to interpret the scene the way I wanted to shoot it. So, I took a couple test exposures, and set the exposure manually to use the exact shutter speed and f/stop I needed. You might be working in a studio environment using multiple flash units. The additional flash units are triggered by slave devices (gadgets that set off the flash when they sense the light from another flash, or, perhaps from a radio or infrared remote control). Your camera's exposure meter doesn't compensate for the extra illumination, and can't interpret the flash exposure at all, so you need to set the aperture manually.

Although, depending on your proclivities, you might not need to set exposure manually very often, you should still make sure you understand how it works. Fortunately, the Sony Alpha NEX makes setting exposure manually very easy. First, go to the Shoot Mode screen and set the virtual shooting mode dial to M. Then, turn the left control dial and watch the bottom of the screen to see which numbers turn orange. (If you have the screen set to the graphic display using the DISP button, the vertical indicator in the aperture or shutter speed scale will also turn orange.) If the shutter speed value turns orange, then you're adjusting shutter speed. Continue to make that adjustment by turning the left control dial until you have that value set where you want it. Now you can adjust the aperture using the right control dial. The control wheel changes the ISO values.

When you've finished with your adjustments, the numerical indicator at the bottom of the LCD display, to the left of the M.M. icon reveals how far your chosen setting diverges from the metered exposure. (The M.M. stands for "metered manual.") If your settings go beyond 2 EV greater or less than the metered exposure, the indicator will flash to warn you that the exposure may be incorrect. If you want to set the exposure according to the camera's metering, adjust the aperture or shutter speed, or both, until the indicator reads 0.0.

Figure 4.17
Manual mode allowed setting the exact exposure for this silhouette shot, by metering the subject and then underexposing.

Adjusting Exposure with ISO Settings

Another way of adjusting exposures is by changing the ISO sensitivity setting by rotating the control wheel while using PASM modes. Sometimes photographers forget about this option, because the common practice is to set the ISO once for a particular shooting session (say, at ISO 200 for bright sunlight outdoors, or ISO 800 when shooting indoors) and then forget about ISO. The reason for that is that ISOs higher than ISO 200 are seen as "bad" or "necessary evils." However, changing the ISO is a valid way of adjusting exposure settings, particularly with the Sony Alpha NEX, which produces good results at ISO settings that create grainy, unusable pictures with some other camera models.

Indeed, I find myself using ISO adjustment as a convenient alternate way of adding or subtracting EV when shooting in Manual mode, and as a quick way of choosing equivalent exposures when in semi-automatic modes (P, A, and S). For example, I've selected a manual exposure with both f/stop and shutter speed suitable for my image using, say, ISO 400. I can change the exposure in full stop increments by bringing up the ISO option on the Brightness/Color menu, and spinning the control wheel (or pressing the up/down buttons) to change the ISO setting. The difference in image quality/noise at the base setting of ISO 400 is negligible if I dial in ISO 200 to reduce exposure a little, or change to ISO 800 to increase exposure. I keep my preferred f/stop and shutter speed, but still adjust the exposure.

Or, perhaps, I am using Shutter priority mode and the metered exposure at ISO 400 is 1/500th second at f/11. If I decide on the spur of the moment I'd rather use 1/500th second at f/8, I can either spin the control wheel, or enter the Brightness/Color menu, choose ISO, and spin the control wheel to switch to ISO 200. Of course, it's a good idea to monitor your ISO changes, so you don't end up at ISO 6400 accidentally, likely resulting in more graininess in your image than you would like. ISO settings can, of course, also be used to boost or reduce sensitivity in particular shooting situations, such as in deeply shaded or brightly illuminated areas. The Sony Alpha NEX can use ISO settings from ISO 100 all the way up to the impressive maximum of ISO 16000.

The camera can adjust the ISO automatically as appropriate for various lighting conditions. In Auto and Scene modes, in which Auto ISO is the only available option, the camera normally sets the ISO between 200 and 1600, but the setting varies depending on the particular mode. Similarly, when you set the camera to Auto ISO in Program, Aperture priority, or Shutter priority modes, sensitivity will be set within the range of ISO 200-1600. If you want to use a higher ISO setting in those modes, you must select it manually. In Manual exposure mode, you have to select your ISO setting manually; the camera will not accept an Auto ISO setting, and it will initially set the ISO to 100 if it had been set to Auto ISO before you switched into Manual mode. You can then reset the ISO to any numerical value you want, but not to Auto ISO.

Bracketing

Bracketing is a method for shooting several consecutive exposures automatically using different settings, as a way of improving the odds that one of the images will be exactly right for your needs. Before digital and electronic film cameras took over the universe, it was common to bracket exposures, shooting, say, a series of three photos at 1/125th second, but varying the f/stop from f/8 to f/11 to f/16. In practice, smaller than wholestop increments were used for greater precision. Plus, it was just as common to keep the same aperture and vary the shutter speed, although in the days before electronic shutters, film cameras often had only whole increment shutter speeds available.

Today, cameras like the Sony Alpha NEX can bracket exposures much more precisely. When this feature is activated, the NEX takes three consecutive photos: one at the metered "correct" exposure, one with less exposure, and one with more exposure, in your choice of 1/3 or 2/3 stop increments. Figure 4.18 shows an image with the metered exposure (center), flanked by exposures of 2/3 stop more (left), and 2/3 stop less (right).

Bracketing cannot be performed when using the Intelligent Auto mode, Scene modes, Panorama modes, or the Anti Motion Blur mode, or when using the Smile Shutter or Auto HDR features. If the flash is popped up, it will be forced off and cannot be used while bracketing is activated. The Alpha NEX camera has just one exposure bracketing

Figure 4.18
Metered exposure (center)
accompanied by
bracketed exposures of 2/3 stop
more (left) and
2/3 stop less
(right).

mode: Continuous (BRK C), in which three exposures at the adjusted settings are taken when you hold down the shutter button.

Here are some points to keep in mind about bracketing:

- Drive, he said. You'll find the bracketing choices on the Drive mode menu. Press the drive mode button (left direction button) or select the first option on the Camera menu, and use the control wheel or the up/down buttons to scroll to BRK C. Then press the Option button (lower soft key) to switch between 0.3 and 0.7 bracket increments. Use 0.3 if you want to fine-tune exposure, or 0.7 if you'd like more dramatic changes between shots.
- HDR isn't hard. The 0.7 stop setting is the best choice available for exposure bracketing if you plan to perform High Dynamic Range magic later on in Photoshop or another image editor. The Merge to HDR Pro command in later versions of Photoshop allows you to combine three or more images with different exposures into one photo with an amazing amount of detail in both highlights and shadows. To get the best results, mount your camera on a tripod, shoot in RAW format, use BRK C, and set the exposure increment to 0.7 stops. Of course, with these Alpha NEX models, you also have the option of using the Auto HDR feature, discussed in Chapter 6, which can achieve excellent results in the camera without the need to use any special HDR software.
- Adjust the base value. You can bracket your exposures based on something other than the base (metered) exposure value. Make an adjustment for extra or less exposure with the exposure compensation button and the control wheel. Bracketing will be over, under, and equal to the *compensated* value.
- What changes? In Aperture priority mode, exposure bracketing will be achieved by changing the shutter speed if possible, and then by ISO if necessary; in Shutter priority mode, bracketing will be done using different f/stops if possible, and then by ISO if necessary; in Manual exposure mode, bracketing is applied by changing the shutter speed. In Program mode, the Alpha NEX will vary shutter speed, aperture, and ISO, as appropriate for your scene. Choose your bracketing method based on whether you want to keep a particular aperture (say, for selective focus), or a certain shutter speed (to blur or stop action).

Dealing with Noise

Image noise is that random grainy look that some like to use as a visual effect, but which, most of the time, is objectionable because it robs your image of detail even as it adds that "interesting" texture. Noise is caused by two different phenomena: high ISO settings and long exposures.

High ISO noise commonly appears when you raise your camera's sensitivity setting above ISO 400. With the Sony Alpha NEX, noise may become visible at ISO 800, and is usually fairly noticeable at ISO 1600 and above. This kind of noise appears as a result of the amplification needed to increase the sensitivity of the sensor. While higher ISOs do pull details out of dark areas, they also amplify non-signal information randomly, creating noise. The Sony Alpha NEX automatically applies noise reduction that is strong enough to be visible as a reduction of sharpness in the image for any exposures taken at the higher ISOs, generally 1600 or above. Figure 4.19 shows two pictures shot during different at-bats at the same baseball game. Both were exposed at ISO 1600, but

Figure 4.19
High noise reduction applied (top) produces a less grainy image than the version at bottom, which has low noise reduction.

with high noise reduction applied in the version at top, and with low noise reduction at bottom. (I've exaggerated the differences between the two so the grainy/less grainy images are more evident on the printed page. The halftone screen applied to printed photos tends to mask these differences.)

A similar noisy phenomenon occurs during long time exposures, which allow more photons to reach the sensor, increasing your ability to capture a picture under low-light conditions. However, the longer exposures also increase the likelihood that some pixels will register random phantom photons, often because the longer an imager is "hot" the warmer it gets, and that heat can be mistaken for photons.

With a CCD like the one used in some other cameras in the Alpha series, the entire signal is conveyed off the chip and funneled through a single amplifier and analog-to-digital conversion circuit. Any noise introduced there is, at least, consistent. CMOS imagers like the one in the Alpha NEX-7, on the other hand, contain millions of individual amplifiers and A/D converters, all working in unison. Because these circuits don't necessarily all process in precisely the same way all the time, they can introduce something called fixed-pattern noise into the image data.

The Sony Alpha NEX performs long exposure noise reduction for any exposures longer than one full second. Fortunately, Sony's electronics geniuses have done an exceptional job minimizing noise. Even so, there are situations in which you might want to adjust your camera's automatic noise reduction features. For example, noise reduction can mask some detail as it removes random pixels from your image. Some of the imagemaking pixels are unavoidably vanquished at the same time. To change the settings for either type of noise reduction, navigate to the Setup menu and turn Long Exposure NR on or off or set High ISO NR to either Low, Normal, or High. The menu setting for Long Exposure NR is disabled when you are using Intelligent Auto, any Scene mode, Anti Motion Blur mode, or a Panorama mode. You can't change High ISO NR when using either of the Panorama modes or when shooting with Quality set to RAW. Finally, no noise reduction is applied, even if it is turned on, in certain situations, including when you are using Continuous shooting or Bracketing.

You can also apply noise reduction to a lesser extent using Photoshop, and when converting RAW files to some other format, using your favorite RAW converter, or using an industrial-strength product like Noise Ninja (www.picturecode.com) to wipe out noise after you've already taken the picture.

Fixing Exposures with Histograms

While you can often recover poorly exposed photos in your image editor, your best bet is to arrive at the correct exposure in the camera, minimizing the tweaks that you have to make in post-processing. However, you can't always judge exposure just by viewing the image on your Alpha NEX's LCD either before or after the shot is made. Ambient

light may make the LCD difficult to see, and the brightness level you've set can affect the appearance of the playback or live view image.

Instead, you can use a histogram, which is a chart displayed on the Sony Alpha's LCD that shows the number of tones being captured at each brightness level. One variety of histogram can be displayed for images that are being viewed in playback mode; that histogram screen shows overall brightness levels for the image as well as for the red, green, and blue channels combined. (See Figure 4.20.) In addition, any areas of the image on that screen that are either underexposed or overexposed will flash, alerting you that you may need to change your settings to avoid blowing highlights or losing detail in the shadows. You can use the histogram information along with the flashing alerts to guide your settings for the next shots you take.

When the camera is in shooting mode and you have turned on the Histogram option through the Setup menu, the LCD will display a basic histogram that shows the brightness levels of the image, given the current values of aperture, shutter speed, exposure compensation, and other settings. (See Figure 4.21.)

Both types of histograms are charts that include a representation of up to 256 vertical lines on a horizontal axis that show the number of pixels in the image at each brightness level, from 0 (black) on the left side to 255 (white) on the right. (The 3-inch LCD doesn't have enough pixels to show each and every one of the 256 lines, but, instead, provides a representation of the shape of the curve formed.) The more pixels at a given level, the taller the bar at that position. If no bar appears at a particular position on the scale from left to right, there are no pixels at that particular brightness level.

Figure 4.20
The playback mode histogram screen shows the relationship of tones in an image, including brightness (top right), and red, green, and blue tones (middle and bottom right).

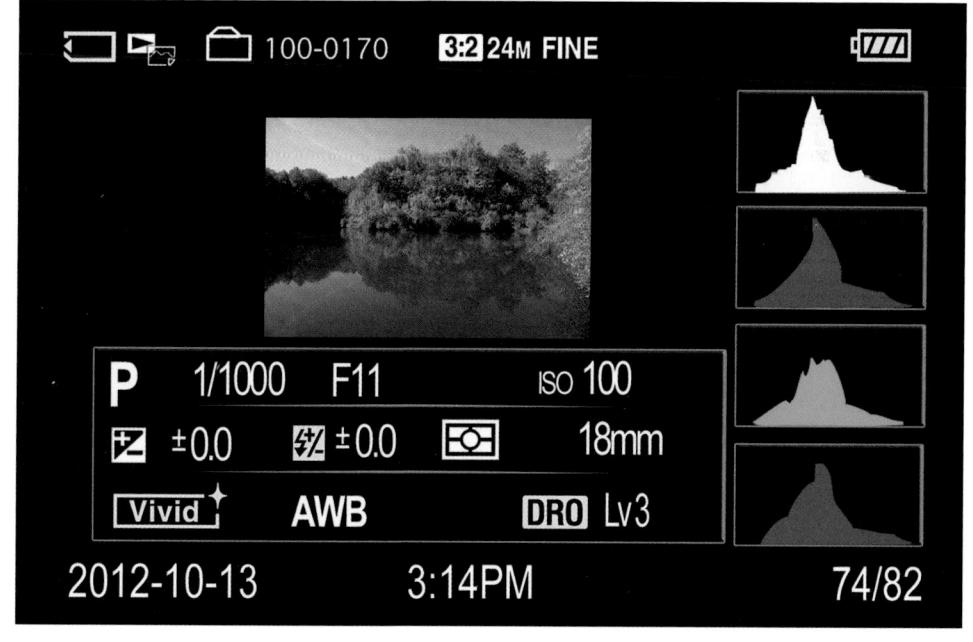

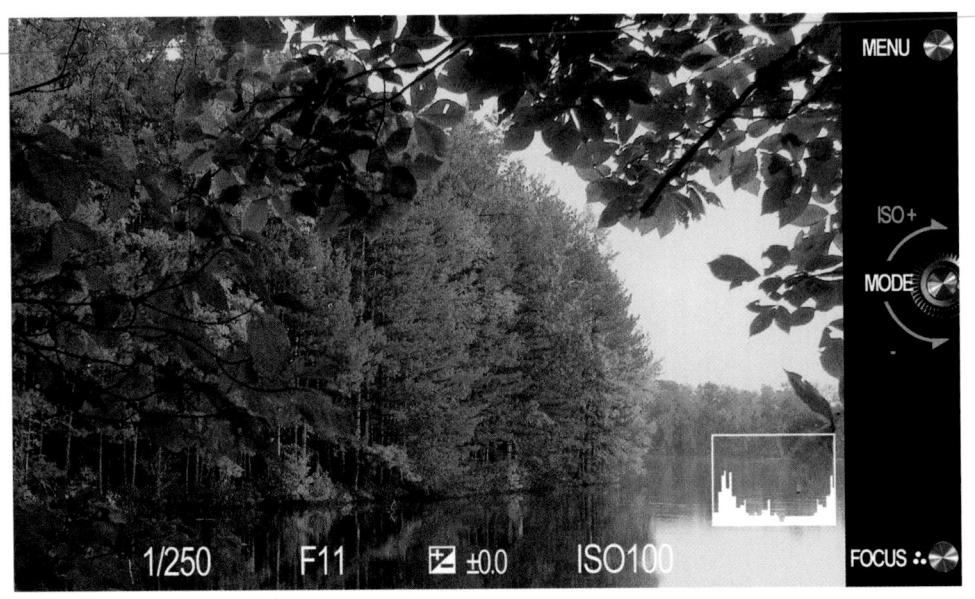

Figure 4.21
The shooting mode histogram screen provides a basic display showing the overall brightness levels of the image being viewed on the LCD screen.

DISPLAYING HISTOGRAMS

To view histograms on your screen in playback mode, press the DISP button while an image appears on the LCD. Keep pressing the button until the histogram screen appears. The playback histogram screen shows overall brightness levels as well as levels for each of the red, green, and blue channels (Figure 4.20). On that histogram display, you'll also see a thumbnail at the top left of the screen with your image displayed. In shooting mode, the histogram display is less detailed; all that is shown is a basic chart representing the overall brightness levels of the image, superimposed over the live view image (Figure 4.21). That display must be activated by turning it on in the Camera menu.

A typical histogram produces a mountain-like shape, with most of the pixels bunched in the middle tones, with fewer pixels at the dark and light ends of the scale. Ideally, though, there will be at least some pixels at either extreme, so that your image has both a true black and a true white representing some details. Learn to spot histograms that represent over- and underexposure, and add or subtract exposure using an EV modification to compensate.

For example, Figure 4.22 shows the histogram for an image that is badly underexposed. You can guess from the shape of the histogram that many of the dark tones to the left of the graph have been clipped off. There's plenty of room on the right side for additional pixels to reside without having them become overexposed. Or, a histogram might look like Figure 4.23, which is overexposed. In either case, you can increase or decrease the exposure (either by changing the f/stop or shutter speed in Manual mode

Figure 4.22 This histogram shows an underexposed image.

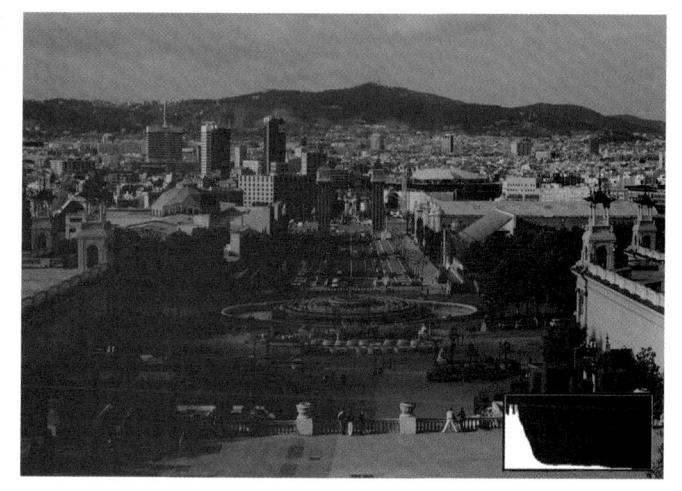

Figure 4.23
This histogram reveals that the image is overexposed.

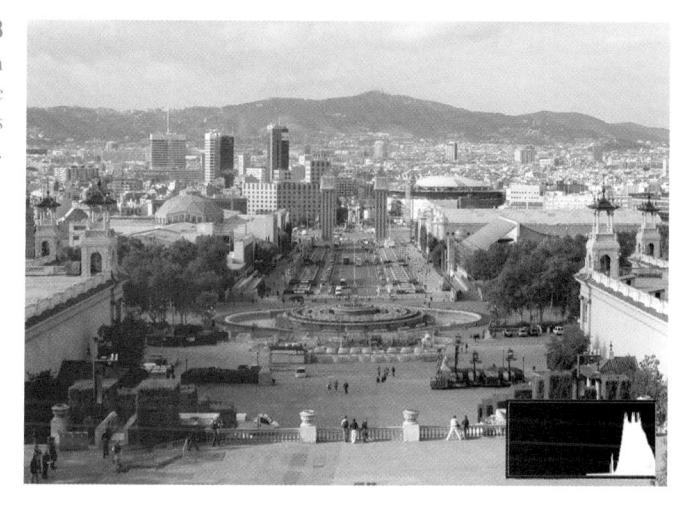

Figure 4.24
A histogram for a properly exposed image should look like this.

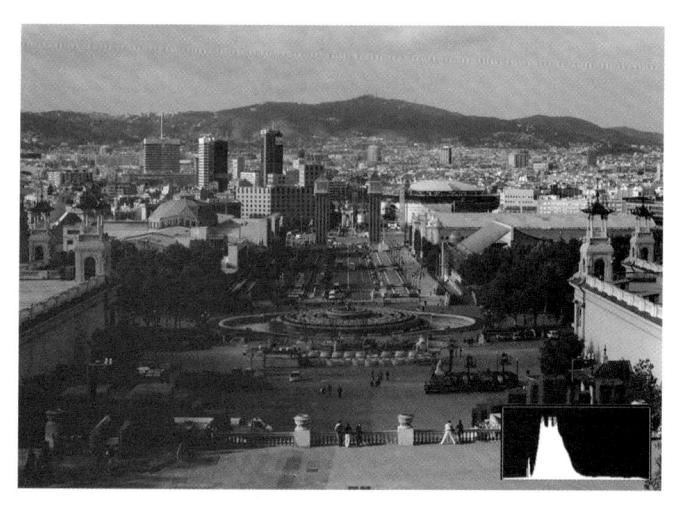

or by adding or subtracting an exposure compensation value in P, S, or A modes) to produce the corrected histogram shown in Figure 4.24, in which the tones span the histogram from left to right, with most in the middle to provide a full range of tones. See "Making Exposure Value Changes," above, for information on dialing in exposure compensation.

The histogram can also be used to aid in fixing the contrast of an image, although gauging incorrect contrast is more difficult. For example, if the histogram shows all the tones bunched up in one place in the image, the photo will be low in contrast. If the tones are spread out more or less evenly, the image is probably high in contrast. In either case, your best bet may be to switch to RAW quality (if you're not already using that format) so you can adjust contrast in post processing.

Automatic and Specialized Shooting Modes

As you've seen from the discussion so far, the Sony Alpha NEX-7 is a sophisticated camera with a full range of adjustments available to the serious photographer. It also comes equipped with automatic or special-purpose shooting modes that can do a lot of the photographic heavy lifting for you, if you so choose. These include eight Scene modes, which automatically make all the basic settings needed for certain types of shooting situations, such as portraits, landscapes, close-ups, sports, night portraits, and sunsets. If you choose the universal Intelligent Auto mode, the camera will use its programmed intelligence to try to identify the type of scene and set itself accordingly. These "autopilot" modes are useful when you suddenly encounter a picture-taking opportunity and don't have time to decide exactly which semi-automatic or manual mode (P, A, S, or M) you want to use. Instead, you can spin the virtual mode dial to the green camera icon for the Intelligent Auto setting, or, if you have a little more time, to an appropriate Scene mode, and fire away, knowing that you have a fighting chance of getting a good or usable photo.

Finally, the NEX offers you several more specialized modes, for use in particular situations: Anti Motion Blur, Sweep Panorama, and 3D Sweep Panorama. Those modes provide special capabilities, and give you a bit more leeway in adjusting the camera's settings than the Intelligent Auto and Scene modes do.

Intelligent Auto and Scene Modes

The Intelligent Auto and Scene modes are especially helpful when you're just learning to use your Alpha NEX, because they let you get used to composing and shooting, and obtaining excellent results, without having to struggle with unfamiliar controls to adjust things like shutter speed, aperture, ISO, and white balance. Once you've learned how to make those settings, you'll probably prefer one of the PASM modes that provide
more control over shooting options. The Intelligent Auto and Scene modes may give you few options or none at all. For example, the AF mode, AF area, ISO, white balance, Dynamic Range Optimizer, and metering mode are all set for you. In most modes, you can select the drive setting and the flash mode, though not all settings for those options are available. You cannot adjust exposure compensation or Creative Styles in any of these modes. Here are some essential points to note about the Intelligent Auto and Scene modes:

- Intelligent Auto. This is the setting to use when you hand your camera to a total stranger and ask him or her to take your picture posing in front of the Eiffel Tower. All the photographer has to do is press the shutter release button. Every other decision is made by the camera's electronics, and many settings, such as ISO, white balance, metering mode, and autofocus mode are not available to you for adjustment. However, you still are able to set the drive mode to Continuous shooting, self-timer, or Remote Commander (but not to Bracketing), and you can set the flash mode to Auto Flash or Flash Off.
- **Portrait.** This mode tends to use wider f/stops and faster shutter speeds, providing blurred backgrounds and images with no camera shake. The drive mode cannot be set to Continuous shooting, though you can set the self-timer to take three shots, you can use the Remote Commander, and you can set the flash mode to Auto Flash, Fill Flash, or forced off.
- Landscape. The Alpha tries to use smaller f/stops for more depth-of-field, and boosts saturation slightly for richer colors. You have some control over flash and can use the self-timer; most other settings are not available in this mode.
- Macro. This mode is similar to the Portrait setting, with wider f/stops to isolate your close-up subjects, and high shutter speeds to eliminate the camera shake that's accentuated at close focusing distances. However, if you have your camera mounted on a tripod or are using SteadyShot, you might want to use Aperture priority mode instead, so you can specify a smaller f/stop with additional depth-of-field.
- **Sports action.** In this mode, the Alpha tries to use high shutter speeds to freeze action, switches to Continuous drive mode to let you take a quick sequence of pictures with one press of the shutter release, and uses Continuous Autofocus to continually refocus as your subject moves around in the frame. You can find more information on autofocus options in Chapter 5.
- Sunset. Increases saturation to emphasize the red tones of a sunrise or sunset. You can use the Fill Flash or Flash Off settings, but most other adjustments are unavailable to you.

- Night Portrait. Sets Flash mode to the Slow Sync setting, which combines flash with ambient light to produce an image that is mainly illuminated by the flash, but with the background exposed by the available light. This mode uses longer exposures, so a tripod, monopod, or SteadyShot (if available with your lens; it will be indicated with an OSS reference in the lens name) is a must. To switch from Night Portrait to Night View mode, just set the Flash mode to Flash Off.
- **Night Scene.** Similar to Night Portrait, but the flash is forced off. Use a tripod if possible. Most settings are not available.
- Hand-held Twilight. This mode is designed to let you take hand-held shots in dark conditions without a tripod. The camera takes a burst of six exposures and then combines them in the camera into a single image. Depending on how dark the scene is, the camera may set the ISO to a high level so it can use a fast shutter speed to avoid blur from camera shake. Taking six images and combining them in the camera allows the camera to use the multiple sets of image information to reduce the noise that would otherwise be produced by the high ISO setting. Almost no settings are available for you to adjust when using this mode.

Anti Motion Blur and Panorama Modes

Finally, the NEX camera has three other shooting modes with specific capabilities for particular situations.

Anti Motion Blur

At first blush, this setting appears to be almost identical to the Hand-held Twilight Scene mode, except that Anti Motion Blur occupies its own slot on the virtual shooting mode dial. That is, in Anti Motion Blur mode the camera takes a rapid-fire set of six shots, at high ISO if necessary, and then combines them in the camera to create a single image with low noise. There is a significant difference, though. With Anti Motion Blur, unlike Hand-held Twilight, you have the ability to adjust several important exposure settings, including exposure compensation, white balance, metering mode, and Creative Style. So, if you want to take advantage of the special in-camera processing to avoid blur from camera shake, but still want to retain several creative options, this is the shooting mode to use.

Sweep Panorama

With other cameras, you can shoot a series of overlapping shots of a panoramic vista, and then "stitch" them together in special software programs to make a single, very wide, panoramic image. Some cameras can even do this for you with in-camera processing if you use a tripod and are quite careful about how much the images overlap. The Sony NEX though, is particularly adept at creating panoramas from hand-held shots.

Here are a few tips to consider:

- Choose a direction. You can select four directions for your panorama: left, right, up, or down. You make this choice on the Image Size menu, using the Panorama Direction setting; you can't set it unless the camera is set to Sweep Panorama mode. The default setting, right, is probably the most natural for many people, but it's good to have options. Of course, up or down motion is what you will need for certain subjects, including skyscrapers and nearby mountains.
- Change settings while in Panorama mode. When you select this shooting mode, the camera presents you with a large arrow and urgent sounding instructions to press the shutter button and move the camera in the direction of the arrow. Don't let the camera intimidate you with this demand; what it is neglecting to tell you is that you can take all the time you want, and that you are free to change certain settings before you shoot. Just press the Menu button and go into the Image Size or Brightness/Color menus, and you will find several items that can be adjusted, including image size, white balance, exposure composition, and metering mode. You also can choose the direction for the panorama from the Image Size menu. Once you have those settings fine-tuned to your satisfaction, *then* go ahead and press the shutter button.
- Smooth and steady does it. Press the shutter button and immediately start moving the camera smoothly and steadily around in an arc, and keep going until the shutter stops clicking. If you went too fast or too slow, you'll get an error message and the camera will prompt you to start over.
- Beware of moving objects. The Sweep Panorama shooting mode is best used for stationary subjects, such as mountain ranges, city skylines, or expansive gardens. Figure 4.25 is an example of a panorama taken in a nature preserve. There's nothing to stop you from shooting a scene that contains moving cars, people, or other objects, but be aware of problems that can arise in that situation. Because you're taking multiple overlapping shots that are then stitched into a single image, the camera may capture the same car or person twice (or more) in slightly different positions, which can result in a truncated or otherwise distorted picture of that particular subject. You may want to experiment with that type of image for creative purposes, but if you want an accurate depiction of the scene, be sure to scrutinize the finished product to see that it doesn't contain any unwelcome surprises. Press the Playback button to view your just completed panorama, or press the center controller button to view a moving playback of the image.

Figure 4.25 This image was taken by a hand-held Sony NEX-7 with the 16mm "pancake" lens using the standard image size for panoramas.

3D Sweep Panorama

The 3D Sweep Panorama mode was designed to create panoramas that will appear in 3D on certain models of Sony Bravia 3D HDTV sets, although those models are new, and are not widely available at this writing. However, if you're the experimenting type, you can enjoy the benefits of 3D images without shelling out \$2,000 or so for a new TV. The 3D panoramas taken by the NEX create image files with an extension of MPO. You can download software that will convert these files to JPEG images in the "anaglyph" 3D format, which will look blurry to the naked eye, but will appear in 3D if you view them through standard-issue 3D glasses (with a red filter over the left eye and a blue one over the right). Here are some pointers for dealing with 3D images taken with the NEX:

- Choose right or left. You can select only two directions for a 3D panorama: left or right. Make this setting on the Image Size menu while the camera is set to 3D Panorama shooting mode.
- Create a non-panoramic panorama. In 3D Panorama mode, the camera offers you one additional option for image size, in addition to the Standard and Wide options that are available with the normal Sweep Panorama mode. You can select 16:9, which, of course, is the same aspect ratio as that of normal still images taken using the 16:9 settings. In other words, a non-panoramic image! So, if you just want to take a 3D image that is not a panorama, you can do so by selecting the 16:9 setting from the Image Size menu, under the 3D Panorama heading, while in 3D Panorama shooting mode.

■ View 3D with no 3D TV. I appreciate the benefits of 3D images and enjoy viewing them, but I would prefer to view them without shelling out \$2,000 or so to acquire a 3D HDTV. It turns out that you can accomplish this fairly easily if you're willing to take a few steps to process the 3D files that the NEX generates. Go to http://stereo.jpn.org/eng/stphmkr/ and download a free program for Windows called Stereo Photo Maker. From the program's File menu select Open Stereo Image. Check the box for file type Anaglyph Color, and open your MPO file. You should now see two images on the screen. Go to the Stereo menu and select Color Anaglyph—Dubois (red/cyan). Now you should see a single image that is blurry, like any other 3D image that needs to be viewed through red and blue lenses. You can then save that image by going to the File menu. Choose Save Stereo Image and save the image using file type JPEG. (See Figure 4.26.) Now go find a pair of 3D glasses that came with a DVD or comic book, open your saved file, and voilà! You're viewing your image in 3D and just saved \$2,000! (Note to Mac users: There is a downloadable program called Anaglyph Workshop that might accomplish the same result, but I have not tested it.)

Figure 4.26 This JPEG version of a 3D image taken by a NEX-7 will look blurry until you find a pair of red/blue 3D glasses to view it with!

Mastering the Mysteries of Autofocus

One of the most useful and powerful features of modern digital cameras is their ability to lock in sharp focus faster than the blink of an eye. Sometimes. Although autofocus has been with us for more than 20 years, it continues to be problematic. While vendors like Sony are giving us faster and more precise autofocus systems—like the full-time autofocus possible with the NEX series' mirrorless technology—it's common for the sheer number of options to confuse even the most advanced photographers.

One key problem is that the camera doesn't really know, for certain, what subject you want to be in sharp focus. It may select an object and lock in focus with lightning speed—even though the subject is not the one that's the center of interest of your photograph. Or, the camera may lock focus too soon, or too late. This chapter will help you choose the options available with your Sony NEX-7 that will help the camera understand what you want to focus on, when, and maybe even why.

Getting into Focus

Learning to use the Sony Alpha NEX's autofocus system is easy, but you do need to fully understand how the system works to get the most benefit from it. Once you're comfortable with autofocus, you'll know when it's appropriate to use the manual focus option, too. The important thing to remember is that focus isn't absolute. For example, some things that appear to be in sharp focus at a given viewing size and distance might not be in focus at a larger size and/or closer distance. In addition, the goal of optimum focus isn't always to make things look sharp. Not all of an image will be or should be sharp. Controlling exactly what is sharp and what is not is part of your creative palette.

164

Use of depth-of-field characteristics to throw part of an image out of focus while other parts are sharply focused is one of the most valuable tools available to a photographer. But selective focus works only when the desired areas of an image are in focus properly. For the digital camera photographer, correct focus can be one of the trickiest parts of the technical and creative process.

There are two major focusing methods used by modern digital cameras. The one used in many advanced cameras including current Sony Alpha models is *Phase Detection*. That's also the method the NEX-7 applies when you use the LA-EA2 A-mount lens adapter, which has its own built-in Phase Detection autofocus system. With that focusing method, the autofocus sampling area is divided into two halves by a lens in the sensor. The two halves are compared, much like (actually, exactly like) a two-window rangefinder used in surveying, weaponry, and non-SLR cameras like the venerable Leica M film models. The contrast between the two images changes as focus is moved in or out, until sharp focus is achieved when the images are "in phase," or lined up.

You can visualize how Phase Detection autofocus works if you look at Figures 5.1 and 5.2. (This is a greatly simplified view just for illustration purposes.) In Figure 5.1, a typical horizontally oriented focus sensor is looking at a series of parallel vertical lines in a weathered piece of wood. The lines are broken into two halves by the sensor's rangefinder prism, and you can see that they don't line up exactly; the image is slightly out of focus. The rangefinder approach of Phase Detection tells the camera exactly how much out of focus the image is, and in which direction (focus is too near, or too far) thanks to the amount and direction of the displacement of the split image. The camera can snap the image into sharp focus and line up the vertical lines, as shown in Figure 5.2, in much the same way that rangefinder cameras align two parts of an image to achieve sharp focus.

In designing the Alpha NEX-7, Sony sought to keep the camera body as small and light as possible, and thereby eliminated some of the mechanisms used for the Phase Detection focusing method, such as a mirror and a separate autofocus sensor. (You'll find those components in the LA-EA2 A-mount adapter.) Instead, the Sony Alpha NEX-7 incorporates a focusing system called *Contrast Detection*. This method of focusing is illustrated by Figure 5.3. At top in the figure, the transitions between the edges found in the image are soft and blurred because of the low contrast between them. Although the illustration uses the same vertical lines used with the Phase Detection example, the orientation of the features doesn't matter. The focus system looks only for contrast between edges, and those edges can run in any direction. At the bottom of Figure 5.3, the image has been brought into sharp focus, and the edges have much more contrast; the transitions are sharp and clear. Although this example is a bit exaggerated so you can see the results on the printed page, it's easy to understand that when maximum contrast in a subject is achieved, it can be deemed to be in sharp focus.

Figure 5.1 When an image is out of focus, the split lines don't align precisely.

Figure 5.2 Using Phase Detection, a camera can align the features of the image and achieve sharp focus quickly.

Figure 5.3 Using the Contrast Detection method of autofocus, the Sony Alpha NEX can evaluate the increase in contrast in the edges of subjects, starting with a blurry image (top) and producing a sharp, contrasty image (bottom).

Although the Phase Detection approach to focusing is generally considered state-of-the art because of its speed and efficiency, the Contrast Detection approach has certain advantages of its own:

- Works with more image types. Contrast Detection doesn't require subject matter rotated 90 degrees from the sensor's orientation to work optimally, as Phase Detection does. Any subject that has edges can be used to achieve sharp focus.
- Focus on any points. Whereas Phase Detection focus can be achieved *only* at the points that fall under one of the special autofocus sensors, with Contrast Detection any portion of the image can be used as a focus point. Focus is achieved with the actual sensor image, so focus point selection is simply a matter of choosing which part of the sensor image to use. (This point is highlighted by the fact, discussed below, that in Flexible Spot mode, you can move the NEX's Autofocus Area to virtually any part of the LCD whereas, with a Phase Detection system, you can move the Autofocus Area only to a small number of specific locations where the special autofocus sensors used for Phase Detection are located.)
- Potentially more accurate. Phase Detection can fall prey to the vagaries of uncooperative subject matter: if suitable lines aren't available, the system may have to hunt for focus or achieve less than optimal focus. Contrast Detection focus is more clear-cut. In most cases, the camera is able to determine clearly when sharp focus has been achieved.

Although Contrast Detection systems have the reputation of being slower than Phase Detection systems, Sony's implementation of Contrast Detection in the Alpha NEX-7 leaves little or no room for complaint. This camera is equipped with a system that is very quick and effective at achieving focus under a great variety of conditions. And, as I'll discuss later in the next chapter, the NEX focusing system works admirably when you're shooting movies as well, which is unusual for a camera that is designed primarily for shooting still images. With this camera, it appears that Contrast Detection focusing has advanced to the stage at which it can compare very favorably to the Phase Detection approach.

Focus Modes and Options

Now that you understand the fundamental principles of how the Sony Alpha NEX camera achieves focus, it's time to discuss the practical application of these principles to your everyday picture-taking activities by setting the various modes and options for use of the autofocus system. We'll also discuss the use of manual focus, and when that method might be preferable to autofocus.

As you've come to appreciate by now, the Sony Alpha NEX offers many options for your photography. Focus is no exception. Of course, as with other aspects of this camera, you can set the shooting mode to Intelligent Auto, and the camera will do just fine in its focusing in most situations, using its default settings for autofocus. But, if you want more creative control, the choices are there for you to make. In fact, with the NEX camera, even in the Intelligent Auto and Scene shooting modes, you always have the option of choosing manual focus. (If you select autofocus in those shooting modes, though, you have no further choices available—the autofocus method and Autofocus Area are set for you.)

So, no matter what shooting mode you have set the camera to, your first choice is whether to use autofocus or manual focus. Manual focus, of course, was the only choice available to photographers from the nineteenth century days of Daguerreotypes until about the 1980s, when autofocus started becoming available. Manual focus presents you with great flexibility along with the challenge of keeping the image in focus under what may be challenging conditions, such as rapid motion of the subject, darkness of the scene, and the like. We'll talk more about manual focus later in this chapter. For now, we'll assume you're going to rely on the camera's AF capabilities.

The Sony Alpha NEX-7 has two basic AF modes: AF-S (Single-shot autofocus) and AF-C (Continuous autofocus). Once you have decided on which of these AF modes to use, you also need to tell the camera how to set the AF frame. In other words, after you tell the camera how to autofocus, you also have to tell it where to direct its focusing attention. I'll explain all of these points in more detail later in this section.

MANUAL FOCUS

When you select manual focus with the AF/MF Select option on the Camera menu, or by switching temporarily with the AF/MF switch on the back of the camera (to the right of the Playback button), your Sony NEX lets you set the focus yourself by turning the focus ring on the lens. There are some advantages and disadvantages to this approach. While your batteries will last slightly longer in manual focus mode, it will take you longer to focus the camera for each photo, a process that can be tricky when using the LCD. Modern digital cameras depend so much on autofocus that they are in most cases no longer designed for optimum manual focus. Pick up any advanced film camera and you'll see a big, bright viewfinder with a focusing screen that's a joy to focus on manually. So, although manual focus is still an option for you to consider in certain circumstances, it's not as easy to use as it once was. I recommend that you try to use the camera's various AF options first, and switch to manual focus only if AF is not working for you. You can also fine-tune the camera's autofocus using the DMF (direct manual focus) feature, which allows you to fine-tune autofocus, as discussed in Chapter 3.

Focus Pocus

Although some cameras added autofocus capabilities in the 1980s, back in the days of film cameras, prior to that focusing was always done manually. Honest. Even though viewfinders were bigger and brighter than they are today, special focusing screens, magnifiers, and other gadgets were often used to help the photographer achieve correct focus. Imagine what it must have been like to focus manually under demanding, fast-moving conditions such as sports photography.

Focusing was problematic because our eyes and brains have poor memory for correct focus, which is why your eye doctor must shift back and forth between sets of lenses and ask "Does that look sharper—or was it sharper before?" in determining your correct prescription. Similarly, manual focusing involves jogging the focus ring back and forth as you go from almost in focus, to sharp focus, to almost focused again. The little clockwise and counterclockwise arcs decrease in size until you've zeroed in on the point of correct focus. What you're looking for is the image with the most contrast between the edges of elements in the image.

The Sony Alpha NEX's Contrast Detection autofocus mechanism, like all such systems found in modern digital cameras, also evaluates these increases and decreases in sharpness, but it is able to remember the progression perfectly, so that autofocus can lock in much more quickly and, with an image that has sufficient contrast, more precisely. Unfortunately, while the NEX's focus system finds it easy to measure degrees of apparent focus at each of the focus points in the viewfinder, it doesn't really know with any certainty *which* object should be in sharpest focus. Is it the closest object? The subject in the center? Something lurking *behind* the closest subject? A person standing over at the side of the picture? Many of the techniques for using autofocus effectively involve telling the NEX exactly what it should be focusing on.

Adding Circles of Confusion

But there are other factors in play, as well. You know that increased depth-of-field brings more of your subject into focus. But more depth-of-field also makes autofocusing (or manual focusing) more difficult because the contrast is lower between objects at different distances. So, autofocus with a zoom lens set to its maximum 300mm focal length may be easier than with a wide-angle lens at a focal length of 27mm, because, at the longer focal length the lens has less apparent depth-of-field.

To make things even more complicated, many subjects aren't polite enough to remain still. They move around in the frame, so that even if the NEX's lens is sharply focused on your main subject, the subject may change position and require refocusing. An intervening subject may pop into the frame and pass between you and the subject you meant to photograph. You (or the NEX) have to decide whether to lock focus on this new subject, or remain focused on the original subject. Finally, there are some kinds of

subjects that are difficult to bring into sharp focus because they lack enough contrast to allow the NEX's AF system (or our eyes) to lock in. Blank walls, a clear blue sky, or other low-contrast subject matter may make focusing difficult.

If you find all these focus factors confusing, you're on the right track. Focus is, in fact, measured using something called a *circle of confusion*. An ideal image consists of zillions of tiny little points, which, like all points, theoretically have no height or width. There is perfect contrast between the point and its surroundings. You can think of each point as a pinpoint of light in a darkened room. When a given point is out of focus, its edges decrease in contrast and it changes from a perfect point to a tiny disc with blurry edges (remember, blur is the lack of contrast between boundaries in an image). (See Figure 5.4.)

Figure 5.4
When a pinpoint of light
(left) goes out of
focus, its blurry
edges form a
circle of confusion (center
and right).

If this blurry disc—the circle of confusion—is small enough, our eye still perceives it as a point. It's only when the disc grows large enough that we can see it as a blur rather than as a sharp point that a given point is viewed as being out of focus. You can see, then, that enlarging an image, either by displaying it larger on your computer monitor or by making a large print, also magnifies the size of each circle of confusion. Moving closer to the image does the same thing. So, parts of an image that may look perfectly sharp in a 5×7 -inch print viewed at arm's length, might appear blurry when blown up to 11×14 and examined at the same distance. Take a few steps back, however, and the image may look sharp again.

To a lesser extent, the viewer also affects the apparent size of these circles of confusion. Some people see details better at a given distance and may perceive smaller circles of confusion than someone standing next to them. For the most part, however, such differences are small. Truly blurry images will look blurry to just about everyone under the same conditions.

Technically, there is just one plane within your picture area, parallel to the back of the camera (or sensor, in the case of a digital camera), that is in sharp focus. That's the plane

in which the points of the image are rendered as precise points. At every other plane in front of or behind the focus plane, the points show up as discs that range from slightly blurry to extremely blurry. In practice, the discs in many of these planes will still be so small that we see them as points, and that's where we get depth-of-field. Depth-of-field is just the range of planes that includes discs that we perceive as points rather than blurred splotches. The size of this range increases as the aperture is reduced in size and is allocated roughly one-third in front of the plane of sharpest focus, and two-thirds behind it. The range of sharp focus is always greater behind your subject than in front of it. (See Figure 5.5.)

Figure 5.5
The front of the train is in focus, but the area behind it appears blurry because the depth-of-field is limited.

Making Sense of Sensors and Autofocus Points

The number and type of autofocus points can affect how well the system operates. In Phase Detection systems, as discussed above, the AF points are determined by the locations of the special focus sensors. These sensors can consist of vertical or horizontal lines of pixels, cross-shapes, and often a mixture of these types within a single camera. Two of the larger dSLR siblings of the NEX, the Alpha A580 and A850, each has only 9 primary AF points, though some high-end dSLRs, like the 21MP Canon EOS-1Ds Mark III, have a whopping 45 autofocus points. With Phase Detection systems, the more AF points available, the more easily the camera can differentiate among areas of the frame, and the more precisely you can specify the area you want to be in focus if you're manually choosing a focus spot.

With Contrast Detection systems, as I noted earlier, the AF points are not limited by the number of special sensors, because there *are* no special sensors—the camera uses the entire surface of the image sensor for focusing. With the Sony Alpha NEX camera, Sony states that there are 25 AF points. What this number means in this case is that there are 25 locations on the image sensor where the camera will attempt to direct its focus when you leave it up to the camera to set the AF. In fact, the camera can focus on almost any spot located on the surface of the sensor. This situation is illustrated by the fact that, when you set the Autofocus Area to Flexible Spot, you are then able to set the AF Area to any one of 187 precise spots on the sensor (a matrix of 17 horizontal columns in 11 rows).

As the camera collects contrast information from the AF points, it then evaluates it to determine whether the desired sharp focus has been achieved. The calculations may include whether the subject is moving, and whether the camera needs to "predict" where the subject will be when the shutter release button is fully depressed and the picture is taken. The speed with which the camera is able to evaluate focus and then move the lens elements into the proper position to achieve the sharpest focus determines how fast the autofocus mechanism is. Although your Sony Alpha NEX will almost always focus more quickly than a human, there are types of shooting situations where that's not fast enough. For example, if you're having problems shooting sports because the NEX's autofocus system manically follows each moving subject, a better choice might be to shift into manual focus and prefocus on a spot where you anticipate the action will be, such as a goal line or soccer net. At night football games, for example, when I am shooting with a telephoto lens almost wide open, I often focus manually on one of the referees who happens to be standing where I expect the action to be taking place (say, a halfback run or a pass reception). When I am less sure about what is going to happen, I may switch to Continuous AF and let the camera decide.

Using Manual Focus

As I noted earlier, manual focus is not as attractive an option nowadays as it used to be when cameras were designed for that method of focusing and were equipped with readily visible focusing aids. But Sony's designers have done a good job on the NEX of letting you exercise your initiative in the focusing realm, so you certainly should become familiar with the techniques for those occasions when it makes sense to take control in this area. Here are the basic steps:

■ Select Manual Focus from the AF/MF Selection option on the Camera menu. When you return to the live view on your LCD, the letters MF will appear on the left of the screen, unless you have turned the information display off with the DISP button.

- Aim at your subject and turn the focusing ring on the lens to focus. As soon as you start turning the focusing ring, the image on the LCD will enlarge to help you assess whether the image is in focus. (That is, unless you turned off this feature, called MF Assist, through the Setup menu.) Turn the focusing ring until the subject appears to be in the sharpest possible focus. Use the left and right control dials to position the focus frame within the image if they have been selected for this purpose.
- If you have difficulty focusing, zoom in if possible and focus at your longest available focal length. It may be easier to see focusing changes while zoomed in. When you zoom back out to take the picture, the image will still be in sharp focus.
- Consider using the DMF option. DMF, or Direct Manual Focus, is the third option on the AF/MF Select screen. If you choose this option, the camera will autofocus in Single-shot mode when you press the shutter button halfway, but you can then turn the focusing ring to make fine-tuning adjustments, as long as you keep the shutter pressed halfway. In this way, you get the benefit of the camera's attempt at autofocusing, but you then get a chance to make sure the focus is exactly how you want it. This option is useful in particularly critical focusing situations, such as when you're focusing on a small object at close range, and the depth-of-field is very narrow.

Your Autofocus Mode Options

Manual focus is a great option to have available, but autofocus is likely to be your choice in the great majority of shooting situations. Choosing the right autofocus mode and the way in which focus points are selected is your key to success. Using the wrong mode for a particular type of photography can lead to a series of pictures that are all sharply focused—on the wrong subject. When I first started shooting sports with an autofocus camera (back in the film camera days), I covered one baseball game alternating between shots of base runners and outfielders with pictures of a promising young pitcher, all from a position next to the third base dugout. The base runner and outfielder photos were great, because their backgrounds didn't distract the autofocus mechanism. But all my photos of the pitcher had the focus tightly zeroed in on the fans in the stands behind him. Because I was shooting with film instead of a digital camera, I didn't know about my gaffe until the film was developed. A simple change, such as locking in focus or focus zone manually, or even manually focusing, would have done the trick.

But autofocus isn't some mindless beast out there snapping your pictures in and out of focus with no feedback from you. There are several settings you can modify that return a fair amount of control to you. Your first decision should be whether you set

the autofocus mode to Single-shot or Continuous AF. Press the Menu button, go to the Camera menu, and navigate to the line for Autofocus Mode. Press the center controller button, then highlight your choice from the submenu, and press the center controller button again.

Single-Shot AF

When you select Single-shot AF on the Sony Alpha NEX, you may notice something that seems strange: the camera's autofocus mechanism will continuously keep seeking focus, even before you press the shutter button halfway to lock focus. You may well say to yourself, "I thought that Single-shot autofocus means the camera doesn't focus until you press the shutter button halfway." And with many other cameras, you would be correct. But the Sony NEX is different in various ways, and this is one of them. When the camera is set to autofocus as opposed to manual focus, no matter which AF mode is selected, the camera will continually alter its focus as it is aimed at various subjects, *until* you press the shutter button halfway. It's at that point that the camera stops seeking focus, in Single-shot AF mode. The difference between Single-shot AF and Continuous AF comes at the point the shutter is pressed halfway. With Single-shot mode, focus is locked at that point; with Continuous mode, the camera locks on a subject when the shutter is pressed halfway, but continues to vary its focus as required to keep that subject in focus.

So, with Single-shot AF, the camera keeps focusing before the shutter button is pressed halfway. Focus is locked when you press the shutter button halfway and it remains locked at that setting until the button is fully depressed, taking the picture, or until you release the shutter button without taking a shot. For non-action photography, this setting is usually your best choice, as it minimizes out-of-focus pictures (at the expense of spontaneity). Because of the small delay while the camera zeroes in on correct focus, you might experience slightly more shutter lag. This mode uses less battery power than Continuous AF.

When sharp focus is achieved, the LCD will display a green focus frame or frames to indicate the focus point(s) used by the AF mechanism, a solid, non-flashing green circle will appear at the bottom left of the LCD, and you'll hear a little beep (assuming you have normal shooting and setup options enabled). By keeping the shutter button depressed halfway, you'll find you can reframe the image by moving the camera to aim at another angle while retaining the focus (and exposure) that's been set. If for some reason the camera cannot achieve sharp focus, such as in a dark or low-contrast environment, the green circle will flash and you will not hear a focus-lock beep. However, unlike the situation with some cameras, which lock the shutter if focus cannot be achieved, the NEX will eventually let you press the shutter button all the way down to take the picture, even though the AF mechanism was unable to zero in on any focus point.

The camera automatically selects Single-shot AF in Intelligent Auto shooting mode and in all Scene modes except Sports Action, when Continuous AF is automatically selected.

Continuous AF

Continuous AF is a mode you might want to use when photographing sports, young kids at play, and other fast-moving subjects. In this mode, as with Single-shot AF, the autofocus system continues to operate all the time before the shutter button is depressed halfway. The difference is that, with Continuous AF, the camera continues to seek focus on the subject it was aimed at when the shutter button was pressed halfway. In other words, the camera continuously focuses on any subject before the shutter button is pressed halfway, but it then locks in on a particular subject, if possible, when the shutter button is pressed halfway. Of course, this option can drain battery power more quickly than Single-shot AF, so turn it off unless you have a definite need for it.

The camera automatically turns on Continuous AF in the Sports Action Scene mode. As noted above, this mode is not available in Intelligent Auto or the other Scene modes, when the camera automatically selects Single-shot AF.

Setting the AF Area

You can specify which spot on the LCD screen the Sony Alpha NEX uses to calculate correct focus, or you can allow the camera to select the point for you. There are three basic AF Area options. (A fourth option is Face Detection, which I'll discuss shortly.) Go to the Camera menu, navigate to the Autofocus Area item, press the center controller button, and select one of these three choices. Press the center controller button again to confirm. You can assign the selection of the AF Area to the center controller button using the Soft Key C Settings option on the Setup menu. If you're likely to change this setting frequently, it's a great time-saver to have this option available at the press of a button. Here is how the three AF Area options work:

- Multi. The Alpha chooses the appropriate focus zone from 25 AF Areas available to it for this purpose. There are no focus brackets visible on the screen until you press the shutter button to lock in focus. At that point, if it can achieve sharp focus, the camera displays one or more green focus brackets to show what areas of the image it has used to focus on. (See Figure 5.6.)
- Center. The Alpha always uses a small focus zone in the center of the screen to calculate correct focus. When this AF Area mode is selected, a pair of focus brackets appears on the screen to indicate the area the camera will use to determine focus. (See Figure 5.7.)

■ Flexible Spot. When you initially select this AF Area mode from the Camera menu, a small set of orange focus brackets appears on the screen along with four triangles pointing towards the four sides of the screen. (See Figure 5.8.) You can then use the controls to move the focus brackets around the screen within an array of fixed positions.

Use the left control dial to move the orange brackets up or down, and the right control dial to move the brackets from side to side. You can also use the directional buttons on the control wheel. In this mode, each of the "zones" overlaps its neighbor by about two thirds, so there are 17 columns and 11 rows, with no gaps in coverage area (except at the borders of the screen), for 187 different focus positions. You can also rotate the control wheel to move the brackets up or down quickly within 4 (not 11) rows. Press the lower soft key to move the orange brackets to the center of the frame.

The procedure changes slightly when you switch to shooting mode. The lower soft key will be labeled Focus. Press it to produce the area selection indicators. In this mode, the left control dial allows you to switch from Flexible Spot to Multi or Center, and the right control dial shifts the orange bracket from left to right. The control wheel is used to move the brackets up and down. The lower soft key centers the orange brackets, as before.

Figure 5.6

When
Autofocus Area
is set to Multi,
the camera displays green
focus brackets
once it has
achieved focus,
to indicate what
areas of the
image it used
for its focus
decision.

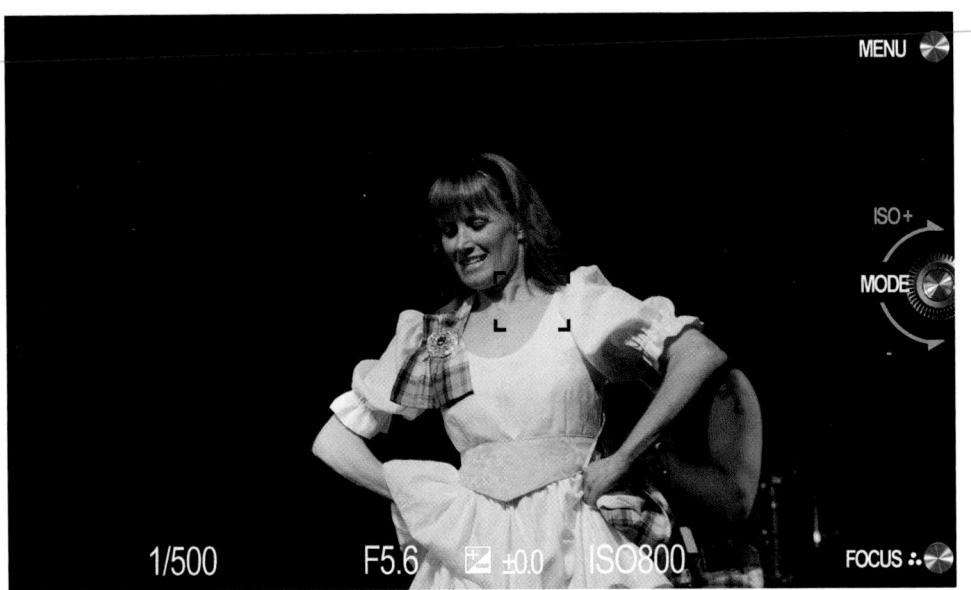

Figure 5.7
In the Center Autofocus Area mode, the camera displays a focus bracket in the center of the screen to show where the focus point will be.

Figure 5.8
When the
Flexible Spot
Autofocus Area
mode is initially
selected, a
screen appears
that lets you
move the focus
frame to any
one of 187 positions on the
screen.

In the same way as with the AF mode, the situations in which you are able to set the AF Area are limited. For example, when the shooting mode is set to Intelligent Auto or any of the Scene modes, the camera automatically selects Multi as the AF Area.

Face Detection

The Sony Alpha NEX-7 has one more trick up its sleeve for setting the AF Area. If you set the Face Detection option to its Auto setting on the Camera menu, the NEX will try to identify any human faces in the scene. If it does, it will surround each one (up to eight in all) with a white frame. If it judges that autofocus is possible for one or more faces, it will turn the frames around those faces orange. When you press the shutter button halfway down to autofocus, the frames will turn green once they are in focus. The camera will also attempt to adjust exposure (including flash, if activated) as appropriate for the scene. Registered faces will be framed in magenta.

Face Detection is available only when the Autofocus Area and the metering mode are both set to Multi. Also, of course, the camera must be set to Autofocus for this function to operate. So, if the Face Detection option is grayed out on the Camera menu, check those other settings to make sure they are in effect. Personally, I prefer to exercise my own control over what parts of a scene to focus on, but this feature might come in handy if you need to hand the camera to someone to photograph you and your family or friends at an outing in the park.

Object Tracking

The final AF magic the NEX-7 can perform is called *Object Tracking*. You can choose a moving subject to lock focus on, and as it moves around the frame, the NEX-7 will attempt to retain focus on that subject. Changes in lighting, lack of contrast with the background, extra small or extra large subjects, and anything moving very rapidly can confuse Object Tracking, but it generally does a good job.

Object Tracking is activated from the Camera menu, as described in Chapter 3. Choose On to enable, or Off to disable the feature. When active, in shooting mode the lower soft key has the Object Tracking icon, and you can press it to produce the object setting screen shown in Figure 5.9. The target box appears in the center of the frame. Move the camera until the object to be tracked is within the box, and then press the center controller button. You can then reframe and the NEX-7 begins tracking the subject as it moves within the image area. (See Figure 5.10.) Press the lower soft key to cancel tracking at any time.

There are some special considerations when using this feature if the target subject is a human face and Face Detection is turned on. The NEX-7 "remembers" the face selected, so if the subject disappears from the frame and then returns, the camera locks in on that face again. If you're using the Smile Shutter function, then the NEX-7 will not only track the individual's face, but release the shutter and take a picture if your subject smiles!

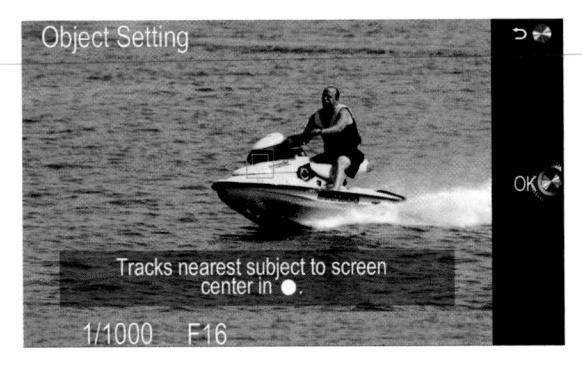

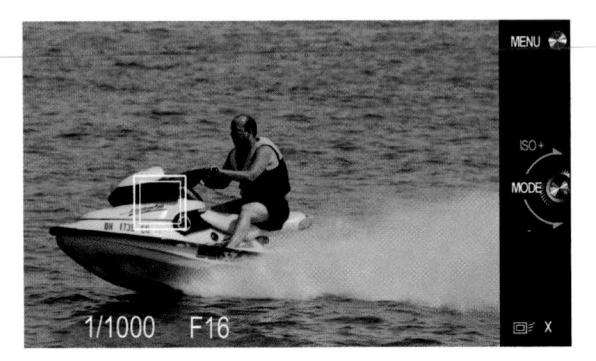

Figure 5.10 The camera tracks the subject as it moves.

AF Lock

The AEL button can lock autofocus when the AF-MF/AEL switch is set to AEL lock. Even so, whenever you press the shutter button halfway while the camera is in Single-shot AF mode, the focus is locked at that distance. You can then move the camera to aim at another subject at the same distance, and the focus will be accurate. This procedure is useful when your subject is difficult to focus on because of lighting conditions or some other factor; you can focus on another object at a similar distance and then shift the camera back to aim at your subject while holding the shutter button down halfway to lock the original focus setting.

Focus Stacking

If you are doing macro (close-up) photography of insects, flowers, or other small objects at short distances, the depth-of-field often will be extremely narrow. In some cases, it will be so narrow that it will be impossible to keep the entire subject in focus in one photograph. Although having part of the image out of focus can be a pleasing effect for a portrait of a person, it is likely to be a hindrance when you are trying to make an accurate photographic record of a flower, insect, or small piece of precision equipment. One solution to this problem is focus stacking, a procedure that can be considered like HDR translated for the world of focus—taking multiple shots with different settings, and, using software as explained below, combining the best parts from each image in order to make a whole that is better than the sum of the parts.

For example, see Figures 5.11 through 5.13, in which I took photographs of three colorful crayons using a Sony macro lens. As you can see from these images, the depth-of-field was extremely narrow, and only a small part of the subject was in focus for each shot.

Now look at Figure 5.14, in which the entire subject is in reasonably sharp focus. This image is a composite, made up of the three shots above, as well as 10 others, each one focused on the same scene, but at very gradually increasing distances from the camera's lens. All 13 images were then combined in Adobe Photoshop using the focus stacking procedure. Here are the steps you can take to combine shots for the purpose of achieving sharp focus in this sort of situation:

- 1. Set the camera firmly on a solid tripod. A tripod or other equally firm support is absolutely essential for this procedure.
- 2. Use an infrared remote control if possible. If not, consider using the self-timer to avoid any movement of the camera when images are captured.
- 3. Set the camera to manual focus mode.

Figure 5.11, Figure 5.12, Figure 5.13 These three shots were all focused on different distances within the same scene. No single shot could bring the entire subject into sharp focus.

Figure 5.14
Three partially out-of-focus shots have been merged, along with ten others, through a focus stacking procedure in Adobe Photoshop, to produce a single image with the entire subject in focus.

- 4. Set the exposure, ISO, and white balance manually, using test shots if necessary to determine the best values. This step will help prevent visible variations from arising among the multiple shots that you'll be taking.
- 5. Set the quality of the images to RAW & JPEG or FINE.
- 6. Focus manually on the very closest point of the subject to the lens. Trip the shutter, using the remote control or self-timer.
- 7. Focus on a point slightly farther away from the lens and trip the shutter again.
- 8. Continue taking photographs in this way until you have covered the entire subject with in-focus shots.
- 9. In Photoshop, select Files > Scripts > Load Files into Stack. In the dialog box that then appears, navigate on your computer to find the files for the photographs you have taken, and highlight them all.
- 10. At the bottom of the next dialog box that appears, check the box that says, "Attempt to Automatically Align Source Images," then click OK. The images will load; it may take several minutes for the program to load the images and attempt to arrange them into layers that are aligned based on their content.
- 11. Once the program has finished processing the images, go to the Layers panel and select all of the layers. You can do this by clicking on the top layer and then Shift-clicking on the bottom one.
- 12. While the layers are all selected, in Photoshop go to Edit > Auto-Blend Layers. In the dialog box that appears, select the two options, Stack Images and Seamless Tones and Colors, then click OK. The program will process the images, possibly for a considerable length of time.
- 13. If the procedure worked well, the result will be a single image made up of numerous layers that have been processed to produce a sharply focused rendering of your subject. If it did not work well, you may have to take additional images the next time, focusing very carefully on small slices of the subject as you move progressively farther away from the lens.

Although this procedure can work very well in Photoshop, you also may want to try it with programs that were developed more specifically for focus stacking and related procedures, such as Helicon Focus (www.heliconsoft.com), PhotoAcute (www.photoacute.com), or CombineZM (a PC-only program) (www.hadleyweb.pwp. blueyonder.co.uk).

Advanced Shooting with Your Sony Alpha NEX-7

Of the primary foundations of great photography, only one of them—the ability to capture a compelling image with a pleasing composition—takes a lifetime (or longer) to master. The art of *making* a photograph, rather than just *taking* a photograph, requires an aesthetic eye that sees the right angle for the shot, as well as a sense of what should be included or excluded in the frame; a knowledge of what has been done in the medium before (and where photography can be taken in the future); and a willingness to explore new areas. The more you pursue photography, the more you will learn about visualization and composition. When all is said and done, this is what photography is all about.

The other basics of photography—equally essential—involve more technical aspects: the ability to use your camera's features to produce an image with good tonal and color values; to achieve sharpness (where required) or unsharpness (when you're using selective focus); and to master appropriate white/color balance. It's practical to learn these technical skills in a time frame that's much less than a lifetime, although most of us find there is always room for improvement. You'll find the basic information you need to become proficient in each of these technical areas in this book.

You've probably already spent a lot of time learning your Sony Alpha NEX's basic features, and setting it up to take decent pictures automatically, with little input from you. It probably felt great to gain the confidence to snap off picture after picture, knowing that a large percentage of them were going to be well exposed, in sharp focus, and rich with color. The Sony NEX camera is designed to produce good, basic images right out of the box.

But after you were comfortable with your camera, you began looking for ways to add your own creativity to your shots. You explored ways of tweaking the exposure, using selective focus, and, perhaps, depending on what lens your camera has, experimenting with the different looks that various lens zoom settings (*focal lengths*) could offer.

The final, and most rewarding, stage comes when you begin exploring advanced techniques that enable you to get stunning shots that will have your family, friends, and colleagues asking you, "How did you *do* that?" These more advanced techniques deserve an entire book of their own, but there is plenty of room in this chapter to introduce you to some clever things you can do with your Sony Alpha NEX-7.

Exploring Ultra-Fast Exposures

Fast shutter speeds stop action because they capture only a tiny slice of time. Electronic flash also freezes motion by virtue of its extremely short duration—as brief as 1/50,000th second or less. The Sony Alpha NEX-7 has a top shutter speed of 1/4,000th second and its flash unit can give you these ultra-quick glimpses of moving subjects. You can read more about using electronic flash to stop action in Chapter 9.

In this chapter, I'm going to emphasize the use of short exposures to capture a moment in time. The Sony Alpha NEX is fully capable of immobilizing all but the fastest movement using only its shutter speeds, which range all the way up to 1/4,000th second. Some cameras have speeds up to 1/8,000th second, but those ultra-fast shutters are generally overkill when it comes to stopping action, and are rarely needed for achieving the exposure you desire. For example, the image shown in Figure 6.1 required a shutter speed of just 1/2,000th second to freeze the runner as she cleared the hurdles.

When it comes to stopping action, most sports can be frozen at 1/2,000th second or slower, and for many sports a slower shutter speed is actually preferable—for example, to allow the wheels of a racing automobile or motorcycle, or the propeller on a classic aircraft, to blur realistically.

In practice, shutter speeds faster than 1/4,000th second are rarely required. If you wanted to use an aperture of f/1.8 at ISO 200 outdoors in bright sunlight, say to throw a background out of focus with a wide aperture's shallow depth-of-field, a shutter speed of 1/4,000th second would more than do the job. You'd need a faster shutter speed only if you moved the ISO setting to a higher sensitivity, and you probably wouldn't do that if your goal were to use the widest f/stop possible. Under *less* than full sunlight, 1/4,000th second is more than fast enough for any conditions you're likely to encounter. That's why electronic flash units work so well for high-speed photography when used as the only source of illumination: they provide both the effect of a very brief shutter speed and the high levels of light needed for an exposure.

Of course, as you'll see, the tiny slices of time extracted by the millisecond duration of an electronic flash exact a penalty. To use flash at its full power setting, you have to use

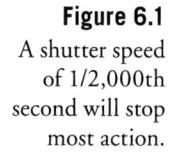

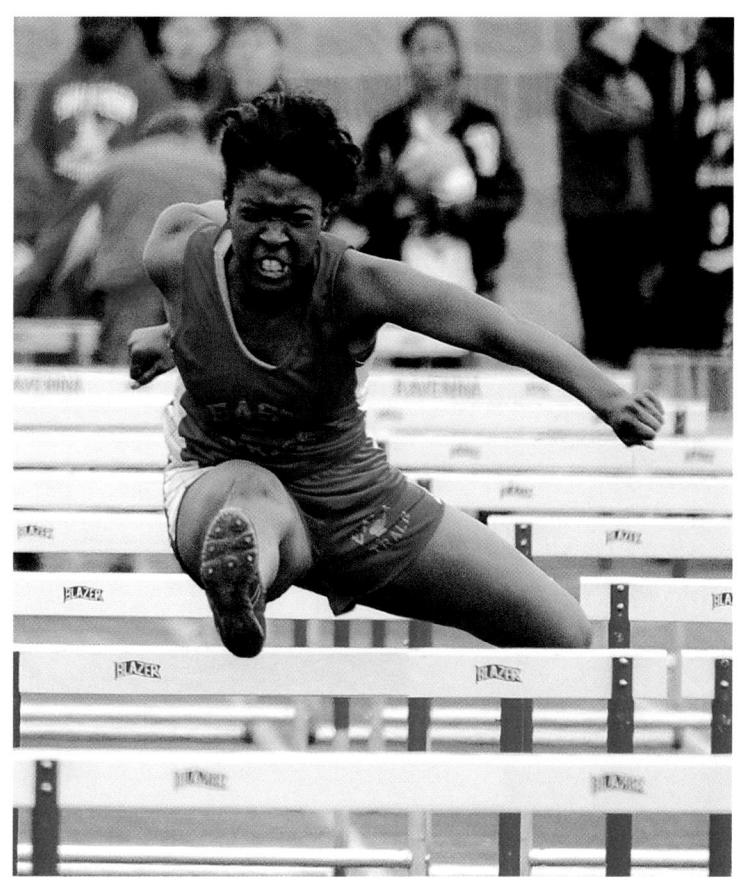

a shutter speed equal to or slower than the *maximum sync speed* of your Alpha camera. With the NEX-7, the top speed usable for flash is 1/160th second. The sync speed is the fastest speed at which the camera's focal plane shutter is completely open. At shorter speeds, the camera uses a "slit" passed in front of the sensor to make an exposure. The flash will illuminate only the portion of the slit exposed during the duration of the flash.

Indoors, that shutter speed limitation may cause problems: at 1/160th second, there may be enough existing ("ambient") light to cause ghost images. Outdoors, you may find it difficult to achieve a correct exposure. In bright sunlight at the lowest ISO settings available with the Alpha NEX camera, an exposure of 1/160th second at f/13 might be required. So, even if you want to use daylight as your main light source, and work with flash only as a fill for shadows, you can have problems. I'll explain the vagaries of electronic flash in more detail in Chapter 9.

You can have a lot of fun exploring the kinds of pictures you can take using very brief exposure times, whether you decide to take advantage of the action-stopping capabilities of your built-in or external electronic flash or work with the motion-freezing

capabilities of the Sony Alpha NEX's faster shutter speeds (between 1/1,000th and 1/4,000th second). Here are a few ideas to get you started:

- Take revealing images. Fast shutter speeds can help you reveal the real subject behind the façade, by freezing constant motion to capture an enlightening moment in time. Legendary fashion/portrait photographer Philippe Halsman used leaping photos of famous people, such as the Duke and Duchess of Windsor, Richard Nixon, and Salvador Dali, to illuminate their real selves. Halsman said, "When you ask a person to jump, his attention is mostly directed toward the act of jumping and the mask falls so that the real person appears." Try some high-speed portraits of people you know in motion to see how they appear when concentrating on something other than the portrait.
- Create unreal images. High-speed photography can also produce photographs that show your subjects in ways that are quite unreal. A helicopter in mid-air with its rotors frozen or a motocross cyclist leaping over a ramp, but with all motion stopped so that the rider and machine look as if they were frozen in mid-air, makes for an unusual picture. (See the frozen rotors at top in Figure 6.2.) When we're accustomed to seeing subjects in motion, seeing them stopped in time can verge on the surreal.

Figure 6.2
Freezing a helicopter's rotors with a fast shutter speed makes for an image that doesn't look natural (top); a little blur helps convey a feeling of motion (bottom).

Figure 6.3
A large amount of artificial illumination and an ISO 1600 sensitivity setting allowed capturing this shot at 1/2,000th second without use of an electronic flash.

■ Capture unseen perspectives. Some things are *never* seen in real life, except when viewed in a stop-action photograph. M.I.T. professor Dr. Harold Edgerton's famous balloon burst photographs were only a starting point for the inventor of the electronic flash unit. Freeze a hummingbird in flight for a view of wings that never seem to stop. Or, capture the splashes as liquid falls into a bowl, as shown in Figure 6.3. No electronic flash was required for this image (and wouldn't have illuminated the water in the bowl as evenly). Instead, a clutch of high-intensity lamps bounced off a green card and an ISO setting of 1600 allowed the Sony Alpha to capture this image at 1/2,000th second.

Long Exposures

Longer exposures are a doorway into another world, showing us how even familiar scenes can look much different when photographed over periods measured in seconds. At night, long exposures produce streaks of light from moving, illuminated subjects like automobiles or amusement park rides. Or, you can move the camera or zoom the lens to get interesting streaks from non-moving light sources, such as the holiday lights

shown in Figure 6.4. Extra-long exposures of seemingly pitch-dark subjects can reveal interesting views using light levels barely bright enough to see by. At any time of day, including daytime (in which case you'll often need the help of neutral-density filters to make the long exposure practical), long exposures can cause moving objects to vanish entirely, because they don't remain stationary long enough to register in a photograph.

Figure 6.4
Zooming during exposure can produce interesting streaks of light.

Three Ways to Take Long Exposures

There are actually three common types of lengthy exposures: *timed exposures*, *bulb exposures*, and *time exposures*. The Sony Alpha NEX offers only the first two, but once you understand all three, you'll see why Sony made the choices it did. Because of the length of the exposure, all of the following techniques should be used with a tripod to hold the camera steady.

■ Timed exposures. These are long exposures from 1 second to 30 seconds, measured by the camera itself. To take a picture in this range, simply set the shooting mode to Manual or Shutter priority and use the control wheel to set the shutter speed to the length of time you want, choosing from preset speeds of 1.0, 1.3, 1.6, 2.0, 2.5, 3.2, 4.0, 5.0, 6.0, 8.0, 10.0, 13.0, 15.0, 20.0, 25.0, and 30.0 seconds. The advantage of timed exposures is that the camera does all the calculating for you. There's no need for a stopwatch. If you review your image on the LCD and decide

to try again with the exposure doubled or halved, you can dial in the correct exposure with precision. The disadvantage of timed exposures is that you can't take a photo for longer than 30 seconds.

- Bulb exposures. This type of exposure is so-called because in the olden days the photographer squeezed and held an air bulb attached to a tube that provided the force necessary to keep the shutter open. Traditionally, a bulb exposure is one that lasts as long as the shutter release button is pressed; when you release the button, the exposure ends. To make a bulb exposure with the Sony Alpha NEX, set the camera on Manual exposure mode and use the control wheel to select the shutter speed immediately after 30 seconds. BULB will be displayed on the LCD. Then, press the shutter button to start the exposure, and release it to close the shutter. If you'd like to minimize camera shake you can use Sony's Remote Commander. With this infrared remote, RMT-DSLR1, you press the remote's shutter release button once to open the shutter, and press it one more time to close the shutter. Be sure to set the camera's drive mode to Remote Commander.
- **Time exposures.** This is a setting found on some cameras to produce longer exposures. With cameras that implement this option, the shutter opens when you press the shutter release button, and remains open until you press the button again. Usually, you'll be able to close the shutter using a mechanical cable release or, more commonly, an electronic cable release. The advantage of this approach is that you can take an exposure of virtually any duration without the need for special equipment. You can press the shutter release button, go off for a few minutes, and come back to close the shutter (assuming your camera is still there). The disadvantages of this mode are that exposures must be timed manually, and that with shorter exposures it's possible for the vibration of manually opening and closing the shutter to register in the photo. For longer exposures, the period of vibration is relatively brief and not usually a problem—and there is always the cable release option to eliminate photographer-caused camera shake entirely. While the Sony Alpha NEX does not have a built in time exposure capability, you can still get lengthy exposures with the NEX-7 using the Bulb setting with the RMT-DSLR1 Remote Commander, the infrared remote control. That unit has a shutter button that you press once to start the exposure, and press a second time to end it, so you can leave the shutter open for any length of time you want. (This remote can also be used to control playback of your images when the NEX-7 is connected to an HDTV.)

Working with Long Exposures

Because the Sony Alpha NEX produces such good images at longer exposures, and there are so many creative things you can do with long-exposure techniques, you'll want to do some experimenting. Get yourself a tripod or another firm support and take some test shots with long exposure noise reduction both enabled and disabled in the Setup

menu (to see whether you prefer low noise or high detail) and get started. Here are some things to try:

- Make people invisible. One very cool thing about long exposures is that objects that move rapidly enough won't register at all in a photograph, while the subjects that remain stationary are portrayed in the normal way. That makes it easy to produce people-free landscape photos and architectural photos at night, or even in full daylight if you use a neutral-density filter (or two or three) to allow an exposure of at least a few seconds. At ISO 200, f/18, and a pair of 8X (three-stop) neutral-density filters, you can use exposures of nearly two seconds; overcast days and/or even more neutral-density filtration would work even better if daylight people-vanishing is your goal. They'll have to be walking *very* briskly and across the field of view (rather than directly toward the camera) for this to work. At night, it's much easier to achieve this effect with the 20- to 30-second exposures that are possible.
- Create streaks. If you aren't shooting for total invisibility, long exposures with the camera on a tripod can produce some interesting streaky effects. Even a single 8X ND filter will let you shoot at f/22 and 1/6th second in daylight. Indoors, you can achieve interesting streaks with slow shutter speeds, as shown in Figure 6.5. I shot the ballet dancers using a 1/2-second exposure, triggering the shot at the beginning of a movement.

Figure 6.5
The shutter opened as the dancers began their movement from a standing position, and finished when they had bent over and paused.

TITE

Neutral-density filters are gray (non-colored) filters that reduce the amount of light passing through the lens, without adding any color or effect of their own.

■ **Produce light trails.** At night, car headlights, taillights, and other moving sources of illumination can generate interesting light trails. Your camera doesn't even need to be mounted on a tripod; hand-holding the Sony Alpha for longer exposures adds movement and patterns to your trails. If you're shooting fireworks, a longer exposure—with a tripod—may allow you to combine several bursts into one picture, as shown in Figure 6.6.

Figure 6.6 I caught the fireworks after a baseball game from a half-mile away, using a four-second exposure to capture several bursts in one shot.

- 190
 - Blur waterfalls, etc. You'll find that waterfalls and other sources of moving liquid produce a special type of long-exposure blur, because the water merges into a fantasy-like veil that looks different at different exposure times, and with different waterfalls. Cascades with turbulent flow produce a rougher look at a given longer exposure than falls that flow smoothly. Although blurred waterfalls and rapids have become almost a cliché, there are still plenty of variations for a creative photographer to explore, as you can see in Figure 6.7. For that shot, I incorporated the flowing stream in the background.
 - Show total darkness in new ways. Even on the darkest, moonless nights, there is enough starlight or glow from distant illumination sources to see by, and, if you use a long exposure, there is enough light to take a picture, too. I was visiting a Great Lakes park hours after sunset, but found that a several-second exposure revealed the skyline scene shown in Figure 6.8, even though in real life, there was barely enough light to make out the boats in the distance. Although the photo appears as if it were taken at twilight or sunset, in fact the shot was made at 10 p.m.

Figure 6.7 Long exposures can transform a waterfall and stream into a display of flowing silk.

Figure 6.8 A long exposure transformed this night scene into a picture apparently taken at dusk.

Delayed Exposures

Sometimes it's desirable to have a delay of some sort before a picture is actually taken. Perhaps you'd like to get in the picture yourself, and would appreciate it if the camera waited 10 seconds after you press the shutter release to actually take the picture. Maybe you want to give a tripod-mounted camera time to settle down and damp any residual vibration after the release is pressed to improve sharpness for an exposure with a relatively slow shutter speed.

The Sony Alpha NEX camera has a built-in self-timer with 10-second and 2-second delays. Activate the timer by pressing the drive button (left direction button) and navigating with the up/down direction buttons or the control wheel to choose the self-timer icon. Then, press the lower soft key (now labeled the "Option" button) and use the up/down buttons to toggle between 2-second and 10-second delays. Press the center controller button to lock in your choice.

Then, press the shutter release button halfway to lock in focus on your subjects (if you're taking a self-portrait, focus on an object at a similar distance and use focus lock). When you're ready to take the photo, continue pressing the shutter release the rest of the way. The lamp on the front of the camera will blink slowly for eight seconds (when using the 10-second timer) and the beeper will chirp (if you haven't disabled it). During the final two seconds, the beeper sounds more rapidly and the lamp remains on until the picture is taken. (With the 2-second timer, you get a burst of rapid chirping accompanied by the lamp, which goes out just before the shutter is triggered.)

If you want to have the camera take multiple shots after the self-timer counts down, select the second self-timer icon on the Drive menu—the icon that has C3 or C5 after it. The C indicates that Continuous shooting will be in effect; the number indicates the number of shots that will be taken. For example, if you select the self-timer icon with C3 after it, after the self-timer counts down the camera will take three continuous shots. You can select either three or five shots for this setting by using the Option button when the self-timer icon with the C after it is highlighted. This is a handy way to avoid family photos being spoiled by a blinker or yawner in the line-up.

One other way to get a self-timer effect with the NEX-7 is to use the infrared remote, RMT-DSLR1, which has a 2-second delay shutter release button in addition to its regular release button. Set the Drive mode to Remote Commander, set up the shot as you want it, then aim the remote at the camera's infrared sensor in the hand grip and press the "2 sec" button on the remote. The camera's self-timer light will blink and you'll hear a series of beeps, just like the built-in self-timer's behavior. The shutter will release at the end of the two seconds, giving you time to put the remote control out of the picture or make other last-second adjustments before the shutter fires.

Finally, although this feature may not have been intended for such use, the Smile Shutter feature of the Alpha NEX camera acts as a self-timer of sorts. Set up the shot the way you want it using a tripod, then you and/or your subjects can stand in front of the camera and trigger it with your built-in remote controller—your smile. The operation of the Smile Shutter feature is discussed in Chapter 3.

Continuous Shooting

The Sony Alpha NEX's Continuous shooting modes remind me how far digital photography has brought us. The first accessory I purchased when I worked as a sports photographer some years ago was a motor drive for my film SLR. It enabled me to snap off a series of shots at a three frames-per-second rate, which came in very handy when a fullback broke through the line and headed for the end zone. Even a seasoned action photographer can miss the decisive instant when a crucial block is made, or a baseball superstar's bat shatters and pieces of cork fly out. Continuous shooting simplifies taking a series of pictures, either to ensure that one has more or less the exact moment you want to capture or to capture a sequence that is interesting as a collection of successive images.

The Sony Alpha NEX's "motor drive" capabilities are, in many ways, much superior to what you get with a film camera. For one thing, a motor-driven film camera can eat up film at an incredible pace, which is why many of them are used with cassettes that hold hundreds of feet of film stock. At three frames per second (typical of film camera), a short burst of a few seconds can burn up as much as half of an ordinary 36 exposure
roll of film. Digital cameras like the Alpha NEX, in contrast, have reusable "film," so if you waste a few dozen shots on non-decisive moments, you can erase them and shoot more.

The increased capacity of digital film cards gives you a prodigious number of frames to work with. At a baseball game I covered earlier this year, I took more than 1,000 images in a couple hours. Yet, even with my Alpha NEX's 24-megapixel resolution I was able to cram more than 500 JPEG Fine images on a single memory card. That's a lot of shooting. Given an average burst of about eight frames per sequence (nobody really takes 15-20 shots or more of one play in a basketball game), I was able to capture more than 70 different sequences like the one shown in Figure 6.9 before I needed to swap cards.

I took several thousand shots at an air show a few months ago, capturing the non-stop action as aerobatic stunts unfolded in front of me. Figure 6.10 shows a typical short burst of three shots taken at the show.

Figure 6.9 Sports make a perfect subject for continuous bursts.

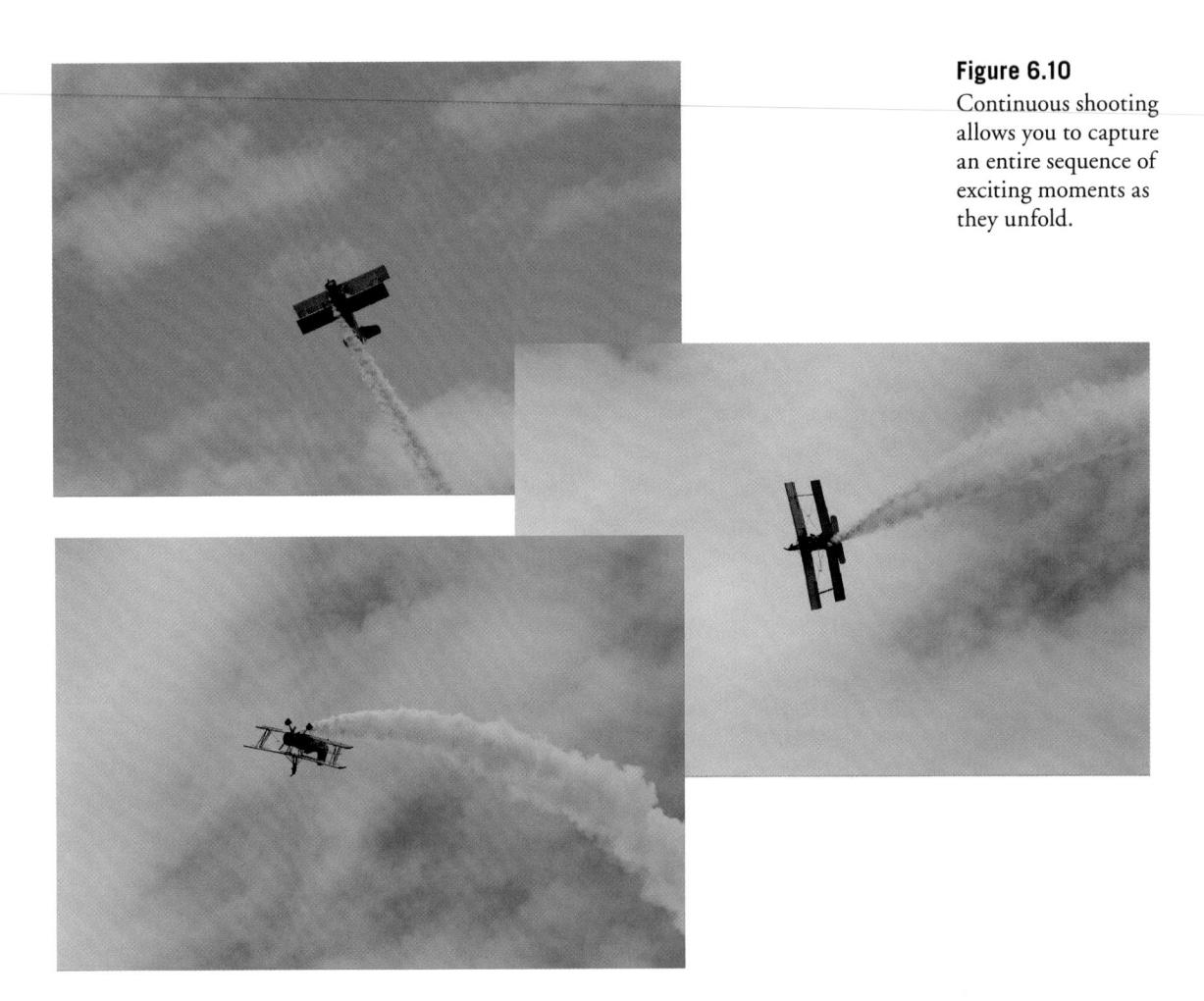

On the other hand, for some types of action (such as football), the longer bursts come in handy, because running and passing plays often last 5 to 10 seconds, and change in character as the action switches from the quarterback dropping back to pass or hand off the ball, then to the receiver or running back trying to gain as much yardage as possible.

To use the Sony Alpha NEX's Continuous Advance mode, press the drive button (left direction button) or go to the first item on the Camera menu. Then navigate down the list with the up/down direction buttons until the Continuous Adv. mode is selected. With this mode, you can shoot at up to about 3 frames per second when you hold down the shutter button. For greater speed, maneuver one notch further down in the Drive menu to the Speed Priority Continuous mode. With that selection, the maximum rate of shooting increases to about 10 frames per second. In either mode, the camera will fix the focus and exposure based on the values it uses for the first shot.

Once you have decided on a Continuous shooting mode and speed, press the center controller button to confirm your choice. While you hold down the shutter button, the Alpha NEX will fire continuously until it reaches the limit of its capacity to store images, given the image size and quality you have selected and other factors, such as the speed of your memory card and the environment you are shooting in. For example, if the lighting is so dim as to require an exposure of about one second, the camera clearly cannot fire the shutter at a rate of about 3 frames per second. Another factor that will affect your continuous shooting is the use of flash, which needs time to recycle after each exposure before it can fire again.

There are no exact figures available for how many images you can shoot continuously, partly because there are so many variables that affect that number. Generally, you can considerably increase the number of continuous shots by reducing the image-quality setting from RAW to JPEG Standard, or even to Fine. The reason the size of your bursts is limited is that continuous images are first shuttled into the Sony Alpha NEX's internal memory buffer, then doled out to the memory card as quickly as they can be written to the card. Technically, the NEX takes the RAW data received from the digital image processor and converts it to the output format you've selected—either JPEG or RAW—and deposits it in the buffer ready to store on the card. Sony estimates that at 3 fps you can shoot 17 Fine JPEG images, 13 RAW images, and 11 RAW+JPEG pairs at full resolution.

This internal "smart" buffer can suck up photos much more quickly than the memory card and, indeed, some memory cards are significantly faster or slower than others. When the buffer fills, you can't take any more continuous shots until the NEX has written some of them to the card, making more room in the buffer. (You should keep in mind that faster memory cards write images more quickly, freeing up buffer space faster.)

So, if you're in a situation in which continuous shooting is an issue, you may need to make some quick judgments. If you're taking photos at a breaking news event where it's crucial to keep the camera firing no matter what and quality of the images is not a huge issue, your best bct may be to set the image size to Small and the quality to Standard. On the other hand, if you're taking candid shots at a family gathering and want to capture a variety of fleeting expressions on people's faces, you may opt for taking Large size shots at the Fine quality setting, knowing that the shooting may slow down or grind to a halt from time to time. A good point to bear in mind at all times is that the speeds given for the two Continuous shooting options are maximums that can be reached under ideal conditions; they are not guaranteed rates for all situations.

Setting Image Parameters

You can fine-tune the images that you take in several different ways. For example, if you don't want to choose a predefined white balance, you can set a custom white balance based on the illumination of the site where you'll be taking photos, or choose a white balance based on color temperature. With the Creative Style options, you can set up customized saturation, contrast, and sharpness for various types of pictures. This section shows you how to use the available image parameters. (As you might expect, if the camera is set to Intelligent Auto or any of the Scene shooting modes, most of these settings are not available for adjustment; the camera will automatically make standard settings for you, such as Automatic White Balance and the Standard Creative Style.) In discussing these settings in the pages that follow, I will outline the procedure for making adjustments using the NEX's menu system.

Customizing White Balance

Back in the film days, color films were standardized, or balanced, for a particular "color" of light. Digital cameras like the Sony Alpha NEX use a "white balance" that is, ideally, correctly matched to the color of light used to expose your photograph. The proper white balance is measured using a scale called *color temperature*. Color temperatures were assigned by heating a theoretical "black body radiator" and recording the spectrum of light it emitted at a given temperature in degrees Kelvin. So, daylight at noon has a color temperature in the 5,500 to 6,000 degree range. Indoor illumination is around 3,400 degrees. Hotter temperatures produce bluer images (think blue-white hot) while cooler temperatures produce redder images (think of a dull-red glowing ember). Because of human nature, though, bluer images are actually called "cool" (think wintry day) and redder images are called "warm" (think ruddy sunset), even though their color temperatures are reversed.

If a photograph is exposed indoors under warm illumination with a digital camera sensor balanced for cooler daylight, the image will appear much too reddish. An image exposed outdoors with the white balance set for incandescent illumination will seem much too blue. These color casts may be too strong to remove in an image editor from JPEG files, although if you shoot RAW you can change the WB setting to the correct value when you import the image into your editor.

Mismatched white balance settings are easier to achieve accidentally than you might think, even for experienced photographers. I'd just arrived at a concert after shooting some photos indoors with electronic flash and had manually set WB for flash. Then, as the concert began, I resumed shooting using the incandescent stage lighting—which looked white to the eye—and ended up with a few shots like Figure 6.11. Eventually, I caught the error during picture review, and changed my white balance. Another time, I was shooting outdoors, but had the camera white balance still set for incandescent illumination. The excessively blue image shown in Figure 6.12 resulted. (I suppose I

An image exposed indoors with the WB set for daylight or electronic flash will appear too reddish.

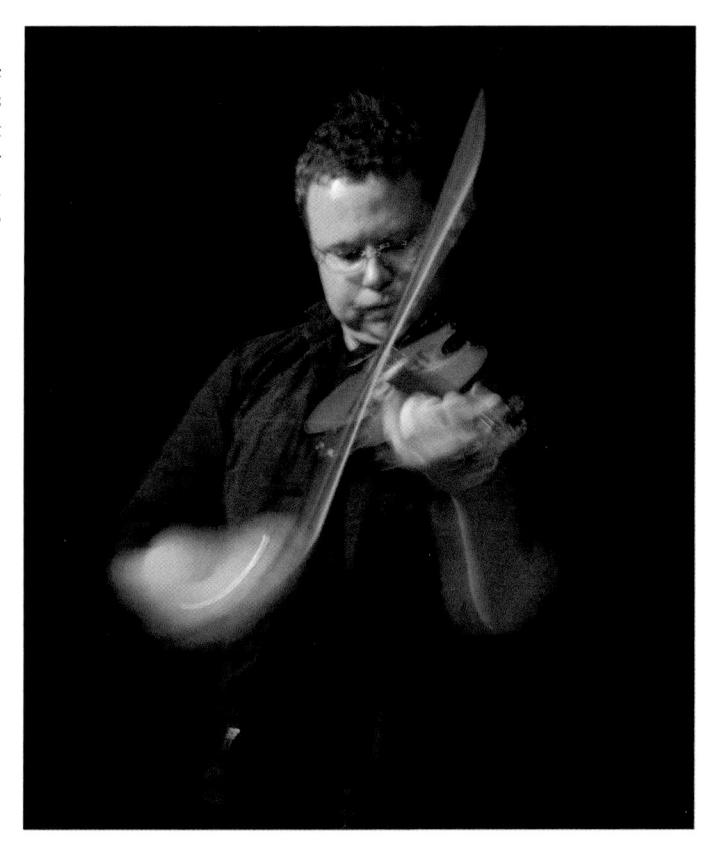

Figure 6.12

An image exposed under daylight illumination with the WB set for tungsten illumination will appear too blue.

should salvage my reputation as a photo guru by admitting that both these images were taken "incorrectly" deliberately, as illustrations for this book; in real life, I'm excessively attentive to how my white balance is set. You do believe me, don't you?)

The Auto White Balance (AWB) setting, available on the White Balance item of the Brightness/Color menu, examines your scene and chooses an appropriate value based on your scene and the colors it contains. However, the Sony Alpha NEX's selection process is not foolproof. Under bright lighting conditions, it may evaluate the colors in the image and still assume the light source is daylight and balance the picture accordingly, even though, in fact, you may be shooting under extremely bright incandescent illumination. In dimmer light, the camera's electronics may assume that the illumination is tungsten, and if there are lots of reddish colors present, set color balance for that type of lighting. With mercury vapor or sodium lamps, correct white balance may be virtually impossible to achieve; in those cases, you should use flash instead, or shoot in RAW and make your corrections when importing the file into your image editor.

The other presets in the WB list apply to specific lighting conditions. You can choose from Daylight, Shade, Cloudy, Incandescent, Fluorescent (four different types: Warm-White, Cool-White, Day-White, and Daylight), and Flash. You can also select Color Temp./Filter, Custom, and Custom Setup.

The Daylight setting puts WB at 5,200K, while the Shade setting uses a much bluer 7,000K. The chief difference between direct daylight and shade or even tungsten light sources is nothing more than the proportions of red and blue light. The spectrum of colors is continuous, but it is biased toward one end or the other.

However, some types of fluorescent lights produce illumination that has a severe deficit in certain colors, such as only *particular* shades of red. If you looked at the spectrum or rainbow of colors encompassed by such a light source, it would have black bands in it, representing particular wavelengths of light that are absent. You can't compensate for this deficiency by adding all tones of red. That's why the fluorescent setting of your Sony Alpha may provide less than satisfactory results with some kinds of fluorescent bulbs. If you take many photographs under a particular kind of non-compatible fluorescent light, you might want to investigate specialized fluorescent light filters for your lenses, available from camera stores, or learn how to adjust for various sources in your image editor. However, you might also get acceptable results using the choice on the WB selection screen.

If you find that none of the presets fit your lighting conditions, and the Automatic setting is not able to set the white balance adequately, you have two other options—using the Color Temperature option, or setting a custom white balance. I'll show you how to use the major tools next.

Fine-Tuning Preset White Balance

When any of the presets (Daylight, Shade, etc.) are chosen, you can fine-tune the white balance by pressing the lower soft key, which will be labeled as the Option button, and then dial in adjustments in the blue/amber or green/magenta directions. The screen shown in Figure 6.13 appears. You can then change the color bias of your image. You can also select White Balance mode by pressing the Navigation button and using Control dial L to make your choice. The right control dial can adjust the color bias along the blue-amber scale, while the control wheel will adjust the balance along the green-magenta axis. Tap the shutter release to escape from the WB settings adjustments.

■ Cooler or warmer. Pressing the left/right directional buttons changes the white balance to cooler (left) or warmer (right) along the Blue/Amber scale. There are seven increments, and the value you "dial in" will be shown in the upper-left corner of the screen as an A-B value (yes, the labels are *reversed* from the actual scale at the right side of the screen). The red dot will move along the scale to show the value you've selected. Typically, blue/amber adjustments are what we think of as "color temperature" changes, or, "cooler" and "warmer." These correspond to the way in which daylight illumination changes: warm at sunrise and sunset, very cool in the shade (because most of the illumination comes from reflections of the blue sky), and at high noon. Indoor light sources can also be cooler or warmer, depending on the kind of light they emit.

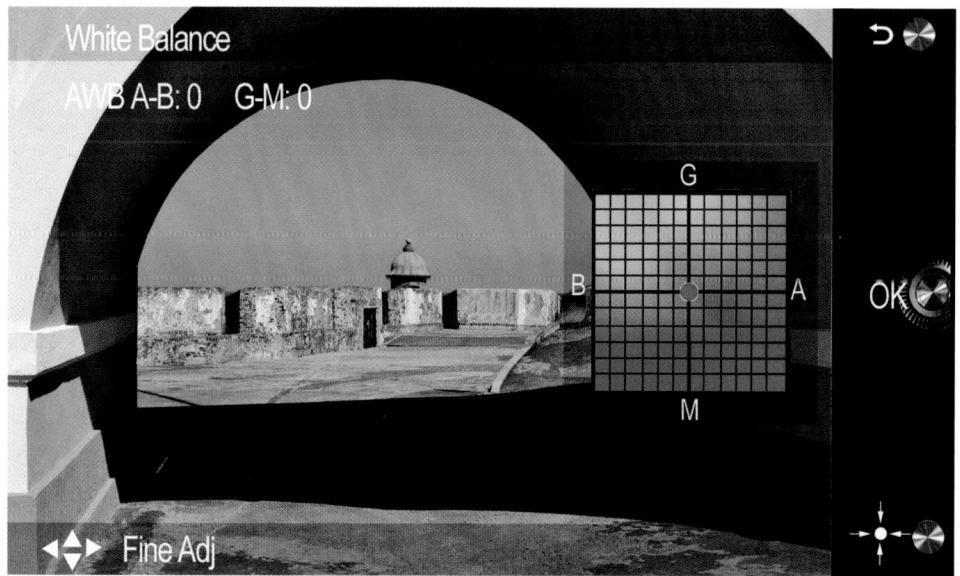

- Green/magenta bias. Press the up/down buttons to change the color balance along the green (upward) or magenta (downward) directions. Seven increments are provided here, too, and shown as vertical movement in the color balance matrix at the right of the screen. Color changes of this type tend to reflect special characteristics of the light source; certain fluorescent lights have a "green" cast, for example.
- Either or both. Because the blue/amber and green/magenta adjustments can be made independently, you're free to choose just one of them, or both if your fine-tuning requires it.
- Nevermind. If you want to cancel all fine-tuning and shift back to neutral, just press the lower soft key. The red dot in the color chart will be restored to the center position.

Setting White Balance by Color Temperature

If you want to set your white balance by color temperature, choose C. Temp/Filter in the White Balance menu's scrolling list, then press the Option button. You'll see an adjustment screen similar to the one shown in Figure 6.13, but with a scrolling list of color temperatures displayed along the right edge of the screen.

- Change color temperature. Use the control wheel to select a specific color temperature (in 100K increments, from 2,500K, making your image bluer, to compensate for the very warm illumination at this setting, to 9,900K, which makes your image redder to counter the extreme blue bias). If you have instrumentation or reliable information that gives you a precise reading of the color temperature of your lighting, this option is likely to be your best bet. Even if you don't have that information, you may want to experiment with this setting, and view the results on the LCD, especially if you are trying to achieve creative effects with color casts along the spectrum from blue to red.
- Fine-tune the color temperature. In addition to color temperature, you can change the blue/amber or green/magenta bias, exactly as described above. If you change your mind, pressing the lower soft key/Option button cancels out the bias adjustments you've made. This corresponds to the use of CC (Color Compensation) filters that were used to compensate for various types of lighting when shooting film. When you use this option, the color filter value you set takes effect in conjunction with the color temperature you have set. In other words, both of these settings work together to give you very precise control over the degree of color correction you are using. Any values you set here will show up on the LCD's Live View screen if you have the full information displayed. For example, if you set the white balance to 5,200K with the G9 filter, those values will appear on the LCD to remind you of the special setting.

Setting a Custom White Balance

Setting a custom white balance expressly for the scene you want to shoot may be the most accurate way of getting the right color balance, short of having a special meter that gives you a precise reading of color temperature. You may want to use this option if, for example, you're shooting in an office or other location that is lit by a mixture of fluorescent, incandescent, and window light. It's easy to do with the Sony Alpha NEX-7. Just follow these steps:

- Press the Menu button, and use the direction buttons or the control wheel to navigate to the Brightness/Color menu. Press the center controller button to enter the menu, and scroll with the direction buttons or the control wheel to the White Balance menu. Press the center controller button to bring up the menu of white balance options.
- 2. Use the direction buttons or the control wheel to scroll through the list of white balance options until the Custom Setup entry (not the Custom entry) is highlighted. Press the center controller button. The LCD will display a message telling you to press the shutter button to capture the white balance data.
- 3. Point the camera at a neutral white object large enough to fill the center of the frame in the viewfinder. The LCD will display a small circle that indicates the area you need to fill with a view of the white surface.
- 4. Press the shutter release. The image that you aimed at, as well as the custom white balance calculated, appears on the LCD. (The image is not recorded on the memory card.)
- 5. Press the center controller button to return to the live view on the LCD.

The Alpha NEX will retain the custom setting you just captured until you repeat the process to replace the setting with a new one. Thereafter, you can activate this custom setting by scrolling down to the Custom (not Custom Setup) option in the White Balance menu and pressing the center controller button to confirm your choice.

Image Processing

As I outlined in Chapter 3, the Sony Alpha NEX camera offers several ways of customizing the rendition of your images. You can use the Dynamic Range Optimizer (aka D-Range Optimizer and DRO), or specify certain changes to contrast, saturation, and sharpness in the Creative Style menu. Both of these options are available on the Brightness/Color menu.

D-Range Optimizer and In-Camera HDR

This innovative tool helps you adjust the relative brightness range of your JPEG images • as they are taken. The DRO has no effect on RAW images. (To apply dynamic range effects to RAW files, use the bundled Image Data Converter SR program described in Chapter 10.) In addition, DRO processing is available only when you are shooting in the Program, Aperture priority, Shutter priority, or Manual exposure mode.

Although DRO has been around for a while on Sony Alpha dSLRs, the NEX-7 offers a particularly broad range of options with this feature, well beyond the plain vanilla DRO processing of some earlier models. The most dramatic enhancement is that this model provides an Auto HDR function, with which the camera does a very reasonable job of producing a High Dynamic Range image of your scene, strictly with in-camera processing with one click of the shutter.

The DRO feature, available by choosing DRO/Auto HDR from the Brightness/Color menu, has three basic settings: Off, DRO, and Auto HDR, with several sub-settings for the last two. Once you have selected either DRO or Auto HDR, you can select further options for those choices by pressing the lower soft key (Option button) and then scrolling with the up/down direction buttons or the control wheel. Figure 6.14 shows how DRO settings affect your image processing at three of its settings: Off, Auto, and Level 3 and Level 6. You can also set up your left and right control dials and the control wheel to make these adjustments.

Here is how the DRO and Auto HDR settings work:

- Off. No optimization. You're on your own. But if you have the foresight to shoot RAW (or RAW & JPEG), you can apply DRO effects to your RAW image when converting it with the Image Data Converter SR software, as I mentioned earlier. Use this setting when shooting subjects of normal contrast, or when you want to capture an image just as you see it, without modification by the camera.
- DRO. Choose Auto, or Level 1 through 5. With the Auto setting, the camera dives into your image, looking at various small areas to examine the contrast of highlights and shadows, making modifications to each section to produce the best combination of brightness and tones with detail. If you choose a specific level of DRO from 1 to 5, the camera again makes changes in the shadows and highlights to improve the lighting of the image, making progressively stronger changes with each higher numbered setting. (See Figure 6.14.)
- Auto HDR. In this mode, the Alpha takes three exposures at different exposure settings, then combines these exposures in the camera and processes them together to achieve a final image with increased dynamic range, using the best-exposed areas from each image. Using the left/right direction buttons, you can set this option to Auto, in which case the camera analyzes the scene and decides on an interval between the exposures, or you can select an interval from 1.0 EV to 6.0 EV (one EV equals one stop of exposure).

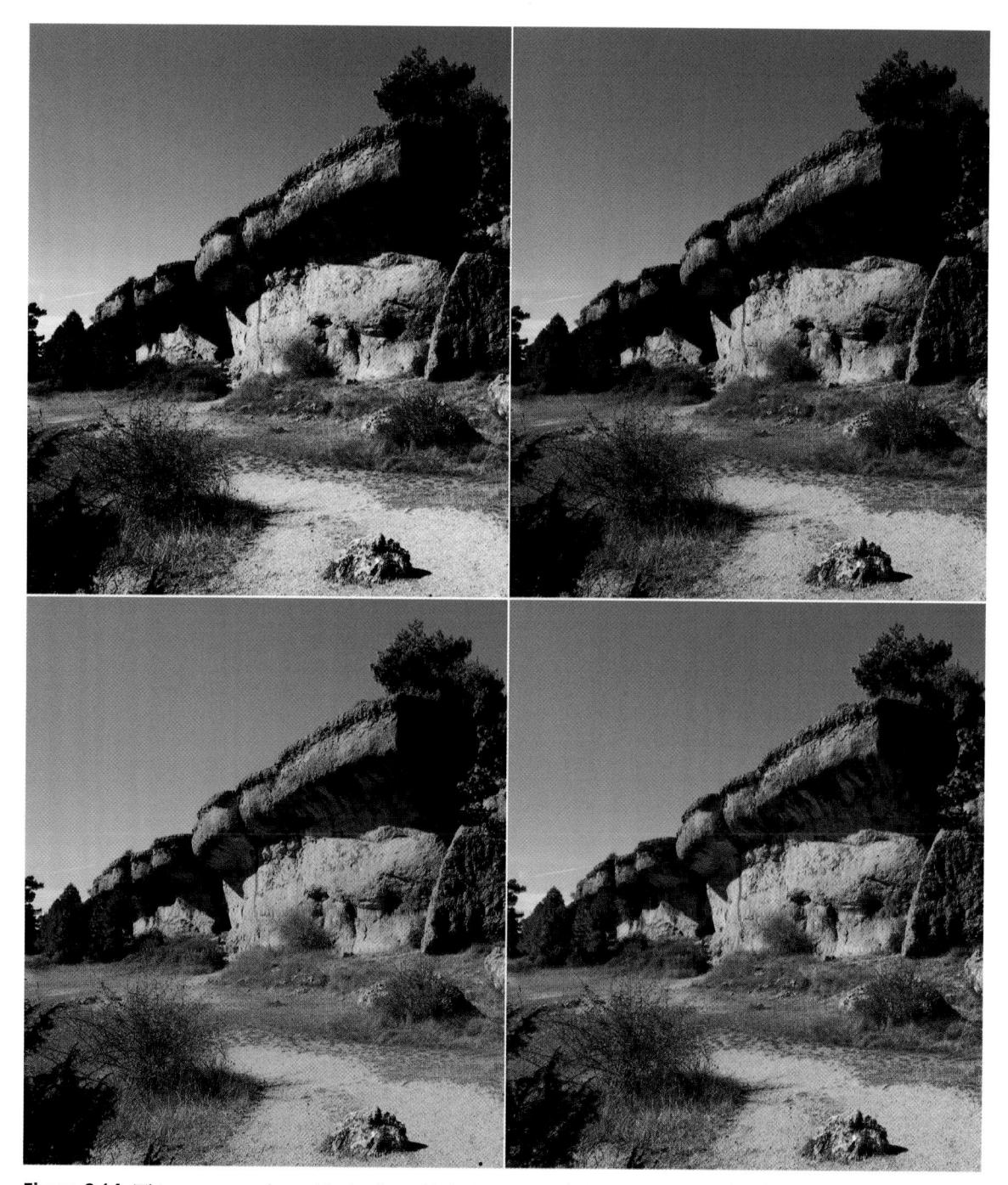

Figure 6.14 This scene was shot with the Sony Alpha NEX-7 with settings of DRO Off (upper left), DRO Auto (upper right), DRO Level 3 (lower left), and DRO Level 5.

When using the in-camera HDR feature, whether you use the Auto setting or a specific exposure interval, you should use a tripod or other solid support, and your subject should be a non-moving one. The camera will be taking three shots, and you don't want there to be significant differences between the three views of the scene. Also, note that the Auto HDR feature, like DRO processing, is not available when shooting RAW or RAW & JPEG images.

HDR in Post-Processing

While my goal in this book is to show you how to take great photos *in the camera* rather than how to fix your errors in Photoshop, the Merge to HDR Pro feature in Adobe Photoshop and Photoshop Elements is too cool to ignore. Using this tool, you can usually get much better HDR results than you can with the NEX-7's in-camera HDR feature.

The ability to have a bracketed set of exposures that are identical except for exposure is key to getting good results with this feature, which allows you to produce images with a full, rich dynamic range that includes a level of detail in the highlights and shadows that is almost impossible to achieve with digital cameras. In contrasty lighting situations, even the NEX-7 has a tendency to blow out highlights when you expose solely for the shadows or midtones.

Suppose you wanted to photograph a dimly lit room that had a bright window showing an outdoors scene. Proper exposure for the room might be on the order of 1/60th second at f/2.8 at ISO 200, while the outdoors scene probably would require f/11 at 1/400th second. That's almost a 7 EV step difference (approximately 7 f/stops) and well beyond the dynamic range of any digital camera, including the NEX-7.

When you're using Merge to HDR Pro, you'd take four pictures, one for the shadows, one for the highlights, and perhaps two for the midtones. (You could also take more than four pictures, but for this example, I'm going to assume you're working with just four.) Then, you'd use the Merge to HDR Pro command to combine all of the images into one HDR image that integrates the well-exposed sections of each version. Because the NEX-7 allows you to take only *three* bracketed images, and with no more than 0.7EV difference between them, you'll need to adjust your exposures manually. (The Auto HDR feature does allow up to 6 steps between just three exposures, but is less versatile than doing HDR manually. You can also shoot RAW when creating do-it-yourself HDR images.)

The images should be as identical as possible, except for exposure. So, it's a good idea to mount the NEX-7 on a tripod, use a remote release, and take all the exposures one after another. Just follow these steps:

- 1. Set up the camera. Mount the NEX-7 on a tripod.
- 2. **Set the camera for Manual exposure.** Press the center controller button and use the virtual mode dial to select Manual exposure.

- 3. **Choose an f/stop.** Rotate the right control dial and select an aperture for your series of manually bracketed shots. *And then leave this adjustment alone!* You don't want the aperture to change for your series, as that would change the depth-of-field. You want to adjust exposure *only* with the shutter speed.
- 4. **Choose a shutter speed for the initial exposure.** For this exercise, we'll be shooting four different bracketed exposures, so set the shutter speed using the left control dial such that the image will be two stops underexposed. If necessary, take a test shot to find the "correct" exposure and adjust from there.
- Choose manual focus. You don't want the focus to change between shots, so use the AF/MF Select entry in the Camera menu to choose manual focus, then carefully focus your shot.
- 6. **Choose RAW exposures.** Set the camera to take RAW files, which will give you the widest range of tones in your images.
- 7. **Take the first shot.** Press the button on the remote (or carefully press the shutter release) and take the first exposure, which will be two stops underexposed.
- 8. **Adjust shutter speed to give one stop more exposure.** For example, if your first shot was at 1/500th second at f/11, rotate the left control dial *gently* to change to 1/250th second.
- 9. **Take the second shot.** Press the button on the remote or press the shutter release and take the second exposure, which will be one stop underexposed.
- 10. **Repeat steps 8 and 9 twice more.** To create exposures at the metered exposure and one stop overexposed. You'll end up with a set of photos like those shown in Figure 6.15.
- 11. **Continue with the Merge to HDR Pro steps listed next.** You can also use a different program, such as Photomatix, if you know how to use it. Note that these steps could also be carried out using Aperture priority, and rotating the right control dial to provide exposure compensation over the same range. I find manual bracketing to be just as fast.

The next steps show you how to combine the separate exposures into one merged high dynamic range image. The sample images in Figure 6.15 show the results you can get from a four-shot bracketed sequence.

- 1. **Copy your images to your computer.** If you use an application to transfer the files to your computer, make sure it does not make any adjustments to brightness, contrast, or exposure. You want the real raw information for Merge to HDR Pro to work with.
- 2. Activate Merge to HDR Pro. Choose File > Automate > Merge to HDR Pro.

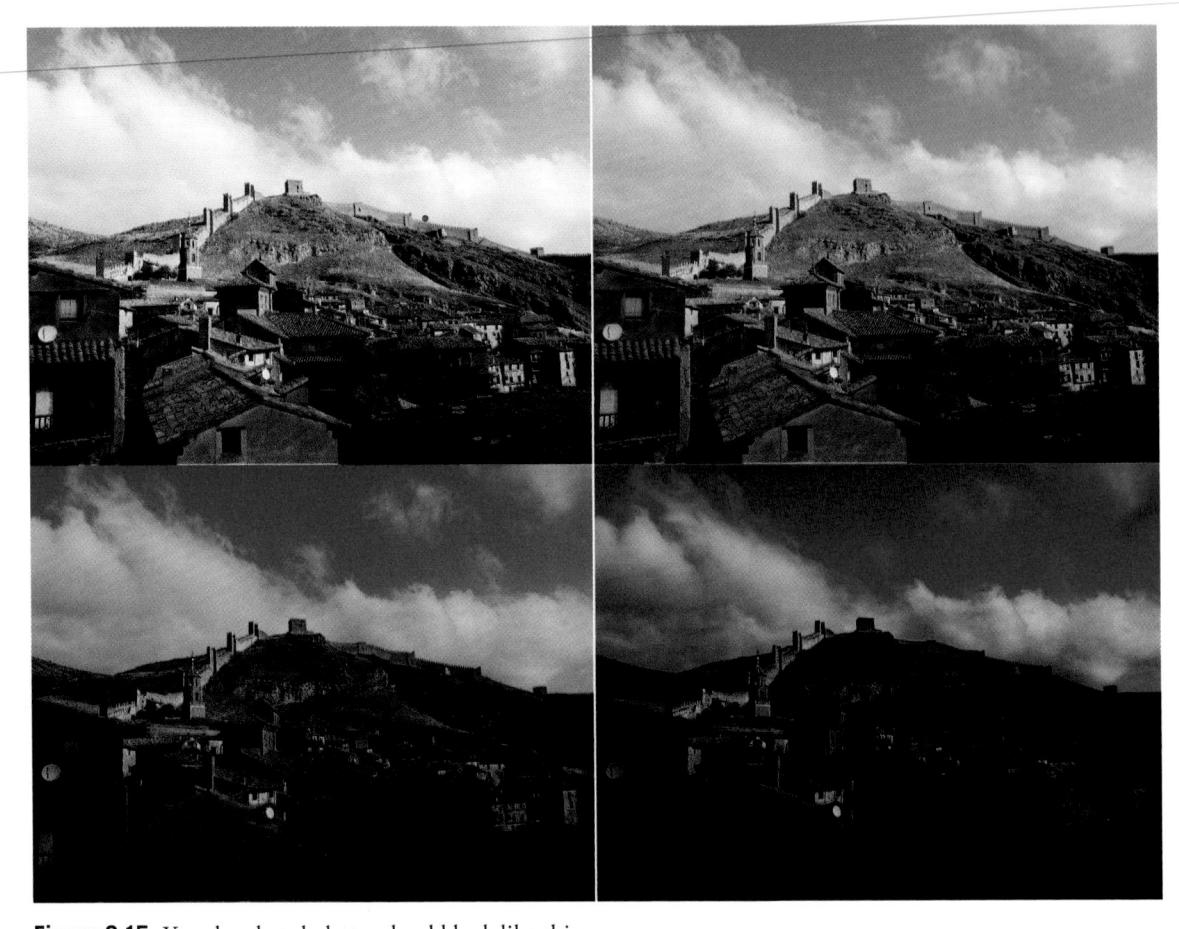

Figure 6.15 Your bracketed photos should look like this.

- 3. Select the photos to be merged. Use the Browse feature to locate and select your photos to be merged. You'll note a checkbox that can be used to automatically align the images if they were not taken with the camera mounted on a rock-steady support. This will adjust for any slight movement of the camera that might have occurred when you changed exposure settings.
- 4. **Choose parameters (optional).** The first time you use Merge to HDR Pro, you can let the program work with its default parameters. Once you've played with the feature a few times, you can read the Adobe help files and learn more about the options than I can present in this non-software-oriented camera guide. (See Figure 6.16.)
- 5. Click OK. The merger begins.
- 6. Save. Once HDR merge has done its thing, save the file to your computer.

If you do everything correctly, you'll end up with a photo like the one shown in Figure 6.17, which has the properly exposed foreground of the first shot, and the well-exposed

Figure 6.16
Use the Merge to HDR Pro command in Photoshop or Photoshop Elements to combine the four images.

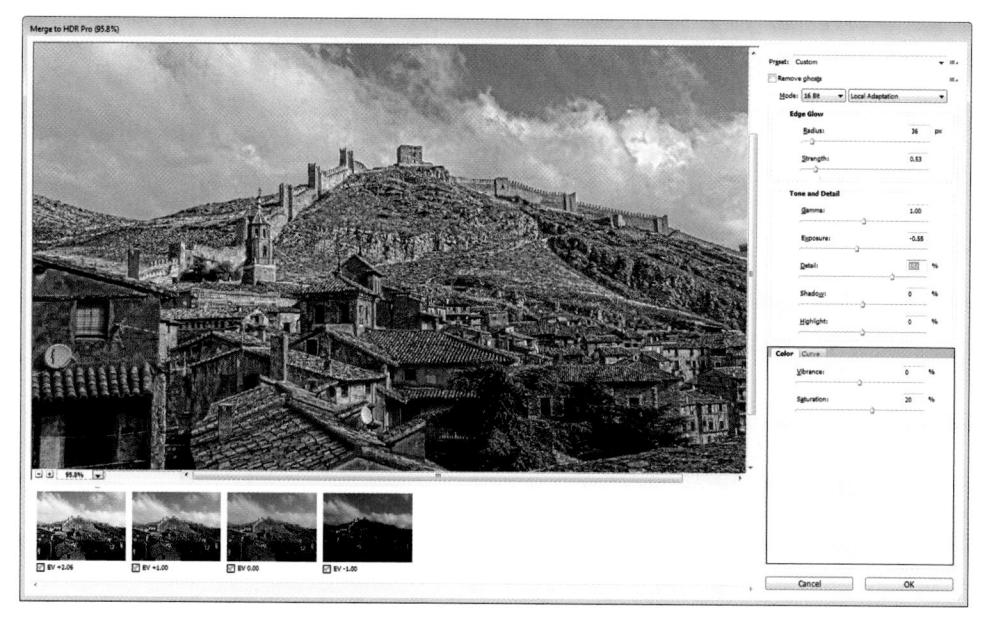

Figure 6.17 You'll end up with an extended dynamic range photo like this one.

rocks of the second and third images. Note that, ideally, nothing should move between shots. In the example pictures, the clouds are moving, but the exposures were made so close together that, after the merger, you can't really tell.

What if you don't have the opportunity, inclination, or skills to create several images at different exposures, as described? If you shoot in RAW format, you can still use Merge to HDR, working with a *single* original image file. What you do is import the image into Photoshop several times, using Adobe Camera Raw to create multiple copies of the file at different exposure levels.

For example, you'd create one copy that's too dark, so the shadows lose detail, but the highlights are preserved. Create another copy with the shadows intact and allow the highlights to wash out. Then, you can use Merge to HDR to combine the two and end up with a finished image that has the extended dynamic range you're looking for. (This concludes the image-editing portion of the chapter. We now return you to our alternate sponsor: photography.)

Using Creative Styles

This option, also found on the Brightness/Color menu, gives you six different combinations of contrast, saturation, and sharpness: Standard, Vivid, Portrait, Landscape, Sunset, and B/W (black-and-white). Those are useful enough that you should make them a part of your everyday toolkit. You can apply Creative Styles *only* when you are not using one of the Alpha's Intelligent Auto or Scene modes. (That is, you're shooting in Program, Aperture priority, Shutter priority, Manual, Anti Motion Blur, or one of the Panorama modes.) But wait, there's more. When working with Creative Styles, you can *adjust* those parameters within each preset option to fine-tune the rendition. First, look at the "stock" creative styles:

- **Standard.** This is, as you might expect, your default setting, with a good compromise of sharpness, color saturation, and contrast. Choose this, and your photos will have excellent colors, a broad range of tonal values, and standard sharpness that avoids the "oversharpened" look that some digital pictures acquire.
- Vivid. If you want more punch in your images, with richer colors, heightened contrast that makes those colors stand out, and moderate sharpness, this setting is for you. It's good for flowers, seaside photos, any picture with expanses of blue sky, and on overcast days where a punchier image can relieve the dullness.
- Neutral. Reduced saturation and sharpness. This is a good choice if you're planning on fine-tuning those aspects in your computer and don't want the camera to overdo either of them.

- Clear. Sony recommends this style for "clear tones" and "limpid colors" in the highlights, especially when you're capturing "radiant light." The description is a bit artsy, but I've found this style useful for foggy mornings and other low-contrast scenes.
- **Deep.** Rich and dense colors with a full range of tones.
- **Light.** Recommended for bright, uncomplicated color expressions. I like it for high-key images with lots of illumination and few shadows.
- **Portrait.** Unless you're photographing a clown, you don't want overly vivid colors in your portraits. Nor do you need lots of contrast to emphasize facial flaws and defects. This setting provides realistic, muted skin tones, and a softer look that flatters your subjects.
- Landscape. As with the Vivid setting, this option boosts saturation and contrast to give you rich scenery and purple mountain majesties, even when your subject matter is located far enough from your camera that distant haze might otherwise be a problem. There's extra sharpness, too, to give you added crispness when you're shooting Fall colors.
- Sunset. Accentuates the red tones found in sunrise and sunset pictures.
- Night Scene. Contrast is adjusted to provide a more realistic nighttime effect.
- Autumn Leaves. Boosts the saturation of reds and yellows for vivid Fall colors.
- B/W. If you're shooting black-and-white photos in the camera, this setting allows you to change the contrast and sharpness (only).
- Sepia. Provides a warm brownish, old-timey tone to images.

To customize any of these settings, go to the Brightness/Color menu and highlight the style you want to alter, using the direction buttons or control wheel, and select it with the center controller button. Then press the lower soft key (Option button) to bring up a screen showing the available adjustments of contrast, saturation, and sharpness. Then, use the left/right direction buttons to choose from (left to right) contrast, saturation, and sharpness. With the parameter you want to modify highlighted, press the up/down direction buttons to change the values up to 3 increments higher or lower than normal. Press the center controller button to confirm.

Here is a summary of how the parameters you can change with Creative Styles affect your images:

■ **Sharpness.** Increases or decreases the contrast of the edge outlines in your image, making the photo appear more or less sharp, depending on whether you've selected 0 (no sharpening), +3 (extra sharpening), to −3 (softening). Remember that boosting sharpness also increases the overall contrast of an image, so you'll want to use this parameter in conjunction with the contrast parameter with caution.

- Contrast. Compresses the range of tones in an image (increase contrast from 0 to +3) or expands the range of tones (from 0 to -3) to decrease contrast. Higher-contrast images tend to lose detail in both shadows and highlights, whereas lower-contrast images retain the detail but appear more flat and have less snap.
- Color Saturation. You can adjust the richness of the color from low saturation (0 to -3) to high saturation (0 to +3). Lower saturation produces a muted look that can be more realistic for certain kinds of subjects, such as humans. Higher saturation produces a more vibrant appearance, but can be garish and unrealistic if carried too far. Boost your saturation if you want a vivid image, or to brighten up pictures taken on overcast days. As I noted, this setting cannot be changed for the B/W Creative Style.

Wi-Fi

These days, GPS and Wi-Fi capabilities work together with your NEX-7 in interesting new ways. Wireless capabilities allow you to upload photos directly from your NEX-7 to your computer at home or in your studio, or, through a hotspot at your hotel or coffee shop back to your home computer or to a photo sharing service like Facebook or Flickr. A special Wi-Fi-enabled memory card that you slip in the SD slot of your camera performs the magic. GPS capabilities—built right into some of those Wi-Fi cards—allow you to mark your photographs with location information, so you don't have to guess where a picture was taken.

Both capabilities are very cool. Wi-Fi uploads can provide instant backup of important shots and sharing. And, as noted in the previous section, geotagging is most important as a way to associate the geographical location where the photographer was when a picture was taken, with the actual photograph itself. It can be done with the location-mapping capabilities of the Wi-Fi card, or through add-on devices that third parties make available for your NEX-7.

A relatively affordable solution is offered by Eye-Fi (www.eye.fi). The Eye-Fi card (see Figure 6.18) is an SDHC memory card with a wireless transmitter built in. You insert it in your camera just as with any ordinary card, and then specify which networks to use. You can add as many as 32 different networks. The next time your camera is on within range of a specified network, your photos and videos can be uploaded to your computer and/or to your favorite sharing site. During setup, you can customize where you want your images uploaded. The Eye-Fi card will only send them to the computer and to the sharing site you choose. Upload to any of 25 popular sharing websites, including Flickr, Facebook, MobileMe, Costco, Adorama, Smugmug, YouTube, Shutterfly, or Walmart. Online Sharing is included as a lifetime, unlimited service with all X2 cards.

When uploading to online sites, you can specify not just where your images are sent, but how they are organized, by specifying preset album names, tags, descriptions, and even privacy preferences on certain sharing sites. Some Eye-Fi cards also include geotagging service, which help you view uploaded photos on a map, and sort them by location. Eye-Fi's geotagging uses Wi-Fi Positioning System (WPS) technology. Using built-in Wi-Fi, the Eye-Fi card senses surrounding Wi-Fi networks as you take pictures. When photos are uploaded, the Eye-Fi service then adds the geotags to your photos. You don't need to have the password or a subscription for the Wi-Fi networks the card accesses; it can grab the location information directly without the need to "log in." You don't need to set up or control the Eye-Fi card from your camera. Software on your computer manages all the parameters. (See Figure 6.19.)

Your NEX-7 has an Eye-Fi Upload entry in the Setup menu (it is visible only when an Eye-Fi card is installed) that allows you to enable or disable this capability. Once you activate it, the Wi-Fi symbol will appear on the top line of the EVF and LCD displays, in the memory card position in the left corner. You'll want to turn off Eye-Fi when traveling on an airplane (just as you disable your cell phone, tablet, or laptop's wireless capabilities when required to do so). In addition, use of Wi-Fi cards may be restricted or banned outside the United States, because the telecommunications laws differ in other countries.

If you frequently travel outside the range of your home (or business) Wi-Fi network, an optional service called Hotspot Access is available, allowing you to connect to any AT&T Wi-Fi hotspot in the USA. In addition, you can use your own Wi-Fi accounts from commercial network providers, your city, even organizations you belong to such as your university.

Figure 6.19
Functions of the Eye-Fi card can be controlled from your computer.

The card has another interesting feature called Endless Memory. When pictures have been safely uploaded to an external site, the card can be set to automatically erase the oldest images to free up space for new pictures. You choose the threshold where the card starts zapping your old pictures to make room.

Eye-Fi currently offers several models, all of which can be used to transmit your photos from the dSLR to a computer on your home network (or any other network you set up somewhere, say, at a family reunion). The most sophisticated option is Eye-Fi Pro X2 which adds geographic location labels to your photo (so you'll know where you took it), and frees you from your own computer network by allowing uploads from more than 10,000 Wi-Fi hotspots around the USA. Very cool, and the ultimate in picture backup.

Tablets, Smart Phones, and the NEX-7

Although tablets and smart phones are still in their infancies, in the future, your iPhone, iPad/tablet computer, iPod Touch/MP3 player, smart phone, or Google Android portable device will be one of the most important accessories you can have for your Nikon 1 (or other) digital camera. We're only now seeing the beginnings of the trend.

The relevant platforms are these:

- Old-style smart phones. I include in this category all smart phones that are *not* iPhones or phones based on Google's Android operating system. You can buy lots of interesting apps for these phones, although not many applications specifically for photography. This type of phone should be on its way out, too, with iPhone and Android smart phones dominating, simply because it's easier to write applications for the iPhone's iOS and Android than to create them for multiple "old" smart phone platforms.
- Android smart phones. There are already more Android-based smart phones on the market than for all other types, including iOS. Although Apple had a head start, the number of Android applications is rapidly catching up.
- iPhones. It might sound strange to say that the skyrocketing sales of iPhones has been held in check, but it's true. The real or imagined shortcomings of AT&T's data network—which only got worse as more users grabbed iPhones—have kept many from switching to the iOS platform. The difficulties may even have contributed to the rapid growth of Android-based phones, which have been offered by other suppliers seen as having "better" communications networks. Even so, iOS leads in number of applications, especially for photography apps. When my first app was developed, it appeared for the iOS platform first.
- iPod Touch. Basically, the latest iPod Touch is an iPhone that can't make phone calls. (Although there are some hacks around that limitation.) Virtually all of the apps that run on the iPhone under iOS also run on the iPod Touch. You need a Wi-Fi connection to access features that use network capabilities, but, these days, Wi-Fi hot spots aren't that difficult to find. Tethering and Mi-Fi (which allow another device to serve as a hot spot for non-connected gadgets like the Touch), and *automobiles* that include built-in Wi-Fi (!) make connectivity almost universal. In my travels through Europe in the last year, I found free Wi-Fi connections in the smallest towns. (Indeed, the only time I was asked to pay for it was when staying in an upscale hotel.) So, for many who are tied to a non-iPhone cell phone, the iPod Touch is a viable alternative.
- **Tablet computers.** I've been welded to my iPad (shown alongside my iPhone in Figure 6.20) since I bought it the first day they became available. I use them to access e-mail, useful apps, and as a portable portfolio. Today, there are alternative tablet computers running Android. I recently picked up an Amazon Kindle Fire, which also does e-mail and a limited number of apps, and which has a Gallery feature (see Figure 6.21) that transforms it into a compact portfolio almost as useful for that purpose as an iPad. (However, only 6 of the Kindle Fire's 8GB of storage are available to the user, so you'll have to limit the size of your portfolio.)

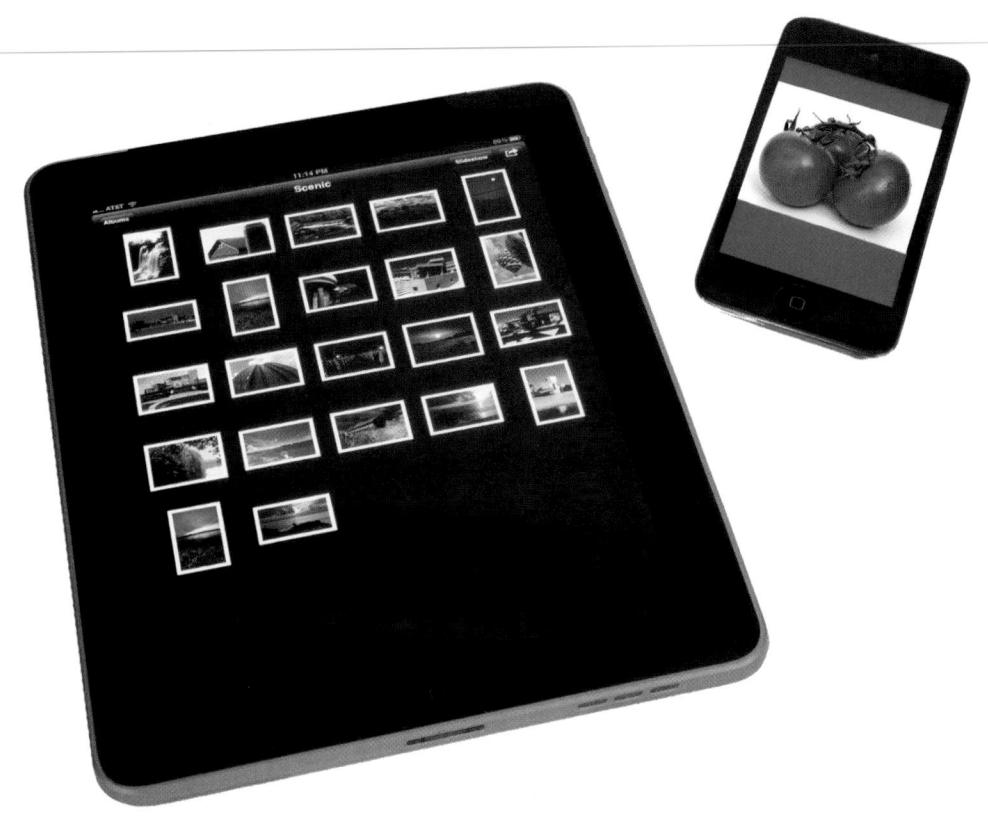

Figure 6.20
The iPad, iPod, and other devices open a whole world of useful apps to the photographer.

Figure 6.21
The Kindle Fire is a smaller, more affordable alternative to the iPad.

I use the Kindle Fire and both an iPhone and iPad. (If I'm traveling overseas where my iPhone can't be used, I usually take along the iPod Touch instead.) The iPhone/iPod slips in a pocket and can be used anywhere. I don't even have to think about taking it with me, because I always have one or the other. I have to remember to tote along the iPad or Kindle Fire, and, I do, to an extent you'd probably find surprising. (After the movie finally starts, I fold them into their cases and use them as a tray for my popcorn bucket.) Tablet computers can do everything a pocket-sized device can do, and are easier to read/view/type on. When I am out shooting, I prefer to have all my apps in a smaller device that I can slip in the camera bag, but if there's room, the iPad goes along instead. Because my iPad (unlike the Kindle Fire) has 3G connectivity, I don't need a Wi-Fi connection to use it almost anywhere. I do have a Wi-Fi hot spot built into my iPhone that I can use to connect the Kindle Fire to the net if I need to.

What Else Can You Do with Them?

Many of these devices can serve as a backup for your NEX-7's memory cards. I've got Apple's camera connection kit, and can offload my pictures to my iPad's 64GB of memory, then upload them to Flickr or Facebook, or send to anyone through e-mail. My iPad also makes a perfect portable portfolio, too. I have hundreds of photos stored on mine, arranged into albums ready for instant display, either individually, or in slide shows. I have the same photo library on my iPhone and iPod Touch, and more than a few pictures available for showing on my Kindle Fire.

But the real potential for using these devices comes from specialized apps written specifically to serve photographic needs. Here are some of the kinds of apps you can expect in the future. (I'm working on more than a few of them myself.)

- Camera guides. Even the rotten manual that came with your camera is too large to carry around in your camera bag all day. I'm converting many of my own camera-specific guides to app form, while adding interactive elements, including hyperlinks and videos. You can already put a PDF version of your camera manual on your portable device and read it, if you like. In the future, you should be able to read any of the more useful third-party guides anywhere, anytime.
- Lens selector. Wonder what's the best lens to use in a specific situation? Enter information about your scene, and your app will advise you.
- Exposure estimator. Choose a situation and the estimated exposure will be provided. Useful as a reality check and in difficult situations, such as fireworks, where the camera's meters may falter.
- **Shutter speed advisor.** The correct shutter speed for a scene varies depending on whether you want to freeze action, or add a little blur to express motion. Other variables include whether the subject is crossing the frame, moving diagonally, or

headed towards you. The photographer also needs to consider the focal length of the lens, and presence/absence of image stabilization features, tripod, monopod, etc. This app will allow you to tap in all the factors and receive advice about what shutter speed to use.

- Hyperfocal length calculator. In any given situation, set the focus point at the distance specified for your lens's current focal length setting, and everything from half that distance to infinity will be in focus. But the right setting differs at various focal lengths. This app tells you, and is a great tool for grab shots.
- Accessory selector. Confused about what flash, remote control, battery grip, lens hood, filter, or other accessory to use with your camera or lens? This selector lists the key gadgets, which ones fit which cameras, and explains how to use them.
- **Before and after.** Images showing before/after versions of dozens of situations with and without corrective/in-camera special effects applied.
- Fill light. Pesky shadows on faces from overhead lighting indoors? This turns your iPod/iPhone or (best of all) iPad into a bright, diffuse fill light panel. Choose from white fill light, or *colors* for special effects. Makes good illumination for viewing your camera's buttons and dials in dark locations, too.
- **Gray card.** Turn your i-device into an 18-percent gray card for metering and color balance.
- **Super links.** If you don't find your answer in the Toolkit, you can link to websites, including mine, with more information.
- How It's Made. A collection of inspiring photos, with details on how they were taken in camera—or manipulated in Photoshop (if that's your thing).
- Quickie guides. Small apps that lead you, step-by-step, through everything you need to photograph lots of different types of scenes. Typical subjects would be sports, landscape photography, macro work, portraits, concerts/performances, flowers, wildlife, and nature.

As you can see, the potential for apps is virtually unlimited. You can expect your smart phone, tablet computer, or other device to be a mainstay in your camera bag within a very short time.

Movie Making with Your Sony Alpha NEX-7

As we've seen in our exploration of its features so far, the Sony Alpha NEX-7 is superbly equipped for taking still photographs of very high quality in a wide variety of shooting environments. But this camera's superior level of performance is not limited to stills. The NEX-7 camera is unusually capable in the movie-making arena as well. So, even though you may have bought your NEX primarily for shooting stationary scenes, you acquired a device that is equipped with a robust set of features for recording high-quality video clips. Whether you're looking to record informal clips of the family on vacation, the latest viral video for YouTube, or a set of scenes that will be painstakingly crafted into a cinematic masterpiece using editing software, the NEX-7 will perform admirably.

Some Fundamentals

Recording a video with the Sony Alpha NEX-7 is extraordinarily easy to accomplish—just press the prominent red-accented button at the upper right of the camera's back to start, and press it again to stop. Before you press that button, though, there are some settings to prepare the camera to record the scene the way you want it to. Setting up the camera for recording video can be a bit tricky, because it's not immediately obvious, either from the camera's menus or from Sony's manuals, which settings apply to video recording and which do not. I will unravel that mystery for you, and throw in a few other tips to help improve your movies.

I'll show you how to optimize your settings before you start shooting video, but here are some considerations to be aware of as you get started. Many of these points will be covered in more detail later in this chapter:

- Use the right card. You'll want to use an SD or SDHC card with Class 6 or higher speed; if you use a slower card, like a Class 4 or especially Class 2, the recording may stop after a minute or two. Choose a memory card with at least 4GB capacity; 8GB or 16GB are even better. If you're going to be recording a lot of HD video, that could be a good reason to take advantage of the ability to use SDXC cards of 64GB capacity. Just make sure your memory card reader is SDXC compatible and your computer can read the files from that type of card. I've standardized on fast Class 6 or Class 10 16GB SDHC cards when I'm shooting movies; one of these cards will hold at least three hours of video. However, the camera cannot shoot a continuous movie scene for more than 29 minutes. You can start shooting the next clip right away, though, missing only about 30 seconds of the action. Of course that assumes there's enough space on your memory card and adequate battery power.
- Add an external mic. For the best sound quality, and to avoid picking up the sound of the autofocus or zoom motor, get an external stereo mic. If you get a Sony microphone, it will slide right into the non-standard Sony/Minolta accessory shoe on top of the camera. Other brands will require an adapter. I'll have more advice about capturing sound later in this chapter.
- Minimize zooming. While it's great to be able to use the zoom for filling the frame with a distant subject, think twice before zooming. Unless you are using an external mic, the sound of the zoom ring rotating will be picked up and it will be audible when you play a movie. Any more than the occasional minor zoom will be very distracting to friends who watch your videos. And digital zoom will definitely degrade image quality. Don't use the digital zoom if quality is more important than recording a specific subject such as a famous movie star from a distance.
- Use a fully charged battery. A fresh battery will allow about one hour of filming at normal (non-Winter) temperatures, but that can be shorter if there are many focus adjustments. Individual clips can be no longer than 29 minutes, however.
- Keep it cool. Video quality can suffer terribly when the imaging sensor gets hot, so keep the camera in a cool place. When shooting on hot days especially, the sensor can get hot more quickly than usual; when there's a risk of overheating, the camera will stop recording and it will shut down about five seconds later. Give it time to cool down before using it again.
- Press the Movie button. You don't have to hold it down. Press it again when you're done to stop recording.

WHY THE 29-MINUTE LIMITATION?

Vendors are really cagey about revealing the reason for the seemingly arbitrary/non-arbitrary 29 minute, 59 second limitation on the length of a single video clip—not only with Sony still cameras, but with other brands as well. So, various theories have emerged, none of which have proven to be definitive.

- The sensor will overheat when you shoot continuously. In a mirrorless camera, the sensor is active virtually all the time the camera is turned on, so that idea doesn't hold water. Plus, you can shoot one 29-minute clip, then immediately begin another one. Thermal protection doesn't seem to be a problem, or the reason for the limitation.
- Some countries, particularly in the European Union, classify cameras that can capture clips of 30 minutes or more as camcorders, at a higher duty rate.
- The FAT32 file format limits the size of video clips to 2GB, or about 30 minutes. Actually, it's the FAT16 file format (used in pre-SDHC memory cards) that has the 2GB limitation. All memory cards larger than 2GB will let you create a file that's 4GB in size. Further, my 64GB SDXC card allows files up to 2 terabytes in size, but when I insert one into my NEX-7, I still can't exceed 29 minutes, 59 seconds.
- Theories aside, the only people who want to shoot clips longer than 30 minutes are the proud parents who plop the NEX-7 down on a tripod and capture an entire Spring Pageant or high school musical. Those who want to go beyond camcorder ennui will shoot segments of only a few seconds each and, perhaps, piece them together into an effective production using easy-to-master editing software.

Preparing to Shoot Video

First, here's what I recommend you do to prepare for your recording session:

- Choose your file format. Go to the Movie settings in the Image Size menu and select the file format for your movies. You can select from AVCHD 60i/60p (for the NTSC television system, which is used in the US, Canada, Japan, and other countries), AVCHD 50i/50p (for the PAL system used in other countries), or MP4.
- Choose record setting. Also in the Image Size menu, you'll find the Record Setting entry, which allows you to choose the image size, frame rate, and image quality for your movies. Your choices are (in all cases, xxM stands for megabits per second recording speed):
 - For AVCHD 60i/60p or 50i/50p: 60i, 24M (FX); 60i, 17M (FH); 60p, 28M (PS); 24p, 24M (FX), 24p, 17M (FH).
 - For MP4: 1440 × 1080, 12M; VGA (640 × 480), 3M

Which format should you choose? It depends in part on your needs. If you want to save space on your memory card or computer and aren't too concerned about quality, you can choose VGA. If you want high quality and also want to edit your videos on a computer, I recommend the higher quality MP4 formats (1440×1080). If you will be connecting the camera directly to an HDTV set, choose AVCHD; that format gives you the best quality, but can be harder to manipulate and edit on a computer than videos in the MP4 formats. I'll explain the difference between 60/50 and 24 fps rates later in this section.

- Set the camera's aspect ratio. The aspect ratio setting (3:2 or 16:9, accessed through the Image Size menu) won't affect your video recording, but it will affect how you frame your images using the live view on the LCD screen. So, if you want to know approximately how your video will be framed on the screen, set the aspect ratio to 3:2 if you're going to be recording in VGA; set it to 16:9 if you'll be using any of the other formats. (If you really want to be precise in knowing how the video will be framed, turn on the Grid Line option in the Setup menu, which will place a small set of movie frame brackets on the screen; those brackets will show you the size of the movie frame before you press the red button to start recording.)
- Turn on autofocus. Make sure autofocus is turned on through the Camera menu's AF/MF select option (assuming you're using a Sony lens that will autofocus with this camera). You have the option of using manual focus, or even Direct Manual Focus if you want, but in most cases there is no reason not to rely on the camera's excellent ability to autofocus during movie making. Don't bother about Autofocus mode or Autofocus Area, though; the camera is automatically set to use its own automation to focus as it sees fit.
- Set white balance and Creative Style as you want them. These are two exposure-related functions that will work for your video shooting, so take advantage of them. Of course, for many purposes you may be content with Auto White Balance and the Standard Creative Style, but be aware that these settings are available if you want to use them for creative purposes. If you want to use particular white balance or Creative Style settings, be sure to set the camera to a shooting mode, such as Program, in which those settings can be made; if you switch back to Intelligent Auto or a Scene mode, the camera will revert back to its automatic settings. Don't worry about setting other exposure-related items, such as DRO, or metering mode, which will have no effect.
- Use the right card. You'll want to use an SD Class 6 memory card or better to store your clips; slower cards may not keep pace with the volume of data being recorded. Choose a memory card with at least 4GB capacity (8GB or 16GB are even better).

- Attach the external microphone if desired. Use a mic like Sony's ECM-SST1 external microphone. Attach it if you want the potential increase in sensitivity and directionality, but I find the internal stereo microphone to yield surprisingly clear audio.
- Press the red Movie recording button. You don't have to hold it down. Press it again when you're done.

GETTING INFO

The information display shown on the LCD screen when shooting movies is fairly sparse, because there are not too many settings you can make. The screen will show recording time elapsed and time remaining and the REC indicator to show that you are shooting a movie. It will also show you the format you are using and any exposure-related settings that are in effect, including white balance, Creative Style, and exposure compensation.

More About Frame Rates and Formats

Even intermediate movie shooters can be confused by the choice between 24 fps and 50/60 fps. The difference lies in the two "worlds" of motion images, film and video. The standard frame rate for motion picture film is 24 fps, while the video rate, at least in the United States, Japan, and other places using the NTSC standard is 30 fps. That's actually 60 interlaced *fields* per second; that's where we get the 60i (60 fps *interlaced* specification). With interlaced video, the capture device grabs odd-numbered lines in one scan, even-numbered video lines in another scan, and they are combined to produce the final image we view. *Progressive* scan images (as in 60p) grab all the video lines of an image in order.

Line-by-line scanning during capture and playback can be done in one of two ways. With *interlaced scanning*, odd-numbered lines (lines 1, 3, 5, 7... and so forth) are captured with one pass, and then the even-numbered lines (2, 4, 6, 8...and so forth) are grabbed. With the 1080/60i format, roughly 60 pairs of odd/even line scans, or 60 *fields* are captured each second. (The actual number is 59.94 fields per second.) Interlaced scanning was developed for and works best with analog display systems such as older television sets. It was originally created as a way to reduce the amount of bandwidth required to transmit television pictures over the air. Modern LCD, LED, and plasma-based HDTV displays must de-interlace a 1080i image to display it. (See Figure 7.1.)

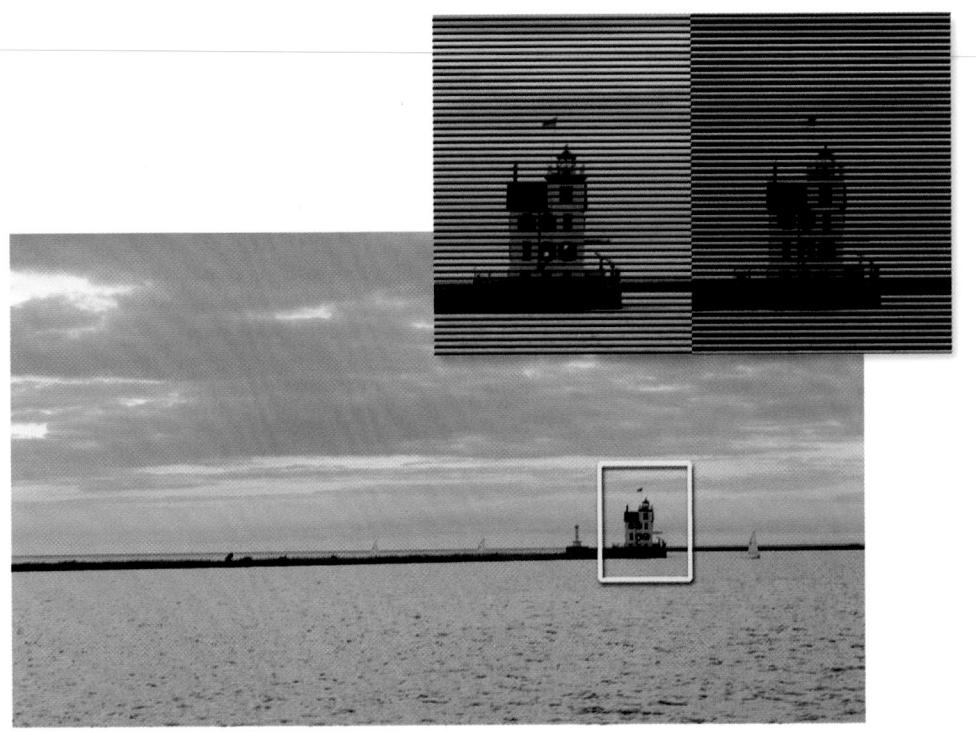

Figure 7.1
The inset shows how lines of the image alternate between odd and even in an interlaced video capture.

Newer displays work better with a second method, called *progressive scanning* or *sequential scanning*. Instead of two interlaced fields, the entire image is scanned as consecutive lines (lines 1,2,3,4...and so forth). This happens at a rate of 30 frames per second (not fields), or, more precisely, 29.97 frames per second. (All these numbers apply to the NTSC television system used in the United States, Canada, Japan, and some other countries; other places use systems like PAL, where the nominal scanning figures are 50/25 rather than 60/30.)

One problem with interlaced scanning appears when capturing video of moving subjects. Half of the image (one set of interlaced lines) will change to keep up with the movement of the subject while the other interlaced half retains the "old" image as it waits to be refreshed. Flicker or *interline twitter* results. That makes your progressive scan options 1080p/30 or 720p/60 a better choice for action photography.

Computer editing software can handle either type (although Sony's proprietary AVCHD format may not be compatible with your applications), and convert between them. The choice between 24 fps and 60 fps is determined by what you plan to do with your video. The short explanation is that, for technical reasons I won't go into here, shooting at 24 fps gives your movie a "film" look, excellent for showing fine detail. However, if your clip has moving subjects, or you pan the camera, 24 fps can produce a jerky effect called "judder." A 60 fps rate produces a home-video look that some feel

is less desirable, but which is smoother and less jittery when displayed on an electronic monitor. I suggest you try both and use the frame rate that best suits your tastes and video-editing software.

If you're using MPEG-4 format, you automatically capture movies at 30 fps in AVC format; with AVCHD, you can select from 60i/50i, 60p/50p (in a proprietary Sony format), or 24/25p. Movies captured with MPEG-4 format can't be burned to disk with Sony's PMB (Picture Motion Browser) software. However, if you capture using AVCHD, you can create Blu-Ray Discs, AVCHD Disks, or DVD-Video discs using the PMB software.

Steps During Movie Making

Once you have set up the camera for your video session and pressed the Movie button, you have done most of the technical work that's required of you. Now your task is to use your skills at composition, lighting, scene selection, and, perhaps, directing actors, to make a compelling video production. I have no advice to give you in those areas, but there are a few technical points you should bear in mind as the camera is (figuratively) whirring away.

- Zoom, autofocus, and autoexposure all work. If you're new to the world of high-quality still cameras that also take video, you may just take it for granted that functions such as autofocus continue to work normally when you switch from stills to video. But until recently, most such cameras performed weakly in their video modes; they would lock their exposure and focus at the beginning of the scene, and you could not zoom while shooting the video. The NEX-7 has no such handicaps, and, in fact, is especially capable in these areas. Autoexposure works very well, and you can zoom to your heart's content (though I'll go back on my promise not to intrude into creative matters, and recommend that you zoom sparingly). Best of all, autofocus works like a charm; the camera can track moving subjects and quickly snap them back into sharp focus with the speedy Contrast Detection focusing mechanism. So don't limit yourself based on the weaknesses of past cameras; the NEX-7 opens up new horizons of video freedom.
- Exposure compensation works while filming. I found this feature to be quite remarkable. Although the autoexposure system works very well to vary the aperture when the ambient lighting changes, you also have the option of dialing in exposure compensation if you see a need for more or less brightness in a particular context. You could even use this function as a limited kind of "fade to black" in the camera, though you probably won't be able to fade quite all the way to black. Again, you may never need to adjust your EV manually while shooting video, but it's great to know that you have the option available.

■ Don't be a Flash in the pan. With HD video, there is a possibility of introducing artifacts or distortion if you pan too quickly. That is, because of the way the lines of video are displayed in sequence, if the camera moves too quickly in a sideways motion, some of the lines may not show up on the screen quickly enough to catch up to the rest of the picture, resulting in a somewhat distorted effect and/or loss of detail. So, if at all possible, make your pans smooth and steady, and slow them down to a comfortable pace.

Tips for Shooting Better Video

Once upon a time, the ability to shoot video with a digital still camera was one of those "Gee whiz" gimmicks camera makers seemed to include just to have a reason to get you to buy a new camera. That hasn't been true for a couple of years now, as the video quality of many digital still camera has gotten quite good. The Sony Alpha NEX-7 is a stellar example. It's capable of HD quality video and is actually capable of outperforming typical modestly priced digital video camcorders, especially when you consider the range of lenses and other helpful accessories available for it.

Producing good quality video is more complicated than just buying good equipment. There are techniques that make for gripping storytelling and a visual language the average person is very used to, but also pretty unaware of. While this book can't make you a professional videographer in half a chapter, there is some advice I can give you that will help you improve your results with the camera.

Producing high-quality videos can be a real challenge for amateur photographers. After all, by comparison we're used to watching the best productions that television, video, and motion pictures can offer. Whether it's fair or not, our efforts are compared to what we're used to seeing produced by experts. While this chapter can't make you into a pro videographer, it can help you improve your efforts.

There are a number of different things to consider when planning a video shoot, and when possible, a shooting script and storyboard can help you produce a higher quality video.

Keep Things Stable and on the Level

Camera shake's enough of a problem with still photography, but it becomes even more of a nuisance when you're shooting video. While the NEX-7's image stabilization found in some lenses with the OSS designation can help minimize this, it can't work miracles. Placing your camera on a tripod will work much better than trying to hand-hold it while shooting. One bit of really good news is that compared to pro dSLRs the NEX-7 can work very effectively on a lighter tripod, due to the camera's light weight.

Shooting Script

A shooting script is nothing more than a coordinated plan that covers both audio and video and provides order and structure for your video. A detailed script will cover what types of shots you're going after, what dialogue you're going to use, audio effects, transitions, and graphics.

Storyboards

A storyboard is a series of panels providing visuals of what each scene should look like. While the ones produced by Hollywood are generally of very high quality, there's nothing that says drawing skills are important for this step. Stick figures work just fine if that's the best you can do. The storyboard just helps you visualize locations, placement of actors/actresses, props and furniture, and also helps everyone involved get an idea of what you're trying to show. It also helps show how you want to frame or compose a shot. You can even shoot a series of still photos and transform them into a "storyboard" if you want, such as in Figure 7.2.

Figure 7.2 A storyboard is a series of simple sketches or photos to help visualize a segment of video.

Storytelling in Video

Today's audience is used to fast-paced, short scene storytelling. In order to produce interesting video for such viewers, it's important to view video storytelling as a kind of shorthand code for the more leisurely efforts print media offers. Audio and video should always be advancing the story. While it's okay to let the camera linger from time to time, it should only be for a compelling reason and only briefly.

It only takes a second or two for an establishing shot to impart the necessary information. For example, many of the scenes for a video documenting a model being photographed in a Rock and Roll music setting might be close-ups and talking heads, but an establishing shot showing the studio where the video was captured helps set the scene. (See Figure 7.3.)

Figure 7.3
An establishing shot from a distance sets the stage for closer views.

Provide variety too. Change camera angles and perspectives often and never leave a static scene on the screen for a long period of time. (You can record a static scene for a reasonably long period and then edit in other shots that cut away and back to the longer scene with close-ups that show each person talking.)

When editing, keep transitions basic! I can't stress this one enough. Watch a television program or movie. The action "jumps" from one scene or person to the next. Fancy transitions that involve exotic "wipes," dissolves, or cross fades take too long for the average viewer and make your video ponderous.

Composition

In movie shooting, several factors restrict your composition, and impose requirements you just don't always have in still photography (although other rules of good composition do apply). Here are some of the key differences to keep in mind when composing movie frames:

■ Horizontal compositions only. Some subjects, such as basketball players and tall buildings, just lend themselves to vertical compositions. But movies are shown in horizontal format only. So if you're interviewing a local basketball star, you can end up with a worst-case situation like the one shown in Figure 7.4. If you want to show how tall your subject is, it's often impractical to move back far enough to show him full-length. You really can't capture a vertical composition. Tricks like getting down on the floor and shooting up at your subject can exaggerate the perspective, but aren't a perfect solution.

- Wasted space at the sides. Moving in to frame the basketball player as outlined by the yellow box in Figure 7.4 means that you're still forced to leave a lot of empty space on either side. (Of course, you can fill that space with other people and/or interesting stuff, but that defeats your intent of concentrating on your main subject.) So when faced with some types of subjects in a horizontal frame, you can be creative, or move in *really* tight. For example, if I was willing to give up the "height" aspect of my composition, I could have framed the shot as shown by the green box in the figure, and wasted less of the image area at either side.
- Seamless (or seamed) transitions. Unless you're telling a picture story with a photo essay, still pictures often stand alone. But with movies, each of your compositions must relate to the shot that preceded it, and the one that follows. It can be jarring to jump from a long shot to a tight close-up unless the director—you—is very creative. Another common error is the "jump cut" in which successive shots vary only slightly in camera angle, making it appear that the main subject has "jumped" from one place to another. (Although everyone from French New Wave director Jean-Luc Goddard to Guy Ritchie—Madonna's ex—have used jump cuts effectively in their films.) The rule of thumb is to vary the camera angle by at least 30 degrees between shots to make it appear to be seamless. Unless you prefer that your images flaunt convention and appear to be "seamy."

Figure 7.4
Movie shooting requires you to fit all your subjects into a horizontally oriented frame.

■ The time dimension. Unlike still photography, with motion pictures there's a lot more emphasis on using a series of images to build on each other to tell a story. Static shots where the camera is mounted on a tripod and everything is shot from the same distance are a recipe for dull videos. Watch a television program sometime and notice how often camera shots change distances and directions. Viewers are used to this variety and have come to expect it. Professional video productions are often done with multiple cameras shooting from different angles and positions. But many professional productions are shot with just one camera and careful planning, and you can do just fine with your NEX-7.

Here's a look at the different types of commonly used compositional tools:

- Establishing shot. Much like it sounds, this type of composition, as shown earlier in Figure 7.3, establishes the scene and tells the viewer where the action is taking place. Let's say you're shooting a video of your offspring's move to college; the establishing shot could be a wide shot of the campus with a sign welcoming you to the school in the foreground. Another example would be for a child's birthday party; the establishing shot could be the front of the house decorated with birthday signs and streamers or a shot of the dining room table decked out with party favors and a candle-covered birthday cake. Or, in Figure 7.3, I wanted to show the studio where the video was shot.
- **Medium shot.** This shot is composed from about waist to head room (some space above the subject's head). It's useful for providing variety from a series of close-ups and also makes for a useful first look at a speaker. (See Figure 7.5.)
- Close-up. The close-up, usually described as "from shirt pocket to head room," provides a good composition for someone talking directly to the camera. Although it's common to have your talking head centered in the shot, that's not a requirement. In Figure 7.6 the subject was offset to the right. This would allow other images, especially graphics or titles, to be superimposed in the frame in a "real" (professional) production. But the compositional technique can be used with NEX-7 videos, too, even if special effects are not going to be added.
- Extreme close-up. When I went through broadcast training back in the '70s, this shot was described as the "big talking face" shot and we were actively discouraged from employing it. Styles and tastes change over the years and now the big talking face is much more commonly used (maybe people are better looking these days?) and so this view may be appropriate. Just remember, the NEX-7 is capable of shooting in high-definition video and you may be playing the video on a high-def TV; be careful that you use this composition on a face that can stand up to high definition. (See Figure 7.7.)
Figure 7.5
A medium shot is used to bring the viewer into a scene without shocking them. It can be used to introduce a character and provide context via their surroundings.

Figure 7.6

A close up generally shows the full face with a little head room at the top and down to the shoulders at the bottom of the frame.

Figure 7.7

An extreme close-up is a very tight shot that cuts off everything above the top of the head and below the chin (or even closer!). Be careful using this shot since many of us look better from a distance!

- **"Two" shot.** A two shot shows a pair of subjects in one frame. They can be side by side or one in the foreground and one in the background. This does not have to be a head to ground composition. Subjects can be standing or seated. A "three shot" is the same principle except that three people are in the frame. (See Figure 7.8.)
- Over the shoulder shot. Long a composition of interview programs, the "Over the shoulder shot" uses the rear of one person's head and shoulder to serve as a frame for the other person. This puts the viewer's perspective as that of the person facing away from the camera. (See Figure 7.9.)

Figure 7.8

A "two-shot" features two people in the frame. This version can be framed at various distances such as medium or close up.

An "over-the-shoulder" shot is a popular shot for interview programs. It helps make the viewers feel like they're the one asking the questions.

Lighting for Video

Much like in still photography, how you handle light pretty much can make or break your videography. Lighting for video can be more complicated than lighting for still photography, since both subject and camera movement are often part of the process.

Lighting for video presents several concerns. First off, you want enough illumination to create a useable video. Beyond that, you want to use light to help tell your story or increase drama. Let's take a better look at both.

Illumination

You can significantly improve the quality of your video by increasing the light falling in the scene. This is true indoors or out, by the way. While it may seem like sunlight is more than enough, it depends on how much contrast you're dealing with. If your subject is in shadow (which can help them from squinting) or wearing a ball cap, a video light can help make them look a lot better.

Lighting choices for amateur videographers are a lot better these days than they were a decade or two ago. An inexpensive incandescent video light, which will easily fit in a camera bag, can be found for \$15 or \$20. You can even get a good-quality LED video light for less than \$100. Work lights sold at many home improvement stores can also serve as video lights since you can set the camera's white balance to correct for any color casts. You'll need to mount these lights on a tripod or other support, or, perhaps, to a bracket that fastens to the tripod socket on the bottom of the camera.

Much of the challenge depends upon whether you're just trying to add some fill light on your subject versus trying to boost the light on an entire scene. A small video light will do just fine for the former. It won't handle the latter. Fortunately, the versatility of the NEX-7 comes in quite handy here. Since the camera shoots video in Auto ISO mode, it can compensate for lower lighting levels and still produce a decent image. For best results though, better lighting is necessary.

Creative Lighting

While ramping up the light intensity will produce better technical quality in your video, it won't necessarily improve the artistic quality of it. Whether we're outdoors or indoors, we're used to seeing light come from above. Videographers need to consider how they position their lights to provide even illumination while up high enough to angle shadows down low and out of sight of the camera.

When considering lighting for video, there are several factors. One is the quality of the light. It can either be hard (direct) light or soft (diffused). Hard light is good for showing detail, but can also be very harsh and unforgiving. "Softening" the light, but diffusing it somehow, can reduce the intensity of the light but make for a kinder, gentler light as well.

While mixing light sources isn't always a good idea, one approach is to combine window light with supplemental lighting. Position your subject with the window to one side and bring in either a supplemental light or a reflector to the other side for reasonably even lighting.

Lighting Styles

Some lighting styles are more heavily used than others. Some forms are used for special effects, while others are designed to be invisible. At its most basic, lighting just illuminates the scene, but when used properly it can also create drama. Let's look at some types of lighting styles:

- Three-point lighting. This is a basic lighting setup for one person. A main light illuminates the strong side of a person's face, while a fill light lights up the other side. A third light is then positioned above and behind the subject to light the back of the head and shoulders. (See Figure 7.10.)
- Flat lighting. Use this type of lighting to provide illumination and nothing more. It calls for a variety of lights and diffusers set to raise the light level in a space enough for good video reproduction, but not to create a particular mood or emphasize a particular scene or individual. With flat lighting, you're trying to create even lighting levels throughout the video space and minimize any shadows. Generally, the lights are placed up high and angled downward (or possibly pointed straight up to bounce off of a white ceiling). (See Figure 7.11.)

Figure 7.10 With three-point lighting, two lights are placed in front and to the side of the subject (45-degree angles are ideal) and positioned about a foot higher than the subject's head. Another light is directed on the background in order to separate the subject and the background. There's also a supplementary hair light above, behind, and to the left of the model.

Figure 7.11 Flat lighting is another approach for creating even illumination. Here the lights can be bounced off of a white ceiling and walls to fill in shadows as much as possible. It is a flexible lighting approach since the subject can change positions without needing a change in light direction.

- "Ghoul lighting." This is the style of lighting used for old horror movies. The idea is to position the light down low, pointed upwards. It's such an unnatural style of lighting that it makes its targets seem weird and ghoulish.
- Outdoor lighting. While shooting outdoors may seem easier because the sun provides more light, it also presents its own problems. As a general rule of thumb, keep the sun behind you when you're shooting video outdoors, except when shooting faces (anything from a medium shot and closer) since the viewer won't want to see a squinting subject. When shooting another human this way, put the sun behind her and use a video light to balance light levels between the foreground and background. If the sun is simply too bright, position the subject in the shade and use the video light for your main illumination. Using reflectors (white board panels or aluminum foil covered cardboard panels are cheap options) can also help balance light effectively.

Audio

When it comes to making a successful video, audio quality is one of those things that separates the professionals from the amateurs. We're used to watching top-quality productions on television and in the movies, yet the average person has no idea how much

effort goes in to producing what seems to be "natural" sound. Much of the sound you hear in such productions is actually recorded on carefully controlled sound stages and "sweetened" with a variety of sound effects and other recordings of "natural" sound.

Tips for Better Audio

Since recording high-quality audio is such a challenge, it's a good idea to do everything possible to maximize recording quality. Here are some ideas for improving the quality of the audio your camera records:

- Get the camera and its microphone close to the speaker. The farther the microphone is from the audio source, the less effective it will be in picking up that sound. While having to position the camera and microphone closer to the subject affects your lens choices and lens perspective options, it will make the most of your audio source. Of course, if you're using a very wide-angle lens, getting too close to your subject can have unflattering results, so don't take this advice too far.
- Use an external microphone. Plug a stereo or monaural mic into the jack on the side of the camera, and you'll immediately enjoy better sound, because you won't be recording noises including autofocus motors or your own breathing.
- Turn off any sound makers you can. Little things like fans and air handling units aren't obvious to the human ear, but will be picked up by the microphone. Turn off any machinery or devices that you can plus make sure cell phones are set to silent mode. Also, do what you can to minimize sounds such as wind, radio, television, or people talking in the background.
- Make sure to record some "natural" sound. If you're shooting video at an event of some kind, make sure you get some background sound that you can add to your audio as desired in postproduction.
- Consider recording audio separately. Lip-syncing is probably beyond most of the people you're going to be shooting, but there's nothing that says you can't record narration separately and add it later. It's relatively easy if you learn how to use simple software video-editing programs like iMovie (for the Macintosh) or Windows Movie Maker (for Windows PCs). Any time the speaker is off-camera, you can work with separately recorded narration rather than recording the speaker on-camera. This can produce much cleaner sound.

External Microphones

The single most important thing you can do to improve your audio quality is to use an external microphone. The NEX-7's internal stereo microphones mounted on the front of the camera will do a decent job, but have some significant drawbacks, partially spelled out in the previous section:

- Camera noise. The NEX-7's shutter may be relatively quiet, but there are plenty of other noise sources emanating from the camera, including your own breathing and rustling around as the camera shifts in your hand. Manual zooming is bound to affect your sound, and your fingers will fall directly in front of the built-in mics as you change focal lengths. An external microphone isolates the sound recording from camera noise.
- **Distance.** Anytime your camera is located more than 6-8 feet from your subjects or sound source, the audio will suffer. An external unit allows you to place the mic right next to your subject.
- Improved quality. Obviously, Sony isn't going to install a super-high quality microphone on this camera. Decent external microphones are not inexpensive, and you might want to spend \$100-\$150 or more on your own if you're serious about good sound.
- **Directionality.** The internal microphone generally records only sounds directly in front of it. An external microphone can be either of the directional type or omnidirectional, depending on whether you want to "shotgun" your sound or record more ambient sound.

You can choose from several different types of microphones, each of which has its own advantages and disadvantages. If you're avid about movie making with your NEX-7, you might want to own more than one. Common configurations include:

- **Shotgun microphones.** These can be mounted directly on your camera (with an adapter, if necessary). I prefer to use a bracket, originally intended for electronic flash units, which further isolates the microphone from any camera noise. Intended to pick up sound from the general direction in which it's pointed, such a microphone will provide decent pickup of ambient sound in its environment.
- Lapel microphones. Also called *lavalieres*, these microphones attach to the subject's clothing and picks up their voice with the best quality. You'll need a long enough cord or a wireless mic (described later). These are especially good for video interviews, so whether you're producing a documentary or grilling relatives for a family history, you'll want one of these.
- Handheld microphones. If you're capturing a singer crooning a tune, or want your subject to mimic famed faux newscaster Wally Ballou, a hand-held mic may be your best choice. They serve much the same purpose as a lapel microphone, and they're more intrusive—but that may be the point. A hand-held microphone can make a great prop for your fake newscast! The speaker can talk right into the microphone, point it at another person, or use it to record ambient sound. If your narrator is not going to appear on-camera, one of these can be an inexpensive way to improve sound.

■ Wired and Wireless external microphones. This option is the most expensive, but you get a receiver and a transmitter (both battery powered, so you'll need to make sure you have enough batteries). The transmitter is connected to the microphone, and the receiver is connected to your NEX-7's microphone port. In addition to being less klutzy and enabling you to avoid having wires on view in your scene, wireless mics let you record sounds that are physically located some distance from your camera. Of course you need to keep in mind the range of your device, and be aware of possible signal interference from other electronic components in the vicinity.

WIND NOISE REDUCTION

Always use the wind screen with an external microphone to reduce the effect of noise produced by even light breezes blowing over the microphone. Both the camera and many mics include a low-cut filter to further reduce wind noise. However, these can also affect other sounds. You can disable the low-cut filters for many microphones with a switch.

Lens Craft

I'll cover the use of lenses with the NEX-7 in more detail in Chapter 8, but a discussion of lens selection when shooting movies may be useful at this point. In the video world, not all lenses are created equal. The two most important considerations are depth-of-field, or the beneficial lack thereof, and zooming. I'll address each of these separately.

Depth-of-Field and Video

Have you wondered why professional videographers have gone nuts over still cameras that can also shoot video? The producers of *Saturday Night Live* could afford to have Alex Buono, their director of photography, use the niftiest, most expensive high-resolution video cameras to shoot the opening sequences of the program. Instead, Buono opted for a pair of digital SLR cameras. One thing that makes digital still cameras so attractive for video is that they have relatively large sensors, which provides improved low-light performance and results in the oddly attractive reduced depth-of-field, compared with most professional video cameras.

Figure 7.12 provides a comparison of the relative size of sensors. The typical size of a professional video camera sensor is shown at lower left. The APS-C sized sensor used in the NEX-7 is shown just north of it. You can see that it is much larger, especially when compared with the sensor found in the typical point-and-shoot camera and most other mirrorless models (at right). Of course, the full-frame sensors found in some

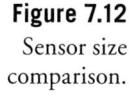

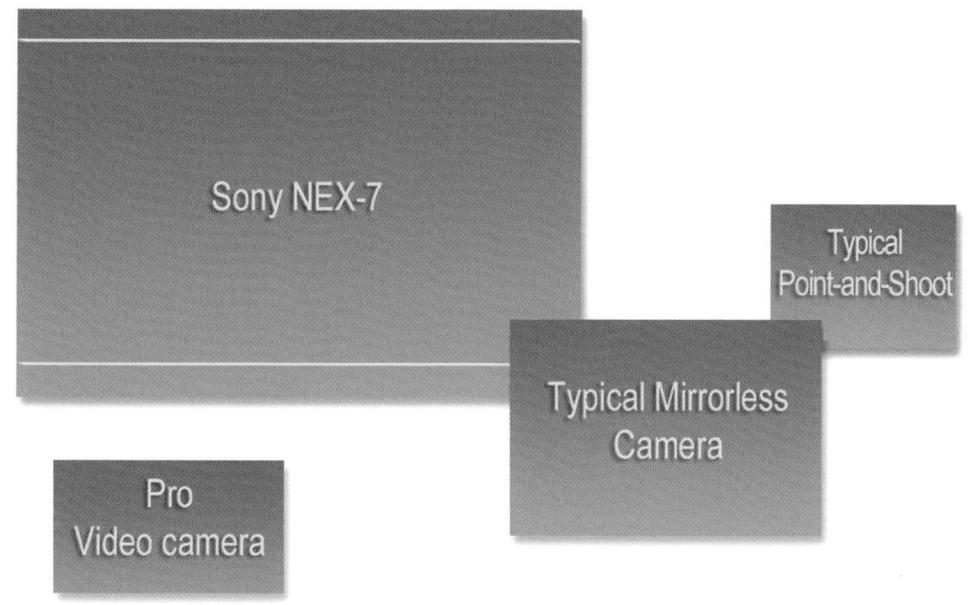

models, including the Sony Alpha SLT-A99 are even larger. But, compared with the sensors used in many pro video cameras and the even smaller sensors found in the typical camcorder, the NEX-7's image-grabber is larger.

As you'll learn in Chapter 8, a larger sensor calls for the use of longer focal lengths to produce the same field of view, so, in effect, a larger sensor has reduced depth-of-field. And *that's* what makes cameras like the NEX-7 attractive from a creative standpoint. Less depth-of-field means greater control over the range of what's in focus. Your NEX-7, with its larger sensor, has a distinct advantage over consumer camcorders in this regard, and even does a much better job than professional video cameras.

Zooming and Video

When shooting still photos, a zoom is a zoom. The key considerations for a zoom lens used only for still photography are the maximum aperture available at each focal length ("How *fast* is this lens?), the zoom range ("How far can I zoom in or out?"), and its sharpness at any given f/stop ("Do I lose sharpness when I shoot wide open?").

When shooting video, the priorities may change, and there are two additional parameters to consider. The first two I listed, lens speed and zoom range, have roughly the same importance in both still and video photography. Zoom range gains a bit of importance in videography, because you can always/usually move closer to shoot a still photograph, but when you're zooming during a shot most of us don't have that option (or the funds to buy/rent a dolly to smoothly move the camera during capture). But, oddly

enough, overall sharpness may have slightly less importance under certain conditions when shooting video. That's because the image changes in some way many times per second (30/60 times per second), so any given frame doesn't hang around long enough for our eyes to pick out every single detail. You want a sharp image, of course, but your standards don't need to be quite as high when shooting video.

Here are the remaining considerations, and the two new ones:

- Zoom lens maximum aperture. The speed of the lens matters in several ways. A zoom with a relatively large maximum aperture lets you shoot in lower light levels, and a big f/stop allows you to minimize depth-of-field for selective focus. Keep in mind that the maximum aperture may change during zooming. The 18-55mm kit lens is an f/3.5 lens at the 18mm focal length, but provides only f/5.6 worth of light at 55mm.
- Zoom range. Use of zoom during actual capture should not be an everyday thing, unless you're shooting a kung-fu movie. However, there are effective uses for a zoom shot, particularly if it's a "long" one from extreme wide angle to extreme close-up (or vice versa). The Sony 18-200mm zoom, which has a relatively quiet autofocus motor and built-in image stabilization, can be used in this way. Most of the time, you'll use the zoom range to adjust the perspective of the camera between shots, and a longer zoom range can mean less trotting back and forth to adjust the field of view. Zoom range also comes into play when you're working with selective focus (longer focal lengths have less depth-of-field), or want to expand or compress the apparent distance between foreground and background subjects. A longer range gives you more flexibility.
- Power zoom. An ideal movie zoom should have a power zoom feature, something that's not yet available for the NEX-7. A power zoom can be optimized for video shooting. Manual zooming with other lenses during capture can produce jerky images, even with vibration reduction turned on. A power zoom gives you smooth zooming, and you can change the speed of the zoom easily as you press the button on the lens.
- Linearity. Interchangeable lenses may have some drawbacks, as many photographers who have been using the video features of their digital SLRs have discovered. That's because, unless a lens is optimized for video shooting, zooming with a particular lens may not necessarily be linear. Rotating the zoom collar manually at a constant speed doesn't always produce a smooth zoom. There may be "jumps" as the elements of the lens shift around during the zoom. Keep that in mind if you plan to zoom during a shot, and are using a non-linear lens (which will be virtually all the lenses at your disposal, unless you have a special E-mount cine lens, or can mount one on your NEX-7 with an adapter).

Working with Lenses

In one sense, your choices of lenses for your NEX-7 camera are (currently) somewhat limited. As I write this, there are only a few lenses, including the 18-55mm f/3.5-5.6 "kit" lens and 16mm f/2.8 wide-angle "pancake" lens for the NEX-series cameras. Other optics include a superb 24mm f/1.8 Zeiss wide angle, a 55-210mm zoom, and a pair of 18-200mm f/3.5-6.3 E-mount lenses—one from Sony, and one from Tamron—both with image stabilization built in. Though the pickings remain slim, it's a good sign when third parties like Tamron begin providing support of the Sony Alpha mirrorless models.

Of course, in another sense, there are dozens of lenses that will work reasonably well with the NEX-7, even if they weren't specifically made for it. Any of the Sony or Minolta lenses designed for the Alpha dSLR line, as well as third-party lenses offered for those cameras will work—as long as you purchase an A-mount-to-E-mount adapter. The LA-EA1 adapter (about \$200) allows Single-shot autofocus with 14 A-mount SAM and SSM lens models. Single shot ΛF is also possible while recording a movie by pressing the shutter button halfway down. There is also the LA-EA2 adapter (about \$400) which allows sophisticated Phase Detection autofocus (described in Chapter 5) with virtually the full line of Alpha A-mount optics.

With any luck, Sony will adapt many more of its existing lens offerings to the E-mount, and that happy future possibility should be kept in mind as you read this chapter. In it, I explain how to select the best lenses for the kinds of photography you want to do, and how to take advantage of the perspectives that different focal lenses and zoom settings provide.

But Don't Forget the Crop Factor

From time to time you've heard the term *crop factor*, and you've probably also heard the term *lens multiplier factor*. Both are misleading and inaccurate terms used to describe the same phenomenon: the fact that cameras like the Sony Alpha NEX (and most other affordable digital cameras with interchangeable lenses) provide a field of view that's smaller and narrower than that produced by certain other (usually much more expensive) cameras, when fitted with exactly the same lens. The correct term for the effect would probably be something like *field of view equivalency factor*, which, while accurate, doesn't provide the clear indication of what's taking place like the other two terms.

Figure 8.1 quite clearly shows the phenomenon at work. The outer rectangle, marked 1X, shows the field of view you might expect with a 50mm lens mounted on a so-called "full-frame" digital model like the Alpha SLT-A99, or a 35mm film camera, like the 1985 Minolta Maxxum 7000 (which happened to be the first SLR to feature both autofocus and motorized advance, something we take for granted in the digital SLR age). The rectangle marked 1.5X shows the field of view you'd get with that 50mm lens installed on a Sony Alpha SLT or Alpha NEX model. It's easy to see from the illustration that the 1X rendition provides a wider, more expansive view, while the other view is, in comparison, *cropped*.

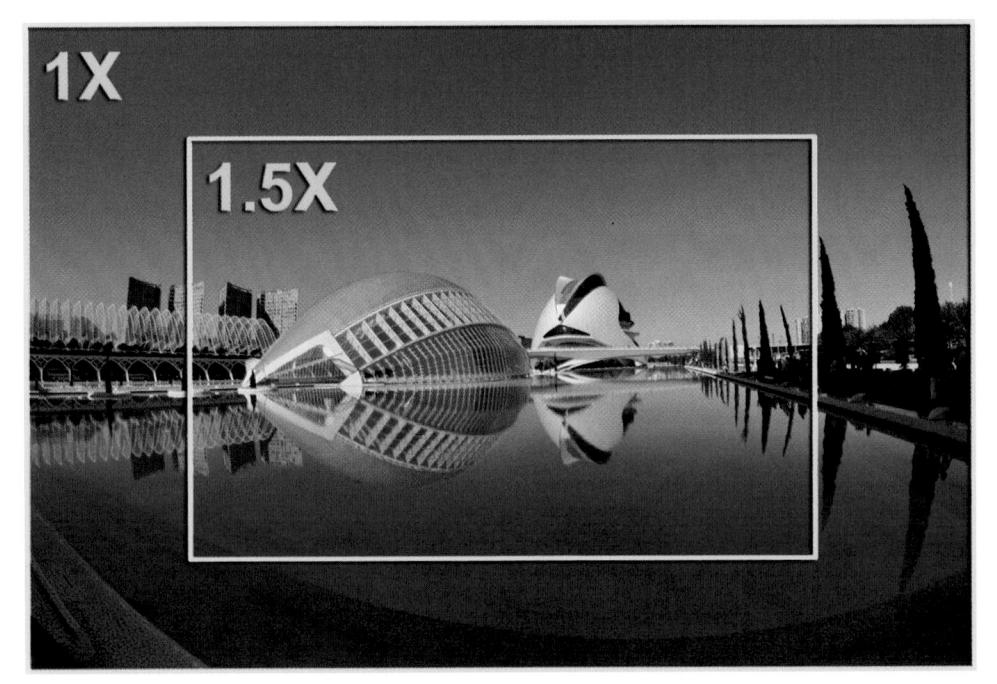

Figure 8.1 Sony offers digital cameras with full-frame (1X) views, as well as 1.5X crops.

The cropping effect is produced because the sensors of the NEX-7 are smaller than the sensors of a full-frame camera, like the SLT-A99. The "full-frame" camera has a sensor that's the size of the standard 35mm film frame, 24mm × 36mm. Your Sony Alpha's sensor does *not* measure 24mm × 36mm; instead, it specs out at roughly 24 × 16mm, or about 66 percent of the area of a full-frame sensor, as shown by the yellow boxes in the figure. You can calculate the relative field of view by dividing the focal length of the lens by .667. Thus, a 100mm lens mounted on a Sony Alpha NEX has the same field of view as a 150mm lens on a full-frame camera like the A850. We humans tend to perform multiplication operations in our heads more easily than division, so such field of view comparisons are usually calculated using the reciprocal of .667—1.5—so we can multiply instead. (100 / .667=150; 100 × 1.5=150.)

This translation is generally useful only if you're accustomed to using a full-frame camera (usually of the film variety) and want to know how a familiar lens will perform on a digital camera. I strongly prefer *crop factor* to *lens multiplier*, because nothing is being multiplied; a 100mm lens doesn't "become" a 150mm lens—the depth-of-field and lens aperture remain the same. (I'll explain more about these later in this chapter.) Only the field of view is cropped. But the term *crop factor* isn't much better, as it implies that the 24 × 36mm frame is "full" and anything else is "less." I get e-mails all the time from photographers who point out that they own full-frame cameras with 36mm × 48mm—and larger—sensors (like the Mamiya 645DF with a Leaf Aptus II digital back, or the Hasselblad H4D-50 medium-format digital camera). By their reckoning, the "half-size" sensors found in full-frame cameras like the Sony Alpha SLT-A99 are "cropped."

If you're accustomed to using a full-frame film camera, you might find it helpful to use the crop factor "multiplier" to translate a lens's real focal length into the full-frame equivalent, even though, as I said, nothing is actually being multiplied. Throughout most of this book, I've been using actual focal lengths and not equivalents, except when referring to specific wide-angle or telephoto focal length ranges and their fields of view.

Choosing a Lens

The Sony Alpha is most frequently purchased with a lens, often the SEL-1855 18-55mm f/3.5-5.6 zoom lens. (See Figure 8.2.) You might prefer the compact SEL-16F28 pancake lens (shown mounted on the NEX-7 in Figure 8.3) for minimum size and maximum portability. Or, if you want a do-everything, walk-around lens, you might prefer the SEL-18200 18-200mm f/3.5-6.3 OSS zoom. If you already own some lenses for an Alpha camera, you might want to just purchase one of two E-mount adapters and use the lenses you already have.

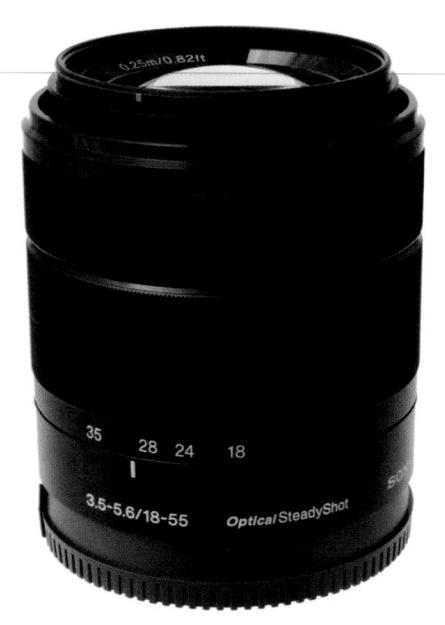

Figure 8.2 This 18-55mm lens is the most popular starter lens for the Sony Alpha NEX-7 camera.

Figure 8.3 This "pancake" lens provides extra compactness.

For starter lenses, here are some of your choices:

- Sony SEL-1855 18-55mm OSS f/3.5-5.6 zoom lens. This lens is sharp, small in size, and is fast enough at the wide-angle end of its zoom range for most available light shooting, although it's a stop and a half slower at the telephoto end. Priced at less than \$300 if purchased separately, this lens is an all-around good choice. The version shown in Figure 8.2 is the nifty all-black edition built (at this writing) especially for the NEX-7. Earlier NEX models got a bright silver-toned kit lens that was less desirable for "stealth" shooting.
- Sony SEL-16F28 16mm f/2.8 lens. This flat, pancake-style lens is also sharp, even more diminutive in size, and is fast enough for most available light shooting. Priced at \$230 if purchased separately, this lens is an all-around good choice. It also accepts two add-on converter lenses, which I'll describe shortly.
- Sony SEL-18200 OSS 18-200mm f/3.5-6.3 zoom lens. This lens dwarfs the NEX-7, and is very slow at its maximum telephoto setting, but has a long enough focal length range to suit most everyday shooting. It's expensive, though, at \$800. Like the kit lens, this one has built-in image stabilization (Optical SteadyShot) for improved sharpness at longer exposure times. At the maximum 200mm focal length, you should notice an improvement in blur reduction at any shutter speed slower than 1/250th second.

Add-on lenses range from the sublime to the meticulous, and can prove useful for various kinds of photographs, from low light to close-up to telephoto photography. Currently available lenses include:

- Sony SEL-24F18Z Carl Zeiss Sonnar T* E 24mm F/1.8 ZA lens. This \$1,000 mid wide-angle is perfect for low-light street photography with its f/1.8 maximum aperture, great for indoor sports up close (you might like it for basketball when shooting at the baseline), and interior photography where an ultra-wide view is not crucial (think larger venues, cathedrals, and museums where flash is prohibited). Bearing the legendary Carl Zeiss Sonnar names, and upscale T* (T-star) branding, this lens could easily be the star of your stable. It's pricey, and not exactly compact at 2 3/8 × 2 1/2-inches and nearly 8 ounces, but if you need its speed and viewing angle, nothing else will do the job. (See Figure 8.4.) This lens can be hard to find. I actually purchased mine while I was still waiting for my NEX-7 to arrive, as there was no guarantee that I'd be able to get one when the cameras resumed deliveries. I'm glad I didn't wait, as this is a superb lens.
- Sony SEL-50F18 50mm F1.8 OSS telephoto lens. A more affordable low-light lens at \$300, this one is a short telephoto that can serve as a street photography lens from moderate distances, and a portrait lens with a wide enough maximum aperture to allow you to blur the backgrounds. Optical image stabilization (OSS) lets you shoot at slower shutter speeds, making this an exceptional lens for available light photography.

Fast, sharp, and expensive, this Zeiss 24mm f/1.8 optic is one of the best you can buy for the NEX-7.

- Sony SEL-55210 55-210mm F4.5-6.3 OSS lens. This is another affordable OSS lens, priced at \$350, with enough telephoto reach for most sports and wildlife photography, if you can abide its f/4.5 to f/6.3 maximum aperture. You probably won't be shooting this lens wide open anyway, and the image stabilization will let you stop down to f/8 at reasonable shutter speeds (you may be able to go as slow as 1/60th second if your subject isn't moving at high speed). At this writing, Sony doesn't have a fast medium to long telephoto in E-mount, so this lens and the 18-200mm are your choices.
- Sony SEL-30M35 30mm macro lens. Featuring a minimum working distance of about one inch with 1:1 magnification, this 30mm f/3.5 macro lens for your NEX camera lets you capture close-up images at reasonable distances.
- Sony VCL-ECU1 wide-angle conversion lens. This five-ounce, \$149 converter (it's not a true standalone lens) mounts on your 16mm f/2.8 pancake wide-angle, transforming the 24mm equivalent wide angle into a super-wide 18mm (equivalent) lens. (See Figure 8.5, left.) I've gotten great results from mine, although it works best when the host lens is stopped down at least one or two apertures from wide open.
- Sony VCL-ECF1 fisheye conversion lens. This five-ounce, \$149 converter (it's not a true standalone lens) mounts on your 16mm f/2.8 pancake wide-angle to give you a fisheye view for interesting landscapes, interiors, and other subjects. Given that fisheye lenses are typically used infrequently by most shooters, the low cost of this accessory offsets the less than tack-sharp results you can expect. (See Figure 8.5, right, and mounted on the 16mm f/2.8 in Figure 8.6.)

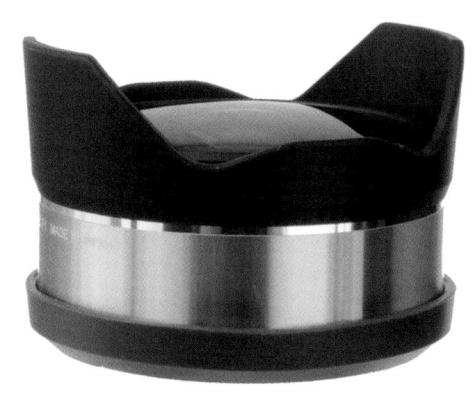

Figure 8.5 Wide-angle converter (left); fisheye converter (right).

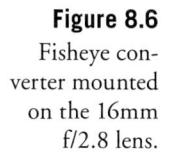

Using the LA-EA1 and LA-EA2 Adapters

If you're willing to buy one of the two A-mount to E-mount adapters, and you already own other lenses in the Alpha lineup, your choices expand. The LA-EA1 adapter (see Figure 8.7) was introduced with the first models in the NEX lineup, and had some serious shortcomings. It was not cheap, at \$200, and didn't allow even Contrast Detection autofocus with most A-mount lenses, that is, until a firmware upgrade added compatibility with a limited list of optics. However, it was fairly affordable, and I actually picked mine up for a reduced price of \$129.

Given the price difference between this model and the LA-EA2, described next, I expect Sony will keep the LA-EA1 in its lineup, at least for awhile, as a perk for cash-strapped NEX owners who have a few A-mount lenses they'd like to use from time to time. The following SAM and SSM lenses can operate in single focus mode with this adapter.

SAM lenses

DT 18-55mm F3.5-5.6 SAM [SAL1855]

28-75mm F2.8 SAM [SAL2875]

DT 55-200mm F4-5.6 SAM [SAL55200-2]

DT 30mm F2.8 Macro SAM [SAL30M28]

DT 35mm F1.8 SAM [SAL35F18]

DT 50mm F1.8 SAM [SAL50F18]

85mm F2.8 SAM [SAL85F28]

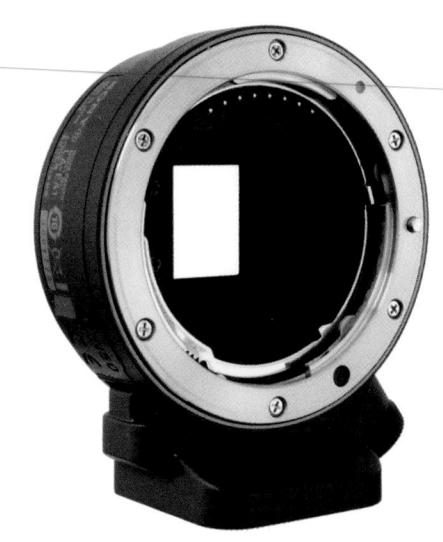

Figure 8.7
Buy this adapter and you can use any Minolta or Sony dSLR lens on your NEX.

SSM lenses

Vario-Sonnar T* 16-35mm F2.8 ZA SSM [SAL1635Z] Vario-Sonnar T* 24-70mm F2.8 ZA SSM [SAL2470Z] Distagon T* 24mm F2 ZA SSM [SAL24F20Z] 70-200mm F2.8 G [SAL70200G] 70-300mm F4.5-5.6 G SSM [SAL70300G] 70-400mm F4-5.6 G SSM [SAL70400G] 300mm F2.8 G [SAL300F28G]

The LA-EA2 adapter is a much more satisfactory solution, but, at \$400, it costs a lot more, too. For some, it may be worth the price because it offers full-time Phase Detection autofocus, just like the NEX's SLT and dSLR siblings, with A-mount lenses, including useful optics like the 30mm f/2.8 macro lens and 18-200mm zoom shown in Figure 8.8. This miracle solution involves, basically, building a version of Sony's Translucent Mirror Technology, found in the SLT cameras, into an adapter, as you can see in the exploded diagram shown in Figure 8.9. (In actual use, the lens and camera must be physically mounted to the adapter.)

If you're not familiar with the SLT cameras, light from the lens reaches a semi-silvered non-moving mirror, with 70 percent continuing through the mirror and adapter to the NEX-7's sensor. The 30 percent of the light reflected downwards by the mirror is directed through a lens and another mirror to a 15-point AF sensor with three extrasensitive cross-type sensors. The camera magically gains the same on-screen AF point selection options and high-speed Phase Detection autofocus in both Continuous AF and Single-shot modes as its SLT stablemates, and an electronic aperture drive mechanism allows full autoexposure functions with all A-mount lenses (except those used with a teleconverter). Virtually any Sony/Minolta A-mount lens can be used.

Figure 8.8

A-mount lenses like this 30mm macro lens (left) and 18-200mm zoom can be used on the NEX-7 with an adapter.

Figure 8.9 The design of the LA-EA2 adapter looks like this.

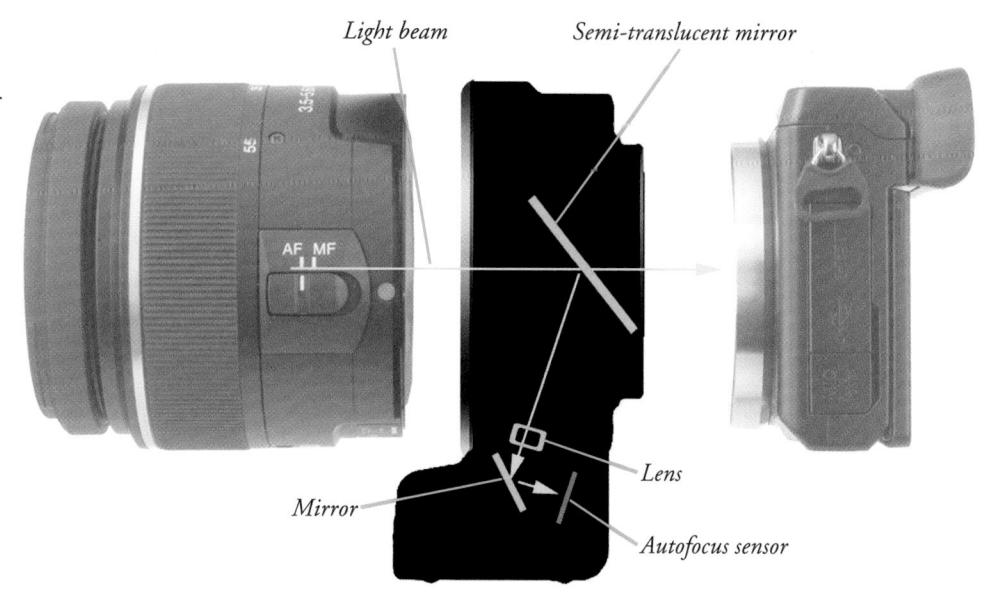

WATCH THAT WEIGHT

Be aware than the NEX-7's lens mount isn't constructed to support the weight of very large lenses, such as the ones you might attach using either A-mount adapter (see Figure 8.10). Support the lens by placing your hand under it (the tripod mount shown in the figure is a good choice), and if using the setup on a tripod or monopod, attach the device to the tripod mount on the adapter, and not to the NEX-7's own tripod thread.

Figure 8.10
Large lenses call for extra support.

The seven-ounce, $3\ 1/8 \times 3\ 1/2 \times 1\ 3/4$ inch adapter is large, but it has a built-in tripod mount, so you can use it with large, heavy lenses that don't have a tripod mount of their own. For \$400 (plus the cost of your A-mount lenses), you can convert your NEX-7 mirrorless camera into one with a mirror! I'm glad Sony has made these accessories available for the NEX-7, but find it amusing that such a petite camera can be fitted with pounds and pounds of adapters, lenses, and viewfinders that transform it from a compact model to one that's easily the same size—or larger—than the SLT and dSLR alternatives.

Other Lens Options

Because of the popularity of the NEX camera line, third-party vendors are rushing to produce adapters and lenses for these models. Tamron has already introduced an 18-200mm Di III VC lens for E-mount cameras, with the same f/stop range (and limitations) of Sony's own 18-200mm optic, and with Tamron's version of OSS, called VC (for Vibration Compensation). I expect additional lenses from Tamron and other vendors (including several new lenses just announced by Sigma) as the number of NEX cameras proliferates.

Because the NEX's "flange to sensor" distance is relatively short, there's room to introduce other types of adapters between the camera and lens, and still allow focusing all the way to infinity. There are already a huge number of adapters that allow mounting just about any lens you can think of on the NEX-7, if you're willing to accept manual focus and, usually, a ring on the adapter that's used to stop down the "adopted" lens to the aperture used to make the exposure. You can find these from Fotodiox (www.fotodiox.com), Rainbow Imaging (www.rainbowimaging.biz), Novoflex (www.novoflex.com), Cowboy Studio (www.cowboystudio.com), and others. Prices range from \$20-\$30 up to around \$250 (for the jewel-like, high-precision Novoflex products). You may not be able to autofocus with any of these, but you can usually retain automatic exposure by setting the NEX-7 to Aperture priority, stopping down to the f/stop you prefer, and firing away. Figure 8.11 shows a Nikon-to-E-Mount adapter I bought from Fotodiox.

My absolute favorite lens bargain is the 35mm f/1.7 Fujian (no relation to Fuji) optic, which I purchased brand new for a total of \$38, with the E-mount adapter included in the price (see Figure 8.12). It's actually a tiny CCTV (closed-circuit television) lens in C-mount (a type of lens mount used for cine cameras). Manual focus and manual f/stop, of course (and it works in Aperture priority on my NEX-7); it's either a toy lens, a super-cheap Lens Baby (described next), or a great experimental lens for fooling around. It covers the full APS-C frame (more or less; expect a bit of vignetting in the corners at some f/stops), is not incredibly sharp wide open, and exhibits a weird kind of "bokeh" (out-of-focus rendition of highlights) that produces fantasy-like images. The only drawback (or additional drawback, if you will) is that you may have to hunt some to find one; the manufacturer doesn't sell directly in the USA. I located mine on Amazon.com.

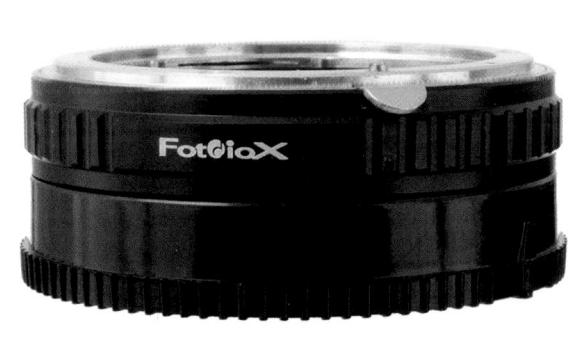

Figure 8.11 Mount Nikon lenses on your NEX-7 with this adapter.

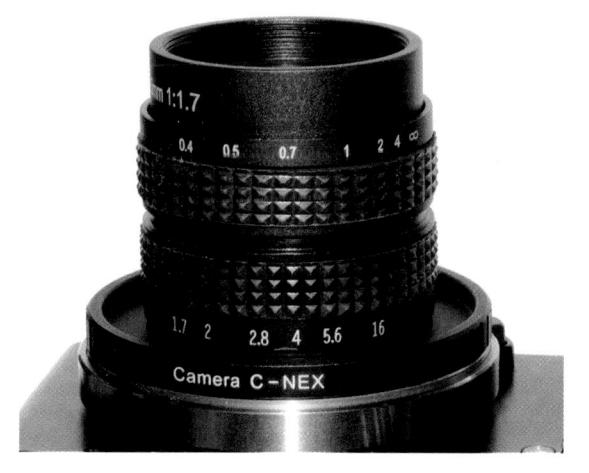

Figure 8.12 This 35mm f/1.7 CCTV lens makes a great "toy" for your NEX-7.

Once you have the included C-mount to E-mount adapter, there are a host of other similar CCTV lenses you can attach to your NEX-7. Also relatively cheap, but not necessarily of equal quality, are a 25mm f/1.4, a Tamron 8mm f/1.4, and other lenses that I haven't tried and probably won't cover the APS-C image area, but are worth borrowing to try out if you have a friend who does CCTV.

Using the Lensbaby

The Lensbaby, which comes in several varieties, including the Composer Pro shown in Figure 8.13, uses distortion-heavy glass elements mounted on a system that allows you to bend, twist, and distort the lens's alignment to produce transmogrified images unlike anything else you've ever seen. Like the legendary cheap-o Diana and Holga cameras, the pictures are prized expressly because of their plastic image quality. Jack and Meg White of the White Stripes are, in fact, selling personalized Diana and Holga cameras on their website for wacky *lomography* (named after the Lomo, another low-quality/high-concept camera). The various Lensbaby models are for more serious photographers, if you can say that about anyone who yearns to take pictures that look like they were shot through a glob of corn syrup.

Lensbabies are capable of creating all sorts of special effects. You use a Lensbaby by shifting the front mount to move the lens's sweet spot to a particular point in the scene. This is basically a selective focus lens that gets very soft outside the sweet spot. There

Figure 8.13 Lensbaby Composer Pro.

are several different types of Lensbabies. The new Lensbaby Edge provides a narrow band of sharp focus, similar to what you get with shift-tilt lenses.

- **Macro.** A Lensbaby accessory makes it possible to use this tool for macro photography.
- Wide-angle/telephoto conversion. Add-on lenses convert the basic Lensbaby into a wide-angle or telephoto version.
- Creative aperture kit. Various shaped cutouts can be used in place of the regular aperture inserts that control depth-of-field. These shapes can include things like hearts, stars, and other shapes.
- Optic swap kit. This three-lens accessory kit provides different adapters that include a pinhole lens, plastic lens, and single glass lens.

The latest Lensbaby models, like the Composer Pro, have the same shifting, tilting lens configuration as previous editions, but are designed for easier and more precise distorting movements. Hold the camera with your finger gripping the knobs as you bend the camera to move the central "sweet spot" (sharp area) to any portion of your image. With two (count 'em) multicoated optical glass lens elements, you'll get a blurry image, but the amount of distortion is under your control. F/stops from f/2 to f/22 are available to increase/decrease depth-of-field and allow you to adjust exposure. The 50mm lens focuses down to 12-inches and is strictly manual focus/manual exposure in operation. At \$300 or so, Lensbabies are not a cheap accessory, but there is really no other easy way to achieve the kind of looks you can get with a Lensbaby.

Figure 8.14 is an example of the type of effect you can get, in a photograph crafted by Cleveland photographer Nancy Balluck. She also produced the back cover photography of yours truly, and one of her specialties is Lensbaby effects. Nancy regularly gives demonstrations and classes on the use of these optics, and you can follow her work at www.nancyballuckphotography.com.

What Lenses Can Do for You

A sane approach to expanding your lens collection is to consider what each of your options can do for you and then choose the type of lens that will really boost your creative opportunities. Here's a general guide to the sort of capabilities you can gain by adding a lens (using an adapter, if necessary) to your repertoire.

■ Wider perspective. Your 18-55mm f/3.5-5.6 lens has served you well for moderate wide-angle shots. Now you find your back is up against a wall and you *can't* take a step backwards to take in more subject matter. Perhaps you're standing on the rim of the Grand Canyon, and you want to take in as much of the breathtaking view

Figure 8.14 Everything is uniquely blurry outside the Lensbaby's "sweet spot," but you can move that spot around within your frame at will. They can be used for selective focus effects, and can simulate the dreamy look of some old-style cameras.

as you can. You might find yourself just behind the baseline at a high school basketball game and want an interesting shot with a little perspective distortion tossed in the mix. If you own either of the E-mount adapters (or can wait until Sony introduces additional E-mount wide-angle lenses), there's a wider lens in your future. Consider the SAL-1118, DT 11-18mm f/4.5-5.6 super-wide zoom lens or SAL-16F28 16mm f/2.8 fisheye lens. With these lenses, the need to manually focus when using the LA-EA1 adapter is less acute: wide-angle lenses have such prodigious depth-of-field that exact focus is less critical, except when shooting up close (closer than about six feet). Figure 8.15 shows the perspective you get from an ultrawide-angle lens, like the 16mm f/2.8 with the Sony VCL-ECU1 wide-angle conversion lens.

- Bring objects closer. A long lens brings distant subjects closer to you, offers better control over depth-of-field, and avoids the perspective distortion that wide-angle lenses provide. They compress the apparent distance between objects in your frame. In the telephoto realm, Sony is right in the ballgame, with lenses like the new E-Mount 18-200mm telephoto zoom I mentioned earlier to some (adaptable) super high-end models like the SAL-70200G 70-200mm f/2.8 G-series telephoto zoom. (You'll pay \$1,800 for this baby; that's rather expensive for a "manual focus" lens, so it would be best if you planned to use it with a DSLR Alpha as well.) Remember that the Sony Alpha's crop factor narrows the field of view of all these lenses, so your 70-200mm lens looks more like a 105mm-300mm zoom through the view-finder. Figures 8.16 and 8.17 were taken from the same position as Figure 8.15, but with an 85mm and 500mm lens, respectively.
- Bring your camera closer. If you don't want to purchase the \$278 SEL30M35 30mm f/3.5 E-mount macro, Sony has three excellent A-mount close-up lenses you might already own or can borrow, the SAL-30M28 30mm f/2.8 macro lens, the SAL-50M28 50mm f/2.8 macro lens, and the SAL-100M28 100mm f/2.8 macro lens.

The need to manually focus several of these A-mount lenses when used with the cheaper LA-EA1 adapter is not a tremendous hardship. (The A-mount 30mm f/2.8 macro does autofocus with the adapter, but is so slow in that mode, I usually mount my camera on a tripod and focus manually when shooting macros, anyway.) So, more often than not, I end up using my A-mount 30mm lens macro lens on my NEX-7. It is the most reasonably priced in the group at \$200 (very inexpensive for a true macro if you already own the adapter), but paying \$479 with the 50mm lens, or \$679 for the 100mm version is not out of order for someone who wants to shoot close-up subjects but wants to stay farther away from a subject to provide more flexibility in lighting and enough distance to avoid spooking small wildlife.

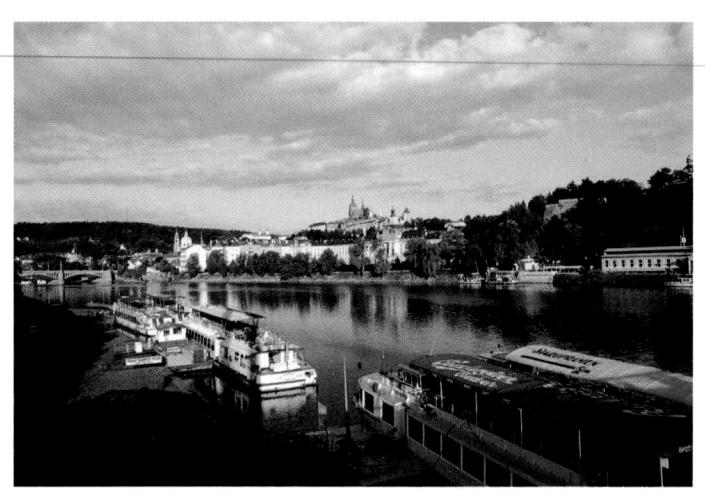

Figure 8.15
An ultrawideangle lens provided this view
of a castle in
Prague.

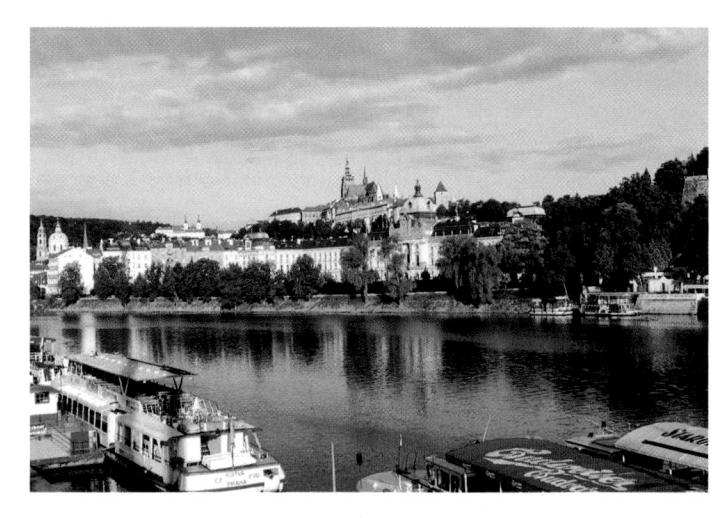

Figure 8.16
This photo, taken from roughly the same distance shows the view using a short telephoto lens.

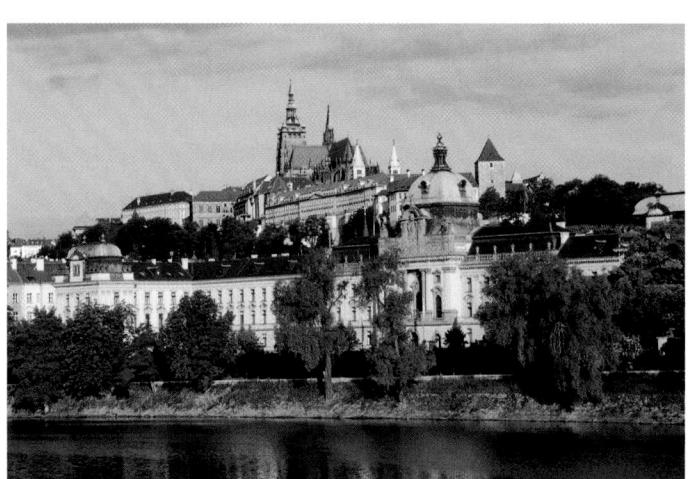

Figure 8.17
A longer telephoto lens captured this closer view from approximately the same shooting position.

- Look sharp. Many lenses, particularly the higher priced Sony optics, are prized for their sharpness and overall image quality. While your run-of-the-mill lens is likely to be plenty sharp for most applications, the very best optics are even better over their entire field of view (which means no fuzzy corners), are sharper at a wider range of focal lengths (in the case of zooms), and have better correction for various types of distortion. That, along with a constant f/2.8 maximum aperture, is why the 70-200mm f/2.8 lens I mentioned earlier sells for \$1,800.
- More speed. Your basic lens might have the perfect focal length and sharpness for sports photography, but the maximum aperture won't cut it for night baseball or football games, or, even, any sports shooting in daylight if the weather is cloudy or you need to use some ungodly fast shutter speed, such as 1/4,000th second. That makes the E-mount 24mm f/1.8 optic a prime choice (so to speak) for low light photography. But, you might be happier with an adapter and the Carl Zeiss SAL-135F18Z 135mm f/1.8 lens (if money is no object, it costs \$1,400). But there are lower cost fast lens options, such as the SAL-50F14 50mm f/1.4 lens (\$350), which might be suitable for indoor sports such as basketball or volleyball.

Categories of Lenses

Lenses can be categorized by their intended purpose—general photography, macro photography, and so forth—or by their focal length. The range of available focal lengths is usually divided into three main groups: wide-angle, normal, and telephoto. Prime lenses fall neatly into one of these classifications. Zooms can overlap designations, with a significant number falling into the catchall wide-to-telephoto zoom range. This section provides more information about focal length ranges, and how they are used.

Any lens with an equivalent focal length of 10mm to 20mm is said to be an *ultrawide-angle lens*; from about 20mm to 40mm (equivalent) is said to be a *wide-angle lens*. Normal lenses have a focal length roughly equivalent to the diagonal of the film or sensor, in millimeters, and so fall into the range of about 45mm to 60mm (on a full framc camera). Telephoto lenses usually fall into the 75mm and longer focal lengths, while those from about 300mm-400mm and longer often are referred to as *super-telephotos*.

Using Wide-Angle and Wide-Zoom Lenses

To use wide-angle prime lenses and wide zooms, you need to understand how they affect your photography. Here's a quick summary of the things you need to know.

■ More depth-of-field. Practically speaking, wide-angle lenses offer more depth-of-field at a particular subject distance and aperture. (But see the sidebar below for an important note.) You'll find that helpful when you want to maximize sharpness of a large zone, but not very useful when you'd rather isolate your subject using selective focus (telephoto lenses are better for that).

- Stepping back. Wide-angle lenses have the effect of making it seem that you are standing farther from your subject than you really are. They're helpful when you don't want to back up, or can't because there are impediments in your way.
- Wider field of view. While making your subject seem farther away, as implied above, a wide-angle lens also provides a larger field of view, including more of the subject in your photos.
- More foreground. As background objects retreat, more of the foreground is brought into view by a wide-angle lens. That gives you extra emphasis on the area that's closest to the camera. Photograph your home with a normal lens/normal zoom setting, and the front yard probably looks fairly conventional in your photo (that's why they're called "normal" lenses). Switch to a wider lens and you'll discover that your lawn now makes up much more of the photo. So, wide-angle lenses are great when you want to emphasize that lake in the foreground, but problematic when your intended subject is located farther in the distance.
- Super-sized subjects. The tendency of a wide-angle lens to emphasize objects in the foreground, while de-emphasizing objects in the background, can lead to a kind of size distortion that may be more objectionable for some types of subjects than others. Shoot a bed of flowers up close with a wide angle, and you might like the distorted effect of the larger blossoms nearer the lens. Take a photo of a family member with the same lens from the same distance, and you're likely to get some complaints about that gigantic nose in the foreground.
- Perspective distortion. When you tilt the camera so the plane of the sensor is no longer perpendicular to the vertical plane of your subject, some parts of the subject are now closer to the sensor than they were before, while other parts are farther away. So, buildings, flagpoles, or NBA players appear to be falling backwards (like the building shown in Figure 8.18). While this kind of apparent distortion (it's not caused by a defect in the lens) can happen with any lens, it's most apparent when a wide angle is used.
- Steady cam. You'll find that it is easier to hand-hold a wide-angle lens at slower shutter speeds, without need for image stabilization, than it is a telephoto lens. The reduced magnification of the wide-lens or wide-zoom setting doesn't emphasize camera shake like a telephoto lens does.
- Interesting angles. Many of the factors already listed combine to produce more interesting angles when shooting with wide-angle lenses. Raising or lowering a telephoto lens a few feet probably will have little effect on the appearance of the distant subjects you're shooting. The same change in elevation can produce a dramatic effect for the much closer subjects typically captured with a wide-angle lens or wide-zoom setting.

DOF IN DEPTH

The DOF advantage of wide-angle lenses is diminished when you enlarge your picture; believe it or not, a wide-angle image enlarged and cropped to provide the same subject size as a telephoto shot would have the *same* depth-of-field. Try it: take a wide-angle photo of a friend from a fair distance, and then zoom in to duplicate the picture in a telephoto image. Then, enlarge the wide shot so your friend is the same size in both. The wide photo will have the same depth-of-field (and will have much less detail, too).

Avoiding Potential Wide-Angle Problems

Wide-angle lenses have a few quirks that you'll want to keep in mind when shooting so you can avoid falling into some common traps. Here's a checklist of tips for avoiding common problems:

- Symptom: converging lines. Unless you want to use wildly diverging lines as a creative effect, it's a good idea to keep horizontal and vertical lines in landscapes, architecture, and other subjects carefully aligned with the sides, top, and bottom of the frame. That will help you avoid undesired perspective distortion. Sometimes it helps to shoot from a slightly elevated position so you don't have to tilt the camera up or down.
- Symptom: color fringes around objects. Lenses are often plagued with fringes of color around backlit objects, produced by *chromatic aberration*, which comes in two forms: *longitudinal/axial*, in which all the colors of light don't focus in the same plane, and *lateral/transverse*, in which the colors are shifted to one side. Axial chromatic aberration can be reduced by stopping down the lens, but transverse chromatic aberration cannot. Better quality lenses reduce both types of imaging defect; it's common for reviews to point out these failings, so you can choose the best performing lenses that your budget allows. The Lens Comp.: Chro. Aber. Feature in the Setup menu, described in Chapter 3, can help reduce this problem. You can set it to Off, or Auto.
- Symptom: lines that bow outward. Some wide-angle lenses cause straight lines to bow outwards, with the strongest effect at the edges. In fisheye (or *curvilinear*) lenses, this defect is a feature, as you can see in Figure 8.19. When distortion is not desired, you'll need to use a lens that has corrected barrel distortion. Manufacturers like Sony do their best to minimize or eliminate it (producing a *rectilinear* lens), often using *aspherical* lens elements (which are not cross-sections of a sphere). You can also minimize barrel distortion simply by framing your photo with some extra space all around, so the edges where the defect is most obvious can be cropped out of the picture. The Lens Comp.: Distortion feature, also described in Chapter 3, can help reduce this problem. You can set it, too, to Off, or Auto.
- Symptom: light and dark areas when using polarizing filter. If you know that polarizers work best when the camera is pointed 90 degrees away from the sun and have the least effect when the camera is oriented 180 degrees from the sun, you know only half the story. With lenses having a focal length of 10mm to 18mm (the equivalent of 16mm-28mm), the angle of view (107 to 75 degrees diagonally, or 97 to 44 degrees horizontally) is extensive enough to cause problems. Think about it: when a 10mm lens is pointed at the proper 90-degree angle from the sun, objects at the edges of the frame will be oriented at 135 to 41 degrees, with only the center at exactly 90 degrees. Either edge will have much less of a polarized effect. The solution is to avoid using a polarizing filter with lenses having an actual focal length of less than 18mm (or 28mm equivalent).

Figure 8.19
Many wideangle lenses
cause lines to
bow outwards
toward the
edges of the
image; with a
fisheye lens,
this tendency is
considered an
interesting
feature.

Using Telephoto and Tele-Zoom Lenses

Telephoto lenses also can have a dramatic effect on your photography, and Sony is especially strong in the long-lens arena, with lots of choices in many focal lengths and zoom ranges. You should be able to find an affordable telephoto or tele-zoom to enhance your photography in several different ways. Here are the most important things you need to know. In the next section, I'll concentrate on telephoto considerations that can be problematic—and how to avoid those problems.

- Selective focus. Long lenses have reduced depth-of-field within the frame, allowing you to use selective focus to isolate your subject. You can open the lens up wide to create shallow depth-of-field, or close it down a bit to allow more to be in focus. The flip side of the coin is that when you *want* to make a range of objects sharp, you'll need to use a smaller f/stop to get the depth-of-field you need. Like fire, the depth-of-field of a telephoto lens can be friend or foe. (See Figure 8.20.)
- Getting closer. Telephoto lenses bring you closer to wildlife, sports action, and candid subjects. No one wants to get a reputation as a surreptitious or "sneaky" photographer (except for paparazzi), but when applied to candids in an open and honest way, a long lens can help you capture memorable moments while retaining enough distance to stay out of the way of events as they transpire.

Figure 8.20 A wide f/stop helped isolate this lemur from its background.

- Reduced foreground/increased compression. Telephoto lenses have the opposite effect of wide angles: they reduce the importance of things in the foreground by squeezing everything together. This compression even makes distant objects appear to be closer to subjects in the foreground and middle ranges. You can use this effect as a creative tool. You've seen the effect hundreds of times in movies and on television, where the protagonist is shown running in and out of traffic that appears to be much closer to the hero (or heroine) than it really is.
- Accentuates camera shakiness. Telephoto focal lengths hit you with a double-whammy in terms of camera/photographer shake. The lenses themselves are bulkier, more difficult to hold steady, and may even produce a barely perceptible seesaw rocking effect when you support them with one hand halfway down the lens barrel. Telephotos also magnify any camera shake. It's no wonder that image stabilization like Optical SteadyShot (OSS) is especially popular among those using longer lenses, and why Sony also produces lenses like the 18-200mm zoom with image-stabilization features.

■ Interesting angles require creativity. Telephoto lenses require more imagination in selecting interesting angles, because the "angle" you do get on your subjects is so narrow. Moving from side to side or a bit higher or lower can make a dramatic difference in a wide-angle shot, but raising or lowering a telephoto lens a few feet probably will have little effect on the appearance of the distant subjects you're shooting.

Avoiding Telephoto Lens Problems

Many of the "problems" that telephoto lenses pose are really just challenges and not that difficult to overcome. Here is a list of the seven most common picture maladies and suggested solutions.

- Symptom: flat faces in portraits. Head-and-shoulders portraits of humans tend to be more flattering when a focal length of 50mm to 85mm is used. Longer focal lengths compress the distance between features like noses and ears, making the face look wider and flat. A wide-angle might make noses look huge and ears tiny when you fill the frame with a face. So stick with 50mm to 85mm focal lengths or zoom settings, going longer only when you're forced to shoot from a greater distance, and wider only when shooting three-quarters/full-length portraits, or group shots.
- Symptom: blur due to camera shake. First, make sure you have Optical SteadyShot turned on! Then, if possible, use a higher shutter speed (boosting ISO if necessary), or mount your camera on a tripod, monopod, or brace it with some other support. Of those three solutions, only the second will reduce blur caused by *subject* motion; SteadyShot or a tripod won't help you freeze a race car in mid-lap.
- Symptom: color fringes. Chromatic aberration is the most pernicious optical problem found in telephoto lenses. There are others, including spherical aberration, astigmatism, coma, curvature of field, and similarly scary-sounding phenomena. The best solution for any of these is to use a better lens that offers the proper degree of correction, or stop down the lens to minimize the problem. But that's not always possible. Your second best choice may be to correct the fringing in your favorite RAW conversion tool or image editor. Photoshop's Lens Correction filter offers sliders that minimize both red/cyan and blue/yellow fringing if the NEX-7's Lens Comp.: Chro. Aber. feature doesn't help.
- Symptom: lines that curve inwards. Pincushion distortion is found in many telephoto lenses. You might find after a bit of testing that it is worse at certain focal lengths with your particular zoom lens. Like chromatic aberration, it can be partially corrected using tools like Photoshop's Lens Correction filter.

- Symptom: low contrast from haze or fog. When you're photographing distant objects, a long lens shoots through a lot more atmosphere, which generally is muddied up with extra haze and fog. That dirt or moisture in the atmosphere can reduce contrast and mute colors. Some feel that a skylight or UV filter can help, but this practice is mostly a holdover from the film days. Digital sensors are not sensitive enough to UV light for a UV filter to have much effect. So you should be prepared to boost contrast and color saturation in your Picture Styles menu or image editor if necessary.
- Symptom: low contrast from flare. Lenses are often furnished with lens hoods for a good reason: to reduce flare from bright light sources at the periphery of the picture area, or completely outside it. Because telephoto lenses often create images that are lower in contrast in the first place, you'll want to be especially careful to use a lens hood to prevent further effects on your image (or shade the front of the lens with your hand).
- Symptom: dark flash photos. Edge-to-edge flash coverage isn't a problem with telephoto lenses as it is with wide angles. The shooting distance is. A long lens might make a subject that's 50 feet away look as if it's right next to you, but your camera's flash isn't fooled. You'll need extra power for distant flash shots, and almost certainly more power than your Alpha's built-in flash provides unless you increase the ISO setting to ISO 3200.

Telephotos and Bokeh

Bokeh describes the aesthetic qualities of the out-of-focus parts of an image and whether out-of-focus points of light—circles of confusion—are rendered as distracting fuzzy discs or smoothly fade into the background. Boke is a Japanese word for "blur," and the h was added to keep English speakers from rendering it monosyllabically to rhyme with broke. Although bokeh is visible in blurry portions of any image, it's of particular concern with telephoto lenses, which, thanks to the magic of reduced depth-of-field, produce more obviously out-of-focus areas.

Bokeh can vary from lens to lens, or even within a given lens depending on the f/stop in use. Bokeh becomes objectionable when the circles of confusion are evenly illuminated, making them stand out as distinct discs, or, worse, when these circles are darker in the center, producing an ugly "doughnut" effect. A lens defect called spherical aberration may produce out-of-focus discs that are brighter on the edges and darker in the center, because the lens doesn't focus light passing through the edges of the lens exactly as it does light going through the center. (Mirror or *catadioptric* lenses also produce this effect.)

Other kinds of spherical aberration generate circles of confusion that are brightest in the center and fade out at the edges, producing a smooth blending effect, as you can see

Figure 8.21 Bokeh is less pleasing when the discs are prominent (left), and less obtrusive when they blend into the background (right).

at right in Figure 8.21. Ironically, when no spherical aberration is present at all, the discs are a uniform shade, which, while better than the doughnut effect, is not as pleasing as the bright center/dark edge rendition. The shape of the disc also comes into play, with round smooth circles considered the best, and nonagonal or some other polygon (determined by the shape of the lens diaphragm) considered less desirable. Most Sony lenses have near-circular irises, producing very pleasing bokeh.

If you plan to use selective focus a lot, you should investigate the bokeh characteristics of a particular lens before you buy. Sony user groups and forums will usually be full of comments and questions about bokeh, so the research is fairly easy.

Fine-Tuning the Focus of Your Lenses

In Chapter 3, I introduced you to the NEX-7's AF Micro Adjustment feature, which, I noted, that you might not ever need to use, because it is applied only when you find that a particular lens is not focusing properly. If the lens happens to focus a bit ahead or a bit behind the actual point of sharp focus, and it does that consistently, you can use the adjustment feature, found in the Setup menu, to "calibrate" the lens's focus.

Why is the focus "off" for some lenses in the first place? There are lots of factors, including the age of the lens (an older lens may focus slightly differently), temperature effects on certain types of glass, humidity, and tolerances built into a lens's design that all add up to a slight misadjustment, even though the components themselves are, strictly speaking, within specs. A very slight variation in your lens's mount can cause focus to vary slightly. With any luck (if you can call it that) a lens that doesn't focus exactly right will at least be consistent. If a lens always focuses a bit behind the subject, the symptom is *back focus*. If it focuses in front of the subject, it's called *front focus*.

You're almost always better off sending such a lens in to Sony to have them make it right. But that's not always possible. Perhaps you need your lens recalibrated right now, or you purchased a used lens that is long out of warranty. If you want to do it yourself, the first thing to do is determine whether or not your lens has a back focus or front focus problem.

For a quick-and-dirty diagnosis (*not* a calibration; you'll use a different target for that), lay down a piece of graph paper on a flat surface, and place an object on the line at the middle, which will represent the point of focus (we hope). Then, shoot the target at an angle using your lens's widest aperture and the autofocus mode you want to test. Mount the camera on a tripod so you can get accurate, repeatable results.

If your camera/lens combination doesn't suffer from front or back focus, the point of sharpest focus will be the center line of the chart, as you can see in Figure 8.22. If you do have a problem, one of the other lines will be sharply focused instead. Should you discover that your lens consistently front or back focuses, it needs to be recalibrated. Unfortunately, it's only possible to calibrate a lens for a single focusing distance. So, if you use a particular lens (such as a macro lens) for close-focusing, calibrate for that. If you use a lens primarily for middle distances, calibrate for that. Close-to-middle distances are most likely to cause focus problems, anyway, because as you get closer to infinity, small changes in focus are less likely to have an effect.

Lens Tune-Up

The key tool you can use to fine-tune your lens is the AF Micro Adj entry in the Setup menu. You'll find the process easier to understand if you first run through this quick overview of the menu options:

- AF Adjustment Setting. On: This option enables AF fine-tuning for all the lenses you've registered using the menu entry. If you discover you don't care for the calibrations you make in certain situations (say, it works better for the lens you have mounted at middle distances, but is less successful at correcting close-up focus errors) you can deactivate the feature as you require. You should set this to On when you're doing the actual fine-tuning. Adjustment values range from −20 to +20. Off: Disables autofocus micro adjustment.
- Amount. You can specify values of plus or minus 20 for each of the lenses you've registered. When you mount a registered lens, the degree of adjustment is shown here. If the lens has not been registered, then +/-0 is shown. If "-" is displayed, you've already registered the maximum number of lenses—up to 30 different lenses can be registered with each camera.
- Clear. Erases *all* user-entered adjustment values for the lenses you've registered. When you select the entry, a message will appear. Select OK and then press the center button of the control wheel to confirm.
Figure 8.22
Correct focus
(top), front
focus (middle),
and back focus
(bottom).

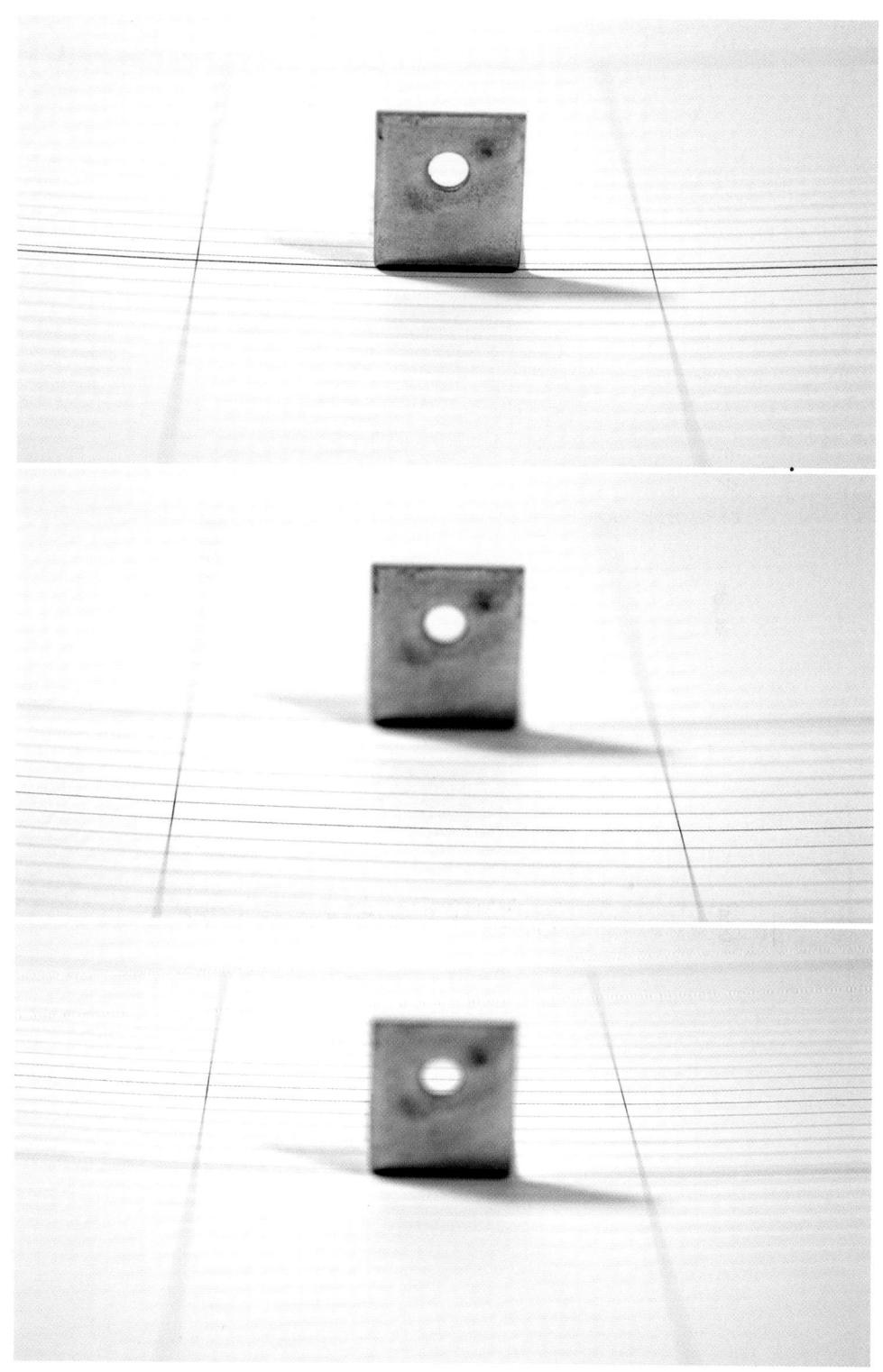

Evaluate Current Focus

The first step is to capture a baseline image that represents how the lens you want to fine-tune autofocuses at a particular distance. You'll often see advice for photographing a test chart with millimeter markings from an angle, and the suggestion that you autofocus on a particular point on the chart. Supposedly, the markings that actually *are* in focus will help you recalibrate your lens. The problem with this approach is that the information you get from photographing a test chart at an angle doesn't actually tell you what to do to make a precise correction. So, your lens back focuses three millimeters behind the target area on the chart. So what? Does that mean you change the Saved Value by -3 clicks? Or -15 clicks? Angled targets are a "shortcut" that don't save you time.

Instead, you'll want to photograph a target that represents what you're actually trying to achieve: a plane of focus locked in by your lens that represents the actual plane of focus of your subject. For that, you'll need a flat target, mounted precisely perpendicular to the sensor plane of the camera. Then, you can take a photo, see if the plane of focus is correct, and if not, dial in a bit of fine-tuning in the AF Fine Tuning menu, and shoot again. Lather, rinse, and repeat until the target is sharply focused.

You can use the focus target shown in Figure 8.23, or you can use a chart of your own, as long as it has contrasty areas that will be easily seen by the autofocus system, and without very small details that are likely to confuse the AF. Download your own copy of my chart from www.dslrguides.com/FocusChart.pdf. (The URL is case sensitive.) Then print out a copy on the largest paper your printer can handle. (I don't recommend just displaying the file on your monitor and focusing on that; it's unlikely you'll have the monitor screen lined up perfectly perpendicular to the camera sensor.) Then, follow these steps:

- 1. **Position the camera.** Place your camera on a sturdy tripod with a remote release attached, positioned at roughly eye-level at a distance from a wall that represents the distance you want to test for. Keep in mind that autofocus problems can be different at varying distances and lens focal lengths, and that you can enter only *one* correction value for a particular lens. So, choose a distance (close-up or mid range) and zoom setting with your shooting habits in mind.
- 2. Set the autofocus mode. Choose the autofocus mode you want to test.
- 3. Level the camera (in an ideal world). If the wall happens to be perfectly perpendicular, you can use a bubble level, plumb bob, or other device of your choice to ensure that the camera is level to match. Many tripods and tripod heads have bubble levels built in. Avoid using the center column, if you can. When the camera is properly oriented, lock the legs and tripod head tightly.

Figure 8.23 Use this focus test chart, or create one of your own.

- 4. Level the camera (in the real world). If your wall is not perfectly perpendicular, use this old trick. Tape a mirror to the wall, and then adjust the camera on the tripod so that when you look through the viewfinder at the mirror, you see directly into the reflection of the lens. Then, lock the tripod and remove the mirror.
- 5. **Mount the test chart.** Tape the test chart on the wall so it is centered in your camera's viewfinder.
- 6. **Photograph the test chart using AF.** Allow the camera to autofocus, and take a test photo, using the remote release to avoid shaking or moving the camera.
- 7. **Make an adjustment and rephotograph.** Navigate to the Setup menu and choose AF Micro Adj. Make sure the feature has been turned on, then press down to Amount and make a fine-tuning adjustment, plus or minus, and photograph the target again.
- 8. **Lather, rinse, repeat.** Repeat steps 6 and 7 several times to create several different adjustments to check.
- 9. **Evaluate the image(s).** If you have the camera connected to your computer with a USB cable or through a Wi-Fi connection, so much the better. An Eye-Fi card is very handy for this, as it can be set to upload each image as taken automatically, with no intervention from you. You can view the image(s) after transfer to your computer. Otherwise, *carefully* open the camera card door and slip the memory card out and copy the images to your computer.
- 10. **Evaluate focus.** Which image is sharpest? That's the setting you need to use for this lens. If your initial range doesn't provide the correction you need, repeat the steps between –20 and +20 until you find the best fine-tuning. Once you've made an adjustment, the NEX-7 will automatically apply the AF fine-tuning each time that lens is mounted on the camera, as long as the function is turned on.

MAXED OUT

If you've reached the maximum number of lenses (which is unlikely—who owns 30 lenses?), mount a lens you no longer want to compensate for, and reset its adjustment value to ± -0 . Or you can reset the values of all your lenses using the Clear function and start over.

SteadyShot and Your Lenses

Sony sells special lenses with anti-shake features built in. Optical SteadyShot (OSS) provides you with camera steadiness that's the equivalent of at least two or three shutter speed increments. This extra margin can be invaluable when you're shooting under dim lighting conditions or hand-holding a long lens for, say, wildlife photography. Perhaps that shot of a foraging deer calls for a shutter speed of 1/1,000th second at f/5.6 with your lens. Relax. You can shoot at 1/250th second at f/11 and get virtually the same results, as long as the deer doesn't decide to bound off.

Or, maybe you're shooting a high school play without a tripod or monopod, and you'd really, really like to use 1/15th second at f/4. Assuming the actors aren't flitting around the stage at high speed, your wide-angle lens can grab the shot for you at its wide-angle position. However, keep these facts in mind:

- Optical SteadyShot doesn't stop action. Unfortunately, no stabilization is a panacea to replace the action-stopping capabilities of a higher shutter speed. Image stabilization applies only to camera shake. You still need a fast shutter speed to freeze action. SteadyShot works great in low light, when you're using long lenses, and for macro photography. It's not always the best choice for action photography, unless there's enough light to allow a sufficiently high shutter speed. If so, stabilization can make your shot even sharper.
- Stabilization might slow you down. The process of adjusting the sensor to counter camera shake takes time, just as autofocus does, so you might find that SteadyShot adds to the lag between when you press the shutter and when the picture is actually taken. That's another reason why image stabilization might not be a good choice for sports.
- **Use when appropriate.** Sometimes, stabilization produces worse results if used while you're panning. You might want to switch off IS when panning or when your camera is mounted on a tripod.
- Do you need SteadyShot at all? Remember that an inexpensive monopod might be able to provide the same additional steadiness as SteadyShot. If you're out in the field shooting wild animals or flowers and think a tripod isn't practical, try a monopod first.

Making Light Work for You

Successful photographers and artists have an intimate understanding of the importance of light in shaping an image. Rembrandt was a master of using light to create moods and reveal the character of his subjects. The late artist Thomas Kinkade's official tagline was "Painter of Light." Dean Collins, co-founder of Finelight Studios, revolutionized how a whole generation of photographers learned and used lighting. It's impossible to underestimate how the use of light adds to—and how misuse can detract from—your photographs.

All forms of visual art use light to shape the finished product. Sculptors don't have control over the light used to illuminate their finished work, so they must create shapes using planes and curved surfaces so that the form envisioned by the artist comes to life from a variety of viewing and lighting angles. Painters, in contrast, have absolute control over both shape and light in their work, as well as the viewing angle, so they can use both the contours of their two-dimensional subjects and the qualities of the "light" they use to illuminate those subjects to evoke the image they want to produce.

Photography is a third form of art. The photographer may have little or no control over the subject (other than posing human subjects) but can often adjust both viewing angle and the nature of the light source to create a particular compelling image. The direction and intensity of the light sources create the shapes and textures that we see. The distribution and proportions determine the contrast and tonal values: whether the image is stark or high key, or muted and low in contrast. The colors of the light (because even "white" light has a color balance that the sensor can detect), and how much of those colors the subject reflects or absorbs, paint the hues visible in the image.

As a Sony Alpha photographer, you must learn to be a painter and sculptor of light if you want to move from *taking* a picture to *making* a photograph. This chapter provides

an introduction to using the two main types of illumination: *continuous* lighting (such as daylight, incandescent, or fluorescent sources) and the brief, but brilliant snippets of light we call *electronic flash*.

Continuous Illumination versus Electronic Flash

Continuous lighting is exactly what you might think: uninterrupted illumination that is available all the time during a shooting session. Daylight, moonlight, and the artificial lighting encountered both indoors and outdoors count as continuous light sources (although all of them can be "interrupted" by passing clouds, solar eclipses, a blown fuse, or simply by switching off a lamp). Indoor continuous illumination includes both the lights that are there already (such as incandescent lamps or overhead fluorescent lights indoors) and fixtures you supply yourself, including photoflood lamps or reflectors used to bounce existing light onto your subject.

The surge of light we call electronic flash is produced by a burst of photons generated by an electrical charge that is accumulated in a component called a *capacitor* and then directed through a glass tube containing xenon gas, which absorbs the energy and emits the brief flash. Electronic flash is notable because it can be much more intense than continuous lighting, lasts only a brief moment, and can be much more portable than supplementary incandescent sources. It's a light source you can carry with you and use anywhere.

Indeed, your Sony Alpha NEX-7 comes with a built-in flash unit, shown elevated in Figure 9.1. That flash is seriously underpowered. At ISO 200, it has a range of 3.3 to 9.8 feet at f/2.8; boost the sensitivity to ISO 800, and it's good from 6.6-20 feet at f/2.8, or 3.3 to 9.8 feet at f/5.6. That limited range makes it useful as a fill-in flash to

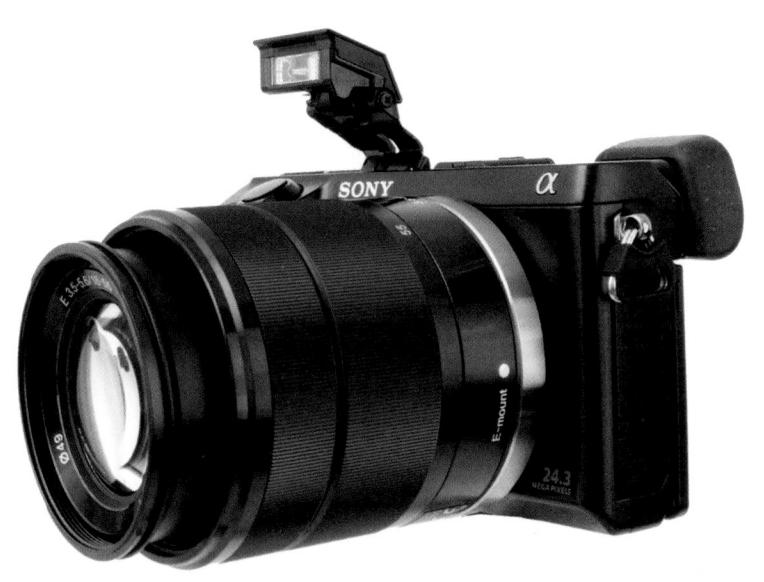

Figure 9.1 One form of light that's always available is the built-in flash on your Sony Alpha.

illuminate inky shadows, or for close-up photography. That's about it. But you can also supplement that with an external flash which can be used in wireless mode to trigger other flashes, or one with a slave mode or separate slave trigger (an electronic device that senses the firing of the other flash, and activates the external flash). That will give you a bit more power to play with. You'll need a slave flash with a "digital" mode that reacts to the main flash, and not the pre-flash (used to measure exposure) that precedes it. There are advantages and disadvantages to each type of illumination. Here's a quick checklist of pros and cons:

■ Lighting preview—Pro: continuous lighting. With continuous lighting, such as incandescent lamps or daylight (see Figure 9.2), you always know exactly what kind of lighting effect you're going to get and, if multiple lights are used, how they will interact with each other. With electronic flash, the general effect you're going to see may be a mystery until you've built some experience, and you may need to review a shot on the LCD, make some adjustments, and then reshoot to get the look you want. (In this sense, a digital camera's review capabilities replace the Polaroid test shots pro photographers relied on in decades past.)

Figure 9.2
You always
know how the
lighting will
look when using
continuous
illumination.

- Lighting preview—Con: electronic flash. While some external flash have a modeling light function, your Alpha lacks such a capability in its built-in flash, and, in any case, this feature is no substitute for continuous illumination, or an always-on modeling lamp like that found in studio flash. As the number of flash units increases, lighting previews, especially if you want to see the proportions of illumination provided by each flash, grow more complex.
- Exposure calculation—Pro: continuous lighting. Your Alpha has no problem calculating exposure for continuous lighting, because the lighting remains constant and can be measured through a sensor that interprets the light reaching the view-finder. The amount of light available just before the exposure will, in almost all cases, be the same amount of light present when the shutter is released. The Alpha's Spot metering mode can be used to measure and compare the proportions of light in the highlights and shadows, so you can make an adjustment (such as using more or less fill light) if necessary. You can even use a hand-held light meter to measure the light yourself.
- Exposure calculation—Con: electronic flash. Electronic flash illumination doesn't exist until the flash fires, and so it can't be measured by the Alpha's exposure sensor before the exposure. Instead, the light must be measured by metering the intensity of a pre-flash triggered an instant before the main flash, as it is reflected back to the camera and through the lens.
- Evenness of illumination—Pro/con: continuous lighting. Of continuous light sources, daylight, in particular, provides illumination that tends to fill an image completely, lighting up the foreground, background, and your subject almost equally. Shadows do come into play, of course, so you might need to use reflectors or fill-in light sources to even out the illumination further, but barring objects that block large sections of your image from daylight, the light is spread fairly evenly. Indoors, however, continuous lighting is commonly less evenly distributed. The average living room, for example, has hot spots and dark corners. But on the plus side, you can see this uneven illumination and compensate with additional lamps.
- Evenness of illumination—Con: electronic flash. Electronic flash units, like continuous light sources such as lamps that don't have the advantage of being located 93 million miles from the subject, suffer from the effects of their proximity. The *inverse square law*, first applied to both gravity and light by Sir Isaac Newton, dictates that as a light source's distance increases from the subject, the amount of light reaching the subject falls off proportionately to the square of the distance. In plain English, that means that a flash or lamp that's eight feet away from a subject provides only one-quarter as much illumination as a source that's four feet away (rather than half as much). (See Figure 9.3.) This translates into relatively shallow "depth-of-light." That's why your built-in flash can only be used at close distances.

Figure 9.3
A light source that is twice as far away provides only one-quarter as much illumination.

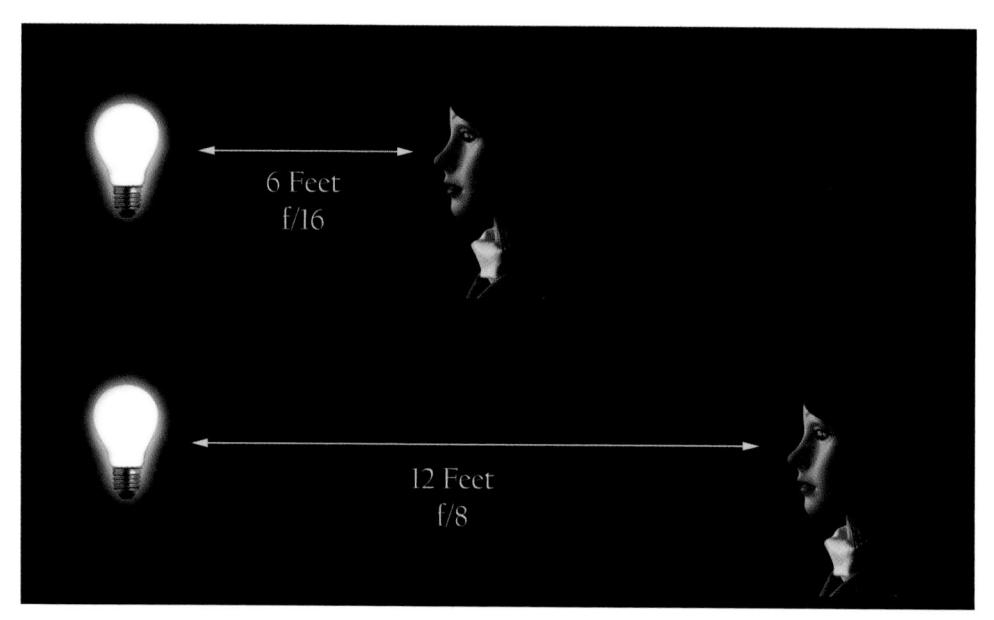

- Action stopping—Con: continuous lighting. Action stopping with continuous light sources is completely dependent on the shutter speed you've dialed in on the camera. And the speeds available are dependent on the amount of light available and your camera's ISO sensitivity setting. Outdoors in daylight, there will probably be enough sunlight to let you shoot at 1/2,000th second and f/6.3 with a nongrainy sensitivity setting of ISO 400. That's a fairly useful combination of settings if you're not using a super-telephoto with a small maximum aperture. But inside, the reduced illumination quickly has you pushing your Sony Alpha to its limits. For example, if you're shooting indoor sports, there probably won't be enough available light to allow you to use a 1/2,000th second shutter speed (although I routinely shoot indoor basketball at ISO 1600 and 1/500th second at f/4). In many indoor sports situations, you may find yourself limited to 1/500th second or slower.
- Action stopping—Pro: electronic flash. When it comes to the ability to freeze moving objects in their tracks, the advantage goes to electronic flash. The brief duration of electronic flash serves as a very high "shutter speed" when the flash is the main or only source of illumination for the photo. Your Sony Alpha's shutter speed may be set for 1/160th second during a flash exposure, but if the flash illumination predominates, the *effective* exposure time will be the 1/1,000th to 1/50,000th second or less duration of the flash, as you can see in Figure 9.4, because the flash unit reduces the amount of light released by cutting short the duration of the flash. The only fly in the ointment is that, if the ambient light is strong enough, it may produce a secondary "ghost" exposure, as I'll explain later in this chapter.

Figure 9.4
Electronic flash can freeze almost any action.

- Cost—Pro: continuous lighting. Incandescent or fluorescent lamps are generally much less expensive than external electronic flash units, which can easily cost several hundred dollars. I've used everything from desktop high-intensity lamps to reflector floodlights for continuous illumination at very little cost. There are lamps made especially for photographic purposes, too, priced up to \$50 or so. Maintenance is economical, too; many incandescent or fluorescents use bulbs that cost only a few dollars.
- Cost—Con: electronic flash. Add-on electronic flash units, other than the one supplied with your NEX camera, aren't particularly cheap, and may not work well with the camera and its exposure system except in manual mode. As mentioned earlier, you'll need a flash unit that can be triggered by the Sony flash's main burst, and not the pre-flash, or by a radio trigger.
- Flexibility—Con: continuous lighting. Because incandescent and fluorescent lamps are not as bright as electronic flash, the slower shutter speeds required (see "Action stopping," above) mean that you may have to use a tripod more often, especially when shooting portraits. The incandescent variety of continuous lighting gets hot, especially in the studio, and the side effects range from discomfort (for your human models) to disintegration (if you happen to be shooting perishable foods like ice cream).
- Flexibility—Pro: electronic flash. Electronic flash's action-freezing power allows you to work without a tripod in the studio (and elsewhere), adding flexibility and speed when choosing angles and positions. Flash units can be easily filtered, and, because the filtration is placed over the light source rather than the lens, you don't need to use high-quality filter material. For example, Roscoe or Lee lighting gels, which may be too flimsy to use in front of the lens, can be mounted or taped in front of your tiny flash with ease.

Continuous Lighting Basics

While continuous lighting and its effects are generally much easier to visualize and use than electronic flash, there are some factors you need to take into account, particularly the color temperature of the light. (Color temperature concerns aren't exclusive to continuous light sources, of course, but the variations tend to be more extreme and less predictable than those of electronic flash.)

Color temperature, in practical terms, is how "bluish" or how "reddish" the light appears to be to the digital camera's sensor. Indoor illumination is quite warm, comparatively, and appears reddish to the sensor. Daylight, in contrast, seems much bluer to the sensor. Our eyes (our brains, actually) are quite adaptable to these variations, so white objects don't appear to have an orange tinge when viewed indoors, nor do they seem excessively blue outdoors in full daylight. Yet, these color temperature variations

are real and the sensor is not fooled. To capture the most accurate colors, we need to take the color temperature into account in setting the color balance (or *white balance*) of the Alpha—either automatically using the camera's smarts or manually using our own knowledge and experience.

Color temperature can be confusing, because of a seeming contradiction in how color temperatures are named: warmer (more reddish) color temperatures (measured in degrees Kelvin) are the *lower* numbers, whereas cooler (bluer) color temperatures are *higher* numbers. It might not make sense to say that 3,400K is warmer than 6,000K, but that's the way it is. If it helps, think of a glowing red ember contrasted with a whitehot welder's torch, rather than fire and ice.

The confusion comes from physics. Scientists calculate color temperature from the light emitted by a mythical object called a black body radiator, which absorbs all the radiant energy that strikes it, and reflects none at all. Such a black body not only *absorbs* light perfectly, but it *emits* it perfectly when heated (and since nothing in the universe is perfect, that makes it mythical).

At a particular physical temperature, this imaginary object always emits light of the same wavelength or color. That makes it possible to define color temperature in terms of actual temperature in degrees on the Kelvin scale that scientists use. Incandescent light, for example, typically has a color temperature of 3,200K to 3,400K. Daylight might range from 5,500K to 6,000K. Each type of illumination we use for photography has its own color temperature range—with some cautions. The next sections will summarize everything you need to know about the qualities of these light sources.

Daylight

Daylight is produced by the sun, and so is moonlight (which is just reflected sunlight). Daylight is present, of course, even when you can't see the sun. When sunlight is direct, it can be bright and harsh. If daylight is diffused by clouds, softened by bouncing off objects such as walls or your photo reflectors, or filtered by shade, it can be much dimmer and less contrasty.

Daylight's color temperature can vary quite widely. It is highest (most blue) at noon when the sun is directly overhead, because the light is traveling through a minimum amount of the filtering layer we call the atmosphere. The color temperature at high noon may be 6,000K. At other times of day, the sun is lower in the sky and the particles in the air provide a filtering effect that warms the illumination to about 5,500K for most of the day. Starting an hour before dusk and for an hour after sunrise, the warm appearance of the sunlight is even visible to our eyes when the color temperature may dip to 5,000-4,500K, as shown in Figure 9.5.

Because you'll be taking so many photos in daylight, you'll want to learn how to use or compensate for the brightness and contrast of sunlight, as well as how to deal with its color temperature. I'll provide some hints later in this chapter.

Figure 9.5 At dawn and dusk, the color temperature of the sky may dip as low as 4,500K.

Incandescent/Tungsten Light

The term incandescent or tungsten illumination is usually applied to the direct descendents of Thomas Edison's original electric lamp. Such lights consist of a glass bulb that contains a vacuum, or is filled with a halogen gas, and contains a tungsten filament that is heated by an electrical current, producing photons and heat. Tungsten-halogen lamps are a variation on the basic light bulb, using a more rugged (and longer-lasting) filament that can be heated to a higher temperature, housed in a thicker glass or quartz envelope, and filled with iodine or brominc ("halogen") gases. The higher temperature allows tungsten-halogen (or quartz-halogen/quartz-iodine, depending on their construction) lamps to burn "hotter" and whiter. Although popular for automobile headlamps today, they've also been popular for photographic illumination.

Although incandescent illumination isn't a perfect light source, it's close enough that the color temperature of such lamps can be precisely calculated (about 3,200-3,400K, depending on the type of lamp) and used for photography without concerns about color variation (at least, until the very end of the lamp's life).

The other qualities of this type of lighting, such as contrast, are dependent on the distance of the lamp from the subject, type of reflectors used, and other factors that I'll explain later in this chapter.

Fluorescent Light/Other Light Sources

Fluorescent light has some advantages in terms of illumination, but some disadvantages from a photographic standpoint. This type of lamp generates light through an electrochemical reaction that emits most of its energy as visible light, rather than heat, which is why the bulbs don't get as hot. The type of light produced varies depending on the phosphor coatings and type of gas in the tube. So, the illumination fluorescent bulbs produce can vary widely in its characteristics.

That's not great news for photographers. Different types of lamps have different "color temperatures" that can't be precisely measured in degrees Kelvin, because the light isn't produced by heating. Worse, fluorescent lamps have a discontinuous spectrum of light that can have some colors missing entirely. A particular type of tube can lack certain shades of red or other colors (see Figure 9.6), which is why fluorescent lamps and other alternative technologies such as sodium-vapor illumination can produce ghastly looking human skin tones. Their spectra can lack the reddish tones we associate with healthy skin and emphasize the blues and greens popular in horror movies.

Figure 9.6
The fluorescent lighting in this gym added a distinct greenish cast to the image.

Adjusting White Balance

I showed you how to adjust white balance in Chapter 3.

In most cases, however, the Sony Alpha will do a good job of calculating white balance for you, so Auto can be used as your choice most of the time. Use the preset values or set a custom white balance that matches the current shooting conditions when you need to. The only really problematic light sources are likely to be fluorescents. Vendors, such as GE and Sylvania, may actually provide a figure known as the *color rendering index* (or CRI), which is a measure of how accurately a particular light source represents standard colors, using a scale of 0 (some sodium-vapor lamps) to 100 (daylight and most incandescent lamps). Daylight fluorescents and deluxe cool white fluorescents might have a CRI of about 79 to 95, which is perfectly acceptable for most photographic applications. Warm white fluorescents might have a CRI of 55. White deluxe mercury vapor lights are less suitable with a CRI of 45, while low-pressure sodium lamps can vary from CRI 0-18.

Remember that if you shoot RAW, you can specify the white balance of your image when you import it into Photoshop, Photoshop Elements, or another image editor using your preferred RAW converter, including Image Data Converter SR. Although color-balancing filters that fit on the front of the lens exist, they are primarily useful for film cameras, because film's color balance can't be tweaked as extensively as that of a sensor.

Electronic Flash Basics

Electronic flash illumination is produced by a flash of photons generated by an electrical charge that is accumulated in a component called a *capacitor* and then directed through a glass tube containing xenon gas, which absorbs the energy and emits the brief flash. For the built-in flash furnished with the NEX camera, the full burst of light lasts about 1/1,000th second, and provides enough illumination to shoot a subject no more than 16 feet away at f/5.6 at an ISO 1600 setting. As you can see, the built-in flash is relatively underpowered and not your best choice when photographing distant subjects. You'll see why external flash units are often a good idea in some situations later in this chapter.

As I mentioned earlier in this book, the Alpha has a vertically traveling shutter that consists of two curtains. The first curtain opens and moves to the opposite side of the frame, at which point the shutter is completely open. The flash can be triggered at this point (so-called *first-curtain sync* or, alternatively, *front sync*), making the flash exposure. Then, after a delay that can vary from 30 seconds to 1/160th second (with the NEX series and many other Sony interchangeable lens camera; other cameras may sync at a faster or slower speed), a second curtain begins moving across the sensor plane, covering up the sensor again.

The NEX-7 also has an "electronic" front-curtain sync setting. When Front Curtain shutter is activated from the Setup menu by choosing On, the shutter opens, and then the exposure begins by activating the sensor one line at a time. When the entire sensor is "live," the electronic flash can be triggered, making the exposure. The second curtain of the shutter then descends to end the exposure. The advantage of this mode is improved response time—the NEX-7 does not have to wait for the first curtain to open.

You can tell which mode is set for your camera by listening; you should be able to hear two rapid "click" sounds if the electronic front curtain sync is turned off—one as the shutter closes/opens, then an additional sound when the second curtain descends. (The sound is easier to discern when using a slow shutter speed, such as 1/5th second.) When electronic first curtain mode is active, the exposure begins with the shutter already open (as it always is while you're viewing the live view display). The existing live view image is "dumped" electronically to prepare for the actual exposure. So, you'll hear only one click when the physical shutter closes.

Front-curtain mode doesn't make much of a difference in your image quality, except if you're using an older A-mount lens from Minolta or Konica-Minolta. Such lenses may produce an incorrect exposure when the electronic first-curtain shutter is used: turn it off when working with these optics. In most other cases, you can leave the electronic version on all of the time, unless you need second-curtain sync, described next. Its "single-click" mode makes the camera feel more responsive, is quieter, and reduces the blanking that can occur in the viewfinder in continuous shooting modes.

If the flash is triggered just before the second curtain starts to close, then *second-curtain sync* (or, *rear sync*) is used. In both cases, though, a shutter speed of 1/160th second is the maximum that can be used to take a photo.

Figure 9.7 illustrates how this works, with a fanciful illustration of a generic shutter (your Alpha's shutter does *not* look like this, and some vertically traveling shutters move bottom to top rather than the top-to-bottom motion shown). Both curtains are tightly closed at upper left. At upper right, the first curtain begins to move downwards, starting to expose a narrow slit that reveals the sensor behind the shutter. At lower left, the first curtain moves downward farther until, as you can see at lower right in the figure, the sensor is fully exposed.

When first-curtain sync is used (either electronic or physical), the flash is triggered at the instant that the sensor is completely exposed/sensitized. The shutter then remains open for an additional length of time (from 30 seconds to 1/160th second), and the second curtain begins to move downward, covering the sensor once more. When second-curtain sync is activated, the flash is triggered *after* the main exposure is over, just before the second curtain begins to move downward. The Alpha camera always defaults to front/first-curtain sync unless you explicitly select another mode using the Flash mode screen or the Setup menu.

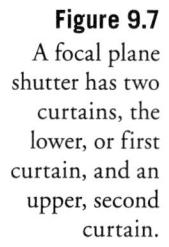

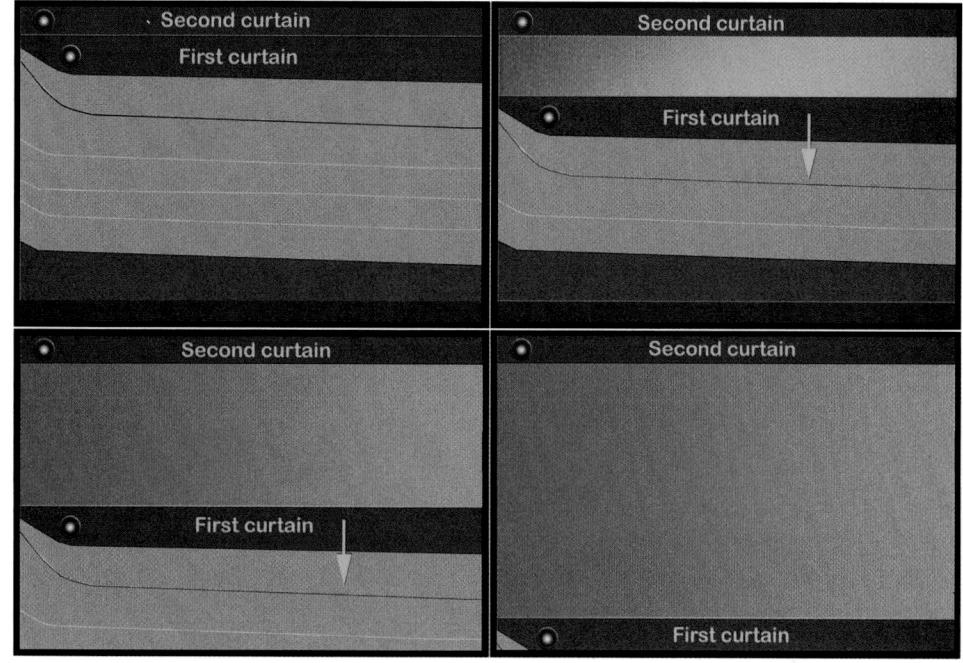

Avoiding Sync Speed Problems

Using a shutter speed faster than 1/160th second can cause problems. Triggering the electronic flash only when the shutter is completely open makes a lot of sense if you think about what's going on. To obtain shutter speeds faster than 1/160th second, the Alpha exposes only part of the sensor at one time, by starting the second curtain on its journey before the first curtain has completely opened. That effectively provides a briefer exposure as the slit of the shutter passes over the surface of the sensor. If the flash were to fire during the time when the first and second curtains partially obscured the sensor, only the slit that was actually open would be exposed.

You'd end up with only a narrow band, representing the portion of the sensor that was exposed when the picture is taken. For shutter speeds *faster* than 1/160th second, the second curtain begins moving *before* the first curtain reaches the bottom of the frame. As a result, a moving slit—the width of the distance between the first and second curtains—exposes one portion of the sensor at a time as it moves from the top to the bottom. Figure 9.8 shows three views of our typical (but imaginary) focal plane shutter. At left is pictured the closed shutter; in the middle version you can see the first curtain has moved about 1/4 of the distance down from the top, and in the right-hand version, the second curtain has started to "chase" the first curtain across the frame towards the bottom.

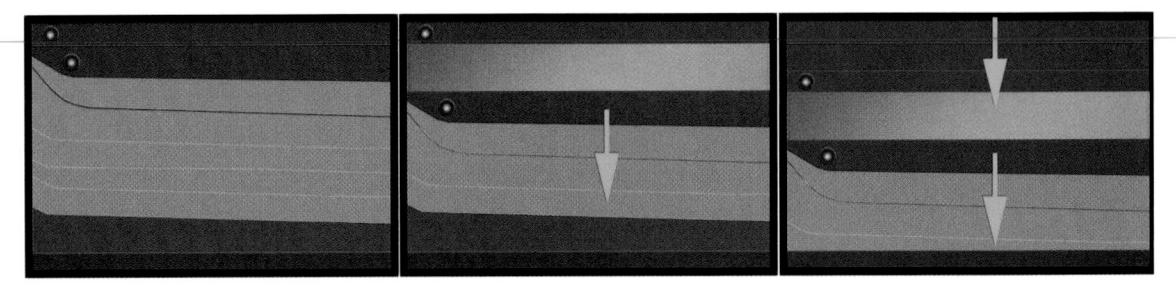

Figure 9.8 A closed shutter (left); partially open shutter as the first curtain begins to move downwards (middle); only part of the sensor is exposed as the slit moves (right).

If the flash is triggered while this slit is moving, only the exposed portion of the sensor will receive any illumination. You end up with a photo like the one shown in Figure 9.9. Note that a band across the bottom of the image is black. That's a shadow of the second shutter curtain, which had started to move when the flash was triggered. Sharpeyed readers will wonder why the black band is at the *bottom* of the frame rather than at the top, where the second curtain begins its journey. The answer is simple: your lens flips the image upside down and forms it on the sensor in a reversed position. You never notice that, because the camera is smart enough to show you the pixels that make up your photo in their proper orientation during picture review. But this image flip is why, if your sensor gets dirty and you detect a spot of dust in the upper half of a test photo, if cleaning manually, you need to look for the speck in the *bottom* half of the sensor.

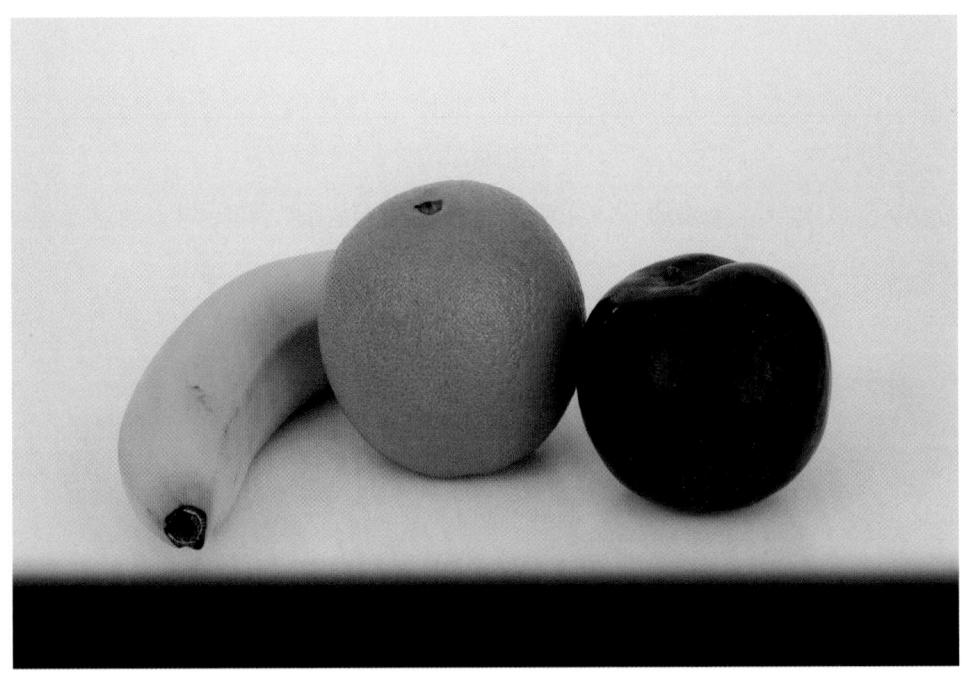

Figure 9.9
If a shutter speed faster than 1/160th second is used, you can end up photographing only a portion of the image.

Ghost Images

The difference might not seem like much, but whether you use first-curtain sync (the default setting) or rear-curtain sync (an optional setting) can make a significant difference to your photograph *if the ambient light in your scene also contributes to the image*. At faster shutter speeds, particularly 1/160th second, there isn't much time for the ambient light to register, unless it is very bright. It's likely that the electronic flash will provide almost all the illumination, so first-curtain sync or second-curtain sync isn't very important.

However, at slower shutter speeds, or with very bright ambient light levels, there is a significant difference, particularly if your subject is moving, or the camera isn't steady. In any of those situations, the ambient light will register as a second image accompanying the flash exposure, and if there is movement (camera or subject), that additional image will not be in the same place as the flash exposure. It will show as a ghost image and, if the movement is significant enough, as a blurred ghost image trailing in front of or behind your subject in the direction of the movement.

As I mentioned earlier, when you're using first-curtain sync, the flash goes off the instant the shutter opens, producing an image of the subject on the sensor. Then, the shutter remains open for an additional period (which can be from 30 seconds to 1/160th second). If your subject is moving, say, towards the right side of the frame, the ghost image produced by the ambient light will produce a blur on the right side of the original subject image, making it look as if your sharp (flash-produced) image is chasing the ghost. For those of us who grew up with lightning-fast superheroes who always left a ghost trail *behind them*, that looks unnatural (see Figure 9.10).

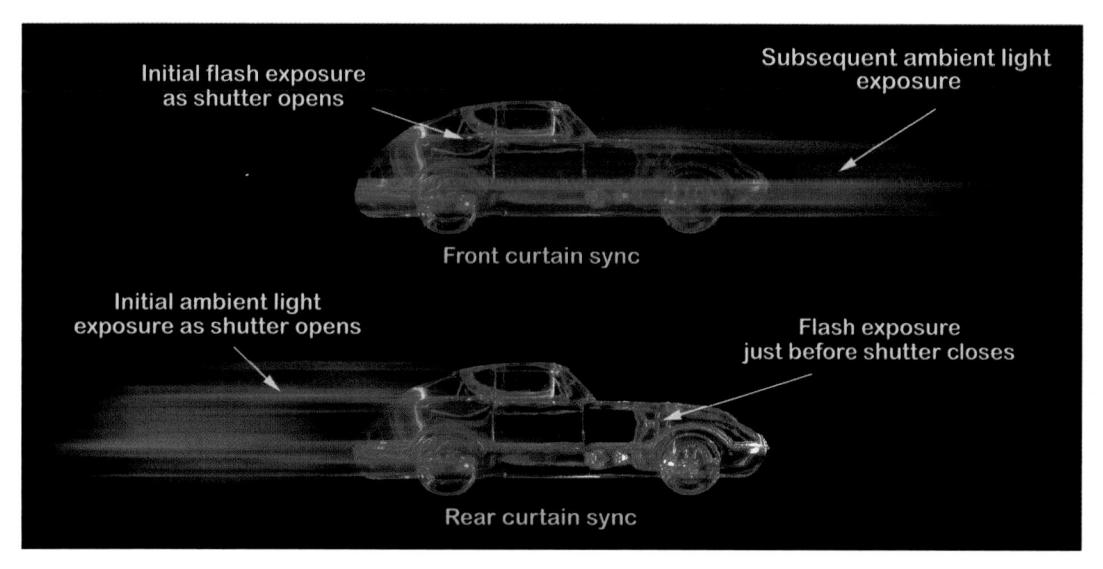

Figure 9.10 Front-curtain sync produces an image that trails in front of the flash exposure (top), whereas rear-curtain sync creates a more "natural looking" trail behind the flash image (bottom).

So, Sony provides rear- (second-) curtain sync to remedy the situation. In that mode, the shutter opens, as before. The shutter remains open for its designated duration, and the ghost image forms. If your subject moves from the left side of the frame to the right side, the ghost will move from left to right, too. *Then*, about 1.5 milliseconds before the second shutter curtain closes, the flash is triggered, producing a nice, sharp flash image *ahead* of the ghost image. Voilà! We have monsieur *le Flash* outrunning his own trailing image. I'll show you how to make these settings later in this section.

EVERY WHICH WAY, INCLUDING UP

Note that, although I describe the ghost effect in terms of subject matter that is moving left to right in a horizontally oriented composition, it can occur in any orientation, and with the subject moving in *any* direction. (Try photographing a falling rock, if you can, and you'll see the same effect.) Nor are the ghost images affected by the fact that modern shutters travel vertically rather than horizontally. Secondary images are caused between the time the first curtain fully opens, and the second curtain begins to close. The direction of travel of the shutter curtains, or the direction of your subject, does not matter.

Using the Built-in Flash

The Sony Alpha's built-in flash is always available as required. There are several flash modes available in the Camera menu:

- Flash Off. The flash never fires; this may be useful in museums, concerts, or religious ceremonies where electronic flash would prove disruptive.
- Auto Flash. The flash fires as required, depending on lighting conditions. (Not available in PSAM modes.)
- Fill-Flash. The Alpha balances the available illumination with flash to provide a balanced lighting effect. Fill-Flash does not work when using Intelligent Auto exposure mode. (See Figure 9.11.)
- **Slow Sync.** The Alpha combines flash with slow shutter speeds, so that the subject can be illuminated by flash, but the longer shutter speed allows the ambient light to illuminate the background.
- **Rear Sync.** Fires the flash at the end of the exposure, producing more "realistic" "ghost" images, as described earlier in this chapter.
- Wireless. Allows you to trigger an external flash wirelessly using a compatible external unit.

Figure 9.11
The flamingo
(top) was in
shadow. Fill
flash (bottom)
brightened up
the bird, while
adding a little
catch light to
its eye.

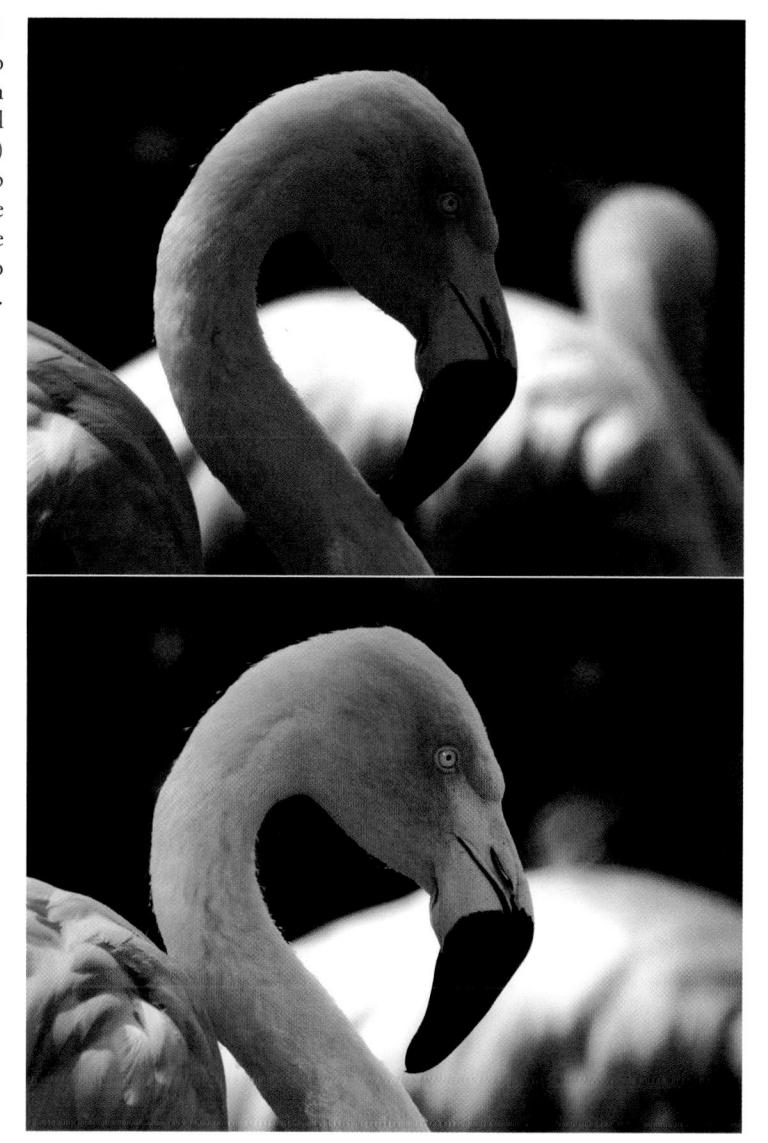

The Sony Alpha's built-in flash is a handy accessory because it is available as required, without the need to carry an external flash around with you constantly. This section explains how to use the flip-up flash. You need to press the flash button (just left of the Playback button on the back of the camera) when there is insufficient light.

When using semi-automatic or manual exposure modes (or any Scene mode in which flash is used), if Red-eye reduction is turned on (as described in Chapter 3), the red-eye reduction flash will emit as you press down the shutter release to take the picture, theoretically causing your subjects' irises to contract (if they are looking toward the camera), and thereby reducing the red-eye effect in your photograph.

BOUNCE FLASH

Although the built-in flash doesn't have detents to allow variable angles, you can easily tilt it with the tip of your index finger while shooting to provide additional flexibility. For example, you can carefully angle the flash downward when shooting close-ups (perhaps with mixed results), or tilt it backward to bounce it off a ceiling or other diffusing surface. Of course, the latter mode won't provide a lot of light given the built-in flash's low power, but if you're using high ISO settings and/or the ceiling or bounce card you use are not too far away, the technique can be useful.

Flash Exposure Compensation

It's important to keep in mind how the NEX-7's exposure compensation system (discussed in Chapter 4) works when you're using electronic flash. To activate exposure compensation for flash, visit the Brightness/Color menu and set the amount of compensation you want. This function is not available when using Auto or Scene exposure modes, nor when you have used the Flash Off option from the Flash menu.

Red Eye Reduction

The other key flash-related control is the Red Eye Reduction option described in Chapter 3. You can turn it on or off. When activated, the Alpha's flip-up flash issues a few brief bursts prior to taking the photo, theoretically causing your subjects' pupils to contract, reducing the effect (assuming the person is looking at the camera during the bursts). This option works only with the built-in flash, and doesn't produce any prebursts if you have an external flash attached. In most cases, the higher elevation of the external flash effectively prevents red eye anyway.

Using the External Electronic Flash

Sony currently offers several accessory electronic flash units for the Sony Alpha cameras. They can be mounted to the flash accessory shoe, or used off-camera with a dedicated cord that plugs into the flash shoe to maintain full communications with the camera for all special features. The beefier units range from the HVL-F58AM (see Figure 9.12), which can correctly expose subjects up to 17 feet away at f/11 and ISO 100, to the (discontinued) HVL-F36AM, which is good out to 11 feet at f/11 and ISO 100. (You'll get greater ranges at even higher ISO settings, of course.) A very inexpensive and useful unit, the \$149 HVL-F20AM, is also available.

Figure 9.12
The Sony
HVL-F58AM is
a top-of-the-line
external flash
unit for the
Alpha.

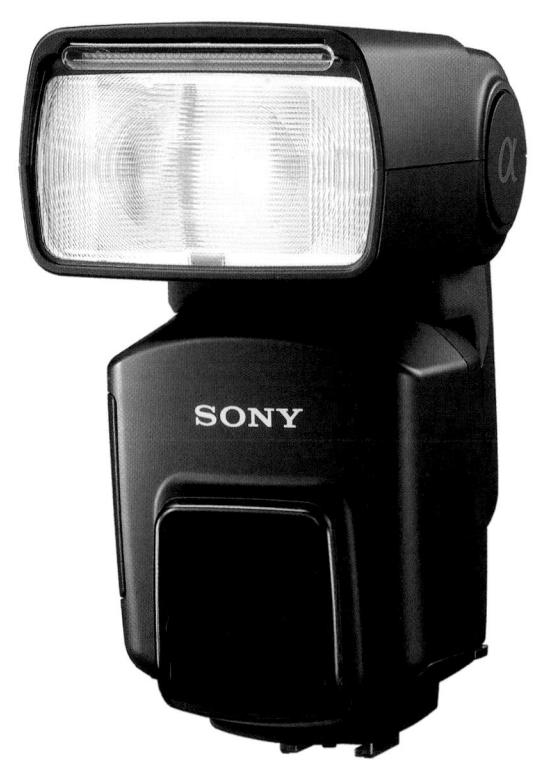

HVL-F58AM Flash Unit

This \$499 flagship of the Sony accessory flash line is the most powerful unit the company offers, with an ISO 100 guide number of 58/190 (meters/feet). Guide numbers are a standard way of specifying the power of a flash in manual, non-autoexposure mode. Divide the guide number by the distance to determine the correct f/stop. With a GN of 190, you would use f/19 at 10 feet (190 divided by 10), or f/8.5 at 20 feet.

This flash automatically adjusts for focal length settings from 24mm to 105mm, and a built-in slide-out diffuser panel boosts wide-angle coverage to 16mm. You can zoom coverage manually, if you like. There's also a slide-out "white card" that reflects some light forward even when bouncing the flash off the ceiling, to fill in shadows or add a catch light in the eyes of your portrait subjects.

Bouncing is particularly convenient and effective, thanks to what Sony calls a "quick shift bounce" system. This configuration is particularly effective when shooting vertical pictures. With most other on-camera external flash units, as soon as you turn the camera vertically, the flash is oriented vertically, too, whether you're using direct flash or bouncing off the ceiling (or, wall, when the camera is rotated). The HVL-58AM's clever pivoting system allows re-orienting the flash when the camera is in the vertical position, so flash coverage is still horizontal, and can be tilted up or down for ceiling bounce.

The 15.6 ounce unit uses convenient AA batteries in a four-pack, but can also be connected to the FA-EB1AM external battery adapter (you just blew another \$250), which has room for 6 AA batteries for increased capacity and faster recycling. It automatically communicates white balance information to your camera, allowing the Alpha to adjust WB to match the flash output.

You can even simulate a modeling light effect. A test button on the back of the flash unit can be rotated for flash mode (one test flash, with no modeling light); three low-power flashes at a rate of two flashes per second, as a rough guide; and a more useful (but more power-consuming) mode that flashes for 40 flashes per second for 4 seconds (160 continuous mini-bursts in all). This switch also has a HOLD position that locks all flash operations except for the LCD data display on the flash, and the test button. Use this when you want to take a few pictures without flash, but don't want to turn off your flash or change its settings.

The HVL-F58AM can function as a main flash, or be triggered wirelessly by another compatible flash unit. The pre-flash from the second "main" flash is used to trigger the remote, wireless flash unit that has been removed or disconnected from the camera. When using flash wirelessly, Sony recommends rotating the unit so that the flashtube is pointed where you want the light to go, but the front (light sensor) of the flash is directed at the flash mounted on the camera. In wireless mode, you can control up to three groups of flashes, and specify the output levels for each group, giving you an easy way to control the lighting ratios of multiple flash units.

Those who are frustrated by an inability to use a shutter speed faster than 1/160th second will love the High Speed Sync (HSS) mode offered by this unit and the discontinued HVL-F36AM flash. When activated, you can take flash pictures at any shutter speed from 1/500th to 1/4,000th second! For example, if you want to use a high shutter speed and a very wide aperture to apply selective focus to a subject, HSS is one way to avoid overexposure when using flash. The mode button on the back of the flash is used to choose either TTL or Manual flash exposure. Once the flash mode is chosen, then use the Select button and flash plus/minus keys to activate HSS mode. HSS appears on the data panel of the flash, and an indicator appears on the camera's LCD monitor. (Note: HSS is not available when using the 2-second self-timer or rear-sync mode.)

Keep in mind that because less than the full duration of the flash is being used to expose each portion of the image as it is exposed by the slit passing in front of the sensor, the effective flash range of this "reduced" output is smaller. In addition, HSS cannot be used when using multiple flash or left/right/up bounce flash. (If you're pointing the flash downwards, say, at a close-up subject, HSS can be used.)

Another feature I like is the HVL-F58AM's multiple flash feature, which allows you to create interesting stroboscopic effects with several images of the same subject presented

in the same frame. If you want to shoot subjects at distances of more than a few feet, however, you'll need to crank up the ISO setting of your Alpha, as the output of each strobe burst is significantly less than when using the flash for single shots.

HVL-F43AM Flash Unit

This less pricey (\$349) electronic flash shares many of the advanced features of the HVL-F58AM, but has a lower guide number of 43/138 (meters/feet). (By now, you've figured out that the number in Sony's electronic flash units represent the GN in meters, so the power rating of the HVL-F36AM, described next, will not come as a surprise to you.)

The shared features include high-speed sync, automatic white balance adjustment, and automatic zoom with the same coverage from 24-105mm (16mm with the slide-out diffuser). This unit also can be used in wireless mode to operate other Sony strobes using a pre-flash signal. Bounce flash swiveling is still versatile, with adjustable angles of 90 degrees up, 90 degrees left, and 180 degrees right, so you can reflect your flash off ceilings, walls, or persons wearing large items of clothing in light colors. The HVL-F43AM is a tad lighter than its bigger sibling, at 12 ounces.

HVL-F36AM Flash Unit

Although discontinued, you can easily find this versatile flash available online or in used condition. The guide number for this lower cost (\$199) Sony flash unit is (surprise!) 36/118 (meters/feet). Although (relatively) tiny at 9 ounces, you still get some big-flash features, such as wireless operation, auto zoom, and high-speed sync capabilities. Bounce flash flexibility is reduced a little, with no swiveling from side to side and only a vertical adjustment of up to 90 degrees available. Like its four siblings, this one uses four AA batteries.

HVL-F20AM Flash Unit

The least expensive Sony flash (see Figure 9.13) is this one (\$149.99), designed to appeal to the budget conscious, especially those who need just a bit of a boost for fill flash, or want a small unit (just 3.2 ounces) on their camera. It has a guide number of 20 at ISO 100, and features simplified operation. For example, there's a switch on the side of the unit providing Indoor and Outdoor settings (the indoor setting tilts the flash upwards to provide bounce light; with the outdoor setting, the flash fires directly at your subject). There are special modes for wide-angle shooting (use the built-in diffuser to spread the flash's coverage to that of a 27mm lens) or choose the Tele position to narrow the flash coverage to that of a 50mm or longer lens for illuminating more distant subjects. While it's handy for fill flash, owners of an Alpha NEX-7 will probably want a more powerful unit as their main electronic flash.

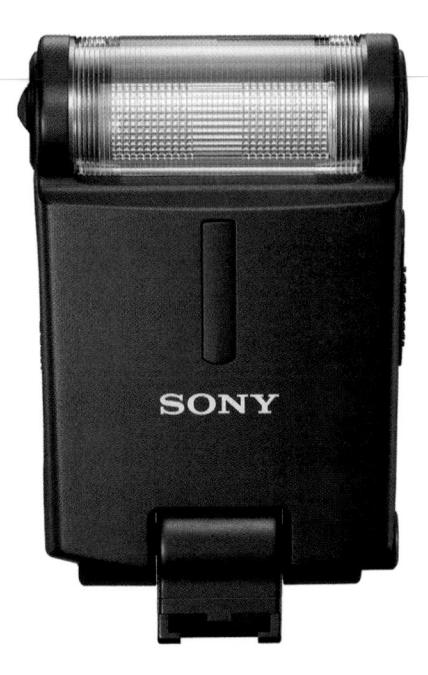

Figure 9.13
The HVLF20AM flash
unit is compact
and
inexpensive.

HVL-F20AM TIP

You may not use your flash very often, but when you do, you want it to operate properly. The problem with infrequent flash use is that conventional nickel-metal hydride batteries lose their charge over time, so if your flash unit is sitting in your bag for a long time between uses, you may not even be aware that your rechargeable batteries are pooped out. Non-rechargeable alkaline cells are not a solution: they generally provide less power for your flash, and replacing them can be costly. I've had excellent luck with a new kind of battery developed by Sanyo called *eneloop* cells. They retain their charge for long periods of time—as much as 75 percent of a full charge over a three-year period (let's hope you don't go that long between uses of your flash). They're not much more expensive than ordinary rechargeables, and can be revitalized up to 1,500 times. They're available in capacities of 1500 mAh to 2500mAh. I use the economical 1900 mAh size.

More Advanced Lighting Techniques

As you advance in your Sony Alpha photography, you'll want to learn more sophisticated lighting techniques, using more than just straight-on flash, or using just a single flash unit. Entire books have been written on lighting techniques. (If you're *really* into complex lighting setups, you might want to check out my book, *David Busch's Quick Snap Guide to Lighting*, available from the same folks who brought you this guidebook.) I'm going to provide a quick introduction to some of the techniques you should be considering.

Diffusing and Softening the Light

Direct light can be harsh and glaring, especially if you're using the flash built into your camera, or an auxiliary flash mounted in the hot shoe and pointed directly at your subject. The first thing you should do is stop using direct light (unless you're looking for a stark, contrasty appearance as a creative effect). There are a number of simple things you can do with both continuous and flash illumination.

■ Use window light. Light coming in a window can be soft and flattering, and a good choice for human subjects. Move your subject close enough to the window that its light provides the primary source of illumination. You might want to turn off other lights in the room, particularly to avoid mixing daylight and incandescent light (see Figure 9.14).

Figure 9.14
Window light
makes the perfect diffuse illumination for
informal soft
focus portraits
like this one.

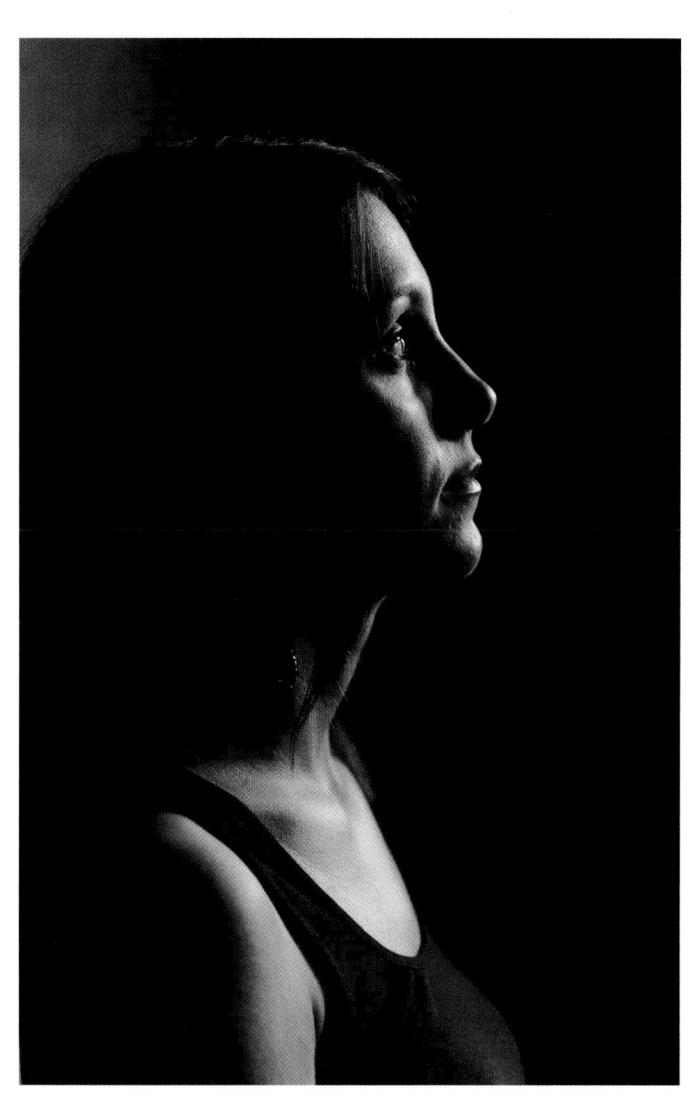

- Use fill light. Your Alpha's flash makes a perfect fill-in light for the shadows, brightening inky depths with a kicker of illumination (see Figure 9.11, shown earlier).
- Bounce the light. All the Sony flashes have a swivel that allows them to be pointed up at a ceiling for a bounce light effect. As I noted, two of them let you bounce the light off a wall. You'll want the ceiling or wall to be white or have a neutral gray color to avoid a color cast.
- Use reflectors. Another way to bounce the light is to use reflectors or umbrellas that you can position yourself to provide a greater degree of control over the quantity and direction of the bounced light. Good reflectors can be pieces of foamboard, Mylar, or a reflective disk held in place by a clamp and stand. Although some expensive umbrellas and reflectors are available, spending a lot isn't necessary. A simple piece of white foamboard does the job beautifully. Umbrellas have the advantage of being compact and foldable, while providing a soft, even kind of light. They're relatively cheap, too, with a good 40-inch umbrella available for as little as \$20.
- Use a diffuser. Sto-fen (www.stofen.com) makes a clip-on diffuser for Sony HVL-series flash units. This simple device (see Figure 9.15) creates a softer light for direct flash or bounce.
- Try a soft box. Inexpensive attachments like the one shown in Figure 9.16 can provide the equivalent of a miniature photo studio "soft box," although in a much smaller, more convenient size.

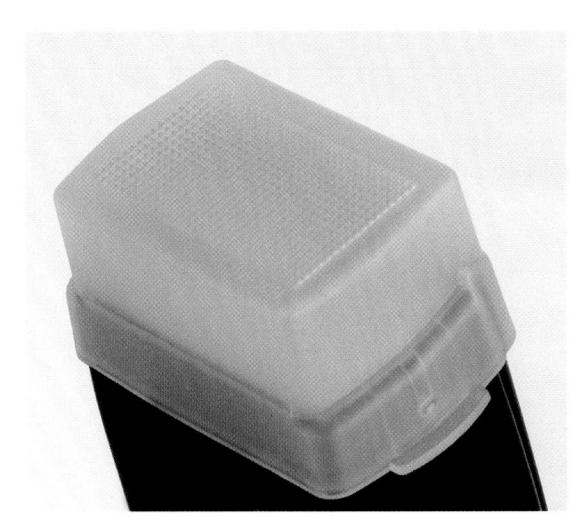

Figure 9.15 Sto-fen's Omni-Bounce diffuser is available for Sony electronic flash units.

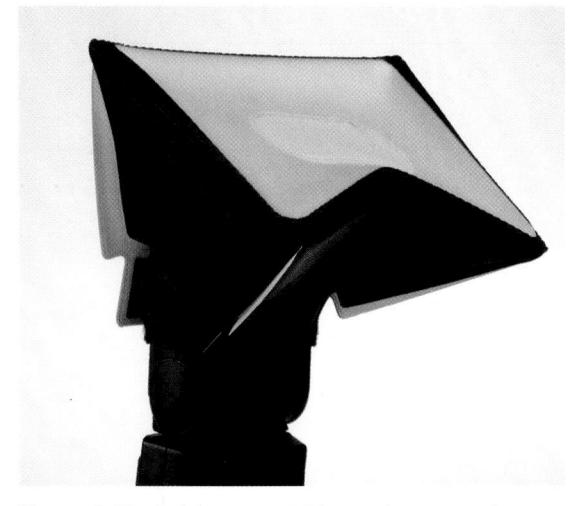

Figure 9.16 Soft boxes use Velcro strips to attach to third-party flash units (like the one shown) or any Sony external flash.

Using Multiple Light Sources

Once you gain control over the qualities and effects you get with a single light source, you'll want to graduate to using multiple light sources. Using several lights allows you to shape and mold the illumination of your subjects to provide a variety of effects, from backlighting to side lighting to more formal portrait lighting. You can start simply with several incandescent light sources, bounced off umbrellas or reflectors that you construct. Or you can use more flexible multiple electronic flash setups.

Effective lighting is the one element that differentiates great photography from candid or snapshot shooting. Lighting can make a mundane subject look a little more glamorous; it can make subjects appear to be soft when you want a soft look, or bright and sparkly when you want a vivid look, or strong and dramatic if that's what you desire. As you might guess, having control over your lighting means that you probably can't use the lights that are already in the room. You'll need separate, discrete lighting fixtures that can be moved, aimed, brightened, and dimmed on command.

Selecting your lighting gear will depend on the type of photography you do, and the budget you have to support it. It's entirely possible for a beginning Alpha photographer to create a basic, inexpensive lighting system capable of delivering high-quality results for a few hundred dollars, just as you can spend megabucks (\$1,000 and up) for a sophisticated lighting system.

Basic Flash Setups

If you want to use multiple electronic flash units, the Sony flash units in wireless mode will serve admirably. The two higher-end models can be used with Sony's wireless feature, which allows you to set up to three separate groups of flash units (several flashes can be included in each group) and trigger them using a master flash and the camera. Just set up one master unit and arrange the compatible slave units around your subject. You can set the relative power of each unit separately, thereby controlling how much of the scene's illumination comes from the main flash, and how much from the auxiliary flash units, which can be used as fill flash, background lights, or, if you're careful, to illuminate the hair of portrait subjects.

Studio Flash

If you're serious about using multiple flash units, a studio flash setup might be more practical. The NEX-7's accessory shoe can accept an adapter that has a built-in PC/X flash connection port, and can accept a cable from non-dedicated studio flash units. It can also operate wireless units like the Pocket Wizard and RadioPopper transmitters using the accessory shoe and an adapter. I use my NEX-7 in the studio with Paul C. Buff CyberSync triggers.

The traditional studio flash is a multi-part unit, consisting of a flash head that mounts on your light stand, and is tethered to an AC (or sometimes battery) power supply. A single power supply can feed two or more flash heads at a time, with separate control over the output of each head.

When they are operating off AC power, studio flash don't have to be frugal with the juice, and are often powerful enough to illuminate very large subjects or to supply lots and lots of light to smaller subjects. The output of such units is measured in watt seconds (ws), so you could purchase a 200ws, 400ws, or 800ws unit, and a power pack to match.

Their advantages include greater power output, much faster recycling, built-in modeling lamps, multiple power levels, and ruggedness that can stand up to transport, because many photographers pack up these kits and tote them around as location lighting rigs. Studio lighting kits can range in price from a few hundred dollars for a set of lights, stands, and reflectors, to thousands for a high-end lighting system complete with all the necessary accessories.

A more practical choice these days are *monolights* (see Figure 9.17), which are "all-in-one" studio lights that sell for about \$200-\$400. They have the flash tube, modeling light, and power supply built into a single unit that can be mounted on a light stand.

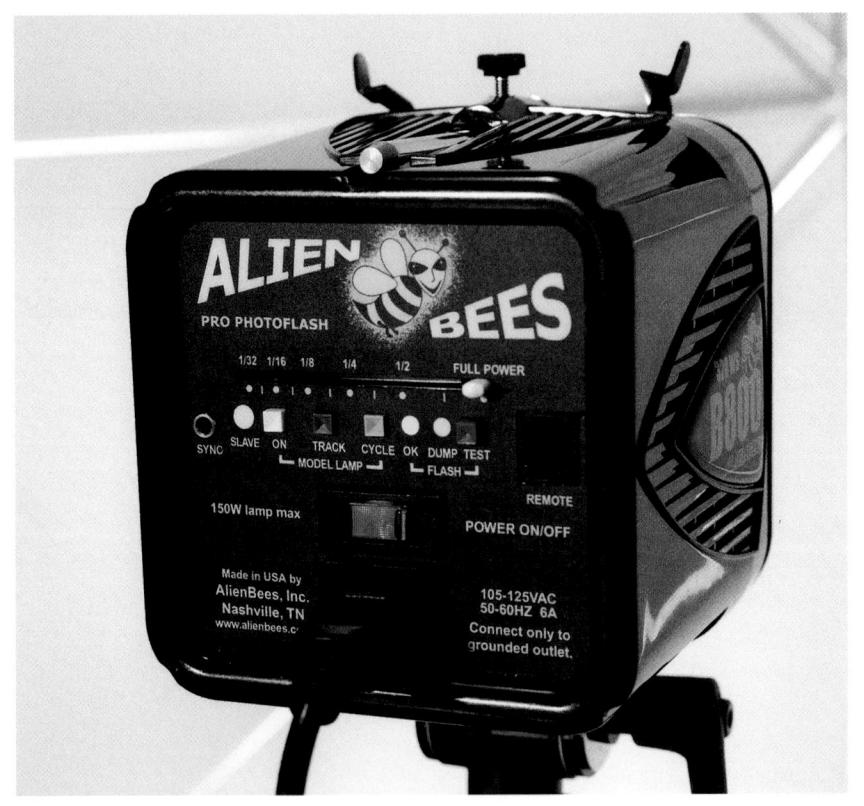

Figure 9.17
All-in-one
"monolights"
contain flash,
power supply,
and a modeling
light in one
compact package (umbrella
not included).

Monolights are available in AC-only and battery-pack versions, although an external battery eliminates some of the advantages of having a flash with everything in one unit. They are very portable, because all you need is a case for the monolight itself, plus the stands and other accessories you want to carry along. Because these units are so popular with photographers who are not full-time professionals, the lower-cost monolights are often designed more for lighter duty than professional studio flash. That doesn't mean they aren't rugged; you'll just need to handle them with a little more care, and, perhaps, not expect them to be used eight hours a day for weeks on end. In most other respects, however, monolights are the equal of traditional studio flash units in terms of fast recycling, built-in modeling lamps, adjustable power, and so forth.

Other Lighting Accessories

Once you start working with light, you'll find there are plenty of useful accessories that can help you. Here are some of the most popular that you might want to consider.

Soft Boxes

Soft boxes are large square or rectangular devices that may resemble a square umbrella with a front cover, and produce a similar lighting effect. They can extend from a few feet square to massive boxes that stand five or six feet tall—virtually a wall of light. With a flash unit or two inside a soft box, you have a very large, semi-directional light source that's very diffuse and very flattering for portraiture and other people photography.

Soft boxes are also handy for photographing shiny objects. They not only provide a soft light, but if the box itself happens to reflect in the subject (say you're photographing a chromium toaster), the box will provide an interesting highlight that's indistinct and not distracting.

You can buy soft boxes, like the one shown in Figure 9.18, or make your own. Some lengths of friction-fit plastic pipe and a lot of muslin cut and sewed just so may be all that you need.

Light Stands

Both electronic flash and incandescent lamps can benefit from light stands. These are lightweight, tripod-like devices (but without a swiveling or tilting head) that can be set on the floor, tabletops, or other elevated surfaces and positioned as needed. Light stands should be strong enough to support an external lighting unit, up to and including a relatively heavy flash with soft box or umbrella reflectors. You want the supports to be capable of raising the lights high enough to be effective. Look for light stands capable of extending six to seven feet high. The nine-foot units usually have larger, steadier bases, and extend high enough that you can use them as background supports. You'll be using these stands for a lifetime, so invest in good ones. I bought the light stand shown in Figure 9.19 when I was in college, and I have been using it for decades.

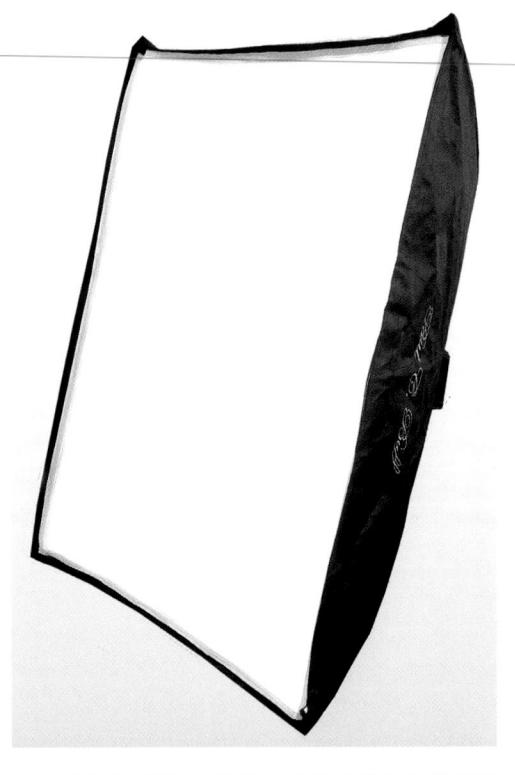

Figure 9.18
Soft boxes provide a large, diffuse light source.

Figure 9.19 Light stands can hold lights, umbrellas, backdrops, and other equipment.

Backgrounds

Backgrounds can be backdrops of cloth, sheets of muslin you've painted yourself using a sponge dipped in paint, rolls of seamless paper, or any other suitable surface your mind can dream up. Backgrounds provide a complementary and non-distracting area behind subjects (especially portraits) and can be lit separately to provide contrast and separation that outlines the subject, or which helps set a mood.

I like to use plain-colored backgrounds for portraits, and white seamless backgrounds for product photography. You can usually construct supports for these yourself from cheap materials and tape them up on the wall behind your subject, or mount them on a pole stretched between a pair of light stands.

Snoots and Barn Doors

These fit over the flash unit and direct the light at your subject. Snoots are excellent for converting a flash unit into a hair light, while barn doors give you enough control over the illumination by opening and closing their flaps that you can use another flash as a background light, with the capability of feathering the light exactly where you want it. Barn doors are shown in Figure 9.20.

Figure 9.20
Barn doors
allow you to
modulate the
light from a
flash or lamp,
and they are
especially useful
for hair lights
and background
lights.

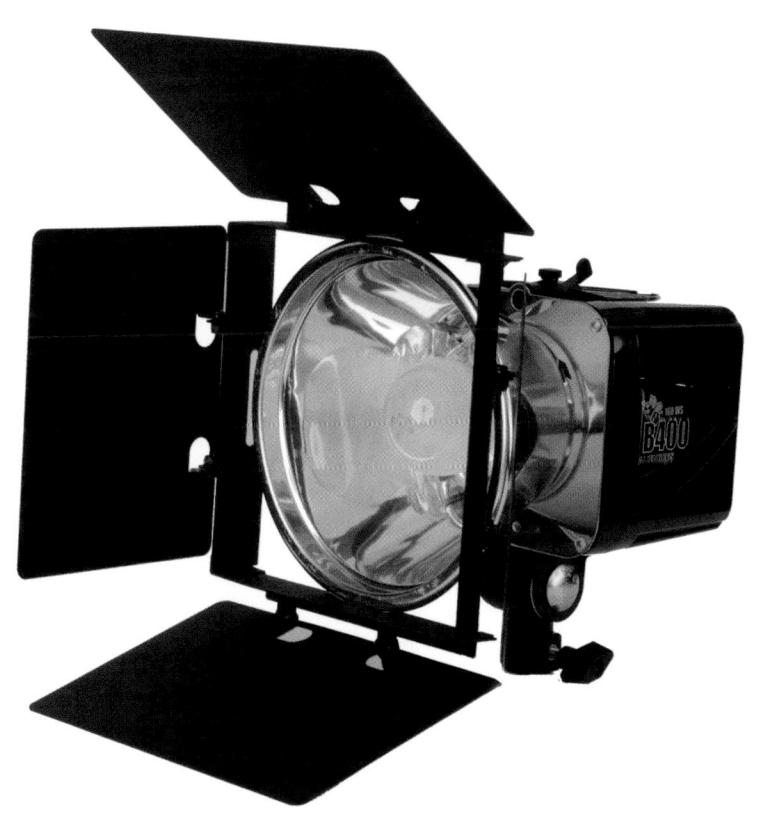

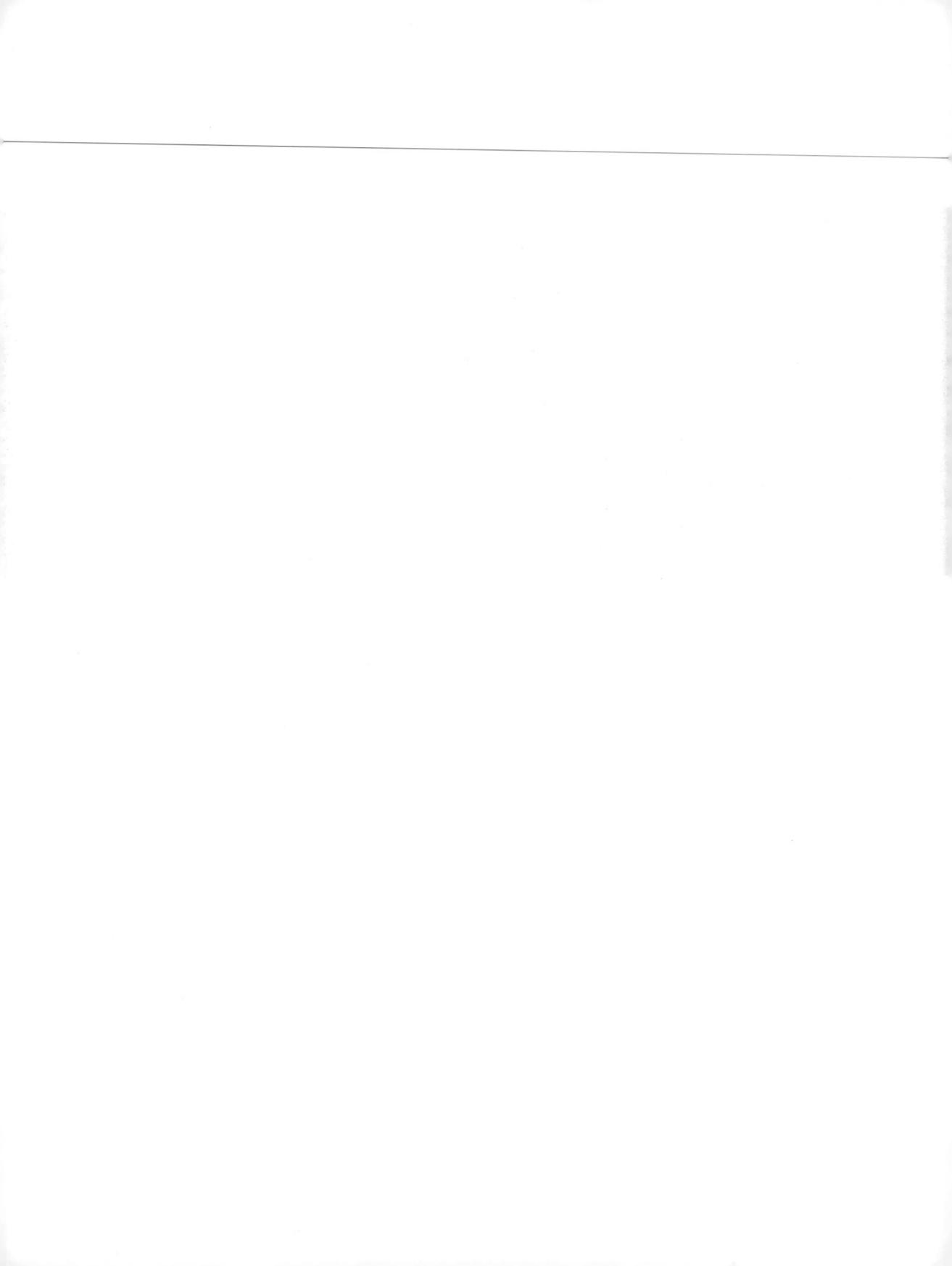
Downloading and Editing Your Images

Taking the picture is only half the work and, in some cases, only half the fun. After you've captured some great images and have them safely stored on your Sony Alpha's memory card, you'll need to transfer them from your camera and memory card to your computer, where they can be organized, fine-tuned in an image editor, and prepared for web display, printing, or some other final destination.

Fortunately, there are lots of software utilities and applications to help you do all these things. This chapter will introduce you to a few of them. Don't expect a lot of "how-to-do-it" or instructions on using the software itself. This is primarily a *camera* guide, rather than a software manual. My intent in this chapter is to let you know what options are available, to help you choose what is right for you.

What's in the Box?

Sony includes three basic software utilities with the Alpha NEX-7. They are the Picture Motion Browser (abbreviated PMB, and compatible with Windows only), Image Data Lightbox SR (for Windows and Macs), and Image Data Converter SR (supplied for both Windows and Mac operating systems). Unfortunately, for those using 64-bit versions of Windows, PMB is the only application compatible with that operating system. You'll have to use a different "lightbox" application, such as Adobe Lightroom, and an additional RAW translating program (such as Adobe Camera Raw) if you're using 64-bit Windows.

Install these applications using the CD supplied with the camera. Picture Motion Browser is an importing utility that collects images into folders and offers some simple editing capabilities for making minor fixes. Image Data Lightbox is a more advanced image browsing and workflow manager, while Image Data Converter SR is a sophisticated tool for importing and manipulating RAW images.

Picture Motion Browser

This tool, supplied with a variety of Sony cameras, camcorders, and other imaging devices, works with both still images and video files. It is available for Windows only, but Mac users can get most of its functions in iPhoto, and can import images to their computer by dragging and dropping image files as described in the "Transferring Your Photos" section that follows. Once you've imported/registered images with this browser, they are displayed in index view (see Figure 10.1), map view, or in a calendar view that

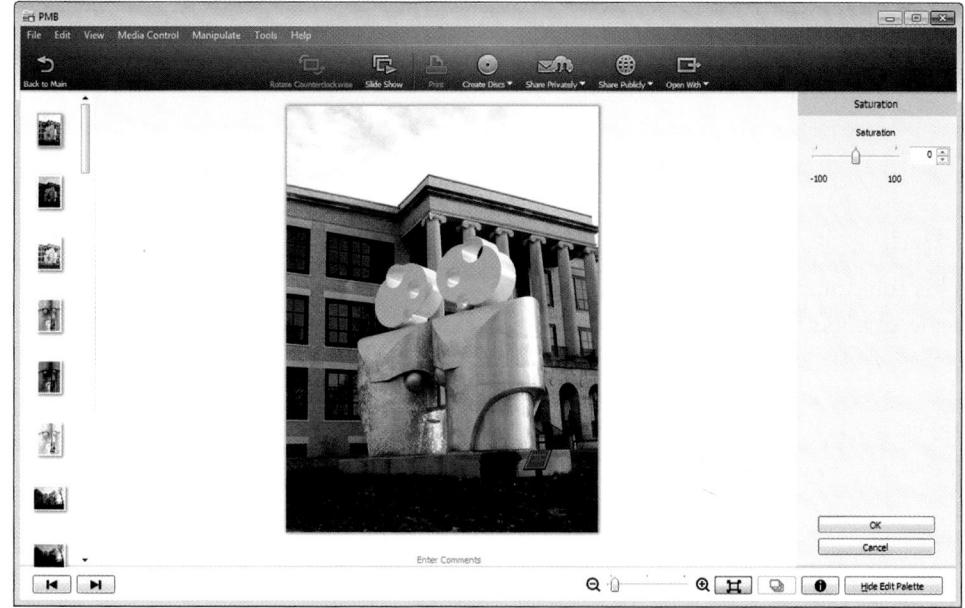

arranges the photos by the date they were taken. There is also a player included for AVCHD movies.

Double-click a thumbnail to display it in an editing window (see Figure 10.2), along with tools for trimming, rotating, adjusting brightness and contrast, enhancing or reducing saturation, adjusting sharpness, manipulating tonal curves, and activating red-eye reduction. You can also put the date on your photo. Picture Motion Browser can display all the photos in a folder as a slide show, burn them to a CD or DVD, and mark them for printing or e-mailing directly from the application. PMB lets you create Blu-Ray and AVCHD format video DVDs that can be played on compatible equipment.

Picture Motion Browser has a photo-downloading utility that you can activate or deac tivate in the Tools menu. As images are imported, they are moved into a folder within your My Pictures folder and are named after the import date, or deposited in a folder with a different name that you specify.

Image Data Lightbox SR

This is a newer application than Picture Motion Browser and is better for viewing, sorting, and comparing images than the older program. It's no Adobe Lightroom (or Apple Aperture, for that matter), but the price—free—is right. The application lets you compare images, even when still in RAW format, and apply star ratings, so you can

Figure 10.3
Image Data
Lightbox SR

helps you man-

age your picture collection.

segregate your best shots from a group of similar images (as shown in Figure 10.3) while you manage your photo library. You can choose to view the images as all thumbnails or in the Preview Display format, which features a line of images and one large image. It includes tools for creating image collections, batch printing, and converting photos to JPEG or TIFF format. To manipulate RAW files, you need Image Data Converter SR, discussed next.

Image Data Converter SR

This RAW converter is Sony's equivalent of Adobe Camera Raw, except that as your .arw files are converted, they can be transferred to the image editor of your choice, such as Corel Paint Shop Pro, rather than just to Adobe Photoshop or Photoshop Elements.

Like all RAW converters, Image Data Converter SR (see Figure 10.4) enables you to change any of the settings you could have made in the camera, plus modify a selection of additional settings, such as tonal curves, that you can't normally adjust when you take the photo. Making these changes after the picture is taken allows you to fine-tune your images, correct errors you might have made when you shot the photo, and fix things such as color balance that the camera (or you) might have set incorrectly.

Figure 10.4
Image Data
Converter SR
lets you manage
any of the incamera settings
as RAW files
are imported—
as well as many
other options.

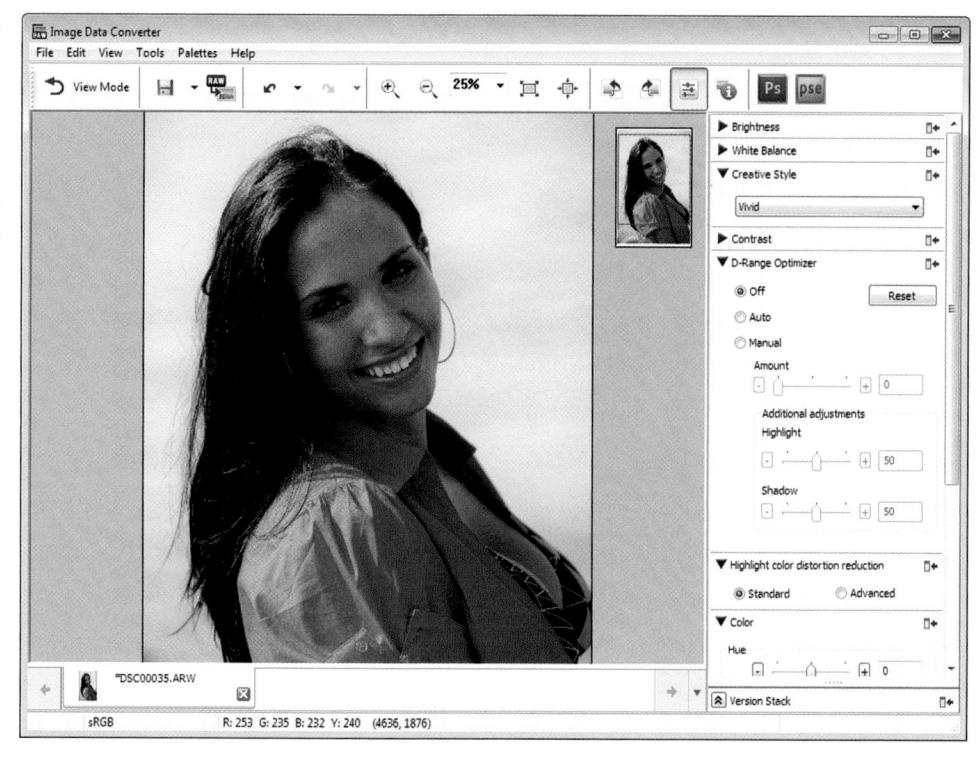

This program includes four Adjustment Palettes that enable you to invoke specific dialog boxes with sliders and other adjustments. For example, there are separate exposure value (EV) adjustment settings, contrast and saturation settings, and a three-channel histogram, which can, optionally, display separate red, green, and blue histograms rather than the simple brightness (luminance) histogram shown in the camera.

Palette 1 is used for adjusting and setting white balance, color correction, hue, and saturation; Palette 2 is used to modify exposure, contrast, D-Range Optimizer, and other settings; Palette 3 makes it easy to set Creative Style adjustments, and specify sharpness, noise reduction, and picture effects, etc.; Palette 4 is where you'll find controls for display area, histograms, and tone curves.

The Image Properties dialog box, shown in Figure 10.5, has an icon in the toolbar you can click to view a complete listing of all the settings you applied when you originally took the photo, such as lens, f/stop, shutter speed, ISO setting, and metering mode. These can all be changed within Image Data Converter SR as the files are imported for your image editor.

nage Properties	
Item	Value
File name	DSC00035.ARW
File type	ARW 2.3 (compressed) format
Date taken	01/05/2012 1:30 AM
Created	01/05/2012 1:30 PM
Image width	6000
Image height	4000
Orientation	Standard
Manufacturer name	SONY
Model name	NEX-7
Lens name	50mm F1.4
Max aperture	F1.4
Lens focal length	50.0 mm
35mm equivalent focal length	75.0 mm
Shutter speed	1/160 sec.
Fnumber	F22.0
Exposure correction value	+0.0 EV
Flash compensation	+0.0 EV
Exposure program	Manual exposure
Metering mode	Multi segment
ISO	100
Multi Frame Noise Reduct.	Off
White balance settings	Flash (0)
White balance adjustment	A-B: 0 G-M: 0
Color temperature	
Flash	Not used
Flash mode	No flash
Red-eye reduction	Off
Saturation	Standard
Contrast	Standard
Sharpness	Standard
Brightness	Standard
Color space	sRGB
Creative Style	Standard
Scene selection	
Zone matching	Off
D-Range Optimizer	Off
Auto HDR	Off
High ISO NR	Off
Long Exposure NR	Off
Distortion compensation	off
Color aberration compensa	Auto
Shading compensation	Auto
Super SteadyShot	On

Figure 10.5

Check out your original settings in the Image Properties dialog box.

Transferring Your Photos

While it's rewarding to capture some great images and have them ensconced in your camera, eventually you'll be transferring them to your laptop or PC, whether you're using a Windows or Macintosh machine. You have four options for image transfer: direct transfer over a USB cable; automated transfer using a card reader and transfer software such as the Sony Import Media Files utility that is a part of the Picture Motion Browser and Image Data Converter SR applications; Adobe Photoshop Elements Photo Downloader; or manual transfer using drag and drop from a memory card inserted in a card reader.

If you want to transfer your photos directly from your Sony Alpha camera to your computer, you'll first need to visit the Setup menu and make sure that the USB connection option is set to Mass Storage or Auto. That allows your computer to recognize the memory card in your computer as just another external drive, as if the camera were

a hard drive or thumb/flash drive. While this method consumes a lot more battery power than the card reader option discussed later, and may be quite a bit slower, it is convenient (assuming you have the USB cable handy) and easy. Just follow these steps:

- 1. With the Alpha's USB connection option set to Mass Storage, turn the camera and computer on.
- Open the door over the connector ports and plug the smaller connector of the USB cable into the camera. Then, plug the larger cable plug into a USB socket on your computer.
- 3. If you're using Windows, its Autoplay Wizard may pop up (see Figure 10.6), offering a selection of downloading utilities (including the Windows Scanner and Camera Wizard, Adobe Photo Downloader, and the Media Importer). Choose one. Mac OS X offers similar options.

Figure 10.6
Windows
Autoplay
Wizard allows
you to choose
which utility to
use to transfer
your photos.

- 4. Use the options in the downloading utility you selected. You may be able to specify automatic red-eye correction, rename your files, place your files in a folder you select, or even view thumbnails of the available images so you download only the ones you want.
- 5. Activate the download process.

Using a Card Reader and Software

You can also use a memory card reader and software to transfer photos and automate the process using any of the downloading applications available with your computer. The process is similar to downloading directly from the camera, except that you must remove the memory card from the Alpha camera and insert it into a memory card reader attached to your computer.

Where USB-to-computer transfers are limited to the speed of your USB connection, card readers can be potentially much faster. This method is more frugal in its use of your camera's battery and can be faster if you have a speedy USB 2.0 or 3.0 or FireWire card reader attached to an appropriate port. I have FireWire 800 ports in my computer, and a FireWire 800 card reader, and I get roughly four times the transfer speed I got with my old USB card reader.

The installed software automatically remains in memory as you work, and it recognizes when a memory card is inserted in your card reader; you don't have to launch it yourself. You'll see the Import Media Files dialog box (see Figure 10.7), or, sometimes, several competing downloaders will pop up at once. If that happens, you may want to disable the superfluous downloaders so your utility of choice will take precedence.

With Photoshop Elements Photo Downloader, you can choose basic options, such as file renaming and folder location, and then click Get Photos to begin the transfer of all images immediately. (See Figure 10.8.) Or choose Advanced Dialog for additional options, such as the ability to select which images to download from the memory card by marking them on a display of thumbnails. You can select other options, such as Automatically Fix Red Eyes, or inserting a copyright notice of your choice. Start the download by clicking Get Photos, and a confirmation dialog box like the one in Figure 10.9 shows the progress.

Figure 10.7 The Picture Motion Browser is installed automatically with the Sony software suite.

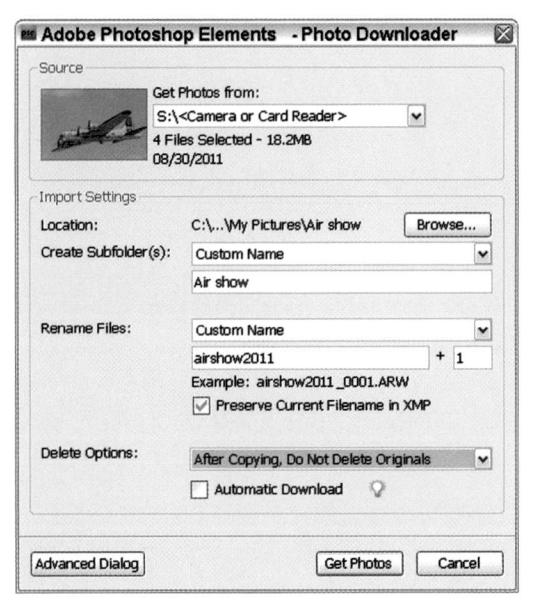

Figure 10.8 With Basic view activated, Photoshop Elements Photo Downloader allows you to choose a filename and destination for your photos.

Figure 10.9
The Photo
Downloader's
confirmation
dialog box
shows the progress as images
are transferred.

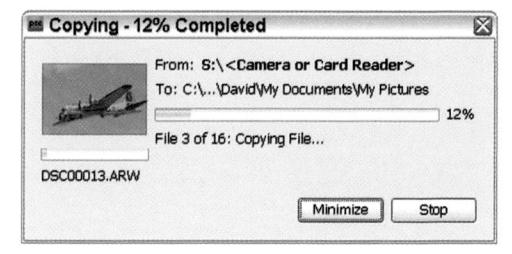

Dragging and Dropping

The final way to move photos from your memory card to your computer is the old-fashioned way: manually dragging and dropping the files from one window on your computer to another. The procedure works pretty much the same whether you're using a Mac or a PC.

- Remove the memory card from the Sony Alpha and insert it in your memory card reader. (Make sure the USB connection option in the Setup menu is set to Mass Storage.)
- Using Windows Explorer, My Computer, Computer, or your Mac desktop, open the icon representing the memory card, which appears on your desktop as just another disk drive.
- 3. Open a second window representing the folder on your computer that you want to use as the destination for the files you are copying or moving.
- 4. Drag and drop the files from the memory card window to the folder on your computer. You can select individual files, press Ctrl/Command+A to select all the files, or Ctrl/Command+click to select multiple files.

Editing Your Photos

Image manipulation tasks fall into several categories. You might want to fine-tune your images, retouch them, change color balance, composite several images together, and perform other tasks we know as image editing, with a program like Adobe Photoshop, Photoshop Elements, or Corel Photo Paint.

You might want to play with the settings in RAW files, too, as you import them from their .arw state into an image editor. There are specialized tools expressly for tweaking RAW files, ranging from Sony's own Digital Image Converter to Adobe Camera Raw, and PhaseOne's Capture One 5 Pro (C1 Pro). A third type of manipulation is the specialized task of noise reduction, which can be performed within Photoshop, Adobe Camera Raw, or other tools.

Each of these utilities and applications deserves a chapter of its own, so I'm simply going to enumerate some of the most popular image editing and RAW conversion programs here and tell you a little about what they do.

Image Editors

Image editors are general-purpose photo-editing applications that can do color correction, tonal modifications, retouching, combining of several images into one, and usually include tools for working with RAW files and reducing noise. So, you'll find programs like those listed here good for all-around image manipulation. The leading programs are as follows:

Adobe Photoshop/Photoshop Elements. Photoshop is the serious photographer's number one choice for image editing, and Elements is an excellent option for those who need most of Photoshop's power, but not all of its professional-level features. Both Photoshop and Elements editors use the latest version of Adobe's Camera Raw plug-in, which makes it easy to adjust things like color space profiles, color depth (either 8 bits or 16 bits per color channel), image resolution, white balance, exposure, shadows, brightness, sharpness, luminance, and noise reduction. One plus with the Adobe products is that they are available in identical versions for both Windows and Macs.

Corel Photo Paint. This is the image-editing program that is included in the popular CorelDRAW Graphics suite. Although a Mac version was available in the past, this is exclusively a Windows application today. It's a full-featured photo retouching and image-editing program with selection, retouching, and painting tools for manual image manipulations, and it also includes convenient automated commands for a few common tasks, such as red-eye removal. Photo Paint accepts Photoshop plug-ins to expand its assortment of filters and special effects.

Corel Paint Shop Pro. This is a general-purpose Windows-only image editor that has gained a reputation as the "poor person's Photoshop" for providing a substantial portion of Photoshop's capabilities at a fraction of the cost. It includes a nifty set of wizard-like commands that automate common tasks, such as removing red eye and scratches, as well as filters and effects, which can be expanded with other Photoshop plug-ins.

Corel Painter. Here's another image-editing program from Corel for both Mac and Windows. This one's strength is in mimicking natural media, such as charcoal, pastels, and various kinds of paint. Painter includes a basic assortment of tools that you can use to edit existing images, but the program is really designed for artists to use in creating original illustrations. As a photographer, you might prefer another image editor, but if you like to paint on top of your photographic images, nothing else really does the job of Painter.

Corel PhotoImpact. Corel finally brought one of the last remaining non-Adobe image editors into its fold when it acquired PhotoImpact. This is a general-purpose photoediting program for Windows with a huge assortment of brushes for painting, retouching, and cloning in addition to the usual selection, cropping, and fill tools. If you frequently find yourself performing the same image manipulations on a number of files, you'll appreciate PhotoImpact's batch operations. Using this feature, you can select multiple image files and then apply any one of a long list of filters, enhancements, or auto-process commands to all the selected files.

RAW Utilities

Your software choices for manipulating RAW files are broader than you might think. Camera vendors always supply a utility to read their cameras' own RAW files, but sometimes, particularly with those point-and-shoot cameras that can produce RAW files, the options are fairly limited.

Because in the past digital camera vendors offered RAW converters that weren't very good, there is a lively market for third-party RAW utilities available at extra cost. The third-party solutions are usually available as standalone applications (often for both Windows and Macintosh platforms), as Photoshop-compatible plug-ins, or both. Because the RAW plug-ins displace Photoshop's own RAW converter, I tend to prefer to use most RAW utilities in standalone mode. That way, if I choose to open a file directly in Photoshop, it automatically opens using Photoshop's fast and easy-to-use Adobe Camera Raw (ACR) plug-in. If I have more time or need the capabilities of another converter, I can load that, open the file, and make my corrections there. Most are able to transfer the processed file directly to Photoshop even if you aren't using plug-in mode.

The latest version of Photoshop includes a built-in RAW plug-in that is compatible with the proprietary formats of a growing number of digital cameras, both new and old, and it's continually updated to embrace any new cameras that are introduced. This plug-in also works with Photoshop Elements.

To open a RAW image in Photoshop, just follow these steps (Elements users can use much the same workflow, although fewer settings are available):

- 1. Transfer the .arw images from your camera to your computer's hard drive.
- 2. In Photoshop, choose Open from the File menu, or use Bridge or, with Elements, Organizer.
- 3. Select an .arw image file. The Adobe Camera Raw plug-in will pop up, showing a preview of the image, like the one shown in Figure 10.10.

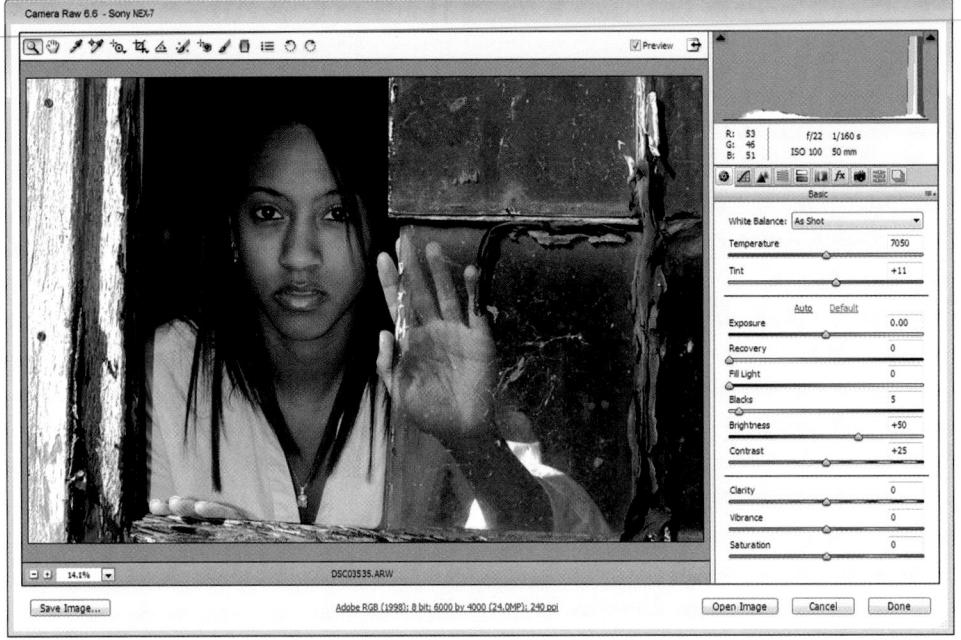

Figure 10.10
The basic ACR

The basic ACR dialog box looks like this when processing a single image.

- 4. If you like, use one of the tools found in the toolbar at the top left of the dialog box. From left to right, they are as follows:
 - **Zoom.** Operates just like the Zoom tool in Photoshop.
 - Hand. Use like the Hand tool in Photoshop.
 - White Balance. Click an area in the image that should be neutral gray or white to set the white balance quickly.
 - Color Sampler. Use to determine the RGB values of areas you click with this eyedropper.
 - **Crop.** Pre-crop the image so that only the portion you specify is imported into Photoshop. This option saves time when you want to work on a section of a large image, and you don't need the entire file.
 - **Straighten.** Drag in the preview image to define what should be a horizontal or vertical line, and ACR will realign the image to straighten it.
 - **Retouch.** Use to heal or clone areas you define.
 - Red-Eye Removal. Quickly zap red pupils in your human subjects.
 - ACR Preferences. Produces a dialog box of Adobe Camera Raw preferences.
 - Rotate Counterclockwise. Rotates counterclockwise in 90-degree increments with a click.
 - Rotate Clockwise. Rotates clockwise in 90-degree increments with a click.

- 5. Using the Basic tab, you can have ACR show you red and blue highlights in the preview that indicate shadow areas that are clipped (too dark to show detail) and light areas that are blown out (too bright). Click the triangles in the upper-left corner of the histogram display (shadow clipping) and upper-right corner (highlight clipping) to toggle these indicators on or off.
- 6. Also in the Basic tab you can choose white balance, either from the drop-down list or by setting a color temperature and green/magenta color bias (tint) using the sliders.
- 7. Other sliders are available to control exposure, recovery, fill light, blacks, brightness, contrast, vibrance, and saturation. A checkbox can be marked to convert the image to grayscale.
- 8. Make other adjustments (described in more detail below).
- ACR makes automatic adjustments for you. You can click Default and make the changes for yourself, or click the Auto link (located just above the Exposure slider) to reapply the automatic adjustments after you've made your own modifications.
- 10. If you've marked more than one image to be opened, the additional images appear in a "filmstrip" at the left side of the screen. You can click on each thumbnail in the filmstrip in turn and apply different settings to each.
- 11. Click Open Image/Open Image(s) into Photoshop using the settings you've made. You can also click Save or Done to save the changes you've made *without* opening the file in your image editor.

The Basic tab is displayed by default when the ACR dialog box opens, and it includes most of the sliders and controls you'll need to fine-tune your image as you import it into Photoshop. These include:

- White Balance. Leave it As Shot or change to a value such as Daylight, Cloudy, Shade, Tungsten, Fluorescent, or Flash. If you like, you can set a custom white balance using the Temperature and Tint sliders.
- Exposure. This slider adjusts the overall brightness and darkness of the image.
- Recovery. Restores detail in the red, green, and blue color channels.
- Fill Light. Reconstructs detail in shadows.
- **Blacks.** Increases the number of tones represented as black in the final image, emphasizing tones in the shadow areas of the image.
- Brightness. This slider adjusts the brightness and darkness of an image.
- **Contrast.** Manipulates the contrast of the midtones of your image.

- 314
 - **Clarity.** Use this slider to apply a hybrid type of contrast enhancement to boost midtone contrast.
 - **Vibrance.** Prevents over-saturation when enriching the colors of an image.
 - **Saturation.** Manipulates the richness of all colors equally, from zero saturation (gray/black, no color) at the −100 setting to double the usual saturation at the +100 setting.

Additional controls are available on the Tone Curve, Detail, HSL/Grayscale, Split Toning, Lens Corrections, Camera Calibration, FX, Presets, and Snapshots tabs, shown in Figure 10.11. The Tone Curve tab can change the tonal values of your image. The Detail tab lets you adjust sharpness, luminance smoothing, and apply color noise reduction. The HSL/Grayscale tab offers controls for adjusting hue, saturation, and lightness, and converting an image to black-and-white. Split Toning helps you colorize an image with sepia or cyanotype (blue) shades. The Lens Corrections tab has sliders to adjust for chromatic aberrations and vignetting. The Camera Calibration tab provides a way for calibrating the color corrections made in the Camera Raw plug-in.

Figure 10.11 More controls are available within the additional tabbed dialog boxes in Adobe Camera Raw.

Sony Alpha NEX-7: Troubleshooting and Prevention

One of the nice things about modern electronic cameras like the Alpha NEX series is that they have fewer mechanical moving parts to fail, so they are less likely to "wear out." No film transport mechanism, no wind lever or motor drive, no complicated mechanical linkages from camera to lens to physically stop down the lens aperture. Instead, tiny, reliable motors are built into each lens (and you lose the use of only that lens should something fail). The NEX camera even lacks the one major moving part found in its dSLR counterparts—the mirror that flips up and down with each shot.

Of course, the camera also has a moving shutter that can fail, but the shutter is built rugged enough that you can expect it to last 100,000 shutter cycles or more. Unless you're shooting sports in continuous mode day in and day out, the shutter on your Alpha is likely to last as long as you expect to use the camera.

The only other things on the camera that move are switches, dials, buttons, the pop-up electronic flash, and the door that slides open to allow you to remove and insert the memory card. The NEX camera uses "soft" buttons that change function depending on your shooting mode, so they have even fewer of these controls than most cameras. Unless you're extraordinarily clumsy or unlucky and manage to give your built-in flash a good whack while it is in use, there's not a lot that can go wrong mechanically with your Sony Alpha.

On the other hand, one of the chief drawbacks of modern electronic cameras is that they are modern *electronic* cameras. Your Alpha is fully dependent on its battery. Without it, the camera can't be used. There are numerous other electrical and electronic connections in the camera (many connected to those mechanical switches and dials). The camera also relies on its "operating system," or *firmware*, which can be plagued by bugs that cause unexpected behavior. Luckily, electronic components are generally more reliable and trouble-free, especially when compared to their mechanical counterparts from the pre-electronic film camera days. (Film cameras of the last 10 to 20 years have had almost as many electronic features as digital cameras, but, believe it or not, there were whole generations of film cameras that had *no* electronics or batteries.)

Digital cameras have problems unique to their breed, too; the most troublesome being the need to clean the sensor of dust and grime periodically. This chapter will show you how to diagnose problems, fix some common ills, and, importantly, learn how to avoid them in the future.

Updating Your Firmware

As I said, the firmware in your Sony Alpha is the camera's operating system, which handles everything from menu display (including fonts, colors, and the actual entries themselves), what languages are available, and even support for specific devices and features. Upgrading the firmware to a new version makes it possible to add new features while fixing some of the bugs that sneak in.

The exact changes made to the firmware are generally spelled out in the firmware release announcement. You can examine the remedies provided and decide if a given firmware patch is important to you. If not, you can usually safely wait a while before going through the bother of upgrading your firmware—at least long enough for the early adopters to report whether the bug fixes have introduced new bugs of their own. Each new firmware release incorporates the changes from previous releases, so if you skip a minor upgrade you should have no problems.

WARNING

Use a fully charged battery to ensure that you'll have enough power to operate the camera for the entire upgrade. Moreover, you should not turn off the camera while your old firmware is being overwritten. Don't open the memory card door or do anything else that might disrupt operation of the Alpha while the firmware is being installed.

To see which firmware version is currently installed in your camera, press the upper soft key (Menu button) to enter the main menu system; select the Setup menu (red toolbox icon); then scroll down using the control wheel or down button to the Version line. Press the center controller button to select the Version item. If the Body version is 01, you need to upgrade to whatever version has been released since the camera was introduced. (If you own the adapter, update the Lens/Mount Adapter firmware version as well.)

If you find you do need to upgrade your firmware, you must download the updater file from the Sony support website. The URL for the site varies from country to country. I wouldn't bother navigating through the Sony support pages to find it. To find updates for the NEX-7 model, just Google "Sony NEX-7 firmware update" and locate the correct link quickly. Download the file, with a name like NEX-7X_Updatennnn.exe (where X is the latest version number, and nnnn is the date of the release), and you'll be ready to follow the instructions for Windows outlined below, and shown in Figure 11.1. If you're using a Mac, download the updater for your operating system instead. The procedures are basically the same. As no update for the NEX-7 was available when this book was written, the steps outlined below may be slightly different.

- 1. Turn on the camera.
- 2. Press the Menu button and navigate to the Setup menu, then scroll down to USB Connection and verify that Auto or Mass Storage is selected.
- 3. Launch the firmware file that you downloaded.

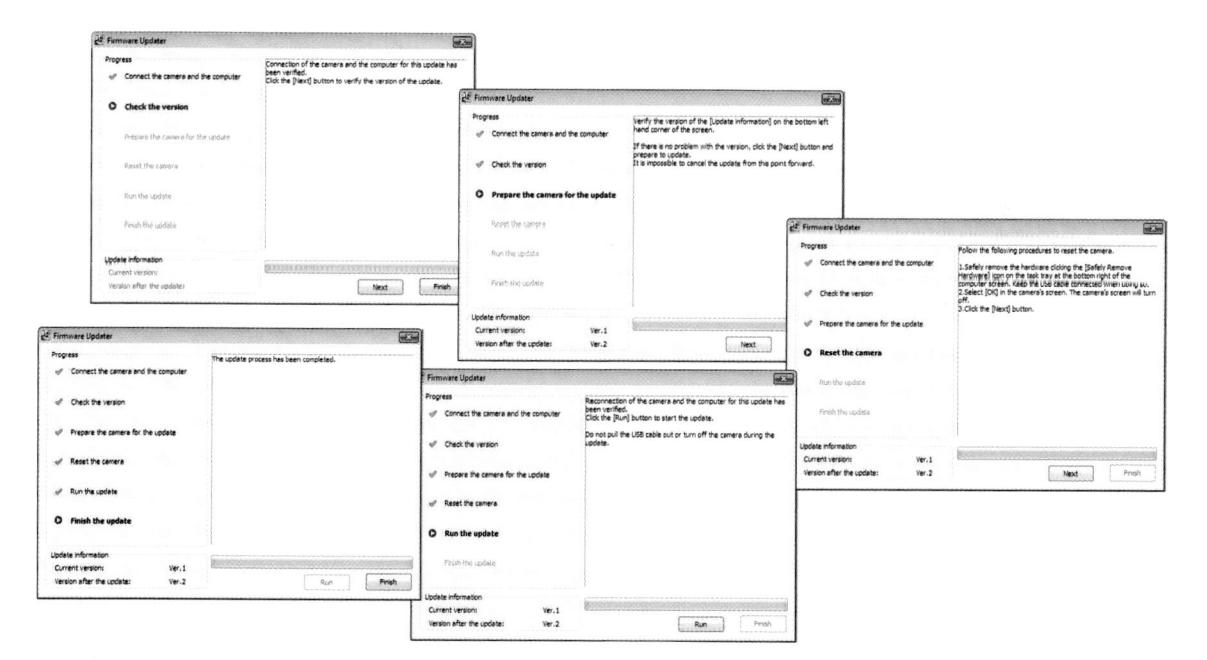

Figure 11.1 You'll follow these steps in upgrading your firmware.

- 4. Connect your camera to the computer using the USB cable.
- 5. Click the Next button in the updater window, and follow the instructions that appear on the screens to verify the firmware version you have, shown in Figure 11.1.
- 6. With the USB cable still connected, click the Safely Remove Hardware icon in the Windows notification/task tray and stop the USB connection.
- 7. Press the center controller button to reset the camera.
- 8. Click Next in the firmware updater window to continue.
- 9. Follow the instructions as the firmware is updated. It will take several minutes to install the firmware in your camera. Do not interrupt the process, turn the camera off, or disconnect the cable during the update.
- 10. Click the Finish button when the firmware is updated.
- 11. Disconnect the USB cable, turn off the camera, and remove the battery pack or AC adapter. Then reconnect. This forces a "cold" reset of the camera, and ensures that your firmware is activated and ready to go.

Protecting Your LCD

The 3-inch color LCD on the back of your Sony Alpha almost seems like a target for banging, scratching, and other abuse, especially when it is swiveled up or down for viewing from high or low vantage points. Fortunately, this LCD is quite rugged, and a few errant knocks are unlikely to shatter the protective cover over the LCD, and scratches won't easily mar its surface. However, if you want to be on the safe side, there are several products you can purchase to protect your LCD—and, in some cases, make it a little easier to view. Here's a quick overview of your options.

- Plastic overlays. The simplest solution (although not always the cheapest) is to apply a plastic overlay sheet or "skin" cut to fit your LCD. These adhere either by static electricity or through a light adhesive coating that's even less clingy than stick-it notes. You can cut down overlays made for PDAs (although these can be pricey at up to \$19.95 for a set of several sheets), or purchase overlays sold specifically for digital cameras. Vendors such as Zagg (www.zagg.com) offer overlays of this type. These products will do a good job of shielding your Alpha's LCD screen from scratches and minor impacts, but will not offer much protection from a good whack.
- Acrylic/glass/polycarbonate shields. A company in China called GGS makes a very popular glass screen protector for various Alpha models. One was not available for the NEX-7 at the time I wrote this book (although I did find one when the book went to press), so Figure 11.2 shows the NEX-5 version, which should be very similar. The important thing to look for in a shield is an opening for the NEX's light

sensor at lower left. Unfortunately, the GGS products seem to be available only from third parties like Amazon and eBay, so I can't give you a specific URL to visit. There are a number of different sellers offering these shields for \$5 to \$12, plus shipping, including Amazon, and I've ordered from several of them with good luck. The protectors attach using strips of sticky adhesive that hold the panel flush and tight, but which allow the protector to be pried off and the adhesive removed easily if you want to remove or replace the shield. They don't attenuate your view of the LCD and are non-reflective enough for use under a variety of lighting conditions.

■ Hoods. Although I haven't used any myself as I write this, it's probably inevitable that some vendors will offer various hood-type devices for the NEX series. They are best suited for protecting/shielding the LCD in bright sunlight. You should be able to get one for the NEX-7 from Rainbow Imaging at http://www.rainbowimaging.biz/shop/product.php?id_product=414/.

All Your Eggs in One Basket?

The debate about whether it's better to use one large memory card or several smaller ones has been going on since even before there were memory cards. I can remember when computer users wondered whether it was smarter to install a pair of 200MB (not *gigabyte*) hard drives in their computer, or if they should go for one of those new-fangled 500MB models. By the same token, a few years ago the user groups were full of proponents who insisted that you ought to use 128MB memory cards rather than the huge 512MB versions. Today, most of the arguments involve 4GB cards versus 8GB cards, and I expect that as prices for 16 and 32GB memory cards continue to drop, they'll find their way into the debate as well. I just bought two high-speed 32GB cards for *less* than I paid for a 4GB Secure Digital or Memory Stick card only 18 months ago.

Why all the fuss? Are 8GB memory cards more likely to fail than 4GB cards? Are you risking all your photos if you trust your images to a larger card? Isn't it better to use several smaller cards, so that if one fails you lose only half as many photos? Or, isn't it wiser to put all your photos onto one larger card, because the more cards you use, the better your odds of misplacing or damaging one and losing at least some pictures?

In the end, the "eggs in one basket" argument boils down to statistics, and how you happen to use your Alpha. The rationales can go both ways. If you have multiple smaller cards, you do increase your chances of something happening to one of them, so, arguably, you might be boosting the odds of losing some pictures. If all your images are important, the fact that you've lost 100 rather than 200 pictures isn't very comforting.

Also, consider that the eggs/basket scenario assumes that the cards that are lost or damaged are always full. It's actually likely that your 8GB card might suffer a mishap when it's less than half full. Indeed, it's more likely that a large card won't be completely filled before it's offloaded to a computer. I often use only one quarter to one half of the capacity of my larger cards in a single session. I'm thankful that the extra room is there when I need it, but I don't always use it. So the reality is that you might not lose any more shots with a single 8GB card than with multiple 4GB cards. A bad card—of whatever size—might contain, say 3GB of images, so the size of the card won't really matter in such cases.

If you shoot photojournalist-type pictures, you probably change memory cards when they're less than completely full in order to avoid the need to do so at a crucial moment. (When I shoot sports, my cards rarely reach 80 to 90 percent of capacity before I change them.) Using multiple smaller cards means you have to change them that more often, which can be a real pain when you're taking a lot of photos. As an example, if you use 1GB memory cards with an Alpha NEX and shoot RAW & JPEG FINE, you may get only a few dozen pictures on the card. That's almost exactly the capacity of a 36-exposure roll of film (remember those?). In my book, I prefer keeping all my eggs in one basket, and then making very sure that nothing happens to that basket.

There is really only one good reason to justify limiting yourself to smaller memory cards when larger ones can be purchased at the same cost per-gigabyte. One of them is when every single picture is precious to you and the loss of any of them would be a disaster. If you're a wedding photographer, for example, and unlikely to be able to restage the nuptials if a memory card goes bad, you'll probably want to shoot no more pictures than you can afford to lose on a single card, and have an assistant ready to copy each card removed from the camera onto a backup hard drive or DVD onsite.

To be even safer, you'd want to alternate cameras or have a second photographer at least partially duplicating your coverage so your shots are distributed over several memory cards simultaneously. Or, you might consider *interleaving* your shots. Say you don't shoot weddings, but you do go on vacation from time to time. Take 50 or so pictures

on one card, or whatever number of images might fill about 25 percent of its capacity. Then, replace it with a different card and shoot about 25 percent of that card's available space. Repeat these steps with diligence (you'd have to be determined to go through this inconvenience), and, if you use four or more memory cards you'll find your pictures from each location scattered among the different memory cards. If you lose or damage one, you'll still have *some* pictures from all the various stops on your trip on the other cards. That's more work than I like to do (I usually tote around a netbook and portable hard disk and copy the files to the drive as I go), but it's an option. (See Figure 11.3.)

Figure 11.3
A netbook and a portable hard drive make a good backup option when you travel.

What Can Go Wrong?

There are lots of things that can go wrong with your memory card, but the ones that aren't caused by human stupidity are statistically very rare. Yes, a memory card's internal bit bin or controller can suddenly fail due to a manufacturing error or some inexplicable event caused by old age. However, if your memory card works for the first week or two that you own it, it should work forever. There's really not a lot that can wear out.

The typical memory card is rated for a Mean Time Between Failures of 1,000,000 hours of use. That's constant use 24/7 for more than 100 years! According to the manufacturers, they are good for 10,000 insertions in your camera, and should be able to retain their data (and that's without an external power source) for something on the order of 11 years. Of course, with the millions of memory cards in use, there are bound to be a few lemons here or there.

Given the reliability of solid-state memory, compared to magnetic memory, though, it's more likely that your memory card problems will stem from something that you do.

Secure Digital or Memory Stick memory cards are small and easy to misplace if you're not careful. For that reason, it's a good idea to keep them in their original cases or a "card safe" offered by Gepe (www.gepecardsafe.com), Pelican (www.pelican.com), and others. Always placing your memory card in a case can provide protection from the second-most common mishap that befalls memory cards: the common household laundry. If you slip a memory card in a pocket rather than a case or your camera bag often enough, sooner or later it's going to end up in the washing machine and probably the clothes dryer, too. There are plenty of reports of relieved digital camera owners who've laundered their memory cards and found they still worked fine, but it's not uncommon for such mistreatment to do some damage.

Memory cards can also be stomped on, accidentally bent, dropped into the ocean, chewed by pets, and otherwise rendered unusable in myriad ways. It's also remotely possible to force a card into your Alpha's memory card slot incorrectly if you're diligent enough, doing little damage to the card itself, but possibly damaging the camera internally, eliminating its ability to read or write to any memory card. This almost never happens, but don't discount the ingenuity of a determined fumble-fingers.

Or, if the card is formatted in your computer with a memory card reader, your Alpha may fail to recognize it. Occasionally, I've found that a memory card used in one camera would fail if used in a different camera (until I reformatted it in Windows, and then again in the camera). Every once in awhile, a card goes completely bad and—seemingly—can't be salvaged.

Another way to lose images is to do commonplace things with your memory card at an inopportune time. If you remove the card from the Alpha while the camera is writing images to the card, you'll lose any photos in the buffer and may damage the file structure of the card, making it difficult or impossible to retrieve the other pictures you've taken. The same thing can happen if you remove the memory card from your computer's card reader while the computer is writing to the card (say, to erase files you've already moved to your computer). You can avoid this by *not* using your computer to erase files on a memory card but, instead, always reformatting the card in your Alpha before you use it again.

What Can You Do?

Pay attention: If you're having problems, the *first* thing you should do is *stop* using that memory card. Don't take any more pictures. Don't do anything with the card until you've figured out what's wrong. Your second line of defense (your first line is to be sufficiently careful with your cards that you avoid problems in the first place) is to *do no harm* that hasn't already been done. Read the rest of this section and then, if necessary, decide on a course of action (such as using a data recovery service or software described later) before you risk damaging the data on your card further.

Things get more exciting when the card itself is put in jeopardy. If you lose a card, there's not a lot you can do other than take a picture of a similar card and print up some "Have You Seen This Lost Flash Memory?" flyers to post on utility poles all around town.

If all you care about is reusing the card, and have resigned yourself to losing the pictures, try reformatting the card in your camera. You may find that reformatting removes the corrupted data and restores your card to health. Sometimes I've had success reformatting a card in my computer using a memory card reader (this is normally a no-no because your operating system doesn't understand the needs of your Alpha), and *then* reformatting again in the camera.

If your memory card is not behaving properly, and you *do* want to recover your images, things get a little more complicated. If your pictures are very valuable, either to you or to others (for example, a wedding), you can always turn to professional data recovery firms. Be prepared to pay hundreds of dollars to get your pictures back, but these pros often do an amazing job. You wouldn't want them working on your memory card on behalf of the police if you'd tried to erase some incriminating pictures. There are many firms of this type, and I've never used them myself, so I can't offer a recommendation. Use a Google search to turn up a ton of them.

THE ULTIMATE IRONY

I recently purchased an 8GB Kingston memory card that was furnished with some nifty OnTrack data recovery software. The first thing I did was format the card to make sure it was okay. Then I hunted around for the free software, only to discover it was preloaded onto the memory card. I was supposed to copy the software to my computer before using the memory card for the first time.

Fortunately, I had the OnTrack software that would reverse my dumb move, so I could retrieve the software. No, wait. I *didn't* have the software I needed to recover the software I erased. I'd reformatted it to oblivion. Chalk this one up as either the ultimate irony or Stupid Author Trick #523.

A more reasonable approach is to try special data recovery software you can install on your computer and use to attempt to resurrect your "lost" images yourself. They may not actually be gone completely. Perhaps your memory card's "table of contents" is jumbled, or only a few pictures are damaged in such a way that your camera and computer can't read some or any of the pictures on the card. Some of the available software was written specifically to reconstruct lost pictures, while other utilities are more general-purpose applications that can be used with any media, including floppy disks and hard disk drives. They have names like OnTrack, Photo Rescue 2, Digital Image Recovery, MediaRecover, Image Recall, and the aptly named Recover My Photos.

You'll find a comprehensive list and links, as well as some picture-recovery tips at www. ultimateslr.com/memory-card-recovery.php. I like RescuePRO (Figure 11.4), which came free with one of my SanDisk cards.

Figure 11.4
RescuePRO is available from SanDisk.

DIMINISHING RETURNS

Usually, once you've recovered any images on a memory card, reformatted it, and returned it to service, it will function reliably for the rest of its useful life. However, if you find a particular card going bad more than once, you'll almost certainly want to stop using it forever. See if you can get it replaced by the manufacturer, if you can, but, in the case of memory card failures, the third time is never the charm.

Cleaning Your Sensor

Yes, your Alpha NEX does have an anti-static coating on the cover that protects the sensor. And it does have an automatic sensor dust removal system that activates every time you turn the camera off. But, even with those high tech aids, you'll still get some stubborn dust on your sensor. There's no avoiding it. No matter how careful you are, some dust is going to settle on your camera and on the mounts of your lenses, eventually making its way inside your camera to settle onto the sensor. There, dust and particles can show up in every single picture you take at a small enough aperture to bring the foreign matter into sharp focus. No matter how careful you are and how cleanly you work, eventually you will get some of this dust on your camera's sensor.

Dust the FAQs, Ma'am

Here are some of the most frequently asked questions about sensor dust issues.

Q. I see a bright spot in the same place in all of my photos. Is that sensor

A. You've probably got either a "hot" pixel or one that is permanently "stuck" due to a defect in the sensor. A hot pixel is one that shows up as a bright spot only during long exposures as the sensor warms. A pixel stuck in the "on" position always appears in the image. Both show up as bright red, green, or blue pixels, usually surrounded by a small cluster of other improperly illuminated pixels, caused by the camera's interpolating the hot or stuck pixel into its surroundings, as shown in Figure 11.5. A stuck pixel can also be permanently dark. Either kind is likely to show up when they contrast with plain, evenly colored areas of your image.

Q. I see an irregular out-of-focus blob in the same place in my photos. Is that sensor dust?

A. Yes. Sensor contaminants can take the form of tiny spots, larger blobs, or even curvy lines if they are caused by minuscule fibers that have settled on the sensor. They'll appear out of focus because they aren't actually on the sensor surface but, rather, a fraction of a millimeter above it on the filter that covers the sensor. The smaller the f/stop used, the more in-focus the dust becomes. At large apertures, it may not be visible at all.

Q. I never see any dust on my sensor. What's all the fuss about?

A. Those who never have dust problems with their Sony Alpha fall into one of four categories: those for whom the camera's automatic dust removal features are working well; those who seldom change their lenses and have clean working habits that minimize the amount of dust that invades their camera in the first place; those who simply don't notice the dust (often because they don't shoot many macro photos or other pictures using the small f/stops that make dust evident in their images); and those who are very, very lucky.

Figure 11.5
A stuck pixel is surrounded by improperly interpolated pixels created by the Alpha's demosaicing algorithm.

Identifying and Dealing with Stubborn Dust

Sensor dust that isn't automatically removed by the Alpha's anti-dust features is less of a problem than it might be because it shows up only under certain circumstances. Indeed, you might have dust on your sensor right now and not be aware of it. The dust doesn't actually settle on the sensor itself, but, rather, on a protective filter a very tiny distance above the sensor, subjecting it to the phenomenon of *depth-of-focus*. Depth-of-focus is the distance the focal plane can be moved and still render an object in sharp focus. At f/2.8 to f/5.6 or even smaller, sensor dust, particularly if small, is likely to be outside the range of depth-of-focus and blur into an unnoticeable dot.

However, if you're shooting at f/16 to f/22 or smaller, those dust motes suddenly pop into focus. Forget about trying to spot them by peering directly at your sensor with the shutter open and the lens removed. The period at the end of this sentence, about .33mm in diameter, could block a group of pixels measuring 40×40 pixels (160 pixels in all!). Dust spots that are even smaller than that can easily show up in your images if you're shooting large, empty areas that are light colored. Dust motes are most likely to show up in the sky, as in Figure 11.6, or in white backgrounds of your seamless product shots and are less likely to be a problem in images that contain lots of dark areas and detail.

To see if you have dust on your sensor, take a few test shots of a plain, blank surface (such as a piece of paper or a cloudless sky) at small f/stops, such as f/22, and a few wide open. Open Photoshop, copy several shots into a single document in separate layers, then flip back and forth between layers to see if any spots you see are present in all layers. You may have to boost contrast and sharpness to make the dust easier to spot.

Figure 11.6 Only the dust spots in the sky are apparent in this shot.

Avoiding Dust

Of course, the easiest way to protect your sensor from dust is to prevent it from settling on the sensor in the first place. Here are my stock tips for eliminating the problem before it begins.

- Clean environment. Avoid working in dusty areas if you can do so. Hah! Serious photographers will take this one with a grain of salt, because it usually makes sense to go where the pictures are. Only a few of us are so paranoid about sensor dust (considering that it is so easily removed) that we'll avoid moderately grimy locations just to protect something that is, when you get down to it, just a tool. If you find a great picture opportunity at a raging fire, during a sandstorm, or while surrounded by dust clouds, you might hesitate to take the picture, but, with a little caution (don't remove your lens in these situations, and clean the camera afterwards!) you can still shoot. However, it still makes sense to store your camera in a clean environment. One place cameras and lenses pick up a lot of dust is inside a camera bag. Clean your bag from time to time, and you can avoid problems.
- Clean lenses. There are a few paranoid types that avoid swapping lenses in order to minimize the chance of dust getting inside their camera. It makes more sense just to use a blower or brush to dust off the rear lens mount of the replacement lens first, so you won't be introducing dust into your camera simply by attaching a new, dusty lens. Do this before you remove the lens from your camera, and then avoid stirring up dust before making the exchange.
- Work fast. Minimize the time your camera is lens-less and exposed to dust. That means having your replacement lens ready and dusted off, and a place to set down the old lens as soon as it is removed, so you can quickly attach the new lens.
- Let gravity help you. Face the camera downward when the lens is detached so any dust in the interior will tend to fall away from the sensor. Turn your back to any breezes, indoor forced air vents, fans, or other sources of dust to minimize infiltration.
- Protect the lens you just removed. Once you've attached the new lens, quickly put the end cap on the one you just removed to reduce the dust that might fall on it.
- Clean out the vestibule. From time to time, remove the lens while in a relatively dust-free environment and use a blower bulb like the one shown in Figure 11.7 (not compressed air or a vacuum hose) to clean out the interior of the camera. A blower bulb is generally safer than a can of compressed air, or a strong positive/negative airflow, which can tend to drive dust further into nooks and crannies.

Figure 11.7
Use a robust air bulb like the Giottos Rockets for cleaning your sensor.

- **Be prepared.** If you're embarking on an important shooting session, it's a good idea to clean your sensor *now*, rather than come home with hundreds or thousands of images with dust spots caused by flecks that were sitting on your sensor before you even started. Before I left on my recent trip to Spain, I put both cameras I was taking through a rigid cleaning regimen, figuring they could remain dust-free for a measly 10 days. I even left my bulky blower bulb at home. It was a big mistake, but my intentions were good. I now have a smaller version of the Giottos Rocket Blower, and *that* goes with me everywhere.
- Clone out existing spots in your image editor. Photoshop and other editors have a clone tool or healing brush you can use to copy pixels from surrounding areas over the dust spot or dead pixel. This process can be tedious, especially if you have lots of dust spots and/or lots of images to be corrected. The advantage is that this sort of manual fix-it probably will do the least damage to the rest of your photo. Only the cloned pixels will be affected. Photoshop's Healing Brush used in Content Aware mode is especially adept at removing artifacts of this type. The latest versions of Photoshop Elements have similar capabilities.
- Use filtration in your image editor. A semi-smart filter like Photoshop's Dust & Scratches filter can remove dust and other artifacts by selectively blurring areas that the plug-in decides represent dust spots. This method can work well if you have many dust spots, because you won't need to patch them manually. However, any automated method like this has the possibility of blurring areas of your image that you didn't intend to soften.

Sensor Cleaning

Those new to the concept of sensor dust actually hesitate before deciding to clean their camera themselves. Isn't it a better idea to pack up your Alpha and send it to a Sony service center so their crack technical staff can do the job for you? Or, at the very least, shouldn't you let the friendly folks at your local camera store do it?

If you choose to let someone else clean your sensor, they will be using methods that are more or less identical to the techniques you would use yourself. None of these techniques are difficult, and the only difference between their cleaning and your cleaning is that they might have done it dozens or hundreds of times. If you're careful, you can do just as good a job.

Of course vendors like Sony won't tell you this, but it's not because they don't trust you. It's not that difficult for a real goofball to mess up his camera by hurrying or taking a shortcut. Perhaps the person uses the "Bulb" method of holding the shutter open and a finger slips, allowing the shutter curtain to close on top of a sensor cleaning brush. Or, someone tries to clean the sensor using masking tape, and ends up with goo all over its surface. If Sony recommended *any* method that's mildly risky, someone would do it wrong, and then the company would face lawsuits from those who'd contend they did it exactly in the way the vendor suggested, so the ruined camera is not their fault.

You can see that vendors like Sony tend to be conservative in their recommendations, and, in doing so, make it seem as if sensor cleaning is more daunting and dangerous than it really is. Some vendors recommend only dust-off cleaning, through the use of reasonably gentle blasts of air, while condemning more serious scrubbing with swabs and cleaning fluids. However, these cleaning kits for the exact types of cleaning they recommended against are for sale in Japan only, where, apparently, your average photographer is more dexterous than those of us in the rest of the world. These kits are similar to those used by official repair staff to clean your sensor if you decide to send your camera in for a dust-up.

As I noted, sensors can be affected by dust particles that are much smaller than you might be able to spot visually on the surface of your lens. The filters that cover sensors tend to be fairly hard compared to optical glass. Cleaning the 23.5mm × 15.6mm sensor in your Sony Alpha within the tight confines of the interior can call for a steady hand and careful touch. If your sensor's filter becomes scratched through inept cleaning, you can't simply remove it yourself and replace it with a new one. There are four basic kinds of cleaning processes that can be used to remove dusty and sticky stuff that settles on your sensor.

- Air cleaning. This process involves squirting blasts of air inside your camera with the shutter locked open. This works well for dust that's not clinging stubbornly to your sensor.
- **Brushing.** A soft, very fine brush is passed across the surface of the sensor's filter, dislodging mildly persistent dust particles and sweeping them off the imager.

- Liquid cleaning. A soft swab dipped in a cleaning solution such as ethanol is used to wipe the sensor filter, removing more obstinate particles.
- **Tape cleaning.** There are some who get good results by applying a special form of tape to the surface of their sensor. When the tape is peeled off, all the dust goes with it. Supposedly. I'd be remiss if I didn't point out right now that this form of cleaning is somewhat controversial; the other three methods are much more widely accepted. Now that Sony has equipped the front-sensor filter with a special antidust coating, I wouldn't chance damaging that coating by using any kind of adhesive tape.

Getting Started

Make sure you're using a fully charged battery. Remove the lens. You'll see the sensor, as shown in Figure 11.8. Then, follow one of the described cleaning techniques.

Figure 11.8 With the lens removed, the sensor is exposed and available for manual cleaning.

Air Cleaning

Your first attempts at cleaning your sensor should always involve gentle blasts of air. Many times, you'll be able to dislodge dust spots, which will fall off the sensor and, with luck, out of the interior. Attempt one of the other methods only when you've already tried air cleaning and it didn't remove all the dust.

Here are some tips for air cleaning:

■ Use a clean, powerful air bulb. Your best bet is bulb cleaners designed for the job, like the Giottos Rockets shown earlier in Figure 11.7. Smaller bulbs, like those air bulbs with a brush attached sometimes sold for lens cleaning or weak nasal aspirators may not provide sufficient air or a strong enough blast to do much good.

- Hold the Sony Alpha upside down. Then look up into the interior as you squirt your air blasts, increasing the odds that gravity will help pull the expelled dust downward, away from the sensor. You may have to use some imagination in positioning yourself. (And don't let dust fall into your eye!)
- **Never use air canisters.** The propellant inside these cans can permanently coat your sensor if you tilt the can while spraying. It's not worth taking a chance.
- Avoid air compressors. Super-strong blasts of air are likely to force dust under the sensor filter.

Brush Cleaning

If your dust is a little more stubborn and can't be dislodged by air alone, you may want to try a brush, charged with static electricity, which can pick off dust spots by electrical attraction. One good, but expensive, option is the Sensor Brush sold at www.visible-dust.com. A cheaper version can be purchased at www.copperhillimages.com. You need a 16mm version, like the one shown in Figure 11.9, which can be stroked across the long dimension of your Alpha's sensor.

Ordinary artist's brushes are much too coarse and stiff and have fibers that are tangled or can come loose and settle on your sensor. A good sensor brush's fibers are resilient and described as "thinner than a human hair." Moreover, the brush has a wooden handle that reduces the risk of static sparks.

Brush cleaning is done with a dry brush by gently swiping the surface of the sensor filter with the tip. The dust particles are attracted to the brush particles and cling to them. You should clean the brush with compressed air before and after each use, and store it in an appropriate air-tight container between applications to keep it clean and dust-free. Although these special brushes are expensive, one should last you a long time.

Figure 11.9
A proper brush is required for dusting off your sensor. The long cord shown is attached to a grounded object to reduce static electricity.

Liquid Cleaning

Unfortunately, you'll often encounter really stubborn dust spots that can't be removed with a blast of air or flick of a brush. These spots may be combined with some grease or a liquid that causes them to stick to the sensor filter's surface. In such cases, liquid cleaning with a swab may be necessary. During my first clumsy attempts to clean my own sensor, I accidentally got my blower bulb tip too close to the sensor, and some sort of deposit from the tip of the bulb ended up on the sensor. I panicked until I discovered that liquid cleaning did a good job of removing whatever it was that took up residence on my sensor.

You can make your own swabs out of pieces of plastic (some use fast food restaurant knives, with the tip cut at an angle to the proper size) covered with a soft cloth or Pec-Pad, as shown in Figures 11.10 and 11.11. However, if you've got the bucks to spend, you can't go wrong with good-quality commercial sensor cleaning swabs, such as those sold by Photographic Solutions, Inc. (www.photosol.com/swabproduct.htm).

You want a sturdy swab that won't bend or break so you can apply gentle pressure to the swab as you wipe the sensor surface. Use the swab with methanol (as pure as you can get it, particularly medical grade; other ingredients can leave a residue), or the Eclipse solution also sold by Photographic Solutions. Eclipse is actually quite a bit purer than even medical-grade methanol. A couple drops of solution should be enough, unless you have a spot that's extremely difficult to remove. In that case, you may need to use extra solution on the swab to help "soak" the dirt off.

Figure 11.10 You can make your own sensor swab from a plastic knife that's been truncated.

Figure 11.11 Carefully wrap a Pec-Pad around the swab.

Once you overcome your nervousness at touching your Alpha's sensor, the process is easy. You'll wipe continuously with the swab in one direction, then flip it over and wipe in the other direction. You need to completely wipe the entire surface; otherwise, you may end up depositing the dust you collect at the far end of your stroke. Wipe; don't rub.

If you want a close-up look at your sensor to make sure the dust has been removed, you can pay \$50-\$100 for a special sensor "microscope" with an illuminator. Or, you can do like I do and work with a plain old Carson MiniBrite PO-55 illuminated 5X magnifier, as seen in Figure 11.12. It has a built-in LED and, held a few inches from the lens mount with the lens removed from your Alpha, provides a sharp, close-up view of the sensor, with enough contrast to reveal any dust that remains. If you want to buy one, you'll find a link at www.dslrguides.com/carson.

Figure 11.12
The Carson
Mini-Brite is an
inexpensive illuminated magnifier you can use
to examine your
sensor.

Tape Cleaning

There are people who absolutely swear by the tape method of sensor cleaning. The concept seems totally wacky, and I have never tried it personally, so I can't say with certainty that it either does or does not work. In the interest of completeness, I'm including it here. I can't give you a recommendation, so if you have problems, please don't blame me. The Sony Alpha NEX series is still too new to have generated any reports of users accidentally damaging the anti-dust coating on the sensor filter using this method.

Tape cleaning works by applying a layer of Scotch Brand Magic Tape to the sensor. This is a minimally sticky tape that some of the tape cleaning proponents claim contains no adhesive. I did check this out with 3M, and can say that Magic Tape certainly *does* contain an adhesive. The question is whether the adhesive comes off when you peel

back the tape, taking any dust spots on your sensor with it. The folks who love this method claim there is no residue. There have been reports from those who don't like the method that residue is left behind. This is all anecdotal evidence, so you're pretty much on your own in making the decision whether to try out the tape cleaning method.
Glossary

Here are some terms you might encounter while reading this book or working with your Sony Alpha NEX-7.

additive primary colors The red, green, and blue hues that are used alone or in combinations to create all other colors that you capture with a digital camera, view on a computer monitor, or work with in an image-editing program, such as Photoshop. *See also* CMYK color model.

Adobe RGB One of two color space choices offered by the Sony Alpha. Adobe RGB is an expanded color space useful for commercial and professional printing, and it can reproduce a larger number of colors. Sony recommends against using this color space if your images will be displayed primarily on your computer screen or output by your personal printer. *See also* sRGB.

ambient lighting Diffuse, non-directional lighting that doesn't appear to come from a specific source but, rather, bounces off walls, ceilings, and other objects in the scene when a picture is taken.

analog/digital converter The electronics built into a camera, Sony's BIONZ processing engine, that converts the analog information captured by the Alpha's sensor into digital bits that can be stored as an image bitmap.

angle of view The area of a scene that a lens can capture, determined by the focal length of the lens. Lenses with a shorter focal length have a wider angle of view than lenses with a longer focal length.

anti-alias A process that smoothes the look of rough edges in images (called *jaggies* or *staircasing*) by adding partially transparent pixels along the boundaries of diagonal lines that are merged into a smoother line by our eyes. *See also* jaggies.

Aperture priority A camera setting that allows you to specify the lens opening or f/stop that you want to use, with the camera selecting the required shutter speed automatically based on its light meter reading. This setting is represented by the abbreviation A on the Alpha's mode dial. *See also* Shutter priority.

APS-C sensor The size of the sensor used in Sony Alpha cameras, including the NEX-7, which produces a 1.5X "crop" factor.

artifact A type of noise in an image, or an unintentional image component produced in error by a digital camera during processing, usually caused by the JPEG compression process in digital cameras.

aspect ratio The proportions of an image as printed, displayed on a monitor, or captured by a digital camera. The Sony Alpha NEX-7 offers both the traditional 3:2 aspect ratio used by most digital SLRs, and also the 16:9 ("HDTV") aspect ratio.

autofocus A camera setting that allows the Sony Alpha to choose the correct focus distance for you, based on the contrast of an image (the image will be at maximum contrast when in sharp focus). The camera can be set for Single-Shot (Single Autofocus), in which the lens is not focused until the shutter release is partially depressed; Continuous Autofocus, in which the lens refocuses constantly as you frame and reframe the image; and Object Tracking, which allows the camera to follow focus on objects based on subject movement.

backlighting A lighting effect produced when the main light source is located behind the subject. Backlighting can be used to create a silhouette effect, or to illuminate translucent objects. *See also* front lighting and side lighting.

barrel distortion A lens defect that causes straight lines at the top or side edges of an image to bow outward into a barrel shape. *See also* pincushion distortion.

blooming An image distortion caused when a photosite in an image sensor has absorbed all the photons it can handle so that additional photons reaching that pixel overflow to affect surrounding pixels, producing unwanted brightness and overexposure around the edges of objects.

blur To soften an image or part of an image by throwing it out of focus, or by allowing it to become soft due to subject or camera motion. Blur can also be applied in an image-editing program.

bokeh A term derived from the Japanese word for blur, which describes the aesthetic qualities of the out-of-focus parts of an image. Some lenses produce "good" bokeh and others offer "bad" bokeh. Some lenses produce uniformly illuminated out-of-focus discs. Others produce a disc that has a bright edge and a dark center, creating a "doughnut" effect, which is the worst from a bokeh standpoint. Lenses that generate a bright center that fades to a darker edge are favored, because their bokeh allows the circle of confusion to blend more smoothly with the surroundings. The bokeh characteristics of a lens are most important when you're using selective focus (say, when shooting a portrait) to deemphasize the background, or when shallow depth-of-field is a given because you're working with a macro lens, with a long telephoto, or with a wide-open aperture. See also circle of confusion.

bounce lighting Light bounced off a reflector, including ceiling and walls, to provide a soft, natural-looking light.

bracketing Taking a series of photographs of the same subject at different settings, including exposure and white balance, to help ensure that one setting will be the correct one.

buffer The digital camera's internal memory where an image is stored immediately after it is taken until it can be written to the camera's non-volatile (semi-permanent) memory or a memory card.

Bulb A release mode in which the shutter remains open while the shutter-release button is held down. This setting is available when the camera is set to Manual mode. The term refers to the way an early camera was operated using a long tube and a rubber bulb to activate the shutter.

burst mode The digital camera's equivalent of the film camera's motor drive, used to take multiple shots within a short period of time, at a rate of up to 10 frames per second, each stored in a memory buffer temporarily before writing them to the media.

calibration A process used to correct for the differences in the output of a printer or monitor when compared to the original image. Once you've calibrated your scanner, monitor, and/or your image editor, the images you see on the screen more closely represent what you'll get from your printer, even though calibration is never perfect.

Camera Raw A plug-in included with Photoshop and Photoshop Elements that can manipulate the unprocessed images captured by digital cameras, such as the Sony Alpha's ARW files. The latest versions of this module can also work with JPEG and TIFF images.

camera shake Movement of the camera, aggravated by slower shutter speeds, that produces a blurred image, unless countered by the Alpha's image stabilization feature.

Center metering A light-measuring system that emphasizes the area in the middle of the frame when calculating the correct exposure for an image. See ulso Multi and Spot metering.

chromatic aberration An image defect, often seen as green or purple fringing around the edges of an object, caused by a lens failing to focus all colors of a light source at the same point. *See also* fringing.

circle of confusion A term applied to the fuzzy discs produced when a point of light is out of focus. The circle of confusion is not a fixed size. The viewing distance and amount of enlargement of the image determine whether we see a particular spot on the image as a point or as a disc. *See also* bokeh.

close-up lens A lens add-on that allows you to take pictures at a distance that is less than the closest-focusing distance of the lens alone.

CMYK color model A way of defining all possible colors in percentages of cyan, magenta, yellow, and frequently, black. (K represents black, to differentiate it from blue in the RGB color model.) Black is added to improve rendition of shadow detail. CMYK is commonly used for printing (both on press and with your inkjet or laser color printer).

color correction Changing the relative amounts of color in an image to produce a desired effect, typically a more accurate representation of those colors. Color correction can fix faulty color balance in the original image, or compensate for the deficiencies of the inks used to reproduce the image.

compression Reducing the size of a file by encoding using fewer bits of information to represent the original. Some compression schemes, such as JPEG, operate by discarding some image information, while others, such as RAW, preserve all the detail in the original, discarding only redundant data.

Continuous Autofocus An automatic focusing setting in which the camera constantly refocuses the image as you frame the picture. This setting is often the best choice for moving subjects. *See also* Single-shot Autofocus.

contrast The range between the lightest and darkest tones in an image. A high-contrast image is one in which the shades fall at the extremes of the range between white and black. In a low-contrast image, the tones are closer together.

dedicated flash An electronic flash unit designed to work with the automatic exposure features of a specific camera.

depth-of-field A distance range in a photograph in which all included portions of an image are at least acceptably sharp.

diaphragm An adjustable component, similar to the iris in the human eye, that can open and close to provide specific-sized lens openings, or f/stops, and thus control the amount of light reaching the sensor or film.

diffuse lighting Soft, low-contrast lighting.

digital processing chip A solid-state device found in digital cameras that's in charge of applying the image algorithms to the raw picture data prior to storage on the memory card.

diopter A value used to represent the magnification power of a lens, calculated as the reciprocal of a lens's focal length (in meters). Diopters are most often used to represent the optical correction used in a viewfinder to adjust for limitations of the photographer's eyesight, and to describe the magnification of a close-up lens attachment.

equivalent focal length A digital camera's focal length translated into the corresponding values for a 35mm film camera. This value can be calculated for lenses used with the Sony Alpha by multiplying by 1.5.

Evaluative metering A system of exposure calculation that looks at many different segments of an image to determine the brightest and darkest portions. The Sony Alpha uses this system when you select the Multi metering mode.

exchangeable image file format (Exif) Developed to standardize the exchange of image data between hardware devices and software. A variation on JPEG, Exif is used by most digital cameras, and includes information such as the date and time a photo was taken, the camera settings, resolution, amount of compression, and other data.

Exif See exchangeable image file format (Exif).

exposure The amount of light allowed to reach the film or sensor, determined by the intensity of the light, the amount admitted by the iris of the lens, the length of time determined by the shutter speed, and the ISO sensitivity setting.

exposure values (EV) EV settings are a way of adding or decreasing exposure without the need to reference f/stops or shutter speeds. For example, if you tell your camera to add +1EV, it will provide twice as much exposure, by using a larger f/stop, slower shutter speed, or both.

fill lighting In photography, lighting used to illuminate shadows. Reflectors or additional incandescent lighting or electronic flash can be used to brighten shadows. One common technique outdoors is to use the camera's flash as a fill.

filter In photography, a device that fits over the lens, changing the light in some way. In image editing, a feature that changes the pixels in an image to produce blurring, sharpening, and other special effects. Photoshop includes several interesting filter effects, including Lens Blur and Photo Filters.

flash sync The timing mechanism that ensures that an internal or external electronic flash fires at the correct time during the exposure cycle. A digital camera's flash sync speed is the highest shutter speed that can be used with flash, ordinarily 1/160th of a second with the Sony Alpha. *See also* front sync (first-curtain sync) and rear sync (second-curtain sync).

focal length The distance between the film and the optical center of the lens when the lens is focused on infinity, usually measured in millimeters.

format To erase a memory card and prepare it to accept files.

fringing A chromatic aberration that produces fringes of color around the edges of subjects, caused by a lens's inability to focus the various wavelengths of light onto the same spot. Purple fringing is especially troublesome with backlit images.

342

front sync (first-curtain sync) The default kind of electronic flash synchronization technique, originally associated with focal plane shutters, which consists of a traveling set of curtains, including a *front curtain*, which opens to reveal the film or sensor, and a *rear curtain*, which follows at a distance determined by shutter speed to conceal the film or sensor at the conclusion of the exposure. For a flash picture to be taken, the entire sensor must be exposed at one time to the brief flash exposure, so the image is exposed after the front curtain has reached the other side of the focal plane, but before the rear curtain begins to move. Front-curtain sync causes the flash to fire at the beginning of this period when the shutter is completely open, in the instant that the first curtain of the focal plane shutter finishes its movement across the film or sensor plane. With slow shutter speeds, this feature can create a blur effect from the ambient light, showing as patterns that follow a moving subject with the subject shown sharply frozen at the beginning of the blur trail. In addition to traditional front-curtain sync, the NEX-7 also has an electronic version. *See also* rear sync (second-curtain sync).

front lighting Illumination that comes from the direction of the camera. *See also* backlighting and side lighting.

f/stop The relative size of the lens aperture, which helps determine both exposure and depth-of-field. The larger the f/stop number, the smaller the f/stop itself.

graduated filter A lens attachment with variable density or color from one edge to another. A graduated neutral-density filter, for example, can be oriented so the neutral-density portion is concentrated at the top of the lens's view with the less dense or clear portion at the bottom, thus reducing the amount of light from a very bright sky while not interfering with the exposure of the landscape in the foreground. Graduated filters can also be split into several color sections to provide a color gradient between portions of the image.

gray card A piece of cardboard or other material with a standardized 18-percent reflectance. Gray cards can be used as a reference for determining correct exposure or for setting white balance.

high contrast A wide range of density in a print, negative, or other image.

highlights The brightest parts of an image containing detail.

histogram A kind of chart showing the relationship of tones in an image using a series of 256 vertical bars, one for each brightness level. A histogram chart, such as the one the Sony Alpha can display during picture review, typically looks like a curve with one or more slopes and peaks, depending on how many highlight, midtone, and shadow tones are present in the image. The Alpha can also display separate histograms for brightness, as well as the red, green, and blue channels of an image.

hyperfocal distance A point of focus where everything from half that distance to infinity appears to be acceptably sharp. For example, if your lens has a hyperfocal distance of four feet, everything from two feet to infinity would be sharp. The hyperfocal distance varies by the lens and the aperture in use. If you know you'll be making a grab shot without warning, sometimes it is useful to turn off your camera's automatic focus, and set the lens to infinity, or, better yet, the hyperfocal distance. Then, you can snap off a quick picture without having to wait for the lag that occurs with most digital cameras as their autofocus locks in.

image rotation A feature that senses whether a picture was taken in horizontal or vertical orientation. That information is embedded in the picture file so that the camera and compatible software applications can automatically display the image in the correct orientation.

image stabilization A technology that compensates for camera shake, which, in Sony's SteadyShot implementation, is achieved by adjusting the position of the camera sensor. Some other vendors, such as Nikon and Canon, move the lens elements in response to movements of the camera (which means that the feature is available only with lenses designed to provide it).

incident light Light falling on a surface.

International Organization for Standardization (ISO) A governing body that provides standards used to represent film speed, or the equivalent sensitivity of a digital camera's sensor. Digital camera sensitivity is expressed in ISO settings.

interpolation A technique digital cameras, scanners, and image editors use to create new pixels required whenever you resize or change the resolution of an image based on the values of surrounding pixels. Devices such as scanners and digital cameras can also use interpolation to create pixels in addition to those actually captured, thereby increasing the apparent resolution or color information in an image.

ISO See International Organization for Standardization (ISO).

jaggies Staircasing effect of lines that are not perfectly horizontal or vertical, caused by pixels that are too large to represent the line accurately. *See also* anti-alias.

JPEG A file "lossy" format (short for Joint Photographic Experts Group) that supports 24-bit color and reduces file sizes by selectively discarding image data. Digital cameras generally use JPEG compression to pack more images onto memory cards. You can select how much compression is used (and, therefore, how much information is thrown away) by selecting from among the Standard, Fine, Super Fine, or other quality settings offered by your camera. *See also* RAW.

Kelvin (**K**) A unit of measure based on the absolute temperature scale in which absolute zero is zero; it's used to describe the color of continuous-spectrum light sources and applied when setting white balance. For example, daylight has a color temperature of about 5,500K, and a tungsten lamp has a temperature of about 3,400K.

latitude The range of camera exposures that produces acceptable images with a particular digital sensor or film.

lens flare A feature of conventional photography that is both a bane and a creative outlet. It is an effect produced by the reflection of light internally among elements of an optical lens. Bright light sources within or just outside the field of view cause lens flare. Flare can be reduced by the use of coatings on the lens elements or with the use of lens hoods. Photographers sometimes use the effect as a creative technique, and Photoshop includes a filter that lets you add lens flare at your whim.

lighting ratio The proportional relationship between the amount of light falling on the subject from the main light and other lights, expressed in a ratio, such as 3:1.

lossless compression An image-compression scheme, such as TIFF, that preserves all image detail. When the image is decompressed, it is identical to the original version.

lossy compression An image-compression scheme, such as JPEG, that creates smaller files by discarding image information, which can affect image quality.

macro lens A lens that provides continuous focusing from infinity to extreme closeups, often to a reproduction ratio of 1:2 (half life-size) or 1:1 (life-size).

maximum burst The number of frames that can be exposed at the current settings until the buffer fills.

midtones Parts of an image with tones of an intermediate value, usually in the 25 to 75 percent brightness range. Many image-editing features allow you to manipulate midtones independently from the highlights and shadows.

Multi metering An exposure measuring mode in which the camera determines which of the 1,200 areas within the frame is used for metering.

neutral color A color in which red, green, and blue are present in equal amounts, producing a gray.

neutral-density filter A gray camera filter that reduces the amount of light entering the camera without affecting the colors.

noise In an image, pixels with randomly distributed color values. Visual noise in digital photographs tends to be the product of low-light conditions and long exposures, particularly when you've set your camera to a higher ISO rating than normal.

noise reduction A technology used to cut down on the amount of random information in a digital picture, usually caused by long exposures and/or increased sensitivity ratings.

normal lens focal length A lens or zoom setting that makes the image in a photograph appear in a perspective that is like that of the original scene, typically with a field of view of roughly 45 degrees.

overexposure A condition in which too much light reaches the film or sensor, producing a dense negative or a very bright/light print, slide, or digital image.

pincushion distortion A type of lens distortion in which lines at the top and side edges of an image are bent inward, producing an effect that looks like a pincushion. *See also* barrel distortion.

polarizing filter A filter that forces light, which normally vibrates in all directions, to vibrate only in a single plane, reducing or removing the specular reflections from the surface of objects.

Program mode The exposure mode where the Alpha makes all the settings for you, but allows some fine-tuning of shutter speed, aperture, and other settings.

RAW An image file format, such as the ARW format in the Sony Alpha, that includes all the unprocessed information captured by the camera after conversion to digital form. RAW files are very large compared to JPEG files and must be processed by a special program such as Sony Image Data Converter SR, or Adobe's Camera Raw filter after being downloaded from the camera.

Rear sync (second-curtain sync) An optional kind of electronic flash synchronization technique, originally associated with focal plane shutters, which consists of a traveling set of curtains, including a *front (first) curtain* (which opens to reveal the film or sensor) and a *rear (second) curtain* (which follows at a distance determined by shutter speed to conceal the film or sensor at the conclusion of the exposure). For a flash picture to be taken, the entire sensor must be exposed at one time to the brief flash exposure, so the image is exposed after the front curtain has reached the other side of the focal plane, but before the rear curtain begins to move. Rear-curtain sync causes the flash to fire at the end of the exposure, an instant before the second or rear curtain of the focal plane shutter begins to move. With slow shutter speeds, this feature can create a blur effect from the ambient light, showing as patterns that follow a moving subject with the subject shown sharply frozen at the end of the blur trail. If you were shooting a photo of The Flash, the superhero would appear sharp, with a ghostly trail behind him. *See also* front sync (first-curtain sync).

red-eye An effect from flash photography that appears to make a person's eyes glow red, or an animal's yellow or green. It's caused by light bouncing from the retina of the eye and is most pronounced in dim illumination (when the irises are wide open) and when the electronic flash is close to the lens and, therefore, prone to reflect directly back. Image editors can fix red-eye through cloning other pixels over the offending red or orange ones.

RGB color A color model that represents the three colors—red, green, and blue—used by devices such as scanners or monitors to reproduce color. Photoshop works in RGB mode by default, and even displays CMYK images by converting them to RGB.

saturation The purity of color; the amount by which a pure color is diluted with white or gray.

selective focus Choosing a lens opening that produces a shallow depth-of-field. Usually this is used to isolate a subject in portraits, close-ups, and other types of images, by causing most other elements in the scene to be blurred.

self-timer A mechanism that delays the opening of the shutter for some seconds after the release has been operated.

sensitivity A measure of the degree of response of a film or sensor to light, measured using the ISO setting.

shadow The darkest part of an image, represented on a digital image by pixels with low numeric values.

sharpening Increasing the apparent sharpness of an image by boosting the contrast between adjacent pixels that form an edge.

shutter In a conventional film camera, the shutter is a mechanism consisting of blades, a curtain, a plate, or some other movable cover that controls the time during which light reaches the film. Digital cameras may use actual mechanical shutters for the slower shutter speeds (less than 1/160th second) and an electronic shutter for higher speeds.

Shutter priority An exposure mode, represented by the letter S on the Alpha's virtual mode dial, in which you set the shutter speed and the camera determines the appropriate f/stop. *See also* Aperture priority.

side lighting Applying illumination from the left or right sides of the camera. *See also* backlighting and front lighting.

slave unit An accessory flash unit that supplements the clip-on main flash, usually triggered electronically when the slave senses the light output by the main unit, or through radio waves. Slave units can also be trigged by the pre-flash normally used to measure exposure, so you may need to set your main flash to Manual to avoid this, or use a slave with a "digital" mode that ignores the pre-flash.

slow sync An electronic flash synchronizing method that uses a slow shutter speed so that ambient light is recorded by the camera in addition to the electronic flash illumination. This allows the background to receive more exposure for a more realistic effect.

specular highlight Bright spots in an image caused by reflection of light sources.

Spot metering An exposure system that concentrates on a small area in the center of the frame. *See also* Center metering and Multi metering.

sRGB One of two color space choices available with the Sony Alpha. The sRGB setting is recommended for images that will be output locally on the user's own printer, as this color space matches that of the typical inkjet printer and a properly calibrated monitor fairly closely. *See also* Adobe RGB.

subtractive primary colors Cyan, magenta, and yellow, which are the printing inks that theoretically absorb all color and produce black. In practice, however, they generate a muddy brown, so black is added to preserve detail (especially in shadows). The combination of the three colors and black is referred to as CMYK. (K represents black, to differentiate it from blue in the RGB model.)

time exposure A picture taken by leaving the shutter open for a long period, usually more than one second. The camera is generally locked down with a tripod to prevent blur during the long exposure. For exposures longer than 30 seconds, you need to use the Bulb setting.

through-the-lens (TTL) A system of providing viewing and exposure calculation through the actual lens taking the picture.

tungsten light Light from ordinary room lamps and ceiling fixtures, as opposed to fluorescent illumination.

underexposure A condition in which too little light reaches the film or sensor, producing a thin negative, a dark slide, a muddy-looking print, or a dark digital image.

unsharp masking The process for increasing the contrast between adjacent pixels in an image, increasing sharpness, especially around edges.

vignetting Dark corners of an image, often produced by using a lens hood that is too small for the field of view, a lens that does not completely fill the image frame, or generated artificially using image-editing techniques.

white balance The adjustment of a digital camera to the color temperature of the light source. Interior illumination is relatively red; outdoor light is relatively blue. Digital cameras like the Alpha set correct white balance automatically or let you do it through menus. Image editors can often do some color correction of images that were exposed using the wrong white balance setting, especially when working with RAW files that contain the information originally captured by the camera before white balance was applied.

Index

A	Adobe Photoshop/Photoshop Elements,
A (Aperture priority) mode, 16, 18	309, 310. <i>See also</i> Adobe Camera Raw
bracketing in, 150 equivalent exposures in, 135 flash options, 24 triple-dial-control settings, 51 working with, 142–143 A-mount lenses adapters for, 246–247 close-ups with, 253	bracketing with, 150 chromatic aberration correction with, 111 distortion correction with, 111 dust, cloning out, 328, 330 Dust & Scratches filter, 330 focus stacking with, 179–180 HDR (High Dynamic Range) with,
first-curtain sync and, 282	131–132
AC power connection plate cover for adapters, 57–58 for monolights, 297 for studio flash, 296	Lens Correction filter, 261 Merge to HDR Pro command, 150, 204–208 Photo Downloader, 308–309
accessories, apps for selecting, 216	Adobe RGB, 106–107
accessory shoe, 48 acrylic shields for LCD, 320–321 adapters. <i>See also</i> AC power; lens	AE-L/AF-L lock, 37, 39 Setup menu options, 99 in standard information display, 43 working with, 178
adapters AF Micro Adjustment options, Sctup menu, 115	AF (autofocus), 163–180. See also Contrast Detection; Eye-Start AF; Phase Detection
Adobe Camera Raw, 80, 301, 309, 311–314 Basic tab in, 313–315 opening RAW image, 311 Adobe Lightroom, 301	Camera menu options, 65 circles of confusion, 168–170 Micro Adjustment options, Setup menu, 115 for movies, 220, 223
	AF-A (automatic AF), 40 center controller button and, 41

AF-area, 21. See also center AF-area; multi AF-area

Camera menu options, 65–66 setting, 174–175

AF-C (continuous-servo AF), 20, 167

AF-S (single-shot AF) compared, 173 Camera menu options, 66 working with, 174

AF illuminator lamp

LCD panel readout on, 46 Setup menu options, 100 in standard information display, 43

AF/MF switch, 37, 39, 167

Camera menu options, 65 Setup menu options, 99–100

AF-S (single-shot AF), 20, 167

AF-C (continuous-servo AF) compared, 173

Camera menu options, 66 working with, 173–174

air blowers. See bulb blowers air cleaning sensors, 331-333

Alien Bees monolights, 295

Amazon Kindle Fire, 213-215

ambient light, ghost images and, 285

Anaglyph Workshop, 161

Android smart phones, 213

angles

with telephoto lenses, 261 with wide-angle lenses, 256

Anti Motion Blur mode, 16, 18

triple-dial control settings, 51 working with, 158

aperture, 133. See also f/stops

exposure settings with, 135 LCD panel readout on, 47 Lensbabies and, 251 in P (Program) mode, 135 in standard information display, 43 zoom lens, maximum aperture of, 238

Aperture priority mode (A). See A (Aperture priority) mode

Apple. See also iPads

Aperture, 303 camera connection kid, 215 iPhones, 213, 215

iPod Touch, 213–214 application software CD, 4

apps, 215–216

aspect ratio. See also HDTV

LCD panel readout on, 45 for movies, 220 remaining shots and, 14 in standard information display, 43 still image options, Image Size menu, 77–78

aspherical lenses, 258

audio. See also microphones; wind noise reduction

adjusting, 25 recording options, Setup menu, 114 separately recording audio, 234 in standard information display, 43 tips for recording, 233–236 volume settings, Playback menu, 96

Auto Flash, 24, 286

Camera menu options, 65

Auto HDR, 131

Brightness/Color menu options, 88 in standard information display, 43 triple-dial control settings, 54 working with, 202–204

Auto Review

deleting images in, 92 Setup menu options, 103

Auto Rotate options, Setup menu, 119-120

Auto WB (white balance), 87, 198 Autumn Leaves Creative Style, 91, 209 *Avatar*, 49

AVCHD format, 219-220, 222-223

В	blurring, 168-170. See also Anti Motion
back focus, 263-264	Blur mode; bokeh
back view of camera, 37-45	with A (Aperture priority) mode, 143
backgrounds, 299	with long exposures, 190
light stands holding, 297–298	with short exposures, 180
backing up images, 82	with telephoto lenses, 261
memory cards, photos on, 323	body cap, removing, 8
backlighting, 129	bokeh
Balluck, Nancy, 251–252	with Fujian 35mm f/1.7 optic, 249
barn doors, 299	with telephoto lenses, 262–263
barrel distortion with wide-angle lenses,	bottom view of camera, 57–58
258–259	bouncing light and flash, 288, 294
basic information display, 11	bowing outward lines with wide-angle
batteries	lenses, 258–259
charging, 6–7	box, unpacking, 3–4 bracketing, 64–65, 149–150
compartment door for, 57	_
extra batteries, 4	Merge to HDR Pro command and, 204–208
for firmware updates, 318	brightness. See also Brightness/Color
for HVL-F20AM flash unit, 292	menu; DRO (D-Range Optimizer)
initial setup, 5–7	Adobe Camera Raw, adjusting in, 313
LCD panel readout on, 46	EVF (electronic viewfinder) brightness
for movies, 218	settings, Setup menu, 119
Sanyo eneloop cells, 292	histograms, 153–156
for sensor cleaning, 122, 332	LCD options, Setup menu, 118
unpacking, 4	Brightness/Color menu, 62, 85–91
battery chargers, 4	Auto HDR options, 88
on initial setup, 6–7	Creative Style options, 91
Beep options, Setup menu, 116	DRO (D-Range Optimizer) options, 88
BIONZ chip, 80	EV (exposure compensation) options,
Black & White Creative Style, 91, 209	85–86
black and white	FEV (flash exposure compensation)
Adobe Camera Raw, controls in,	options, 87–88
314–315	ISO options, 86
Black & White Creative Style, 91, 209	Metering mode options, 87
High contrast monochrome effect, 90	Picture Effect options, 89–91
Rich-tone monochrome effect, 90	WB (white balance) options, 87
black body radiators, 196, 278	bromine light, 279
blower bulbs. See bulb blowers	brush cleaning sensors, 333
Blu-Ray Discs with PMB (Picture	buffer and continuous shooting mode,
Motion Browser), 223	195

camera shake. See also SteadyShot built-in flash, 23-24, 48-49, 262-263 and movies, 224 bouncing, 288 FEV (flash exposure compensation) telephoto lenses and, 260-261 with, 288 wide-angle lenses and, 256 red-eye reduction with, 287-288 Cameron, James, 49 Canon EOS-1D Mark II cameras, 170 working with, 286-288 Capture One 5 (C1 Pro), 309 bulb blowers card readers for sensor cleaning, 332 for vestibule cleaning, 329-330 FireWire 800 card readers, 308 bulb exposures, 186–187 transferring images to computer with, 27-28, 307-309 Buono, Alex, 236 Carson MiniBright magnifiers, 335 catadioptric lenses, 262 C CC (Color Compensation) filters, 200 C-mount lenses, 249-250 CCD sensors and long exposure noise, cables. See USB cables 152 Camera Calibration, Adobe Camera CCTV lenses, 249-250 Raw, 314-315 CD for application software, 4 camera guide apps, 215 cell phones, 213 Camera menu, 62, 64-75 center AF-area, 174, 176 AF area options, 65-66 Camera menu options, 65-66 AF/MF Select options, 65 center controller, 10-11, 37, 41 Autofocus Mode options, 66 LCD panel readout on, 47 DISP button options, 70-75 center focus zone, 21 Display All Information options, 70, 72 center metering, 19, 87 Drive Mode options, 64-65 working with, 139-140 Face Detection options, 67–68 chart for evaluating lens focus, 266-268 Face Registration options, 68 chromatic aberration Finder Display options, 70 Setup menu options, 111–112 Flash Mode options, 65 with telephoto lenses, 261 Histogram display, 70, 75 with wide-angle lenses, 258 LCD Display options, 70–71 CIPA (Camera & Imaging Products Level display options, 70, 74 Association), 5 Object Tracking options, 66 circles of confusion, 168-170 Order Exchanging option, 68 clarity adjustments in Adobe Camera Precision Digital Zoom options, 66-67 Raw, 314-315 Smile Detection options, 69 cleaning. See also Sensor cleaning Smile Shutter options, 68 lenses, 329 Soft Skin effect options, 69 vestibule, 329-330

Clear Creative Style, 91, 209

For Viewfinder display options, 70, 75

cloning dust spots, 328, 330	continuous light
close-ups	basics of, 277-281
lenses for, 253-254	color temperature of, 277–279
in movies, 228–229	cost of, 277
with telephoto lenses, 259	degrees Kelvin of, 278
Cloudy WB (white balance), 87, 198	evenness of illumination with, 274
CMOS sensors, 32, 34	exposure calculation with, 274
cleaning, 122	flash compared, 272–277
Collins, Dean, 271	flexibility of, 277
color fringes. See chromatic aberration	fluorescent light, 280
color rendering index (CRI), 281	freezing action with, 275
color spaces	incandescent/tungsten light, 279-280
comparison of Adobe RGB and sRGB,	previewing with continuous light, 273
106	WB (white balance) for, 281
Setup menu options, 106–107	continuous-servo AF (AF-C). See AF-C
color temperature, 196	(continuous-servo AF)
of continuous light, 277–280	continuous shooting, 64–65
Custom WB (white balance) and, 201	number of images, determining, 195
of daylight, 277–279	working with, 192-195
fine-tuning, 200	contrast
of fluorescent light, 280	Adobe Camera Raw, adjusting in, 313
WB (white balance), setting, 200	Creative Styles adjusting, 210
Color Temperature WB (white balance),	with incandescent/tungsten light, 279
87	telephoto lenses, low contrast with, 262
colors. See also Brightness/Color menu	Contrast Detection, 164-166
Display Color options, Setup menu, 119	focus points and, 171
Peaking Color options, Setup menu,	movies and, 223
104–105	control dials, 10-11, 37, 39, 49
CombineZM, 180	Setup menu options, 100
composition tips for movies, 226-230	in standard information display, 43
compression. See also JPEG formats	control wheel, 10-11, 37, 40, 49 50
with telephoto lenses, 260	Setup menu options, 100
computers. See also transferring images	converging lines with wide-angle lenses
to computer	258
formatting memory cards in, 13	copperhillimages.com, sensor brush
netbooks, backing up images on, 323	from, 333
tablet computers, 213–215	Corel Paint Shop Pro, 310
connection plate cover, 57–58	Corel Painter, 310
Continuous Advance mode, 22	Corel Photo Paint, 309-310
	Corel PhotoImpact, 311

cost	dates and times
of continuous light, 277	Date Form folder naming, 125–126
of flash, 277	MF Assist Time options, Setup menu,
Costco, Eye-Fi cards for uploading to,	104
210	printing dates on images, 97
Cowboy Studio adapters, 249	Setup menu options for setting, 117
Creative Styles, 209	world time zone settings, Setup menu,
Brightness/Color menu options, 91	117
LCD panel readout on, 47	David Busch's Quick Snap Guide to
for movies, 220	Lighting, 292
sharpness, adjusting, 209	dawn, color temperature at, 278–279
in standard information display, 43	daylight
triple-dial control settings, 55	color temperature of, 277–279
working with, 208–210	movies, lighting for, 233
crop factor, 240-241 cropping	Daylight Savings Time options, Setup menu, 117
in Adobe Camera Raw, 312	Daylight WB (white balance), 87, 198
crop factor, 240–241	Deep Creative Style, 91, 209
cross fades in movies, 226	default reset options, Setup menu, 123
curving inward lines with telephoto	degrees Kelvin, 196
lenses, 261	of continuous light, 278
Custom Key settings, Setup menu, 115	for fluorescent light, 280
Custom Settings menu, Triple-dial-	delayed exposures, 191-192. See also
control options, 55–56	self-timer
Custom WB (white balance), 87,	Delete button, 40
196–198	Delete options, Playback menu, 92-93
setting, 201	Demo mode options, Setup menu, 123
CyberSync triggers, 295	depth-of-field (DOF). See DOF
36	(depth-of-field)
D	depth-of-focus, dust and, 328
_	depth-of-light, 274-275
Dali, Salvador, 184	Detail control, Adobe Camera Raw,
dark flash with telephoto lenses, 262	314–315
data recovery software, 325-326	diag+square grids, Setup menu, 103
database errors	Diana camera, 250
Recover Image DB function, Setup	diffusers, 294
menu, 126–127	diffusing light. See soft light
in standard information display, 43	Digital Image Converter SR, 309
Date Form folder naming, 125–126	digital image processing (DIP) chips, 80
	Digital Image Recovery, 325

digital zoom options, Camera menu,	drive modes
66–67	bracketing with, 150
diopter correction wheel, 37-38	Camera menu options, 64-65
direction	LCD panel readout on, 46
Sweep Panorama direction, Image Size	in standard information display, 43
menu, 84, 159	DRO (D-Range Optimizer), 40, 129
3D Sweep Panorama direction, Image	Brightness/Color menu options, 88
Size menu, 83, 160	LCD panel readout on, 47
direction buttons, 37, 41–42	triple-dial control settings, 54
DISP button, 37, 42	working with, 202–204
Camera menu options, 70–75	duration of light, 133
Display Color options, Setup menu, 119	dusk, color temperature at, 278–279
dissolves in movies, 226	dust. See also sensor cleaning
distance scale on lens, 59	avoiding, 329-330
distortion	body cap protecting sensors from, 8
movies, panning in, 224	cloning dust spots, 328, 330
Setup menu options, 111–113	FAQs about, 327
with telephoto lenses, 261	identifying/dealing with, 328
with wide-angle lenses, 256–259	DVDs
DMF (direct manual focus)	backing up folders on, 81
Camera menu options, 65	with PMB (Picture Motion Browser),
MF Assist options, Setup menu, 104	223
working with, 172	dynamic range, 131. See also DRO
DOF (depth-of-field), 168-170	(D-Range Optimizer); HDR (High
with A (Aperture priority) mode, 142	Dynamic Range)
focus and, 164	triple-dial control settings, 54
focus stacking and, 178–180	
and movies, 236–237	E
with wide-angle lenses, 255–256	e-mail, offloading pictures to, 215
doughnut effect, 262	E series lenses, 4
Down/exposure compensation/playback	Eclipse solution, Photographic
index button, 37, 42	Solutions, 334
downloading with PMB (Picture Motion	Edgerton, Harold, 185
Browser), 303	Edison, Thomas, 279
DPOF (Digital Print Order Format)	editing, 309-314. See also image editors;
Playback menu options, 96–97	RAW utilities
setup for, 97	18% gray cards, 135-138
drag-and-drop for transferring images to computer, 309	apps for, 216
Drive mode button, 37, 44	electrical contacts on lens, 58-59
Drive mode button, 3/, 44	electronic viewfinder. See EVF
	(electronic viewfinder)

emitted light, 133 exposure modes. See also A (Aperture priority) mode; M (Manual) mode; eneloop cells, 292 P (Program) mode; S (Shutter Enlarge Image options, Playback menu, priority) mode selecting, 141–147 equivalent exposures, 135 external flash, 288-292 establishing shots in movies, 226, 228 HVL-F20AM flash unit, 288, 291-292 European Union and movie recording, HVL-F36AM flash unit, 288, 291 HVL-F43AM flash unit, 291 EV (exposure compensation) HVL-F58AM flash unit, 288-291 Brightness/Color menu options, 85-86 setups for, 295 changing, 145 extra batteries, 4 histograms and adjusting, 156 extreme close-ups in movies, 228-229 ISO sensitivity for adjusting, 148 Eye-Fi cards, 210-212 LCD panel readout on, 47 Endless Memory feature, 212 for movies, 223 geotagging with, 211 in standard information display, 43 movies, uploading, 127 EV (exposure compensation) button, 37, transferring images to computer with, 42 evenness of illumination Upload settings, Setup menu, 127, 211 with continuous light, 274 Eye-Start AF with flash, 274-275 settings, 101 EVF (electronic viewfinder), 5 Setup menu options, 108–109 Brightness settings, Setup menu, 119 eyepiece cup, 37-38 Camera menu display options, 70, 75 eyepiece sensor, 37-38 Setup menu options, 101 window, 37-38 expanded color space, 107 F exposure, 129-162. See also bracketing; f/stops, 133-134 ISO sensitivity; long exposures; explanation of, 134 overexposure; underexposure **Face Detection** Adobe Camera Raw, adjusting in, 313 Camera menu options, 67–68 apps for estimating, 215 LCD panel readout on, 46 calculation of, 135-138 in standard information display, 43 continuous light, calculation with, 274 working with, 177 correct exposure, example of, 136 Face Registration equivalent exposures, 135 Camera menu options, 68 explanation of, 130-135 Order Exchanging option, 68 flash, calculation with, 274 **Facebook** short exposures, 182-185 Eye-Fi cards for uploading to, 210 triple-dial control settings, 50-51 offloading pictures to, 215

faces with telephoto lenses, 261	flange to sensor distance, 249
falling backwards effects with wide-	flare with telephoto lenses, 262
angle lenses, 256–257	flash, 23-24. See also Auto Flash;
FAQs about dust, 327	built-in flash; external flash; fill
fast shutter speeds, 180	flash/fill light
FEV (flash exposure compensation)	basics of, 281–286
Brightness/Color menu options, 87–88	continuous light compared, 272–277
with built-in flash, 288	cost of, 277
LCD panel readout on, 46	evenness of illumination with, 274–275
in standard information display, 43	exposure calculation with, 274
file formats. See movies	flexibility of, 277
files	freezing action with, 275-276
managing, 81	LCD panel readout on, 46
Number options, Setup menu, 124	multiple light sources, 295-297
fill flash/fill light, 286-287	previewing with, 274
Adobe Camera Raw, reconstructing in,	setups for, 295
313	telephoto lenses, dark flash with, 262
apps for, 216	flash modes
Camera menu options, 65	Camera menu options, 65
for movies, 231	LCD panel readout on, 46
working with, 287, 294	Flash Off mode, 24, 286
filter thread on lens, 59	Camera menu options, 65
filters. See also neutral-density (ND)	Flash pop-up button, 37-38
filters	Flash WB (white balance), 87, 198
CC (Color Compensation) filters, 200	flat faces with telephoto lenses, 261
UV filters with telephoto lenses, 262	flat lighting for movies, 232-233
wide-angle lenses, polarizing filters	flexibility
with, 258	of continuous light, 277
final setup, 7-12	of flash, 277
Finder Display options, Camera menu,	Flexible Spot, 21
70	Camera menu options, 65-66
FireWire 800 card readers, 308	center controller button and, 41
firmware, 318	working with, 175–177
batteries for updates, 318	flicker, 222
updating, 318–320	Flickr
Version display, Setup menu, 122, 319	Eye-Fi cards for uploading to, 210
first-curtain sync, 281–286	offloading pictures to, 215
ghost images and, 285–286	fluorescent light, 280
Setup menu options, 109	WB (white balance), adjusting, 281
fisheye lenses, bowing outward lines with, 258	Fluorescent WB (white balance), 87, 198

foamboard reflectors. See reflectors freezing action focal lengths with continuous light, 275 with flash, 275-276 apps for calculating, 216 wide-angle lenses, polarizing filters with S (Shutter priority) mode, 144 with, 258 short exposures for, 182–185 focal plane, 48 SteadyShot and, 269 focus. See also AF (autofocus); Contrast front focus, 263 Detection; MF (manual focus); front sync. See first-curtain sync Phase Detection front view of camera, 33-36 circles of confusion, 168-170 Fujian 35mm f/1.7 optic, 249 explanation of, 163-166 full-frame cameras, crop factor and, 241 focus peaking, 103-105 FX, Adobe Camera Raw, 314–315 lenses, fine-tuning focus of, 263–268 with telephoto lenses, 259-260 G triple-dial control settings, 50-52 GE color rendering index (CRI), 281 focus modes, 20, 166-167. See also AF Gefen's HDMI to Composite Scalar, 36 (autofocus); MF (manual focus) Gepe card safes, 324 Camera menu options, 66 GGS glass shields for LCD, 321-322 LCD panel readout on, 46 ghost images, 275 in standard information display, 43 sync speed and, 285-286 focus peaking, 103-105 ghoul lighting for movies, 233 focus points, 20-21, 170-171 Giottos Rockets, 330, 332 focus stacking, 178-180 glass shields for LCD, 320-321 foggy contrast with telephoto lenses, 262 Goddard, Jean-Luc, 227 folders GPS devices, 210 managing files in, 81 Eye-Fi cards and, 211 Name options, Setup menu, 125 graphic information display, 11-12, 42, New Folder options, Setup menu, 126 44 Select Shooting Folder options, Setup Camera menu options, 70–71 menu, 125-126 gray cards, 135-138 font size display options, Camera menu, apps for, 216 70,72 grids foregrounds for movies, 220 with telephoto lenses, 260 Setup menu options, 103 with wide-angle lenses, 256 foreign language options, Setup menu, 116 Н formatting memory cards. See memory halogen light, 279 cards Halsman, Philippe, 184 Fotodiox adapters, 249 hand grip, 33-34 frame rates for movies, 221-223 Hand-held Twilight mode, 17

working with, 158

Hand tool, Adobe Camera Raw, 312	horizontal composition in movies,
handheld microphones, 235	226–227
Hasselblad H4D-50 camera, 241	hot shoe/accessory shoe, 48
hazy contrast with telephoto lenses, 262	hot/stuck pixels, 327
HDMI port, 35-36	Hotspot Access, 211
HDMI to Composite Scalar, Gefen, 36 HDR (High Dynamic Range), 131–132.	HSL/Grayscale control, Adobe Camera Raw, 314–315
See also Auto HDR	HVL-F20AM flash unit, 288, 291–292
bracketing and, 150	HVL-F36AM flash unit, 288, 291
HDR Painting effect, 90	HVL-F43AM flash unit, 291
Merge to HDR Pro command,	HVL-F58AM flash unit, 288–291
204–208	11 v L-1 JOANI Hash tillt, 200–271
in standard information display, 43	1
HDR Painting effect, 90	Image Data Converter SR, 80, 301–302
HDTV	WB (white balance), adjusting, 281
CTRL for HDMI options, Setup menu,	working with, 304–306
120	Image Data Lightbox SR, 301–302
HDMI port for, 35–36	working with, 303–304
HDMI Resolution options, Setup menu,	image editors, 310–311. See also Adobe
120	Photoshop/Photoshop Elements
interlaced scanning and, 221–222	chromatic aberration correction with,
Playback menu's 3D viewing options for,	111
96	color casts, removing, 196
remaining shots and, 14	distortion correction with, 111
Helicon Focus, 180	dust filters, 330
Help Guide display, Setup menu, 117	flicker, dealing with, 222
High contrast monochrome effect, 90	red-eye reduction with, 100–101
high ISO noise, 150-152	image processing, 201–210
Setup menu options, 109–110, 152	image quality. See also JPEG formats;
high-speed sync with HVL-F58 AM	RAW formats; RAW+JPEG format
flash unit, 290	LCD panel readout on, 45
histograms, 11, 152-156	in standard information display, 43
brightness histograms, 153–156	Image Recall, 325
Camera menu options, 70, 75	image sensors, 32, 34
displaying, 154	image size. See also Image Size menu;
RGB histograms, 153–156	JPEG formats; RAW formats;
in standard information display, 43	RAW+JPEG format
Holga camera, 250	LCD panel readout on, 45
hoods. See also lens hoods	in standard information display, 43
for LCD, 321	still image options, Image Size menu, 76–77

Image Size menu, 62, 76–85 Movie options, 85, 219-220 Quality options, 79-81 still images options, 76-81 Sweep Panorama mode options, 83-84 3D Sweep Panorama mode options, 82 - 83image stabilization. See SteadyShot iMovie, 234 incandescent/tungsten light, 279-280 Incandescent WB (white balance), 87, index screens. See thumbnails information displays, 11-12. See also graphic information display; histograms; standard information display basic information display, 11 Camera menu options, 70 for movies, 221 initial setup, 5-7 instruction manuals. See manuals Intelligent Auto mode, 16-17 Flash Off mode in, 24 triple-dial control settings, 50-51 working with, 156-157 intensity of light, 132 interlaced scanning, 221-222 interleaving shots on memory cards, 322-323 interline twitter, 222 inverse square law, 274–275 iPads, 213-215 offloading pictures to, 215 iPhones, 213, 215 iPod Touch, 213-214 IR remote. See also Remote Commander

for focus stacking, 179

ISO sensitivity. See also high ISO noise

adjusting, 22, 148
Brightness/Color menu options, 86
LCD panel readout on, 47
setting exposure with, 135
in standard information display, 43

I

JPEG formats. See also RAW+JPEG format

DRO (D-Range Optimizer) and, 202–204 Image Size menu options, 79–81 LCD panel readout on, 45 RAW formats compared, 80–81 for 3D Sweep Panorama mode, 160–161 judder, 222–223 jump cuts in movies, 226–227 jumping photos, 184

K

Kelvin standard. *See* degrees Kelvin Kindle Fire, 213–215 Kinkade, Thomas, 271 Kodak Gray Cards, 138

L

LA-EA1/LA-EA2 adapters. See lens adapters Landscape Creative Style, 91, 209 Landscape mode, 16–17 working with, 157 Language options, Setup menu, 116 lapel microphones, 235 lateral/transverse chromatic aberration, 258 lavalieres, 235

LCD	CCTV lenses, 249–250
acrylic/glass/polycarbonate shields for,	chart for evaluating focus, 266-268
320–321	cleaning, 329
brightness options, Setup menu, 118	clearing adjustment values, 264
Camera menu options for LCD display,	compatible lenses, 239
70–71	components of, 58–59
panel readouts, 45–47	contacts for, 33-34
plastic overlays for, 320	current focus, evaluating, 266-268
protecting, 320–321	fine-tuning focus of, 263–268
Setup menu options, 101	focus target for, 266–268
Sunny Weather setting, Setup menu, 118	Lens Compensation options, Setup menu, 111–113
Wide Image options, Setup menu, 119	light passed by, 133
Leaf Aptus II digital back, 241	mounting lenses, 7
leaping photos, 184	for movies, 236–238
LED video lights, 231	point of sharpest focus, 264-265
Left/drive mode/self-timer button, 37,	Release w/o lens options, Setup menu
44	108
lens adapters, 239	selecting lenses, 241–245
third-party adapters, 249	SteadyShot and, 269
working with, 245–248	third party lenses, 248–250
lens bayonet, 58–59	unpacking, 4
Lens Compensation options, Setup	uses for; 251–255
menu, 111–113	weight of lenses, 248
Lens Corrections, Adobe Camera Raw,	Level display, Camera menu, 70, 74
314–315	light, 271-300. See also continuous
lens hoods, 8	light; fill flash/fill light; flash
bayonet for, 58–59	duration of, 133
with telephoto lenses, 262	emitted light, 133
lens mounting index, 33–34	movies, lighting for, 231-233
lens multiplier factor, 240–241	multiple light sources, 295 297
Lens release button, 33–34	reflected light, 133
Lensbabies, 249–251	sensors, light captured by, 133
Composer Pro, 251	shutter, light passed through, 133
Edge, 251	source, light at, 132
example of effects, 251–252	transmitted light, 133
lenses, 239–270. See also A-mount	Light Creative Style, 91, 209
lenses; specific types	light sensor, 37-38
AF (autofocus), fine-tuning for, 264	light stands, 297–298
apps for selecting, 215	light trails with long exposures, 189
calibrating, 264	linearity of lenses and movies, 238
categories of, 255	

liquid cleaning sensors, 332, 334-335	maximum aperture of zoom lens, 238
lithium-ion batteries. See batteries	MediaRecover, 325
live view	medium shots in movies, 228–229
Camera menu options, 70, 73	Memory card access lamp, 58
Setup menu options, 102	memory cards, 1. See also Eye-Fi cards;
shooting modes, selecting, 16	movies; remaining shots
in standard information display, 43	compartment door for, 57
lomography, 250	continuous shooting and, 195
long exposure noise, 152	Display Card Space options, Setup
Setup menu options, 109–111, 152	menu, 127
long exposures, 185-191. See also long	eggs in one basket argument, 321–322
exposure noise	failure rates for, 323-324
bulb exposures, 186–187	formatting, 13–14
time exposures, 186–187	problems with, 324
timed exposures, 186–187	Setup menu options, 13, 123
working with, 187–191	by transferring images to computer,
longitudinal/axial chromatic aberration,	13
258	inserting, 9–10
	interleaving shots on, 322-323
M	LCD panel readout on, 45
	number of shots/movie footage on,
M (Manual) mode, 16, 18	13–14
bracketing in, 150	protecting images on, 324-326
flash options, 24	resolution size and, 79
triple-dial-control settings, 51	in standard information display, 43
working with, 146–147	troubleshooting problems, 321–326
Macro mode, 17	Memory Stick memory cards. See
flash options, 24	memory cards
working with, 157	MENU button, 1
macro photography	shooting mode, selecting, 15
focus stacking and, 178–180	menus
Lensbabies for, 251	explanation of, 62–63
Magic Tape for sensor cleaning,	Setup menu's Menu Start options, 115
335–336	working with, 63
magnifiers for sensor cleaning, 335	Merge to HDR Pro command, 150,
Mamiya 645DF camera, 241	204–208
Manual mode (M). See M (Manual)	metering modes, 19
mode	Brightness/Color menu options, 87
manuals, 4	LCD panel readout on, 46
camera guide apps, 215	selecting, 139–141
Mass Storage setting, 121, 306-307	in standard information display, 43

MF (manual focus)	frame rates for, 221–223
Camera menu options, 65	information displays for, 221
explanation of, 167	interlaced scanning, 221-222
focus peaking with, 103-104	LCD panel readout on, 46
triple-dial control settings, 53	lenses for, 236-238
working with, 171–172	lighting for, 231–233
MF Assist feature	linearity of lenses and, 238
Setup menu options, 104	memory cards
triple-dial control for, 53	recording capacity of, 14
microphones, 33-35	selecting, 218, 220
directionality with external mics, 235	overheating, avoiding, 218-219
external mics, 218, 221, 234-236	panning in, 224
port for, 36	preparing to shoot, 219-221
tips for using, 234	progressive scanning, 222
wireless mics, 236	Protect options, Playback menu, 95
Miniature effect, 90–91	Record Setting options, Image Size
Minolta lenses	menu, 85, 219–220
first-curtain sync and, 282	reviewing, 25
lenses, 239	shooting scripts for, 225
Maxxum 7000, 240	shot types in, 228–230
mirror lenses, 262	side space in, 227
Mode button, 16	Slide Show options for, 93–94
monolights, 295–296	soft light for, 231–232
motion	standard information display, recording
focus and, 168	mode in, 43
and Sweep Panorama mode, 159-160	steps in making, 223–224
motor drive. See continuous shooting	storyboards for, 225
Movie recording button, 37, 39	storytelling in, 225–226
movies, 24-25, 217-238. See also audio;	styles of lighting for, 232–233
wind noise reduction	time dimension in, 228
AF (autofocus) for, 220, 223	tips for shooting, 224–230
aspect ratio for, 220	transition in, 227
barreries for, 218	transitions in, 226
composition tips, 226–230	tripods for, 224
Creative Style for, 220	29 minute limitation, reasons for, 219
DOF (depth-of-field) and, 236-237	types of shots in, 226, 228-230
EV (exposure compensation) for, 223	WB (white balance) for, 220
Eye-Fi cards, uploading movies with,	zoom lenses for, 237-238
127	zooming in/out in, 218, 223
file formats, 219, 221-223	

Image Size menu options, 85

MP4 format, 219–220	normal lenses, 255
multi AF-area, 174–175	Novoflex adapters, 249
Camera menu options, 65–66	NTSC standard, 120, 219
multi focus zone, 21	progressive scanning and, 222
multi metering, 19, 87	numbering files, Setup menu options
working with, 139–140	for, 124
Mylar reflectors. See reflectors	
	0
N	
	Object Tracking
names	Camera menu options, 66
Date Form folder naming, 125–126	in standard information display, 43
Folder Name options, Setup menu, 125	working with, 177–178
natural sounds in movies, 234	On/Off switch, 10, 48–49
Navigation button, 33–34, 48–49	Online Sharing with Eye-Fi cards, 210
neck/shoulder straps, 4-5	OnTrack software, 325
mounting ring for, 33–34	Optical SteadyShot (OSS). See
netbooks, backing up images on, 323	SteadyShot
Neutral Creative Style, 91	out-of-box defects, 3–4
working with, 208	outdoor lighting for movies, 233
neutral-density (ND) filters, 189	over the shoulder shots in movies, 230
long exposures and, 186	overexposure, 136-137
Newton, Isaac, 274	example of, 130–131
Night Creative Style, 91	histogram of, 154–155
night/darkness. See also Hand-held	overheating
Twilight mode	movies and, 218–219
with long exposures, 190-191	standard information display, warning
Night Portrait mode, 17	in, 43
working with, 158	oversized subjects with wide-angle
Night Scene Creative Style, 209	lenses, 256
Night Scene mode, 17	
working with, 158	P
Nikon-to-E-Mount adapter, Fotodiox,	P (Program) mode, 16, 18
249	aperture selection in, 135
Nixon, Richard, 184	
noise, 150-152. See also high ISO noise;	bracketing in, 150
long exposure noise; wind noise	flash options, 24
reduction	shutter speed selection in, 135
explanation of, 110	triple-dial control settings, 51
external mics and, 235	working with, 145
Setup menu options, 109-110, 152	PAL standard, 120, 219

progressive scanning and, 222

panning in movies, 224	plastic overlays for LCD, 320
Panorama mode. See Sweep Panorama	Playback button, 37-38, 42
mode; 3D Sweep Panorama mode	Playback menu, 62, 91–97
Partial Color effect, 90	Delete options, 92–93
Paul C. Buff CyberSync triggers, 295	Enlarge Image options, 96
Peaking Color options, Setup menu,	Image Index options, 94
104–105	Printing options, 96–97
Peaking Level options, Setup menu,	Protect options, 95
103–105	Rotate options, 94
Pec-Pad swabs for sensor cleaning, 334	Slide Show options, 93–94
Pelican card safes, 324	3D viewing options, 96
perspectives	View mode options, 94
with lenses, 251, 253	Volume settings, 96
with short exposures, 185	PMB (Picture Motion Browser), 223,
Phase Detection, 164–166	301
focus points and, 170	working with, 302-303
lens adapters and, 239, 246	Pocket Wizard transmitters, 295
PhaseOne's Capture One 5 (C1 Pro),	polarizing filters with wide-angle lenses,
309	258
Photo Downloader, Photoshop	polycarbonate shields for LCD, 320-321
Elements, 308–309	Pop Color effect, 89
Photo Rescue 2, 325	pop-up flash. See built-in flash
PhotoAcute, 180	Portrait Creative Style, 91, 209
Photographic Solutions	Portrait mode, 16–17
Eclipse solution, 334	flash options, 24
swabs for sensor cleaning, 334	working with, 157
Photomatix, 131–132	portraits
Photoshop/Photoshop Elements. See	backgrounds for, 299
Adobe Photoshop/Photoshop Elements	flat faces with telephoto lenses, 261
	high-speed portraits, 184
PictBridge-compatible printers and PTP (Picture Transfer Protocol), 121	self-portraits, self-timer for, 191
Picture Effects	Posterization effect, 89
Brightness/Color menu options, 89–91	power. See also AC power; batteries
in standard information display, 43	for monolights, 297
triple-dial control settings, 55	Setup menu's Power Save options,
Picture Motion Browser (PMB). See	117–118
PMB (Picture Motion Browser)	for studio flash, 296
pincushion distortion with telephoto	turning on, 10
lenses, 261	power zoom feature for movies, 238
pixels. See also histograms; sensors	Precision digital zoom options, Camera
hot/stuck pixels, 327	menu, 66–67
1	

Presets tab, Adobe Camera Raw, RAW+JPEG format file management for, 81 previewing Image Size menu options, 79–81 with continuous light, 273 LCD panel readout on, 45 with flash, 274 rear-curtain sync. See second-curtain printers and printing. See also DPOF (Digital Print Order Format) rear lens cap, 7-8 PictBridge-compatible printers and PTP Recover Image DB function, Setup (Picture Transfer Protocol), 121 menu, 126-127 Playback menu options, 96-97 Recover My Photos, 325 product photography, backgrounds for, recovering images/details in Adobe Camera Raw, 313 Program mode (P). See P (Program) data recovery software, 325-326 mode Setup menu options, 126–127 progressive scanning, 222 rectilinear lenses, 258 protecting red-eye reduction LCD, 320-321 in Adobe Camera Raw, 312 memory cards, images on, 324-326 with built-in flash, 287-288 Playback menu options, 95 Setup menu options, 100-101 PTP (Picture Transfer Protocol), 121 in standard information display, 43 reflected light, 133 Q reflectors with flash, 294 quick guides, apps for, 216 for movies, 233 registration information, 4 R Release w/o lens options, Setup menu, RadioPopper transmitters, 295 108 Rainbow Imaging remaining shots, 13-14 adapters, 249 LCD panel readout on, 45 LCD, hoods for, 321 in standard information display, 43 RAW formats. See also RAW utilities; Rembrandt, 271 RAW+JPEG format Remote Commander, 22, 64-65 Image Data Lightbox SR with, 303–304 with long exposures, 187 Image Size menu options, 79–81 remote sensor for, 33-34 JPEG formats compared, 80–81 self-timer effect with, 192 LCD panel readout on, 45 remote sensor, 33-34 WB (white balance), adjusting, 281 RescuePRO, 326 RAW utilities, 311-314. See also Adobe Reset Default options, Setup menu, 123 Camera Raw; Image Data resolution and memory cards, 79 Converter SR retouching in Adobe Camera Raw, 312

WB (white balance), adjusting, 281

Retro Photo effect, 90	SAL-70200G 70-200mm f/2.8 G-series
revealing images with short exposures,	telephoto zoom lens, 253, 255
184	SAM lenses with lens adapters, list of,
reviewing images, 25-27. See also Auto	245
Review; Playback menu	saturation
movies, 25	Adobe Camera Raw, adjusting in,
as thumbnails, 26–27	314–315
zooming in/out on, 26	Creative Styles adjusting, 210
RGB histograms, 153-156	Scene (SCN) modes, 1-2, 16-18
Rich-tone monochrome effect, 90	center controller button and, 41
Right button, 37, 44	flash options, 24
Ritchie, Guy, 227	triple-dial control with, 50-51
rotating images	working with, 156-158
in Adobe Camera Raw, 312	Scotch Brand Magic Tape for sensor
Auto Rotate options, Setup menu,	cleaning, 335–336
119–120	SDHC memory cards. See memory card
Playback menu options, 94	SDXC memory cards, 9
on reviewing images, 26	second-curtain sync, 282-286
rule of thirds grids, Setup menu, 103	with built-in flash, 286
	Camera menu options, 65
S	ghost images and, 285–286
	Secure Digital cards. See memory cards
S (Shutter priority) mode, 16, 18	SEL-16F28 16mm f/2.8 lens, 241-242
bracketing in, 150	SEL-24F18Z Carl Zeiss Sonnar T* E
equivalent exposures in, 135	24mm f/1.8 ZA lens, 4, 243
flash options, 24	SEL-30M35 30mm macro lens, 244
triple-dial-control settings, 51	SEL-50F18 50mm f/1.8 OSS telephoto
working with, 144	lens, 243
SAL-16F28 16mm f/2.8 fisheye lenses,	SEL-1855 18-55mm f/3.5-5.6 zoom lens
253	241–242
SAL-30M28 30mm f/2.8 macro lens,	Select Shooting Folder options, Setup
253	menu, 125-126
SAL-50F14 50mm f/1.4 lens, 255	SEL-55210 55-210mm f/4.5-6.3 OSS
SAL-50M28 50mm f/2.8 macro lens,	lens, 244
253	SEL-18200 18-200mm f/3.5-6.3 OSS
SAL-100M28 100mm f/2.8 macro lens,	zoom lens, 241–242
253	self-timer, 64–65
SAL-118 DT 11-18mm f/4.5-5.6 zoom	(continuous) mode, 64–65
lens, 253	working with, 22-23, 191-192
SAL-135F18Z Carl Zeiss 135mm f/1.8 lens, 255	Self-timer button, 37, 44

Self-timer lamp, 33–34	Display Card Space options, 127
Sensor Brush, 333	Display Color options, 119
sensor cleaning, 326, 331-336	Distortion options, 111–113
air cleaning, 331–333	Eye-Start AF options, 108-109
batteries for, 332	File Number options, 124
brush cleaning, 331, 333	Finder/LCD settings, 101
liquid cleaning, 332, 334-335	Folder Name options, 125
Setup menu options, 121–122	Format options, 13, 123
tape cleaning, 332, 335–336	Front Curtain Shutter options, 109-110
sensors. See also sensor cleaning	Function settings, 115
body cap protecting, 8	Grid Line options, 103
eyepiece sensor, 37–38	HDMI Resolution options, 120
flange to sensor distance, 249	Help Guide display, 117
focal plane, 48	High ISO noise options, 109-110, 152
focus sensors, 170–171	Language options, 116
image sensors, 32, 34	LCD Brightness settings, 118
light captured by, 133	Lens Compensation options, 111-113
light sensor, 37–38	Live View display options, 102
relative size, comparison of, 236-237	Long exposure noise options, 109-110,
remote sensor, 33–34	152
Sepia Creative Style, 91, 209	Menu Start options, 115
sequential scanning, 222	MF Assist options, 104
settings cycles, 49-56	MF Assist Time options, 104
setup	Movie Audio Recording options, 114
final setup, 7–12	New Folder options, 126
initial setup, 5–7	Peaking Color options, 104–105
Setup menu, 62, 97-127	Peaking Level options, 103–104
AE-L/AF-L lock options, 99	Playback display options, 119–120
AF illuminator options, 100	Power Save options, 117–118
AF/MF switch options, 99–100	Recover Image DB function, 126–127
AF Micro Adjustment options, 115	Red Eye Reduction options, 100–101
Area settings, 117	Release w/o lens options, 108
Auto Review options, 103	Reset Default options, 123
Beep options, 116	Select Shooting Folder options,
Chromatic Aberration options, 111–113	125–126
Cleaning mode options, 121–122	Shading options, 111–112
Color Space options, 106	SteadyShot options, 107–108
CTRL for HDMI options, 120	Upload settings, 127, 211
Custom Key settings, 115	USB Connection options, 121
Date/Time setup options, 117	Version display, 122
Demo mode options, 123	Wide Image options, 119
Dial/Wheel Lock options, 100	Wind Noise reduction options, 114

Shade WB (white balance), 87, 198	slide shows
Shading options, Setup menu, 111-112	for movies, 93-94
sharpness	Playback menu options, 93–94
Creative Styles adjusting, 209	slow sync, 286
lenses for, 255	Camera menu options, 65
shooting modes, 16, 62	smart phones, 213
LCD panel readout on, 45	Smile Detection options, Camera menu,
selecting, 15–19	69
in standard information display, 43	Smile Shutter
shooting scripts for movies, 225	Camera menu options, 68
short exposures, 182-185	LCD panel readout on, 47
shotgun microphones, 235	in standard information display, 43
shots remaining. See remaining shots	Smugmug, Eye-Fi cards for uploading
shoulder straps. See neck/shoulder straps	to, 210
shutter	Snapshots tab, Adobe Camera Raw,
light passed through, 133	314–315
Release w/o lens options, Setup menu,	snoots, 299
108	sodium-vapor light, 280
Shutter priority mode (S). See S (Shutter	soft boxes, 294, 297-298
priority) mode	Soft Focus effect, 90
Shutter release button, 33, 48-49	Soft High-key effect, 90
shutter speeds. See also sync speed	soft keys, 10-11, 37, 39-41, 317
apps for advice on, 215-216	customizing functions, 50
equivalent exposure and, 135	LCD panel readout on, 47
explanation of, 134	in standard information display, 43
exposure settings with, 135	soft light
fast shutter speeds, 180	flash, diffusing light with, 293–294
ghost images and, 285–286	for movies, 231–232
LCD panel readout on, 47	Soft Skin effect
limits on, 181	Camera menu options, 69
in P (Program) mode, 135	in standard information display, 43
in standard information display, 43	software. See also image editors
Shutterfly, Eye-Fi cards for uploading	CD for application software, 4
to, 210	data recovery software, 325-326
silhouette effects, 129	Sony Alpha NEX-7
M (Manual) mode for, 146-147	back view of, 37–45
single shooting, 64–65	bottom view of, 57–58
Single-Shot Advance mode, 22	front view of, 33–36
single-shot AF (AF-S). See AF-S (single-	top view of, 48–49
shot AF)	Sony Bravia system, 121
	sound. See audio

source, light at, 132	still images
spare batteries, 4	aspect ratio options, Image Size menu,
speaker, 57-58	77–78
speed. See also shutter speeds	Image Size menu options, 76–81
lenses for, 255	quality options, Image Size menu,
SteadyShot and, 269	79–81
Speed Priority Continuous mode, 22,	Sto-fen diffusers, 294
64–65, 194	storyboards for movies, 225
spherical aberration, 262–263	storytelling in movies, 225–226
Split Toning control, Adobe Camera	straightening in Adobe Camera Raw,
Raw, 314–315	312
Sports Action mode, 16-17	streaks with long exposures, 188
working with, 157	stuck pixels, 327
sports photography	studio flash, 294–296
continuous shooting for, 193-194	live view display with, 102
memory cards for, 322	M (Manual) mode and, 146
S (Shutter priority) mode for, 144	Sunny Weather setting for LCD, 118
short exposures for, 182-185	Sunset Creative Style, 91, 209
telephoto lenses for, 259	Sunset mode, 16–17
Spot metering, 19, 87	working with, 157
gray cards with, 138	super-sized subjects with wide-angle
working with, 140–141	lenses, 256
square grids, Setup menu, 103	super-telephoto lenses, 255
sRGB, 106-107	surreal images with short exposures, 184
SSM lenses with lens adapters, list of,	swabs for sensor cleaning, 334
246	Sweep Panorama mode, 16, 18. See also
Standard Creative Style, 91	3D Sweep Panorama mode
working with, 208	Direction options, Image Size menu, 84,
standard information display, 11-12,	159
42–43	Image Size menu options, 83–84
Camera menu options, 70, 72	moving subjects and, 159–160
SteadyShot	working with, 158-159
LCD panel readout on, 47	Sylvania color rendering index (CRI),
lenses and, 269	281
Setup menu options, 107–108	sync speed, 281-286. See also first-
in standard information display, 43	curtain sync; second-curtain sync;
telephoto lenses and, 260	slow sync
Stegmeyer, Al, 4	ghost images and, 285–286
stepping back with wide-angle lenses,	high-speed sync with HVL-F58 AM
256	flash unit, 290
Stereo Photo Maker, 161	problems, avoiding, 283–284

T	Trinavi combination. See
tablet computers, 213–215	triple-dial-control
Tamron VC lenses, 248, 250	triple-dial-control, 34, 49–56
tape cleaning sensors, 332, 335–336	Creative Styles settings, 55
tele-zoom lenses. See telephoto lenses	Custom Settings menu options, 55–56
telephoto lenses, 255, 259–263	exposure settings, 50–51
bokeh and, 262–263	focus settings, 50–52
problems, avoiding, 261–262	MF (manual focus) settings, 53
television. See also HDTV	Picture Effect settings, 55
HDMI port for, 35–36	WB (white balance) settings, 54
interlaced scanning and, 221–222	tripods
three-point lighting for movies, 232	for focus stacking, 179
3D Sweep Panorama mode, 16, 18	lens adapters, mounts on, 248
Direction options, Image Size menu, 83,	for long exposures, 187
160	for movies, 224
Image Size menu options for, 82-83	socket for, 57
triple-dial control settings, 51	tungsten light, 279–280 12 to 18% gray cards, 135–138
viewing images, 161	two shots in movies, 230
working with, 160–161	two shots in movies, 250
3D viewing options, Playback menu, 96	
thumbnails	U
Image Data Lightbox SR displaying,	ultra-wide angle lenses, 255
303–304	umbrellas
Playback menu options, 94	with flash, 294
PMB (Picture Motion Browser)	light stands holding, 297–298
displaying, 302–303	underexposure, 137
reviewing images as, 26–27	example of, 130–131
time exposures, 186–187	histogram of, 154-155
timed exposures, 186–187	in M (Manual) mode, 146–147
Tone Curve control, Adobe Camera Raw, 314–315	unpacking hox, 3-4
top view of camera, 48–49	unreal images with short exposures, 184
Toy Camera effect, 89	Up/DISP button, 37, 42
transferring images to computer, 27–29,	updating firmware, 318–320
306–309	UPstraps, 4–5
with card readers, 27-28, 307-309	USB cables, 4
drag-and-drop for, 309	Connection options, Setup menu, 121
formatting memory cards by, 13	transferring images to computer with, 28, 306–307
with USB cables, 28, 306-307	USB ports, 35
transition in movies, 227	user manuals. See manuals
transitions in movies, 226	UV filters with telephoto lenses, 262
transmitted light, 133	With telephoto lelises, 202

V
VCL-ECF1 fisheye conversion lens,
244-245
VCL-ECU1 wide-angle conversion lens,
244
perspectives with, 253-254
Version display, Setup menu, 122, 319
vestibule, cleaning, 329-330
VGA format, 220
vibrance adjustments in Adobe Camera
Raw, 314–315
video. See movies
View mode options, Playback menu, 94
viewfinder. See EVF (electronic
viewfinder)
vignetting, Setup menu's Shading
options for, 111–112
virtual shooting mode dial, 15
visible light, 132
Vivid Creative Style, 91
working with, 208
VA/

W

Walmart, Eye-Fi cards for uploading to,
210
warranty cards, 4
waterfalls, blurring, 190
WB (white balance). See also Custom
WB (white balance)
adjusting, 22
Adobe Camera Raw, adjusting in, 312,

313
Auto WB (white balance), 87, 198
Brightness/Color menu options, 87
color temperature, setting by, 200
for continuous light, 281
cooler or warming adjustments, 200
fine-tuning preset WB, 199–200
green/magenta bias settings, 200

LCD panel readout on, 46-47 mismatched WB settings, 196-198 for movies, 220 in standard information display, 43 triple-dial control settings with, 54 wedding photography JPEG format for, 80 memory cards for, 322 White, Jack and Meg, 250 white balance (WB). See WB (white balance) Wi-Fi, 210-212. See also Eye-Fi cards Wi-Fi Positioning System (WPS), 211 wide-angle lenses, 255 distortion with, 256-259 perspectives with, 253-254 problems, avoiding, 258–259 working with, 255-257 Wide Image options, Setup menu, 119 wide-zoom lenses. See wide-angle lenses wildlife photography, telephoto lenses for, 259-260 wind noise reduction, 236 Setup menu options, 114 window light, diffusing light and, 293

window light, diffusing light and, 293 Windows Movie Maker, 234 Windsor, Duke and Duchess of, 184 wipes in movies, 226 wireless external microphones, 236

wireless flash, 286 world time zone settings, Setup menu, 117

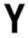

YouTube, Eye-Fi cards for uploading to, 210

Zagg plastic overlays, 320 zoom lenses. *See also* telephoto lenses; wide-angle lenses

for movies, 237–238

zoom range for movies, 238

zoom ring on lens, 58–59

zoom scale on lens, 58–59

Zoom tool, Adobe Camera Raw, 312

zooming in/out

in movies, 218, 223
Precision digital zoom options, Camera menu, 66–67
on reviewing images, 26

Like the Book?

Let us know on Facebook or Twitter!

facebook.com/courseptr

twitter.com/courseptr

YOUR COMPLETE SOLUTION

Course Technology PTR has your complete digital photography solution. Created with the expertise of bestselling author and photographer David Busch, we now offer books, iPhone applications, and field guides on the latest digital and digital SLR cameras from Canon, Nikon, Sony, Olympus, and Panasonic. These three formats allow you to have a comprehensive book to keep at home, an iPhone app to take with you when you're on-the-go, and a pocket-sized compact guide you can store in your camera bag. Now all the camera information you need is at your fingertips in whatever format you prefer.

Camera Guides

David Busch is the #1 bestselling camera guide author. A professional photographer with more than 20 years of experience and over a million books in print, David provides expert authority to these guides, covering digital and digital SLR cameras from Canon, Nikon, Sony, Olympus, and Panasonic. Featuring beautiful full-color images, David Busch camera guides show you how, when, and, most importantly, why to use all the cool features and functions of your camera to take stunning photographs.

iPhone Apps NEW!

Now take the expert advice of bestselling camera guide author David Busch with you wherever you take your iPhone! You'll find the same rich information as our camera guides as well as new interactive and multimedia elements in an easy-to-access, searchable, portable format for your onthe-go needs. Visit the iTunes store for more information and to purchase.

Compact Field Guides

Are you tired of squinting at the tiny color-coded tables and difficult-to-read text you find on the typical laminated reference card or cheat sheet that you keep with you when you're in the field or on location? David Busch's Compact Field Guides are your solution! These new, lay-flat, spiral bound, reference guides condense all the must-have information you need while shooting into a portable book you'll want to permanently tuck into your camera bag. You'll find every settings option for your camera listed, along with advice on why you should use-or not use-each adjustment. Useful tables provide recommended settings for a wide variety of shooting situations, including landscapes, portraits, sports, close-ups, and travel. With this guide on hand you have all the information you need at your fingertips so you can confidently use your camera on-the-go.